MECHADEMIA 7

Lines of Sight

Mechademia
An Annual Forum for Anime, Manga, and Fan Arts

FRENCHY LUNNING, EDITOR

Mechademia is a series of books published by the University of Minnesota Press devoted to creative and critical work on anime, manga, and the fan arts. Linked through their specific but complex aesthetic, anime, manga, and the fan arts have influenced a wide array of contemporary and historical culture through design, art, film, and gaming. This series seeks to examine, discuss, theorize, and reveal this unique style through its historic Japanese origins and its ubiquitous global presence manifested in popular and gallery culture. Each book is organized around a particular narrative aspect of anime and manga; these themes are sufficiently provocative and broad in interpretation to allow for creative and insightful investigations of this global artistic phenomenon.

Mechademia 1: *Emerging Worlds of Anime and Manga*
Mechademia 2: *Networks of Desire*
Mechademia 3: *Limits of the Human*
Methademia 4: *War/Time*
Mechademia 5: *Fanthropologies*
Mechademia 6: *User Enhanced*
Mechademia 7: *Lines of Sight*

MECHADEMIA

Lines of Sight

Frenchy Lunning, Editor

UNIVERSITY OF MINNESOTA PRESS MINNEAPOLIS • LONDON

http://www.mechademia.org

Spot illustrations by Jeff Peterson

Published by the University of Minnesota Press
111 Third Avenue South, Suite 290
Minneapolis, MN 55401-2520
http://www.upress.umn.edu

ISSN: 1934-2489
ISBN: 978-0-8166-8049-8

Printed in the United States of America on acid-free paper

The University of Minnesota is an equal-opportunity educator and employer.

19 18 17 16 15 14 13 12 10 9 8 7 6 5 4 3 2 1

Mechademia Editorial Staff

Contents

Worlds in Perspective

Introduction

THOMAS LAMARRE

RADICAL PERSPECTIVALISM

Lines of Sight sounds a call for *radical perspectivalism*. It calls for *getting to the root of perspective* and aims for a transfiguration of the values associated with a regime initially articulated by René Descartes in the registers of one-point perspective, coordinate geometry, and rationalist dualism. It may seem odd to make so much fuss about a mode or system dating from the seventeenth century. After all, subsequent developments in science and mathematics may be said to have surpassed Cartesian geometry and perspective, or at least to have shown their restrictions and limitations. The Cartesian paradigm may thus appear outdated today, easily relegated to a transitional role within classical or early modern sciences, or to the status of a precursor, an incomplete articulation outstripped by modern and contemporary forms of knowledge.

But *Lines of Sight* is not first and foremost concerned with the bare materiality or scientific accuracy of Cartesian geometry or one-point perspective. Rather it is concerned with *Cartesianism*. As Martin Jay reminds us in the context of visual culture, Cartesianism is not simply a structurally determined outcome of the use of one-point perspective or coordinate geometry. It is the combination of this mathematical mode with "Cartesian ideas of subjective rationality in philosophy" that served to make Cartesianism appear to be "the dominant, and even totally hegemonic, visual model of the modern era."[1] In other words, Cartesianism is a historically articulated mode of rationalism, implying a highly specific field of rationality. Central to Cartesian rationality

is the establishment of a series of conceptual and practical divides—between space and time, between body and mind, between object and subject. These divides became so entrenched and so identified with Enlightenment thought and rational thinking that modern Western thought is still frequently characterized in terms of such unrelenting dualism with its corresponding sense of a subjective mastery over nature implicit in certain modes of visual ordering, scaling, and mapping.

The problem, however, is not only that Cartesianism has dominated conceptualizations of modernity, providing the hegemonic model. But also, as a systematic attempt to ground various forms of inquiry, Cartesianism has shaped the ways in which we make connections across different disciplines or domains of knowledge—aesthetics, mathematics, history, biology, ethnography, physics, and philosophy. Nonetheless, while this collection of essays on Japanese media and popular culture proposes to go to the root of perspective and thus to overturn key aspects of Cartesianism, its goal is not, for instance, to denounce one-point perspective as inherently or deterministically fated to produce a hegemonic regime of modernity. Instead, the aim is to get to the root of this received regime of perspective in order to explore other modes and practices, other potentialities of perspective, which may have radical implications for determining what counts as art, or what makes for identity, and how we work across disciplines today. Indeed, as the use of the term "radical perspectivalism" indicates, *Lines of Sight* does not dispense with perspective. It is concerned with the radical potentiality of perspective, and not only in the field of vision. The emphasis on sight in the title is a lure or point of departure, designed to attract and activate a broader engagement with questions pertaining to aesthetics and to multisensory operations across fields of inquiry.

As such, even as it aims to uproot and overturn Cartesianism, *Lines of Sight* makes no claims to supersede or overcome it. This is not because we feel that Cartesianism plays such a deterministic role in modernity that it can never be overcome but only incessantly displaced or deconstructed. Rather the problem for us is that Japan has so often been situated outside Western modernity, as a site of overcoming Western modernity, that is, Cartesian dualism—yet such a gesture merely reinscribes and reinforces Cartesian dualism in a geopolitical register, usually in the form of an opposition between the spirituality and nondualism of the "Orient" or "Asia" versus the materiality and dualism of the West. The effect, if not the intent, of such a gesture is to shore up a divide between Japan and the West in order to consolidate their identities.

Take, for instance, a recent essay by Ian Hacking, a prominent historian

of science. Although his insightful account of Cartesian vision affords a useful point of departure for a critique of Cartesianism in Japan, he goes to great lengths to situate Japan outside his vision of modernity: "The Japanese had the good or ill fortune never to have a Descartes to form centuries of their culture. Indeed there are excellent Cartesian scholars in Japan, but the philosopher had no effect on the civilization. Thus the first part of my title, 'The Cartesian vision fulfilled,' is about a curiously Western vision of who we are."[2]

Although he presents this vision as "curiously" Western, there is, in fact, nothing unusual about this gesture. It is familiar self/other dialectics, in which self-identity is established by projecting difference onto the other. It is only by fixing the otherness of Japan that Hacking arrives at his Western vision of who he is. Significantly, his point of reference is Tezuka Osamu and manga. Hacking argues that Japanese manga never presents weird sex or cruelty in its exploration of human–machine relations—weird sex and cruelty appear in Western imitations of manga. This is Hacking's way of arguing that Japan integrates machines or robots into human society rather than anxiously objectifying them as Westerners do. The problem with such an approach is that, on the one hand, it generalizes from a handful of examples drawn from Tezuka, ignoring the genuine diversity of ways of dealing with human–machine relations in manga and Japan. On the other hand, it is clear that homogenizing and flattening Japanese society and popular culture is primarily designed to justify speaking, yet again, of a self-identical West. While Hacking to some extent "provincializes" the West's Cartesian vision, he ultimately erases the historical depth of Japanese engagements not only with Descartes and one-point perspective but also with Cartesianism.

Yet Hacking's desire to localize the divide between "analogue bodies and digital minds" as a Western vision is shattered by Livia Monnet's essay on Oshii Mamoru's *Innocence* in this volume, which carefully traces the animated film's evocations of Enlightenment conceptualizations of the mind/body problematic, showing precisely how the digital acerbates the divide. Similarly, Timon Screech's contribution reminds us of the centuries-old experimentation with one-point perspective in Japan. We might also consider the formative role of the philosophy of Nishida Kitarō in Japanese modernity. Nishida did not reject Descartes's philosophy but carefully worked through and incorporates some of its basic tenets even as Nishida engaged a philosophy of pure experience.[3] Indeed, while Nishida strived for nondualism, his geopolitical situation forced an awareness of the paradox of modern nondualism: if nondualism is compared and contrasted with dualism, is it not merely another mode of dualism?

In recent years, beginning with Murakami Takashi's first superflat exhibition and catalog in 2000, theories of superflat art have reopened questions about Cartesianism in manga, anime, and other forms of Japanese popular culture.[4] Such theories overlap with our concerns but embody an ambivalence that we do not share. On the one hand, superflat links Cartesian perspective to Western modernity in a deterministic manner, in an attempt to situate Japan outside modernity. On the other hand, even as superflat makes a linear connection between Edo art and contemporary manga and anime, it is clear that Cartesianism does not merely provide a point of reference for superflat; it refuses to go away. Thus the superflat results in heightened ambivalence, because Cartesianism (or modernity) is not, in fact, outside its self/other dialectics but central to it.

It is precisely to grapple with such concerns that *Lines of Sight* does not provincialize Cartesianism or otherwise propose to overcome it, but instead strives to overturn it from within by attending to the potentiality of perspective, as radical perspectivalism. In fact, it is important to note that the mechanism for producing self-identity, both in superflat theory and in Hacking's essay, is, in effect, Cartesian. Although I first described this gesture in terms of a self/other dialectics, which sounds of Hegelian overtones, the ultimate effect is more Cartesian than Hegelian because its aim is not to explore the movement of historical emergence and interaction but to map out and police the boundaries between self and other. Ironically, such efforts to place Japan outside Cartesian modernity wind up producing a thoroughly static geopolitical map of identities, merely applying the model of coordinate geometry to cultural formations. It is precisely such old-fashioned and self-serving gestures that *Lines of Sight* proposes to overturn, proceeding along four lines of inquiry.

The first group of essays advances the critique of Cartesianism as it has entered film and media studies. One current of film theory, popular in the 1960s and 1970s, argued that the monocular properties of the lens had encouraged cinema to adopt a mode of Cartesianism: the viewer assumed a position of subjective mastery over a world that had been objectified by the application of Cartesian ordering implicit in the camera lens. The argument inspired a series of responses, and while an exclusive emphasis on the lens was largely dismissed as a form of technological determinism, the broader lines of the argument proved compatible with other strands of film and semiotic theory taking issue with the establishment of closed, self-contained, or seamlessly "sutured" worlds in literature, cinema, and other arts—a sort of "illusionary realism" that was seen as an application of Cartesian principles

of subjectivity.[5] Simply put, the world on the screen, on the page, or on some other surface appeared to exist as a seamless objective whole independent of the viewer, affording an imaginary voyage into that world, while sustaining the viewer's sense of self-integrity, privacy, and supremacy. A variety of approaches has arisen for investigating how image-worlds or story-worlds negotiate the relation between subject and object in order to fuel the viewer's illusions of mastery and self-identity. What has proved persistent and powerful, however, is the basic critique of self-contained story- and image-worlds, which is at heart a critique of Cartesian dualism.

Such a critique tends to advance along two fronts. On the one hand, there is a search for gaps and ruptures in the apparently seamless world, calling attention to aesthetic operations that run counter to or disrupt narrative operations and conventions. Thus Marc Steinberg's essay focuses on various gaps or intervals within animation, drawing particular attention to how the gap between 2-D and 3-D imagery affords a way to disrupt homogeneity in animation, and arriving at a "fascinating spectacle of layers and textures" whose critical force lies in its power to forestall the construction of smoothly composited, self-contained worlds. Similarly, in her meticulous excavation of two characteristic features of shōjo manga (star-filled eyes and layouts in which a girl's body stretches across the page), Fujimoto Yukari calls attention to how such features break with regular, static, even rigid forms of layout. She shows how such rigid layouts became associated with story manga, and eventually, with goal-oriented action in shōnen manga. In effect, starry eyes and non-regular layouts do not merely break the rectilinear gridding of the page but, more importantly, reject a form of compositional closure in which regularity of spatialization implies a mode of causality in which subjects achieve mastery over objects through their actions.

On the other hand, resistance to illusionary realism may take the form of an insistence on the activity of viewers in the production of the story- or image-world. In other words, rather than a closed and self-contained world for the disembodied subject to explore and master, the viewer becomes a producer, an actor, an interactor. This is precisely the point of Atsuko Sakaki's account of photography. Rather than condemn the camera for its monocular properties or endorse myths of its veracity, Sakaki highlights the movements of the photographer through the streets. The result is a mobile perspectivalism that does not impose order and closure upon images (a fixed unitary viewing position) but instead allows the photographer to "take his body with him." Significantly, Sakaki finds in this meandering perspectivalism a challenge to cinematic narrative—which is to say, not only the imposition of a

unitary and static viewing position but also the conventions of a goal-oriented cause-and-effect action.

Finally, in her presentation of *kamishibai*, Sharalyn Orbaugh weaves deftly between these two ways of challenging the illusionary realism of Cartesianism, stressing the importance of the interval between panels and of performance, and underscoring the role of the audience in the production of meaning—even in the context of wartime propaganda, in which performances were calculated to place limits on the production of meaning in order to dictate a worldview. Orbaugh's essay thus arrives at a challenge, raising questions about how we gauge the impact of non-Cartesian modalities. Rather than dwell on resistance to rationality, should we not be attentive to the emergence of other "apparatuses of power" or other "fields of rationality," which only appear to us irrational and disruptive because Cartesianism itself has so thoroughly constrained our conceptualization of reason and coordination?

This question—about the relation between non-Cartesian modalities and power formations—returns us to the geopolitical issues mentioned above but in a different register, for now we are less likely to assume a tidy correspondence between a nation or national culture (Japan) and the non-Cartesian. It thus prepares for the second inquiry into perspective—that of the relation between perspective and worlds. Cartesianism has historically encouraged us to think in terms of a fixed and unitary viewing position (as established by one-point or geometric perspective) and by extension to assume a one-to-one correspondence between a perspective and a world. Yet, while perspective may indeed have world-making potential, an actual world entails a composition of perspectives, a relation or set of relations between perspectives, and can only be prolonged by somehow opening or harnessing that potentiality. Through a series of shifting views on Hokusai, for instance, Timon Screech makes two points. First, while the art and name of Hokusai clearly stabilizes something, and something Japanese at that, this is not Japan in isolation from or opposition to a putative West. Instead, it is a Japan in the world, that is, of the globe or planet. Second, conversely, insofar as Hokusai's art includes more than one perspective (and, in fact, more than one kind of perspective), it composes a world. If Fuji is now a "world mountain" in Screech's account, it is because there is a world in Japan.

These points are important to keep in mind in reading the subsequent two essays working through the legacy of superflat theory, because, as we have seen, superflat begins with a binary self/other model assuming a strict divide between Japan and the West from the outset. Waiyee Loh grapples with this self/other binarism in the context of the Goth manga *Kuroshitsuji*

or *Black Butler,* examining its idealization of a Western European past, which she styles as a non-Japanese past. The essay thus directly confronts the risk of homogenizing Japanese history, of eliminating allegedly foreign elements and then arbitrarily identifying the remaining elements as Japanese. (After all, one might well argue that the Gothic, as an invented tradition, is as Japanese as state-sponsored Shintō religion.) Ultimately, however, Loh turns the tables, arguing that the idealization of Europeanness in *Black Butler* tends to "celebrate a dehistoricized 'Japanese' form of (post)modernity in the present," which can be countered by attending to localized readings of it. In a similar vein, David Beynoun explores techno-cute architectures in Thailand, addressing the "Asian values" associated with robot anthropomorphism. Yet he finds that these architectural gestures toward Asian values, redolent of pan-Asianism, prove historically flat—a matter of affluence and global capital in the region rather than deeper values or something held in common. In these essays, the question of "other Asias," succinctly posed by Gayatri Spivak, takes on new urgency, as a matter of how we situate the world in Asia and Asia in the world, particularly in the context of a global urban world comprising manga and superflat design.

The question of "worlds in perspective" literally takes on new depth in Reginald Jackson's essay on *The Tale of Genji* picture scrolls. Disenchanted with the aesthetic flattening of these scrolls in a recent exhibition, Jackson offers a meticulous archaeological counterrestoration of them, moving beyond a binary divide between the 2-D and the 3-D to unearth other formations of depth that do not correspond to or map onto Cartesianism or anti-Cartesianism. Instead, he discovers a nondiegetic perspectivalism, which he contrasts to "illusionism" or illusionary realism. Cumulatively, the essays in this unit remind us that it is not simply a matter of liking or disliking flatness, or condemning or embracing depth, or pitting one world against another; what matters are the negotiations of depth, the relations arising from the potentiality of perspective, that is, worlds in perspective.

One of the other hallmarks of Cartesianism is the fixing of the position of the observer. An image constructed in accordance with one-point perspective, for instance, implies an ideal viewing position, looking directly at the image from a frontal position toward the vanishing point; from this position, everything appears duly ordered, scaled, and proportioned. In addition, coordinate geometry implies that a position can be established and located upon a grid, either two- or three-dimensional, by an observer standing outside it. If we try to situate the ideal viewing position—which Hubert Damisch in his seminal study describes as "a point of view outside nature from which we

might contemplate it unimpeded, all its mystery cleared away, with a single dominating gaze"[6]—within nature, that is, upon the coordinate grid, then we arrive at an impasse: we find the human at the center of a disciplinary paradigm—the human as both object and subject, as shaped by history and culture, and shaping history and culture.

Kant, as Damisch points out, "established a point of orientation within the subject itself" in an attempt to reconcile these tendencies. Yet, as Craig Jackson's essay demonstrates, the paradox persists, not only conceptually or philosophically but also in media worlds. Using mathematics to open some new perspectives on these media, Jackson points out that Pacman's view within his video game world "would not open onto limitless space," rather "he would look off into the distance and see . . . himself." When one tries to map the seeing of seeing, another dimension suddenly comes into play, in a manner that feels distinctively non-Cartesian, with the viewing position folding back on itself. Moreover, as Jackson shows in the context of *Lain*, attempts to fix the position of the self will result in a multiplication of nonlocalizable selves.

This multiplication of nonlocalized selves encountering one another is the very essence of radical perspectivalism, and it implies a crisis in identity, which today is commonly associated with the digital and new media. Jinying Li's essay follows directly from Lain's identity crisis, showing how superflat commercialism ultimately tends to flatten the mobility and multiplicity associated with digital media: the "windows" that "still invite us to imagine a space beyond them" are "completely blocked and flattened into a 'wall.'" Li's discussion shows us that the classic perspectivism of Cartesianism is still very much alive. Recall that classic perspectivism guaranteed "the possibility of switching from one point of view to another" by forcing their ultimate convergence by recourse to God, and it was Nietzsche who first protested in the name of radical perspectivalism, in the name of "different points of view that are anything but complementary, each manifesting a divergence."[7] Indeed, if *Lain* also articulates a problem with God, it is precisely because it strives to know whether (and how) the multiplication of nonlocalized selves might truly arrive at divergence in an era stretched between commercialized browsing and disciplinary education.

As such, the question of Cartesianism is no longer merely that of fixed positions and locatable selves but of whether the multiplication of nonlocalized selves can diverge and thereby introduce new articulations of autonomy, liberty, and identity, which would not be grounded in the mode of convergence known as self-identical individualism. In her account of transgender transition in Ōshima Yumiko's *Tsurubara-tsurubara,* Emily Somers shows how

this manga resists the forces of convergence implied in psychologism and medicalization—both of which impose, we might say, gods of individualist sovereignty—turning instead to reincarnation for a source of deeper material processes to articulate genuine divergence without sacrificing autonomy. And in Somers's take on reincarnation, we also find suggestions for rethinking a fourth aspect of Cartesianism taken up in this volume—the profound dynamism of matter.

In Cartesianism, matter is treated as pure extensity in space, as just so much inert stuff out there, and if it moves, it is only when forces act upon it. Such an approach to matter works well enough in the domain of classical mechanics, that is, when one is dealing with idealized schematics of action and reaction, with situations reduced to simple paradigms of cause and effect. In other words, Cartesianism also implies a dualism of matter and energy that parallels that of body and consciousness, and object and subject, in which the "energetics" of matter becomes unthinkable. If such an approach persists, it is partly because Cartesian dualism also reinforces a version of substantialism inherited from Aristotle, in which even qualities are appended to objects, attributes predicated on substances, and in which form comes to matter from without. Yet, despite a range of cogent alternatives from the domains of psychology, phenomenology, cognitive sciences, and radical empiricism, humanistic studies remain strangely indebted to Cartesian modes grounded on the notion of dead, passive, inert matter.

Our fourth series of essays contests this brand of Cartesianism, exploring the energetics of matter in the context of media. Yuriko Furuhata delves into this question in an encounter between film and manga, in the context of Ōshima Nagisa's film of Shirato Sanpei's *Ninja bugeichō*. Initially, Furuhata's use of the terms "mediation" and "remediation" may appear to assume an inertness of matter insofar as the two terms—film and manga—seem to exist prior to their relation, and their encounter is described as a negation. Yet, even though film appears poised to negate the material qualities of manga, Furuhata finds in Ōshima's film modes of doubling that force a reckoning with the nonsynchronous simultaneity of the two media, akin to what Walter Benjamin called the dialectical image. In her analysis of the same film and manga, Miryam Sas evokes Walter Benjamin and his impact on student movements and revolutionary violence in Japan, to call attention to forms of historical violence that cannot not be mapped, spatialized, predicted, or otherwise contained. No sooner is historical violence located than it multiplies—the hero Kagemaru, once slain, crops up everywhere—becoming pure violence, salvation's violence, bloodless violence. Finally, in Oshii Mamoru's *Innocence,* Livia

Monnet deftly traces the different registers in which digitalization fails to live up to its promise of liberating matter from form, thus failing to allow for genuinely multitudinous transformations. Multiplicity is folded back, that is, twisted or perverted, onto the figure of the gynoid, as if in compensation for a crisis in the goal-oriented cause-and-effect action associated with men within illusionary realism (or shōnen action, as in Fujimoto's essay). Yet, as Monnet says of the gynoid, the genuine challenge of radical perspectivalism arises when matter has a mind of its own.

As matter proves energetic, and even the inorganic has its reasons, we can no longer think in terms of simple causality, mastery of objects, or a one-to-one self-contained correspondence between a viewing position, a self, and a world. We then begin to trace the effects of non-Cartesian modalities, seeking in a radicalization of perspective the potential for an aesthetic and political transfiguration of this world.

Notes

1. Martin Jay, "Scopic Regimes of Modernity," in *Vision and Visuality,* ed. Hal Foster (Seattle: Bay Press, 1988), 4.

2. Ian Hacking, "The Cartesian Vision Fulfilled: Analogue Bodies and Digital Minds," *Interdisciplinary Science Reviews* 30, no. 2 (2005): 154.

3. Nishida Kitarō, *An Inquiry into the Good* (New Haven, Conn.: Yale University Press, 1990), 39–40.

4. See Murakami Takashi. "Sūpaafuratto Nihon bijutsu ron" and "A Theory of Super Flat Japanese Art," in *SUPER FLAT* (Tokyo: Madras, 2000), 8–25.

5. A prime example appears in Kaja Silverman, *The Subject of Semiotics* (Oxford: Oxford University Press, 1983), 127.

6. Hubert Damisch, *The Origin of Perspective* (Cambridge, Mass.: MIT Press, 1994), 47.

7. Ibid., 46–47.

Intervals

MARC STEINBERG

Inventing Intervals:
The Digital Image in
Metropolis and *Gankutsuō*

In Olivier Assayas's 2002 film *Demonlover,* there is a scene in which the president of the pornographic *hentai* anime company "TokyoAnimé" declares that the "wave of the future" of anime production lies in 3-D animation. Cel anime is already outdated, Mr. Ishikawa tells a group of visiting French executives, and the future of anime lies in full 3-D animation. In many ways Assayas's Mr. Ishikawa voices a position implicit in Lev Manovich's now-canonical consideration of cinema in the age of digital media, "What Is Cinema?"[1] As live-action footage becomes merely one element of a wider array of images characterizing contemporary cinema—and contemporary Hollywood cinema in particular—cinema itself is redefined. No longer the "art of the index," digital cinema becomes, for Manovich, "*a particular case of animation that uses live-action footage as one of its many elements.*"[2]

Implicit and explicit in Manovich's account is the importance of 3-D computer animation, which allows for a realism of detail and permits digital filmmaking to "generate film-like scenes directly on a computer with the help of 3-D computer animation."[3] To be sure, Manovich does not see the possibilities of digital film solely in relation to 3-D computer animation; he does emphasize the importance of 2-D computer animation and the "painterly"

in his account of digital cinema.[4] Yet what comes to the fore in Manovich's consideration of digital cinema and in the uses of digital animation in Hollywood films in particular is the importance of *photographic realism* within the computer-generated illusion of reality. The ability to simulate the visual qualities of three-dimensional space as it is photographed makes 3-D animation an invaluable tool of Hollywood cinema. What 3-D computer generated imagery (3-D CGI) offers Hollywood is what Stephen Prince terms "perceptual realism," wherein "even unreal [i.e., animated] images can be perceptually realistic."[5]

It is not so much "animation" that has subsumed cinema, then. Rather, it seems that digital cinema has selected a particular style of animation—the smooth motion of full animation and the perceptual realism of 3-D CGI—to further its own agenda: the realism of fantasy worlds in blockbuster entertainment. Cinema only uses the kind of animation (3-D CGI) that can "repeat" its aesthetics.[6] Despite Manovich's hopes for animation to subsume cinema, it seems that cinema has subsumed animation.

ANIME, REALISM, AND THE PERSPECTIVAL IMAGE

If this were to be the fate of anime as well, this would be a sad fate indeed. Yet anime has long had an ambiguous if not outright critical relationship to the kind of cinematic realism that 3-D CGI reproduces. *Demonlover*'s Mr. Ishikawa's opinion to the contrary, 3-D computer generated animation has not replaced 2-D cel animation, either in *hentai* animation or in Japanese animation on the whole. This is not to say that there have not been dramatic changes in the way anime is produced in Japan, or that the use of 3-D imagery has not grown considerably. The digital revolution has indeed completely transformed animation production in Japan since the late 1990s. Much cel animation at present is made from sketches scanned into a computer where they are colored, composited, and so on. Thus the very term "cel animation" has become something of an anachronism.[7] And the use of 3-D animation has increased exponentially over the past decade and a half.

However, contemporary Japanese animation is best characterized as a hybrid form that includes *both* cel-style and 3-D animation. Indeed, the hybrid use of animation technologies and styles itself became a subject of reflection in anime from the 2000s. In this article I would like to look at two anime made in the early 2000s—the animated feature *Metropolis* (2001, *Metoroporisu*, dir. Rintarō), and the TV series *Gankutsuō: The Count of Monte Cristo* (2004–5, *Gankutsuō*, dir. Maeda Mahiro)—in order to show how the collision of image

spaces and animation technologies is visually and narratively figured in the anime themselves. In his discussion of the impact of digital technologies on cinema, David Rodowick writes that "periods of technological change are always interesting for film theory because the films themselves tend to stage its primary question: What is cinema?"[8] The same might be said about many anime of the late 1990s into the 2000s. As the use of digital animation be-

> CONTEMPORARY JAPANESE ANIMATION IS BEST CHARACTERIZED AS A HYBRID FORM THAT INCLUDES *BOTH* CEL-STYLE AND 3-D ANIMATION. INDEED, THE HYBRID USE OF ANIMATION TECHNOLOGIES AND STYLES ITSELF BECAME A SUBJECT OF REFLECTION IN ANIME FROM THE 2000s.

came more widespread, the anime themselves have tended to stage the question: what is anime? Yet some works go even a step further. *Metropolis* and *Gankutsuō* are particularly stimulating works because they not only ask, "what *is* anime?"; they also ask the far more interesting question: What can anime *become*? As I will argue in my analysis of *Gankutsuō* in particular, the digital revolution has not merely witnessed the combination of cel-style and 3-D image spaces, it has also seen the development of new aesthetic possibilities for cel-style animation itself. That is, the digital revolution has pointed to novel dimensions of 2-D, developing anime in the direction of what I will call the "fourth interval."

Anime has traditionally had a critical relation to realism and a predisposition to experimentation with a nonrealist or antirealist aesthetic. Television anime from its emergence in the early 1960s eschewed both the depth and smooth movement that marked full animation. Thomas Lamarre has suggested that the genesis of anime's style of limited animation comes through the expansion of the interval between images in two sites. On the one hand, there is an expansion of the interval between images in a sequence, leading to a jerky sense of movement (the *first interval*); and on the other hand an expansion of the interval between layers of the composited image, foreground and background, leading to images that seemed particularly flat, or, *superflat* (the *second interval*).[9] Heterogeneity of image styles became the norm within television anime, rather than the exception. For this formal reason it is also not surprising to find that anime producers use 3-D animation in a patchwork style.

Yet if this heterogeneity of styles is the norm within anime, why did anime viewers voice a distinct sense of "discomfort" when cel-style and 3-D CGI spaces were first consistently combined in the series *Blue Submarine 6* (1998–2000, *Ao no rokugō*, dir. Maeda Mahiro)?[10] We can best explain this discomfort by reference to the stylistic dissonance of the two kinds of spaces

and the heterogeneous spectator positions each space presupposes. The photorealistic 3-D CGI image spaces invoked something anime viewers were not accustomed to: cinematic realism and visual verisimilitude. The crashing waves, sea creatures, and submarines rendered in 3-D CGI "looked like" waves, sea creatures, and submarines caught on film. What anime viewers have come to expect is something rather different: codified visual representations of things that are not necessarily perceptually "realistic" and not as rigorously perspectival. The discomfort felt by spectators of *Blue Submarine 6* resulted from the intrusion of photorealistic spaces into the flatter, more expressionistic cel animation. This was not merely heterogeneity within cel-style animation (something anime viewers were used to); it was a dissonance between cel-style animation and photorealistic animation.

The stylistic dissonance comes from the difference in the quality of the images, and the palpability of their articulation. The cel anime image is characterized by stillness or jerky motion, relative planarity or flatness, stylized shading, and black-ink character outlines that give it a graphical or drawn quality. Camera movement, when it occurs, is often lateral movement, sliding across the image.[11] The 3-D image, on the other hand, is characterized by its sense of volume, its weightiness, and its contours being defined by its shape rather than black outlines; it is a photorealistic image rather than a graphical one.[12] Three-dimensional CGI also offers a particular kind of movement difficult to achieve in cel animation: the ability to give the viewer "an experience of moving around the simulated three-dimensional space,"[13] maintaining the perspectival order of the image even when the camera is mobile.

If the dissonance in image style is one reason for the spectators' initial sense of discomfort with the combination of 3-D CGI and cel-style animation, the heterogeneity of the spectator positions offered by these distinct image forms is another. Stylistic difference in images brings into being distinct kinds of spectators. Anime has its own form of spectatorship based in part around the scanning of the image for informational detail.[14] By contrast, the 3-D computer-generated image and the traditional filmic image it mimics are based around the construction of the image and mise-en-scène with the aim of emphasizing depth, perspectival composition, the ability of the spectator to grasp the entirety of the image through a single, constant gaze, and the force of the image in drawing the concentrated spectator into its narrative space.

The filmic image as perspectival image was the subject of several important essays by prominent 1970s film theorists such as Jean-Louis Baudry and Stephen Heath. While their sometimes overly totalizing work has been the subject of critique, their essays are worth considering when we approach the

3-D CGI image—precisely because certain anime treat the 3-D CGI image in a manner analogous to Heath and Baudry's theorization of perspective in cinema.[15] Baudry, Heath, and others have argued that traditional filmic space installs the spectator in the position of the "transcendental subject,"[16] the invisible participant in the film's unfolding drama. Cartesian space and linear perspective give the spectator the illusion of power, a sense that they are participating in what Baudry calls "a total vision which corresponds to the idealist conception of the fullness and homogeneity of 'being.'"[17] As Heath puts it, "the eye in cinema is the *perfect* eye, the steady and ubiquitous control of the scene passed from director to spectator by virtue of the cinematic apparatus."[18] This "perfect eye" allows the spectator to feel in control *of* the film and its events as they unfold before him or her. But in fact, this very seeing submits the spectator to a kind of control *by* the screen image. "Perspective-system images bind the spectator in place," Heath notes, suturing the spectator to the scene before him or her, gluing this spectator to the scene and to the ideological position and regulation of desire it presupposes.[19] Though it gives the spectator the illusion of control over a scene, cinema, in fact, exerts total control over the spectator.

METROPOLIS: THE ANTAGONISM OF 2-D AND 3-D SPACES

This relation between 3-D CGI's photorealistic replication of cinematic space and its power over the spectator is brought to the fore within Rintarō's *Metropolis*. What makes *Metropolis*'s use of 3-D CGI so interesting is the way it aligns the 3-D perspectival image with structures of domination in a manner that strongly recalls the arguments of Baudry and Heath. *Metropolis* is an animated feature directed by Rintarō, written by Ōtomo Katsuhiro, and based on Tezuka Osamu's 1949 manga (itself loosely inspired by Fritz Lang's 1927 film of the same name). It is, in brief, the narrative of an aspiring tyrant who builds a massive tower called the Ziggurat from which, through the direction of a robot girl named Tima, he plans to control the world. Here I would like to examine the film from the angle of its use of cel-style and 3-D animation.[20]

The opening of the film finds the inhabitants of Metropolis staring entranced at the base of the newly unveiled Ziggurat, a massive building rendered in 3-D animation, whose scale dwarfs all other buildings around it. Here the film displays the kind of subject-spectator presumed by the Ziggurat itself:

> THE DIGITAL IMAGE IS
> LITERALLY A SPACE—AND
> PLACE—OF OPPRESSION.
> IT IS A SPACE TO WHICH
> THE REST OF THE IMAGE
> AND ITS INHABITANTS
> (HUMAN AND ROBOT ALIKE)
> ARE SUBJUGATED.

a relatively passive, enchanted spectator, simultaneously alone and in a crowd, marveling at the spectacle of fireworks and lights featuring the newly built Ziggurat, unfolding in front of him or her. In this scene and others, the use of 3-D CGI in *Metropolis*'s image landscape visually depicts a subject position associated with the classical cinematic spectator.[21] The camera movement in this opening sequence is one that will occur several other times throughout the film: a long track back and tilt down, beginning from the heights of the Ziggurat and descending backwards into the city below (Figure 1). Here 3-D CGI recreates the pleasurable experience of cinema—the mobility the camera grants the spectator—along with the spectator's ultimate subjection to something much, much greater: the social order or the power structure represented by the architectural marvel and new Tower of Babel, the mighty Ziggurat.

The 3-D perspectival image thus operates as a space of control—control over the spectator as well as over the entire narrative space of the anime itself. This space of control is crystallized in the Ziggurat, the power center and new weapon of world domination at the heart of the Metropolis urban formation. Not surprisingly, the internal and external architectures of the Ziggurat are represented in 3-D CGI. The towering image of the Ziggurat impresses upon the viewer the absolute power of the structure and its domination of the cityscape, the citizens, and the spectator. Here the digital is not only figured as the spectacle of a new image space but is located narratively as a new space of power. The digital image is literally a space—and place—of oppression. It is a space to which the rest of the image and its inhabitants (human and robot alike) are subjugated. In contrast to this, the subjugated, lower levels of the city—inhabited by the human underclasses, outcasts, and robots—are represented in the classical cel-style of animation. The 3-D image is figured quite explicitly as the oppressor of the cel-style image.

Naturally, the powers of resistance will come from the cel-style image itself. If the Ziggurat can have no other destiny but to be destroyed, then it must be destroyed not only by the actions of the characters, represented in cel-style animation, but also destroyed by cel-animation itself. It is the spectacular cel-style animation explosions, reminiscent of 1970s special effects anime that are responsible for finally bringing the abominable Ziggurat to ruins. The explosions that shake the Ziggurat to the ground are rendered, for the most part, in the baroque cel-style of Kanada Yoshinori, whose animation

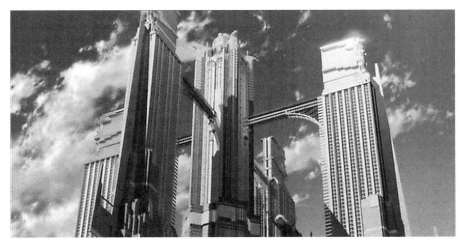

FIGURE 1. Track and tilt down from the Ziggurat in *Metropolis.*

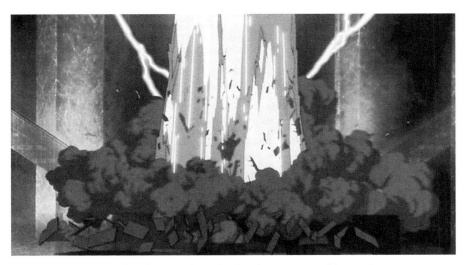

FIGURE 2. Destruction of the Ziggurat through cel-style animation in *Metropolis.*

was used by Rintarō in *Harmagedon* (1983, *Genma taisen*), influenced Ōtomo's *Akira* (1988), and was placed at the center of Murakami Takashi's "superflat" theory of Japanese art (Figure 2).[22]

Cel animation returns to destroy the power structures put in place by 3-D CGI. The narrative consistently puts forward the colorful, cel-style images of the lower levels of the city as alternative spaces to the power structures aboveground. The slum—the wild growth of the city beneath the Metropolis, the colorful and disorganized urban formation represented in the spatially

flatter style of cel animation—is presented as the visually exuberant and soni-
cally jazzy alternative to digital animation, with its centralization of power
and subjectification of the spectator-inhabitant. It is also in the slums that the
potential for new social formations exist. With the destruction of the Ziggurat
and the surface world, the new alliances formed in the slums will emerge. The
film ends with attention placed on the bright colors of the undercity that poke
through the surface of Metropolis, and the union formed between robots and
humans. We thus might read *Metropolis* as a polemic advancing the supremacy
of cel-style animation over 3-D CGI, and emphasizing what we might call the
"third interval"—the interval between cel-style animation and 3-D CGI.[23] Cel-
style animation is associated with a politics of de-centralization (the slum), a
new "transhumanism" (the robot–human alliance), and a freedom of move-
ment that characterizes the spectatorial glance rather than the gaze. Three-
dimensional CGI, on the other hand, is associated with Cartesian space, the
subjectified gaze of the classical cinema spectator, and the totalitarian control
over image space and its subjects.

While this is no doubt a somewhat polemical reading of the use of 3-D CGI
in *Metropolis,* the association of power structures and the classical, absorbed
viewer with 3-D CGI is not unique to this film. A great number of anime films
and television series use 3-D CGI in order to represent battleships and war ma-
chines of all kinds (from the submarines of *Blue Submarine 6,* to the maraud-
ing mecha of *Samurai 7* (2004, dir. Takizawa Toshifumi), to the fighter jets of
Yukikaze (2002–5, *Sentō yōsei Yukikaze,* dir. Ōkura Masahiko) and *Sky Crawlers*
(2008, *Sukai kurora,* dir. Oshii Mamoru) and as a way to absorb viewers into the
perspective of the technologies of flight. The converse association of the relative
flatness of cel-style animation with the forces of resistance would seem to reso-
nate with the fantasy shared by Murakami Takashi and others in the art world
and criticism in the early 2000s: that a world without linear perspective would
be a world without power formations, liberated from a perspectival, Western,
symbolic order.[24] Yet, it goes without saying that limited animation sees not the
absence of power formations but merely different forms of power and different
organizations of the scopic field, one of the most obvious being the organiza-
tion of desire around the anime character.[25] Still, however critical we might be
toward the simple affirmation of cel-style animation, there is a sense in which
we should take *Metropolis*'s privileging of cel-style animation seriously. There
is something about cel-style animation that deserves our attention, especially
when juxtaposed with the more uniform photorealism of 3-D CGI—something
that resides in the intervals it opens up. Here I would like to turn to *Gankutsuō,*
which pushes the intervallic nature of anime one step farther.

GANKUTSUŌ: TEXTURE AND THE FOURTH INTERVAL

Gankutsuō is a visually stunning television anime series that was directed by Maeda Mahiro, was produced by Studio Gonzo, and aired in 2004–5. The narrative of *Gankutsuō* is loosely based on Alexandre Dumas's *The Count of Monte Cristo* (1844–46, *Le comte de Monte-Cristo*) and is the tale of an unjustly imprisoned man who returns as the Count of Monte Cristo to seek revenge on those responsible for his incarceration.[26] Unlike the original novel, however, the narrative is set in the future and is told from the perspective of Albert, the son of the principal target of the Count's vengeance. *Gankutsuō* is one of the most artistically experimental series of the 2000s, one that was praised by fans and critics alike for what Kurabayashi Yasushi calls its "outstanding creativity and imaginative power."[27] Indeed, the series is spectacular in all senses of the word. In part, this comes from *Gankutsuō*'s pairing of 3-D CGI with cel-style animation. Much like *Metropolis,* the citadels of power within the film are all rendered in 3-D animation, while the characters are rendered almost entirely in cel-style animation. Yet, *Gankutsuō*'s most striking innovation comes not from the disjuncture between 3-D and cel animation styles— what I have called the third interval—but rather from the introduction of a disjuncture into the cel animation itself. I will immediately address the latter form of disjuncture, which I call the "fourth interval."

Clothing pattern, or what the *Gankutsuō* animators refer to as "texture," is the site that this disjuncture is made visible. In fact, the image as a whole is highly layered, a layering that has the effect of flattening even the 3-D spaces. But this texturing or layering is most apparent in the clothing of the characters. If *Gankutsuō* offers a splendid visual feast of colors and patterns unmatched by most anime, it is here, at the level of characters' clothing, that its impact is strongest. To describe the process briefly, the digital image of a character was broken down into multiple different sections or layers (shirt, pants, boots, scarf, hair, and so on). Then, a color was assigned to each portion of each character: one layer for the hair, another for the scarf, another for the pants, another for the belt, and so on. Next, the animator would apply the desired texture or pattern to the colored part of the character in question. Each portion of the character would have its own patch of pattern and color.[28]

The choice of colors, patterns, and textures is visually stimulating in its own right, but when the characters start to move, things really get interesting. The swaths applied to each character are not cut to fit the character's clothing, are not fixed to the character's outline, and often do not move with the character. While occasionally the texture layer is moved synchronously with

the character, more often than not the character moves over an immobile or independently mobile texture layer. Each texture layer is like a "base" image over which the outline of the character moves. As the character occupies different parts of the texture layer, different sections of the pattern or image-texture emerge.

This effect is particularly visible with characters whose clothing design uses figurative images, such as Haidé, whose clothes seem to be inspired by figurative works of medieval stained glass. The character of Haidé in effect functions as an outline that moves over a distinct texture layer that has its own faces and figures. As the outline moves, different parts of the texture image are revealed. An excellent example can be found in episode 13, in a sequence when Haidé reaches for a harp. At the opening of the sequence, the large face on her dress first appears on her left sleeve. As Haidé moves toward the right side of the frame, the large face appears to move towards the left side of the frame, eventually settling on her right sleeve. In fact what happens is that the outline of Haidé shifts positions while her dress's texture layer remains static (Figure 3). The pattern of her dress appears to move in a direction opposite her movements, shifting from one sleeve to the other, effectively obscuring the directionality of Haidé's movement. She appears to be moving in two directions at once. A similar effect can be observed in other characters as well, such as the left-leaning journalist Robert Beauchamp whose jacket bears the image of a bearded figure and the word "riches"; as Beauchamp changes positions within the frame the word "riches" and the bearded figure alternately appear and disappear.

As we saw with Haidé, the movements of the characters not only reveal more of the texture layer used; they also render their very movements indistinct. Another example of this is in a scene with Franz and Julien from episode 13, where Franz and Julien are about to enter the database of the Ministry of the Interior. Julien turns around, moving 180 degrees from a position where he is facing the camera to a position where his back is to the camera. However, despite this 180-degree turn, the pattern of his jacket remains immobile and constant. The front, side, and back views of Julien feature the same texture pattern, giving the sense that he has not turned at all. This sense is heightened by the absence of black character outlines that would differentiate the parts of his body; for a brief moment Julien's arm is indistinguishable from his torso. Julien *seems* to move, but he also *seems* not to move at all, since the texture pattern remains constant (Figure 4). We can observe a similar effect with Prosecutor Villefort in episode 9; while his arm is folded across his body, the pattern on his arm matches the pattern of the

FIGURE 3. Movement of Haidé revealing her texture layer as she reaches for her harp in episode 13 of *Gankutsuō*.

section of his jacket that it covers, producing a chameleon effect that renders his arm movement indistinct.

Part of what makes the character's form indistinct is, as I noted, the absence of the black outline that usually defines the contours of the anime character. But the absence of wrinkles or shading that is found in most anime character design also heightens this effect. The completely flat, often immobile texture layer replaces all shading and clothing folds. The character's form is delineated by the texture layer alone, leading it to become indistinct when sections of the character overlap. The texture layer effectively emphasizes the surface or planarity of the image and tends to mask the character's movement. Image textures compete with character actions for the viewer's attention and

FIGURE 4. Julien's 180-degree turn in episode 13 of *Gankutsuō*.

sometimes seem more important than the contours and actions of the charac-ters. Character movement is made visible only when the character changes its spatial location in the frame. When the character remains in place, its gestural movement is downplayed in favor of the stasis of texture. And even when a character *does* move, its movement tends to point to a dimension *below* that of the character; in the case of the figurative images of Haidé's clothes, her movements do not add to the narrative so much as they call attention to the otherwise hidden portions of the texture-layer.

In short, through this technique, the animators have developed a new visual level that works against the movements of the characters on screen, and ultimately against the unity of the character presumed by most anime series. The spectator's attention gravitates toward the sub-character level of the texture. The movement or stasis of texture supplants the movement of characters, producing a different level of spectatorial engagement. In the vi-sual experience of *Gankutsuō*, the textural layer competes with the action of the characters for our attention. A *fourth interval* is introduced within the character image itself.

Gankutsuō develops this fourth interval by breaking down the unity of the character, pointing instead to a dimension of layers and patterns that exists independently of the character in a separate image space. This fourth interval effectively undermines the identity of the character image so essen-tial for the unity of narrative space and for the commercial practice of char-acter merchandizing on which much anime depends.[29] Every movement of the character reveals something beyond it, underneath it, and outside it. The heterogeneous movements of the texture layers threaten the character's iden-tity, which depends among other things on its self-resemblance and its visual containment within delineated boundaries. Moreover, in undermining the unity of the character, the disjunction between image layers also undermines the unity of narrative space in a new way, completely different from the way the disjuncture between 3-D and cel styles had.

The disjuncture between 3-D CGI and cel-style animation—the third interval—opens a rift in the narrative space, while nonetheless allowing this narrative to persist through the negotiation of this disjuncture, as we ob-served in *Metropolis*. *Metropolis*'s narrative-level pairing of 3-D space with the space of control recuperates the potentially threatening rift in the image space by recourse to a generic narrative structure. The space of autonomous image layers that we see with the clothing in *Gankutsuō*, on the other hand, operates at the level of microperceptions of movements and textures that work counter to the macrolevel movements and spaces of the narrative in two ways.

First, they distract the spectator's attention from the macrolevel of the characters and narrative development, refocusing attention on the microlevel of textural and visual shifts of the clothing itself. *Gankutsuō* channels the spectator's attention to a level below the identity of the character, to the autonomy and heterogeneity of layers that very literally color and compose the character.[30] *Gankutsuō* forces the spectator to see beyond and below the macrolevel identity or self-sameness of the character as individual. The spectator's attention is drawn toward the microlevel of the multiple intervals that compose the character, emphasizing visual heterogeneity over narrative development and character unity. This is not, moreover, reducible to a move toward what Azuma Hiroki calls the nonnarrative database of "*moe* elements"—elements such as bunny ears or glasses that represent fixed and generic forms—but rather toward the decidedly non-*moe* level of textures and patterns.[31]

Second, these microlevel texture layers also work counter to the type of optical space required by both linear perspective and conventional narrative formations. Here, *Gankutsuō* takes anime's already critical relation to perspectival realism one step further. The clothing texture layer works through sliding, rather than movement in depth, and flouts the basic laws of traditional perspectival representation, including the ironclad rule that things be drawn smaller when at a distance. The texture layer does away with the fundamental pictorial premise that what is near should be visually larger and what is far should be smaller. A stunning example of this is found in episode 11, in a shot where Albert walks away from the camera. The shot opens with a close-up of Albert's back, and Albert grows progressively smaller as he moves away from the camera. But throughout the shot, the texture size remains constant. In fact, because of the contrast with Albert's form, which decreases in size as he moves away from the camera, the pattern appears to grow larger with every step Albert takes away from the camera. At the beginning of the sequence the circle in the center of the texture pattern occupies a space the size of Albert's elbow, but, by the end of the sequence, the very same circle has "grown" to occupy his entire back (Figure 5). In fact, while remaining the same size, the texture layer does shift and slide over the course of the sequence, accenting the disjunction between the two layers: the character grows smaller while the texture appears to grow larger.

In filmic terms, we might say that the image texture is a form of *permanent close-up* insofar as the close-up is known to abolish perspectival space and potentially threaten narrative stability. Mary Ann Doane writes: "Of all the different types of shots, it is the close-up that is most fully associated with

FIGURE 5. Albert walks away from the camera, as the patterns on his back appear to grow larger in episode 11 of *Gankutsuō*.

the screen as surface, with the annihilation of a sense of depth and its cor-responding rules of perspectival realism."[32] Much like the filmic close-up as Doane describes it, the texture layer points toward the very planarity of the screen as surface. The microlevel of the image texture thus works against the macrolevel of image architecture and narrative space, and negates even the most basic form of perspective deployed in cel-style animation. The pattern or texture works against the linearity and measure of narrative space, and against the centrality of the character that informs anime and its associated practice of character merchandising.

Rather than the intensification of realism often associated with the use of digital technologies in animation over the last few decades, *Gankutsuō* dem-onstrates the potential of digital imaging to move animation in the opposite direction: toward a greater *irrealism* of the image, toward a more flexible and indeed disorienting image space that purposefully rejects the premises of perceptual realism and the "impression of reality" associated with classical cinema, the 3-D CGI animated films of Pixar and Dreamworks (which, while paying homage to the cartoon in their character design, rely on a traditionally realist sense of space and form), and the use of 3-D animation in live-action blockbuster entertainment. This is not to say that *Gankutsuō* does not itself use 3-D CGI; it does, in the rendering of cars, warships, and mecha, and in the rendering of buildings and the Paris in which the narrative takes place. And yet this series also confronts the viewer with a digitally generated planar space of microtextures that actively counteracts both the realism of 3-D CGI *and* the traditional mode of cel-style animation.

As such, *Gankutsuō* does more than merely enact the dissolution of per-spectival space proposed in a utopian vein by Murakami. *Gankutsuō* generates an illegibility of character–space relations that poses a greater challenge to photorealism than the flattening of all depth cues associated with the theory of superflat art. Instead of a uniformly flat or superflat space, *Gankutsuō* offers a mixed space. In addition to the third interval between cel-style animation and 3-D CGI, *Gankutsuō* generates a fourth interval: the interaction of texture layers as they work against both cel-style character unity and the depth of 3-D CGI. With this fourth interval the viewer is presented, on the one hand, with an illegibility of the image, since the nonperspectival nature of the tex-ture would seem to contradict and render illegible the dimensions and move-ments of the rest of the image. On the other hand, the viewer encounters a surplus of legibility, since the texture layer offers a whole other visual world: a microlevel of forms, patterns, and designs revealed through the macrolevel movements of the characters. The pleasures of the TV series thus come not

only from the *Bildungsroman* tale of Albert and the revenge narrative of the Count but also from the movement of the characters through space and the fascinating spectacle of layers and textures revealed and concealed through every onscreen movement.[33]

CONCLUSION

Anime is constituted, as Lamarre suggests, through the expansion of the interval between images in two sites: between images in a sequence and between layers of the image.[34] What I have argued in this essay is that anime's encounter with digital imaging technologies has seen the invention of two additional kinds of intervals within the image. *Metropolis* develops and theorizes the *third interval*: the interval between cel style and 3-D computer-generated imagery, ultimately proposing that the power of cel animation resides in its ability to critique the power relations implicit in 3-D CGI. *Gankutsuō* adopts *Metropolis*'s suggestion that the cel-style image can be used as a site of critique of the pretension to mastery and system of power associated with cinematic 3-D CGI image architecture and cinema's reliance on linear perspective. But *Gankutsuō* also goes a step further by introducing a disjunction into the cel-style image itself, undermining the unity of the character and thereby also undermining the commercial strategies of character merchandising that depend on this unity of the character image. *Gankutsuō* develops a new kind of image space by introducing a nonrealist layer of microtextures and microperceptions: a *fourth interval* within the cel-style image itself. The coexistence of this level of microtextures with the macrolevel image space offers a site of critique of the normativity of Cartesian narrative space and its digital incarnation as 3-D CGI. As *Metropolis* and *Gankutsuō* demonstrate, digital technologies have made possible the invention and development, by animators, of new spaces of image-based critique, one path to which lies in the emphasis on the disjuncture of image styles rather than on their homogeneity, and through the proliferation of intervals between image layers, rather than their closure.

..

Notes

I wish to thank the Iwanami Press for the permission to publish this revised version. I also wish to thank my anonymous reviewers, Ueno Toshiya, and Thomas Lamarre, for their feedback on the present version of the article. An earlier version of this essay was published in Japanese in the collection *Nihon eiga wa ikiteiru, dai 6: Anime wa ekkyōsuru* (Japanese

cinema is alive, volume 6: Anime crosses borders), ed. Kurosawa Kiyoshi, Yomota Inuhiko, Yoshimi Shun'ya, and Ri Bon'u (Tokyo: Iwanami Shoten, 2010).

1. Manovich, *The Language of New Media* (Cambridge, Mass.: MIT Press, 2001).

2. Ibid., 295; 302; emphasis added.

3. Ibid., 300. See also Manovich, "'Reality' Effects in Computer Animation," in *A Reader in Animation Studies,* ed. Jayne Pilling (London: John Libbey, 1997), 5–16.

4. Manovich, *Language of New Media,* 301; 303–5.

5. Stephen Prince, "True Lies: Perceptual Realism, Digital Images, and Film Theory," *Film Quarterly* 49, no. 3 (Spring 1996), 32.

6. Thomas Lamarre, in an essay on photorealism in the fully 3-D CGI film *Final Fantasy: The Spirits Within* (2001), describes the photorealism of *Final Fantasy* as a "fatal repetition" of cinema, a repetition that assumes "the inevitability of certain forms of closure and systematization" (163). In its critique of the position of Manovich vis-à-vis digital cinema, the present essay adopts a position similar to that advanced by Lamarre: digital media and animation should not be conceived on the model of cinema. Lamarre, "First Time as Farce: Digital Animation and the Repetition of Cinema," in *Cinema Anime,* ed. Steven T. Brown, 161–88 (New York: Palgrave Macmillan, 2006). See also Christopher Bolton's reading of the use of 3-D CGI and its intersection with geopolitics in "The Quick and the Undead: Visual and Political Dynamics in *Blood: The Last Vampire,*" in *Mechademia* 2 (2007): 125–42.

7. I will nonetheless refer to this kind of digital drawing and animation as "cel-style animation," recognizing the stylistic continuity of digitally "drawn" animation with classical cel animation.

8. D. N. Rodowick, *The Virtual Life of Film* (Cambridge, Mass.: Harvard University Press, 2007), 28.

9. Thomas Lamarre, "From Animation to *Anime*: Drawing Movements and Moving Drawings," *Japan Forum* 14, no. 2 (2002), 339–40.

10. This sense of discomfort is widely voiced in Internet discussions of the series. Maeda notes in an interview around the time of its release that "there is still a sense of discomfort in inserting CG in anime." Quoted in *Anime no mirai wo shiru* (Knowing the Future of Anime), ed. Funamoto Susumu (Tokyo: Ten Books, 1998), 15.

11. For an extended discussion of the consequences of what he calls induced or relative (lateral) movement, see Lamarre, *The Anime Machine* (Minneapolis: University of Minnesota Press, 2009), esp. 103–9.

12. Here I draw on Norman M. Klein's distinction between what he calls "graphical narrative" and full animation in his account of the development of U.S. animation, *7 Minutes: The Life and Death of the American Animated Cartoon* (London: Verso, 1993).

13. Manovich, "'Reality' Effects in Computer Animation," 6. This movement into the image creates what Lamarre refers to as the "ballistic view" in "The Multiplanar Image," in *Mechademia* 1 (2006): 120–43.

14. Lamarre, "From Animation to *Anime*"; and Okada Toshio, *Otakugaku nyūmon* (An Introduction to Otakuology) (Tokyo: Ōta Shuppan, 1996).

15. Jean-Louis Baudry, "Ideological Effects of the Basic Apparatus," and Stephen Heath, "Narrative Space," both in *Narrative, Apparatus, Ideology,* ed. Philip Rosen (New York: Columbia University Press, 1986), 286–98 and 379–420 respectively.

16. Baudry, "Ideological Effects of the Basic Apparatus," 292.

17. Ibid., 289.

18. Heath, "Narrative Space," 389.

19. Ibid., 404.

20. For an analysis of Rintarō's *Metropolis* that compares it to earlier incarnations (Fritz Lang's 1927 film and Tezuka Osamu's 1949 manga), and their distinct uses of architecture in relation to modernity and the city, see Lawrence Bird, "States of Emergency: Urban Space and the Robotic Body in the *Metropolis* Tales," *Mechademia* 3 (2008): 127–48. Some of the points I make in this article overlap with Bird's discussion of the organization of city space in *Metropolis*. This article differs in linking this spatial organization more closely to the representational forms used to depict them (3-D CGI vs. cel animation). Lamarre also offers a provocative reading of *Metropolis* in "First Time as Farce," where he notes the "productive asymmetry" or nonmediated relation between cel-style animation and 3-D CGI in the film, and opens this reading onto an argument about the (non)relation between old and new at the heart of digital media (183–86).

21. While many writers have since argued that this spectator has never existed—that everyone who has ever watched a film did so in a particular material context, accompanied by particular sensations (discomfort, hunger, distraction, sleepiness, and so on)—I still find this to be a productive generalization of the kind of spectator classical cinema tried to generate.

22. Murakami Takashi, *Super Flat* (Tokyo: Madra, 2000). In fact the sequence of the destruction of the Ziggurat is rendered in both cel-style *and* 3-D CGI. However the 3-D CGI sections involve the collapse of sections of the Ziggurat itself; the explosions are rendered predominantly in cel-style animation. Given that it is the explosions that bring the tower to the ground, I understand the agents of this destruction of the Ziggurat to be these cel-style explosions.

23. While there may be a case to be made for considering this interval as a subset of what Lamarre refers to as the second interval—that between layers of a composited image—given that this gap becomes qualitatively different (in means of production and in perceptual experience) from 3-D CGI, I will refer to it as a distinct, third interval.

24. See especially Murakami and Azuma's essays in Murakami's *Super Flat*.

25. See Lamarre, *The Anime Machine*; Azuma's *Dōbutsukasuru posutomodan* (Animalizing postmodern) (Tokyo: Kōdansha, 2001); translated by Jonathan Abel and Shion Kōno as *Otaku: Japan's Database Animals* (Minneapolis: University of Minnesota Press, 2009); and my *Anime's Media Mix: Franchising Toys and Characters in Japan* (Minneapolis: University of Minnesota Press, 2012).

26. Maeda initially wanted to adapt the 1956 Alfred Bester novel *The Stars My Destination* but ran into difficulties securing the adaptation rights. His solution was to incorporate elements of the Bester novel (which itself was loosely based on *The Count of Monte Cristo*) into *Gankutsuō*. "*Gankutsuō* ga dekiru made" (The making of Gankutsuō), in *Animeeshon nōto* (Animation notes) (February 2006), 10. I thank Ueno Toshiya for calling this connection to my attention.

27. Kurabayashi Yasushi, "Geijutsu no ato no gazō: Gendai bijutsu to shite no 'ganime,'" (Images after art: 'Ganime' as contemporary art), in *New Media Creation* (Tokyo: Gentōsha, 2006), 29–30.

28. For a description of the technique, see *Animeeshon nōto,* February 2006, 16–18. In fact this process resembles the use of "screen tones" within manga. Screen tones are patches of pattern (dots, lines, patterns, and so on) that are applied to particular parts of the manga image for shading, clothing, and other uses. I thank Thomas Lamarre for suggesting the link between these two techniques.

29. The development of on-video-anime (OVAs) in the 1980s and the "midnight anime" time slot in the late 1990s and 2000s (a time slot in which series such as *Gankutsuō* first appeared), permitted anime series to depend less on the character-centric practice of merchandising and focus more on world building and graphical experimentation. DVD sales rather than the sales of character toys or merchandise are the focus of midnight anime, which are aimed toward an older age group—in the case of *Gankutsuō,* twenty- to thirty-five-year-old women ("*Gankutsuō* ga dekiru made," 13). For a brief account of midnight anime, see Masuda Hiromichi's *Anime bijinesu ga wakaru* (Understanding the anime business) (Tokyo: NTT Shuppan, 2007), 131–32. This economic independence from character merchandising arguably allows for the kind of graphical experimentation we find in *Gankutsuō.*

30. Gilles Deleuze suggests that "'Good' macroscopic form always depends on microscopic processes." Deleuze, *The Fold: Leibniz and the Baroque,* trans. Tom Conley (Minneapolis: University of Minnesota Press, 1993), 88. *Gankutsuō* makes visible these microscopic processes but meanwhile takes attention away from macroscopic form.

31. Azuma, *Otaku,* 42. In his discussion of the use of textures in *Gankutsuō,* character designer Matsubara remarks that the elimination of folds in favor of the texture level moved the characters away from the "*moe*" direction. "Supesharu taidan: kyarakutaa hen" (Special dialogue: Character compilation) http://www.Gankutsuou.com/staff/interview/01_01.html (accessed April 29, 2011).

32. Mary Ann Doane, "The Close-Up: Scale and Detail in the Cinema," in *differences: A Journal of Feminist Cultural Studies,* 14, no. 3 (2003): 91.

33. While I do not have the space to properly address the issue here, I should acknowledge that there is also a flip side to this reading: this surplus of legibility may in fact contribute to the narrative or setting in a wider sense. The striking costumes of the characters are fitting for the aristocrats that they clothe. Even as they break down the characters at one level, the clothes also express, and quite literally suit, their wealth at another. And certain costumes contribute to a wider understanding of the characters themselves; reporter Robert Beauchamp's jacket, which features a bearded man older man and the word *riches,* evokes an image of the bearded Karl Marx and paints a picture of the character's own critical stance toward the aristocrats' immense wealth. The costumes can hence add to the narrative setting in their visual evocation of a character's wealth, mood, or political stance. Here, however, I have chosen to emphasize the way the clothing layer *in motion* undermines some of the mainstays of character and narrative space in anime.

34. Lamarre, "From Animation to Anime," 339–40.

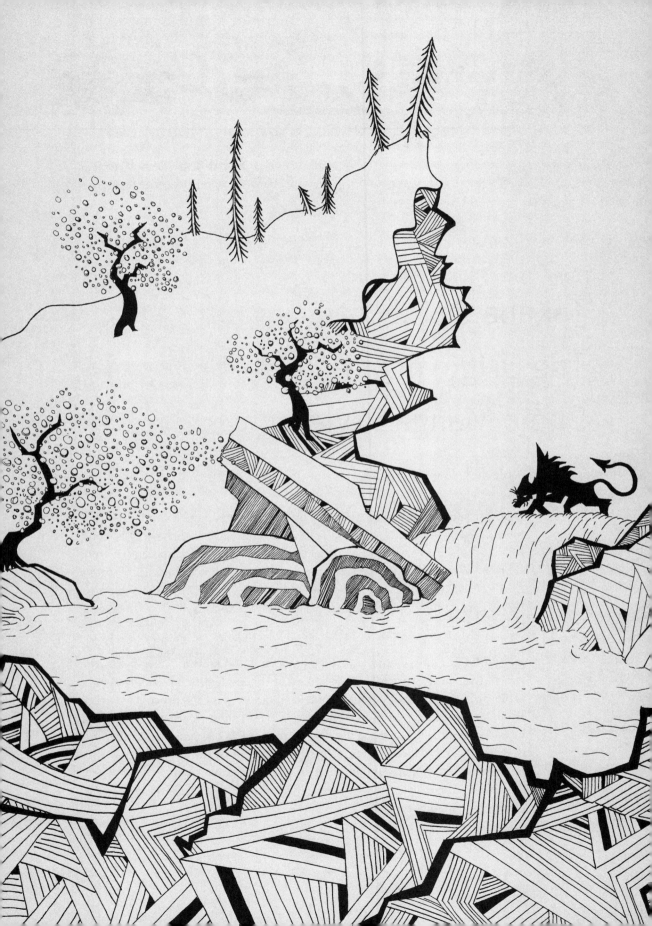

FUJIMOTO YUKARI

Translated by Matt Thorn

Takahashi Macoto: The Origin of Shōjo Manga Style

Features such as star-filled eyes and unconventional page layouts are often mentioned as key features of the style of shōjo manga (Japanese girls' comics). But when, exactly, did a distinct "shōjo manga" style branch off from that of "shōnen" (boys') manga? This essay argues that Takahashi Macoto's *Arashi o koete* (Beyond the storm), serialized in the magazine *Shōjo* beginning in January 1958, pioneered a distinctive shōjo manga style. The "three-row overlaid style picture"—a full-body drawing of a girl that has no direct relation to the story, stretching across three rows or the entire vertical length of the page—did not exist before Takahashi's work. Further, this paper traces the way in which this work led to the spread of the "style picture" (*sutairu-ga*) in other girl's magazines, in a little more than a year, and the process by which shōjo manga developed an unconventional page layout different from that of boys' manga. I will also trace the development of Takahashi's distinctive way of drawing eyes, which are said to be the archetype of the shōjo manga–style eyes, filled with numerous sparkling stars. I will discuss the existence of pre-Takahashi "starry eyes," as well as the influence of Takahashi's starry eyes on other shōjo manga artists.

THE RISE OF THE "STYLE PICTURE" AND CHANGES IN THE PANEL DIVISIONS IN SHŌJO MANGA

The Sudden Appearance of the Style Picture
in the First Chapter of Beyond the Storm

The first time a three-row style picture consisting of a full-body drawing of a girl that did not directly relate to the story appeared in a girls' magazine was in the first chapter of Takahashi Macoto's ballet manga *Beyond the Storm,* which was serialized in the magazine *Shōjo* from the January to July issues of 1958, which I discovered while tracking down Takahashi's works created in preparation for an essay to accompany a replica reprint of *Rows of Cherry Trees* and *Paris–Tokyo,* two of Takahashi's works from his days of producing manga for the "rental manga" market.

Most people associate Takahashi with the many illustrations of girls he created throughout the 1960s and 1970s for the covers and frontispieces of girls' magazines, as well as for his stationery goods such as notepads and pencil cases. Yet his earliest work was in manga, first as a popular creator in the rental manga market in the mid-1950s, and later, in 1957, when he produced a series of short stories for Kōbunsha Publishing's magazine *Shōjo*: "The Seaside of Sorrow" (in the Special Summer issue), "The Swan of Tokyo" (September), "The Swan of the Rose" (November), and "The Cursed Coppéllia" (December). It was in the following issue—in January 1958—that the ballet manga in question, *Beyond the Storm,* began its run.

In that first chapter, readers are confronted immediately after the title page with two style pictures, one on each side of the two-page spread (Figure 1). Although divided into panels, the page is oddly layered with images from one panel overlapping those of other panels. What is compelling is that these are images from different narrative dimensions overlapping each other and, even stranger, although the images are not directly related to the story, they express in an abstract way the atmosphere of the world the artist wishes to convey.

In addition, on another page of this same issue is the first time the phrase "call for style pictures" was used: "Calling for style pictures! Draw Hitomi's style in the picture to the right on a postcard and send it to us! Ten readers will receive a beautiful handkerchief!"(Figure 2). In this work we have the first appearance of what would come to be called a "three-row overlaid style picture," now considered a distinctive technique of shōjo manga, accompanied by layered page layouts and actually given the name "style drawing" from the start.

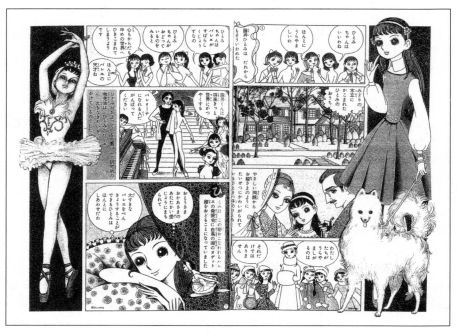

FIGURE 1. Takahashi Macoto, *Arashi o koete* (Beyond the storm), *Shōjo*, January 1958: 36–37.

Beyond the Storm became hugely popular, and each chapter included at least one style picture along with a call for readers to send in their imitative drawings of it for a chance to win a prize. As if this were not enough, the work also included "paste picture seals" (*harie shiiru*) for readers to cut out and paste where they pleased (Figure 3). Though calls for reader participation and other "extras" were often included in manga, this was the first time that such an element was included in the *body* of the manga. Not only was this inconceivable in the genre of boys' manga, it was a bold, new technique that had never appeared even within shōjo manga.

In fact, in his earlier short story "The Cursed Coppéllia," Takahashi Macoto draws a manga with an extraordinarily bold page layout that had never appeared in either his own work or any other shōjo manga. He places a full-body drawing of a posed figure of a girl in the center of the page, drawn vertically through multiple panels, spanning nearly the length of the page, and around this figure he includes panels that explain the story (Figure 4). He uses this layout over several successive pages. This, too, is noteworthy because it is a fully developed, layered structure that is the direct ancestor of page layouts currently used in shōjo manga.

The next month, *Beyond the Storm*, which consciously makes use of style

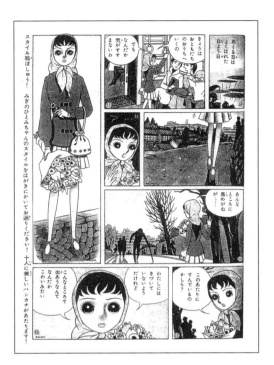

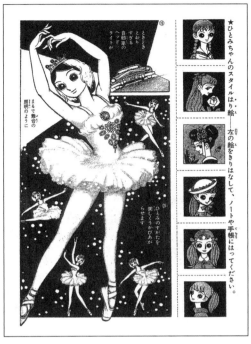

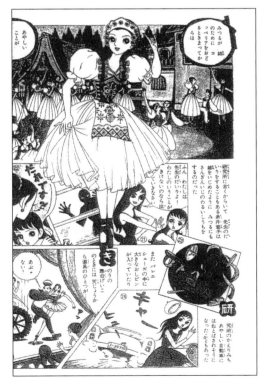

FIGURE 2 (ABOVE, LEFT). Takahashi Macoto, *Arashi o koete* (Beyond the storm), *Shōjo*, January 1958: 45.

FIGURE 3 (ABOVE, RIGHT). Takahashi Macoto, *Arashi o koete* (Beyond the storm), *Shōjo*, March 1958: 60.

FIGURE 4 (LEFT). Takahashi Macoto, *Norowareta Kopperia* (The cursed Coppéllia) *Shōjo*, December 1957: 52.

pictures in every chapter, began its run. Reading the magazines chronologically, the shift in style is conspicuous. In order to confirm that the "three-row overlaid style picture" actually begins with *Beyond the Storm* in the January 1958 issue of *Shōjo*, I went back two years and studied each issue of every girls' magazine published at the time—*Shōjo, Shōjo Book, Nakayoshi, Ribon*—from January 1956 to December 1957, but was unable to find any earlier use of the three-row overlaid style picture.

On the contrary, page layouts prior to 1958 proved to be even more rigid than I had expected, and even the occasional breaking the panel border is by nothing more than the tip of a sword or a character's foot (e.g., Fujiko Fujio's "Tale of White Heron Castle," and Minami Akane's "Ballet and Jewels," Figure 5). Even such modest examples are rare, and I confirmed that there are almost no examples of panels without borders or even oversized panels.

Of course, that is not to say there are no exceptions. Figures spanning two rows (though not three) appear occasionally (e.g., Toriumi Yasuto's "Mama's Lap," Figure 6), and manga artist Ōtomo Yoshiyasu was particularly notable for his use of unusual panel layouts. For example, in "Don't Cry, Don't Cry" (*Shōjo*, November 1956), Ōtomo uses a panel that spans the entire width of a two-page spread, and on the same page draws a figure that spans two panels vertically (Figure 7). Of particular note is a panel in "A Windmill Tale" (*Nakayoshi*, September 1956) that, although it spans just two rows, is a full-body figure of a girl that has no relation whatsoever to the story and effectively serves the same function as the later three-row overlaid style picture (Figure 8).

However, in the case of Ōtomo Yoshiyasu, these artistically distinguishing techniques seem to have had no noticeable influence on other artists. Prior to 1958, with the exception of Takahashi's "The Cursed Coppéllia," the sort of layouts by Ōtomo Yoshiyasu represent the upper limit of deviation from the norm in shōjo magazines, and even these are quite rare. The bulk of manga used an extremely static layout, with regularly arranged panels, and images that remain within the boundaries of those panels.

There is, however, a single precedent that is extremely similar to a three-row overlaid style picture. It is found in Nagashima Shinji's "Flower Petal Tale" (*Shōjo*, April 1956), and although the drawing is completely enclosed within the panel frame, it spans three of four rows, is decorated to look like a ribboned bookmark, and is accompanied by the text "A big call for likenesses! Draw a likeness of this [image of] Hinako and send it to the editorial offices of *Shōjo*! Ten readers who draw her well will receive a prize" (Figure 9). Although the term used is "likeness" (*nigaoe*) and not "style picture" (*sutairu-ga*), the text is very similar to the "call for style pictures" in the first chapter of *Beyond*

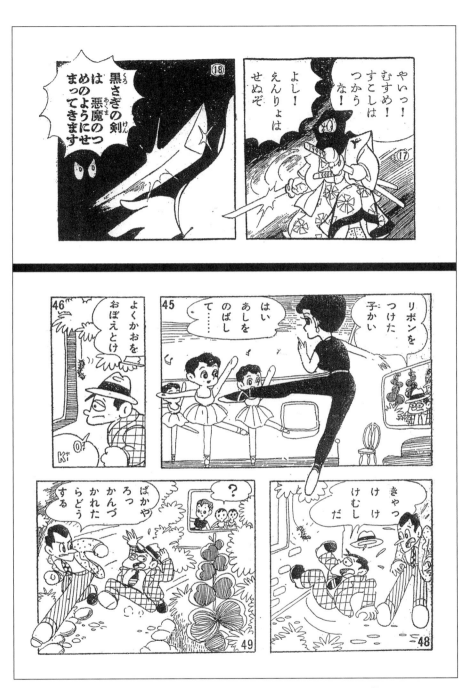

FIGURE 5. Earlier examples of breaking the panel border. *Above*: Fujio Fujiko, "Shirasagi-jō monogatari" (Tale of White Heron Castle), *Shōjo*, March 1956: 97. *Below*: Minami Akane, "Baree to hōseki" (Ballet and jewels)," *Nakayoshi,* extra edition, vol. 3, no. 11: 168.

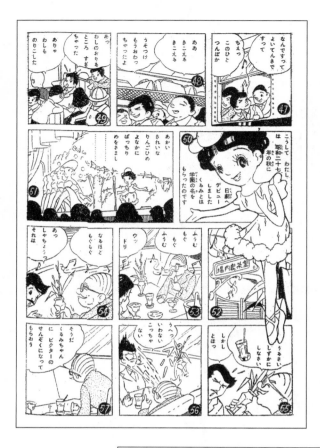

FIGURE 6 (LEFT). Toriumi Yasuto, "Mama's Lap," *Nakayoshi*, September 1956: 70.

FIGURE 7 (BELOW). Ōtomo Yoshiyasu, "Don't Cry, Don't Cry," *Shōjo*, October 1956: 194–95.

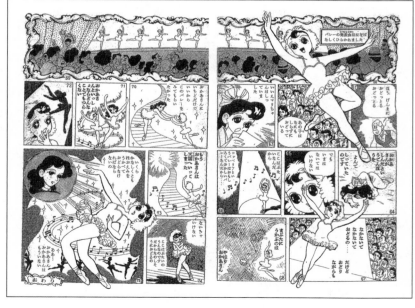

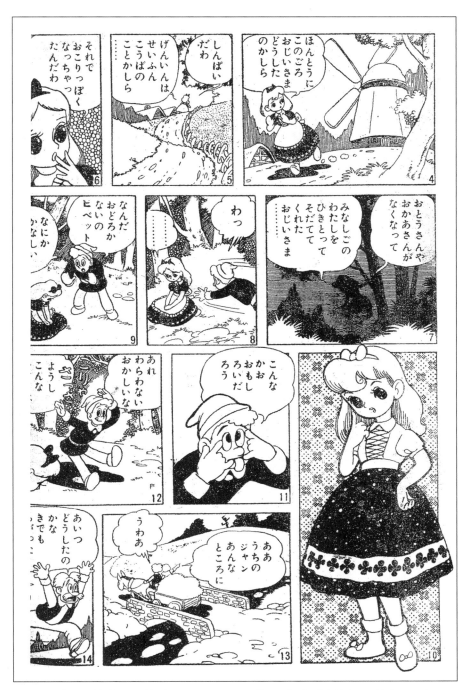

FIGURE 8. Ōtomo Yoshiyasu, *Fushagoya monogatari* (A windmill tale), *Nakayoshi*, September 1956: 98.

the Storm. The panel contains narration reminiscent of the "picture story" (*emonogatari*) form, and the girl is crying, therefore the panel is incorporated into the story and cannot be said to have "no relation to the story," but there is no doubt that this is extremely similar to a style picture. However, this particular usage does not seem to have influenced other artists, and I believe it can be seen as an exceptional precedent.

By contrast, the style picture form begun in Takahashi Macoto's *Beyond the Storm* spread to other magazines and artists in the blink of an eye, and in the span of a single year changed the way pages were laid out in shōjo manga. When seen in that light, even if there should happen to be earlier examples of the three-row overlaid style picture in an issue that was missing from the National Diet Library, or in a magazine published prior to 1956, I believe it can be said with certainty that Takahashi Macoto's *Beyond the Storm* was the starting point of the three-row overlaid style picture that became so popular in shōjo manga.

Some clarification is needed at this point. The three-row overlaid style picture I am discussing here appears in the body of the manga itself; title pages had featured full-body figure drawings and stylized composition prior to 1957. Title pages in the magazine *Shōjo,* in particular, often filled a two-page spread and were decoratively and stylishly designed. At the time, in other magazines, it was common to put the title and a drawing in a large panel occupying the top two-thirds of the first page. These titles pages were static in comparison with those that appeared on the pages of *Shōjo,* and it is conceivable that the elaborate title pages in *Shōjo* were the seedbed for the three-row overlaid style picture.

While the content of earlier shōjo manga was indeed aimed at girls, the rigid page layouts were no different from those of boys' manga. In that context, Takahashi Macoto's *Beyond the Storm* appeared suddenly and transformed the page layouts and expressive techniques of shōjo manga into something quite different from that of boys' manga.

THE DEVELOPMENT OF THE STYLE PICTURE AFTER *BEYOND THE STORM*: SHŌJO MANGA TRANSFORMS

Beyond the Storm immediately influenced other magazines. This is particularly conspicuous in *Shōjo*'s major rivals, *Shōjo Book* from Shūeisha Publishing and *Shōjo Club* from Kōdansha, both of which were aimed at girls in the middle grades of elementary school and older. The change was more gradual in *Ribon* and *Nakayoshi,* which were aimed at a younger readership.

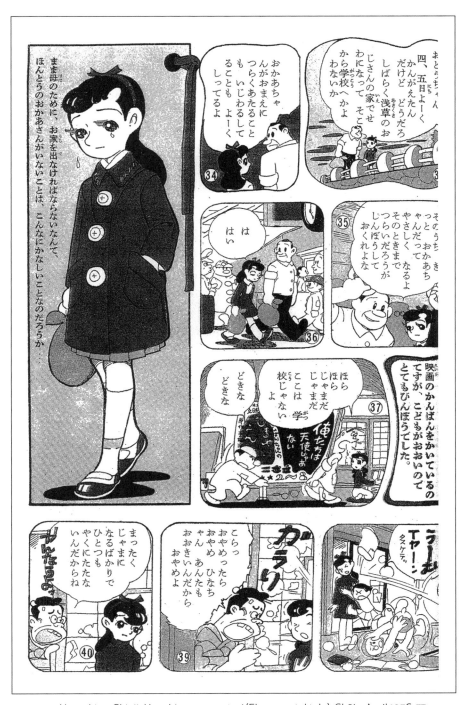

FIGURE 9. Nagashima Shinji, *Hanabira monogatari* (Flower petal tale), *Shōjo*, April 1956: 77.

Shōjo Book

The first clear-cut example of *Beyond the Storm*'s influence is Narumi Akira's *Scarlet Camellia,* which began serialization in the March 1958 issue of *Shōjo Book* (Figure 10). In order to meet the deadline for the March issue, Narumi would have to have read the first chapter of *Beyond the Storm* and begun work immediately. Nonetheless, the fact that his story also deals with ballet, has a similar drawing style, and includes a full-body drawing of a girl spanning the length of the page (though not labeled a "style picture" as such) makes it reasonable to assume that this work was born as a direct result of *Beyond the Storm*.

In the April issue of *Shōjo Book,* Umezu Kazuo began his ballet manga *The Voice That Calls for Mother,* and in the second chapter, published in the May issue, he includes an upper-body drawing of the heroine that, although a part of the story's action, occupies nearly two-thirds the length of the page (Figure 11). In the June chapter of his ballet manga serial *Sad Swan,* Kimura Mitsuhisa also includes a full-body figure of a girl that spans two-thirds of the page's length. Furthermore, a layered page structure is used in both of these cases. When one compares these pages with the layouts of Ōtomo Yoshiyasu, which, prior to Takahashi Macoto, represented the most radical layouts in shōjo manga, it is obvious that drastic changes were underway in a very short span of time.

In addition, the first chapter of Kimura Mitsuhisa's *The Wish of Two* (published in the August issue) includes a "stamp" of the heroine (Figure 13), an obvious influence of the "seals" from *Beyond the Storm*. The influence of *Beyond the Storm* on Watanabe Masako's series *Echo Girls* (which started in the August 1957 issue of *Shōjo Book*) is clear, but the most unmistakable introduction of the "style picture" in the pages of *Shōjo Book* is Ishii Kiyomi's *Mama's Eyes,* which began in the January 1959 issue. Virtually every two-page spread includes a "style picture" or illustration completely unrelated to the story (Figure 14), and these are frequently accompanied by the phrase "style" or "style collection."

Shōjo

In *Shōjo,* the magazine in which *Beyond the Storm* itself was serialized, the first example we find is a full-body drawing of a girl in Higashiura Mitsuo's "Akemi's Wish," in the April 1958 issue (Figure 15). Throughout 1958, we find several examples of full-body drawings of girls spanning two-thirds the length

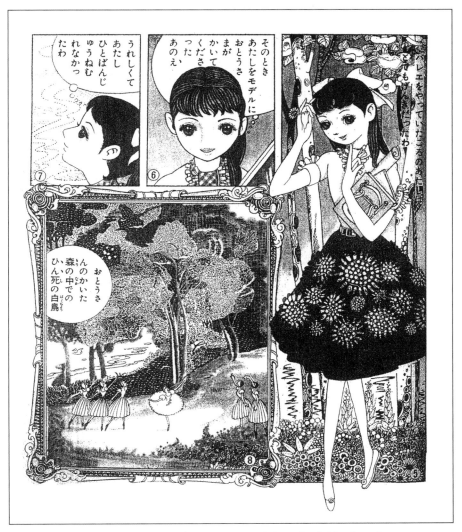

FIGURE 10. Narumi Akira, *Benitsubaki* (Scarlet Camellia), *Shōjo Book,* March 1958: 49.

of the page, such as in the July issue, "The Swan's Prayer," by Tanimoto Jirō and Watanabe Kunio (Figure 16), or, on page 226 of the September issue, Shiro Takeshi's "The Great Detective 'Red Ribbon,' Episode 1: The Living Doll." But the work most clearly influenced is no doubt *Princess Star,* written by Yatsu-rugi Tarō and drawn by Ishii Kiyomi.

Beginning in the second half of 1958, *Princess Star* featured an increasing number of full-body drawings of girls spanning more than half the length of a page. Most notably, in the November issue, the artist goes so far as to

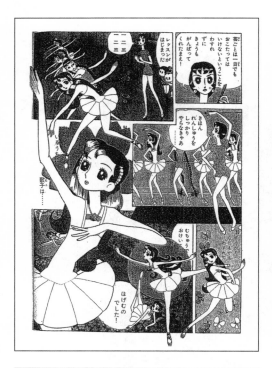

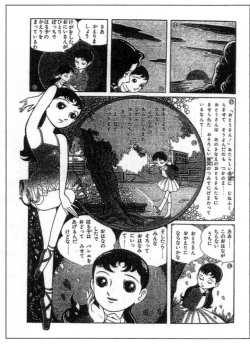

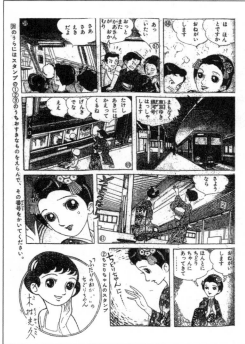

FIGURE 11 (ABOVE, LEFT). Umezu Kazuo, *Haha o yobu koe* (The voice that calls for mother), *Shōjo Book*, May 1958: 58.

FIGURE 12 (ABOVE, RIGHT). Kimura Mitsuhisa, *Kanashii hakuchō* (Sad swan), *Shōjo Book*, June 1958: 75.

FIGURE 13 (LEFT). Kimura Mitsuhisa, *Futari no negai* (The wish of two), *Shōjo Book*, August 1958: 59.

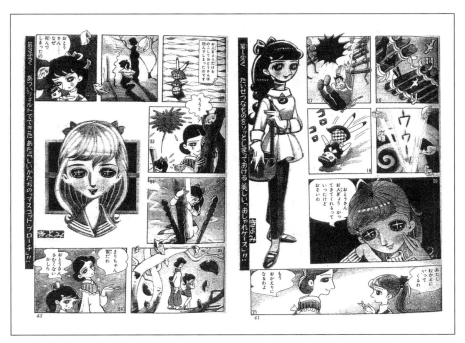

FIGURE 14. A style picture (*right*) and inserted illustration (*left*) from Ishii Kiyomi, *Mama no hitomi* (Mama's eyes), *Shōjo Book,* January 1959: 41, 43.

interrupt the flow of the story abruptly in order to insert a full-body image of the princess (Figure 17). Although the work is a period piece, the technique is purely that of the "style picture," and hereafter the insertion of large, full-drawings of characters, without regard to the narrative, becomes a trademark of this title. In the February 1959 issue, the artist inserts text into his style pictures that summarizes the story and introduces the characters (Figure 18). Ishii Kiyomi is the same artist who began the series *Mama's Eyes* in *Shōjo Book* and is a male artist who also worked under the name Bonten Tarō.

Shōjo Club

Meanwhile, in the June 1958 issue of *Shōjo Club,* Higashiura Mitsuo had already presented a clear-cut example of a style picture in his story "Where the Blue Bird" (Figure 19). The influence of *Beyond the Storm* is clear: the image is completely separated from the story and is accompanied by the text, "Send us your style pictures of Hizuru. Draw the picture on the right in black ink [. . .]."

As it happens, *Shōjo Club* had been soliciting "style drawings" from readers. In this case, style drawings refer literally to drawings of clothing styles,

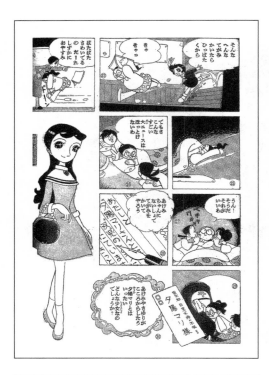

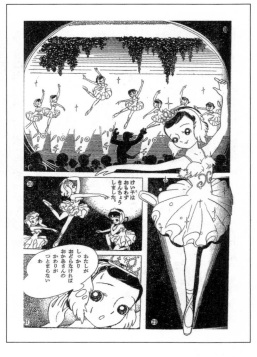

FIGURE 15 (ABOVE, LEFT). Higashiura Mitsuo, *Akemi no negai* (Akemi's wish), *Shōjo*, April 1958: 70.

FIGURE 16 (ABOVE, RIGHT). Tanimoto Jirō/Watanabe Kunio, *Hakuchō no inori* (The swan's prayer), *Shōjo*, July 1958: 157.

FIGURE 17 (LEFT). Ishii Kiyomi, *Hoshihime-sama* (Princess Star), *Shōjo*, November 1958: 87.

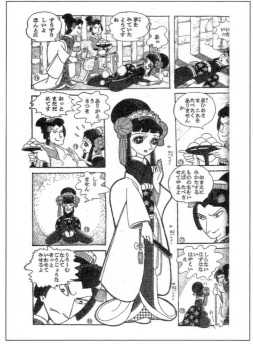

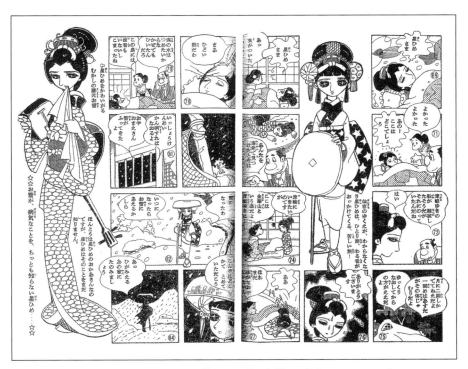

FIGURE 18. Ishii Kiyomi, *Hoshihime-sama* (Princess Star), *Shōjo*, February 1959: 228–29.

rather than drawings copied from manga. This was done under the title of
"My Favorite Style" (Figure 20). The magazine's early adoption of the term
"style picture" might be attributable to this precedent, but I have yet to con-
firm whether or not the term first appeared in the June 1958 issue where Hi-
gashiura Mitsuo's work appeared. Nevertheless, the fact that the solicitation
of "style pictures" of Mana, the heroine of Chiba Tetsuya's *Mama's Violin,* in
the December 1958 issue is accompanied by the explanation, "This is a style
picture" (Figure 21), suggests that the term "style picture" had not yet become
so common that readers could be expected to understand its meaning.

Eventually, however, it was *Shōjo Club*'s term "style picture" (*sutairu-ga*),
and not the forerunner *Shōjo*'s term "style drawing" (*sutairu-e*) that took hold.
The reason for this is not entirely clear. *Shōjo* called for "style drawings" as
an eligibility requirement to win prizes, and accordingly, the quality of the
printed submissions was less than spectacular. In fact, for some time they had
been soliciting "likenesses of popular people" or "my school-dress style," but
in these instances, they took the trouble to explain that "It is not necessarily
the best drawings that will win. Winners are chosen by lottery." *Shōjo Club*, on
the other hand, solicited character likenesses for each of their popular manga,
publishing only the best. They also used the term "style picture" in reference

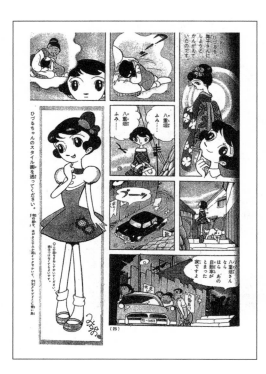

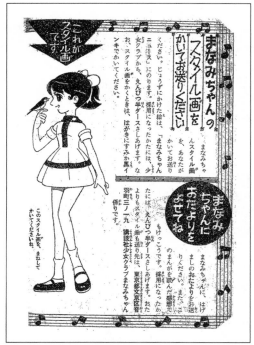

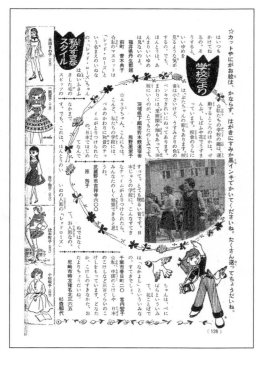

FIGURE 19 (LEFT). Higashiura Mitsuo, *Doko ni aoi tori* (Where the blue bird), *Shōjo Club*, January 1958: 25.

FIGURE 20 (BELOW, LEFT). Readers' submissions, *Watashi no suki na sutairu* (My favorite style), *Shōjo Club*, April 1958: 128.

FIGURE 21 (BELOW, RIGHT). Solicitation for style pictures of Chiba Tetsuya, *Mama no baiorin* (Mama's violin), *Shōjo Club*, December 1958 supplement: 82.

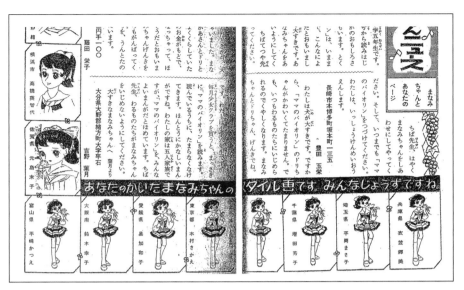

FIGURE 22. Readers' style pictures of Chiba Tetsuya, *Mama no baiorin* (Mama's violin), *Shōjo Club*, September 1958 supplement: 92–93.

to fashion, and it may be that manga followed that precedent. A clearer explanation would require further research. Furthermore, *Shōjo Book* had been simply using the terms "style" or "style collection" at least until the end of 1959, and the term first appeared in the February 1960 issue in the readers' pages, which included the copy, "We're waiting for your style pictures."

Maki Miyako and Watanabe Masako

All of the artists I have mentioned so far are men, but the page layouts of two of the most prominent women artists of the day—Maki Miyako and Watanabe Masako—also changed following *Beyond the Storm*. In the case of Maki Miyako, the first example we find is in her series *Three Girls* (based on a story by Nishitani Kenji), which begins in the August 1958 issue of *Shōjo*. Here we find a panel made to look as if it is enveloped in another panel, which itself has no frame (Figure 23). Two months later, drawings of girls, made to look like stamps and separated from the story, appear in the same series (Figure 24). Thereafter, Maki regularly begins to insert illustrations of girls that have no relation to the story (e.g., in the February 1959 issue). Whereas Maki made her full-body drawings blend into the stories at first (Figure 25), she later experimented with incorporating drawings of girls (though not full-body drawings) that were completely unrelated to the immediate narrative action (Figure 26).

It may be that Maki did this in *Three Girls* so that even when the story was focusing on just one of the girls, the reader would be reminded that this was the story of *three* girls.

Meanwhile, Watanabe Masako, in her first serialized work, *Echo Girls,* begins by timidly drawing small, unrelated to the story, portraits of the twin protagonists on each side of a two-page spread in the October 1958 issue (Figure 27). By the December issue, she has done the same thing using the entire vertical length of the page. In the March 1959 issue, she draws both the twins in a "princess style"—a look that may have seemed natural to the character of Harumi but was striking for the character of Natsumi, considering that she was a "child of the mountains" (Figure 28). This is surely nothing if not a "style picture."

While it is common to think of the "style picture" as appearing with no connection to the story, an examination of the full- and half-body drawings of girls extending two-thirds or more the height of the page that appeared after "The Cursed Coppéllia" and *Beyond the Storm* reveals that roughly half are, in fact, incorporated directly into the story's action. Furthermore, it is not uncommon for these drawings to be "layered," overlapping neighboring panels and images. In other words, the introduction of full- and half-body drawings of girls extending two-thirds or more the height of the page was not simply the introduction of decorative style pictures with no relation to the stories in which they appeared but was intimately connected to the eventual transformation of page layouts, composition, and expression that shōjo manga were to undergo.

Nakayoshi *and* Ribon

In the case of the magazines *Nakayoshi* and *Ribon,* whose targeted readers were younger than those of *Shōjo Club* or *Shōjo,* the influence I have described was somewhat slower in appearing. Particularly in the case of *Nakayoshi,* the change in page layouts was quite gradual. The format of the style picture had appeared in both magazines no later than the summer of 1959. For example, in a glance at Maki Kazuma's ballet manga (based on a concept by Nitan'osa Nakaba), *The Swan's Wish* (Figure 29), which began serialization in the July 1959 issue of *Ribon,* the relationship is clear. By the July 1959 issue of *Nakayoshi,* a genuine style picture (a ballet pose spanning the entire height of the page) had appeared in the pages of Nakajima Toshiyuki's "Nanako!"

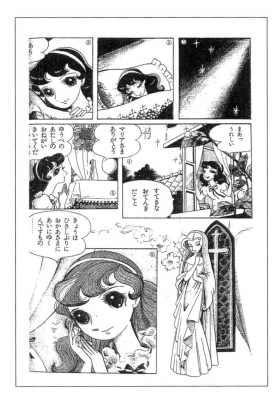

Nishitani Kenji/ Maki Miyako, *Shōjo sannin* (Three girls), *Shōjo*, August 1958: 52.

FIGURE 24 (BELOW). Stamp-like panels in Nishitani Kenji/Maki Miyako, *Shōjo sannin* (Three girls), *Shōjo*, October 1958: 54–55.

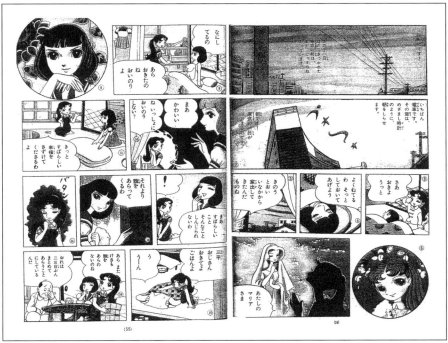

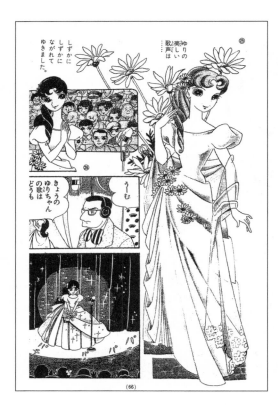

FIGURE 25 (LEFT). Full-body drawing in Nishitani Kenji/Maki Miyako, *Shōjo sannin* (Three girls), *Shōjo*, January 1959: 66.

FIGURE 26 (BELOW). Experimental style pictures in Nishitani Kenji/Maki Miyako, *Shōjo sannin* (Three girls), *Shōjo*, January 1959.

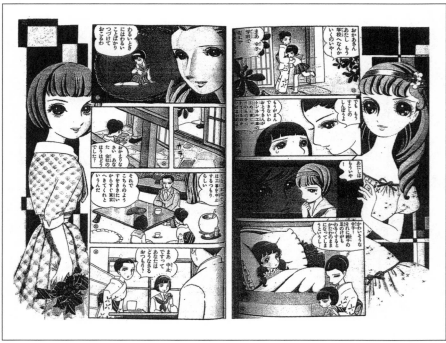

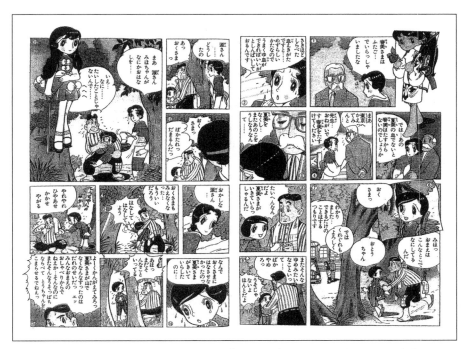

FIGURE 27. Watanabe Masako, *Yamabiko shōjo* (Echo girls), *Shōjo Book*, October 1958: 6–7.

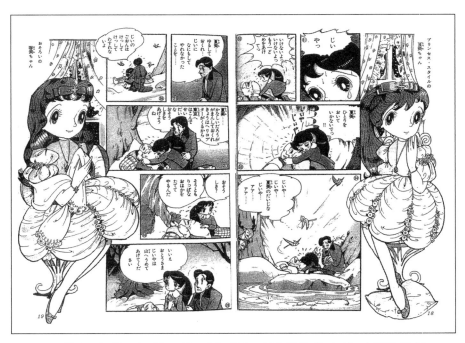

FIGURE 28. Watanabe Masako, *Yamabiko shōjo* (Echo girls), *Shōjo Book*, March 1959: 18–19.

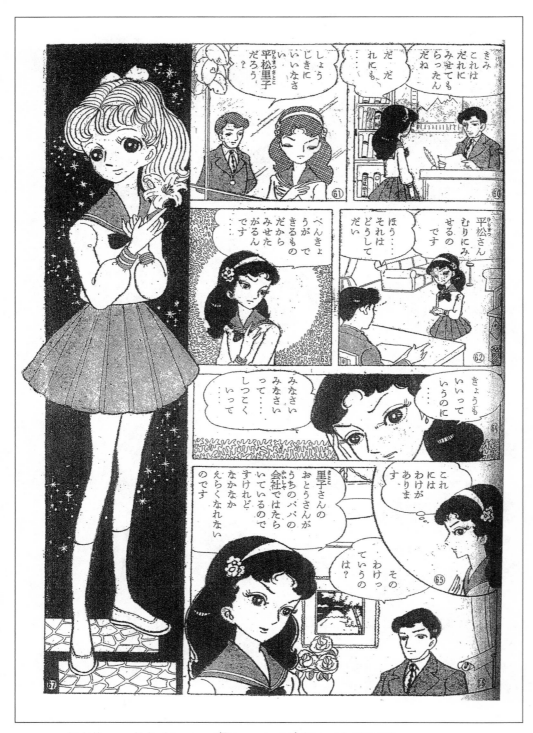

FIGURE 29. Maki Kazuma, *Hakuchō no negai* (The swan's wish), *Ribon*, July 1959: 105.

SHŌJO MANGA ARE TO SHŌNEN MANGA
WHAT *EMONOGATARI* ARE TO MOVIES

As the development I have traced here shows, prior to the appearance of Takahashi Macoto's first serialized shōjo manga, *Beyond the Storm,* and his prototypical "The Cursed Coppéllia," shōjo manga used the same standardized page layouts as those used in shōnen manga. But with the appearance of *Beyond the Storm,* page layouts in shōjo manga changed dramatically.

At the same time, this was a break from the established grammar of manga that dictated that pages must be clearly divided into panels, and the start of a maverick form of shōjo manga in which the expression of mood became paramount. It was no longer required that characters always be enclosed in panels or that panels always have clear lines or that one picture not overlap another—in short, a form of manga emerged in which style was driven by consumer desire for emotional expressions. *Beyond the Storm* became a catalyst for shōjo manga to part ways with shōnen manga and start on a journey of its own. Whereas shōnen manga followed a path of development intended to show "movement" through a series of panels, shōjo manga prioritized a visual sensibility that portrayed "mood" with the two-page spread as the basic unit of design.

The introduction of style pictures not directly related to the physical actions of characters subtly symbolized the situation or atmosphere of the narrative. Symbolic figure drawings were consciously incorporated to make the entire page an integrated situational whole. This introduction signified the birth of two levels of time and of two dimensions of space on the page. In other words, it is the beginning of a technique of dovetailing different narrative dimensions and visually integrating the page, primarily through the use of drawings of human figures that span multiple panels. From this arose the foundation for a versatile form of shōjo manga—a form of expression ideally suited to the portrayal of character psychology and of an unconscious that cannot be expressed in words.

It can also be said that this was made possible because Takahashi Macoto brought not merely a sense of design but also the techniques of *emonogatari* to the genre of shōjo manga. Meaning "picture story," *emonogatari* refers to a specific genre of heavily illustrated fiction in which text and illustrations are arranged across a two-page spread with an eye to overall design. The term encompasses a range of material from simple alternating blocks of text and image to forms that, to the modern eye, are all but indistinguishable from comics. All *emonogatari,* however, include far more expository prose than is

typically found in manga. This genre was particularly popular in the postwar period through the 1950s, but declined as story manga became increasingly popular. For example, when I asked Takahashi how the kind of bold page layouts he used in "The Cursed Coppéllia" came to be, this is how he responded:

> Hmm. I just drew it the way I wanted to, and that's how it turned out. "The Cursed Coppéllia" is half *emonogatari,* anyway. . . . That's how it always is with me. I draw a picture of a girl, and people from the world of illustration say, "That's manga," while the people from the world of manga say, "That's not manga, it's *emonogatari.*"

It is precisely because Takahashi took that middle ground, boldly incorporating the techniques of *emonogatari* in his manga in order to draw just the way he wanted to, and because readers responded with such enthusiasm, that shōjo manga acquired a style of expression and path of development very different from that of shōnen manga. In fact, Takahashi's page composition often includes a great many words and are very much like *emonogatari* (e.g., *Beyond the Storm, Shōjo,* February 1958, 62–63). Thereafter, shōjo manga developed in the direction of making the page overflow with atmosphere and words.

Because the story can be told through words, images can be used not to break down action but rather to express psychological mood, with an emphasis on composition and design. The *emonogatari* style of narration then transformed into unspoken thoughts by the protagonists, that in turn helped enable the literary "psychological depiction" associated with the later women shōjo manga artists known collectively as the "Year 24 Group" or "Magnificent Forty-Niners" (so named because they were born in or around 1949, or the Japanese year Showa 24).

Nonetheless, it would seem that the artists of the day were largely unconscious of these various changes that began with Takahashi Macoto. Mizuno Hideko, herself an influential shōjo manga artist of the late 1950s and 1960s, invited a group of artists and editors active in this early period of shōjo manga to form the "Shōjo Manga Discussion Group," yet although meeting several times, they were ultimately unable to pinpoint the origin of the three-row overlaid style picture despite the seemingly obvious influence of Takahashi's work.

Takahashi was himself a member of the Discussion Group, and, strange though it may seem, when I directly asked him, "It was you who started the three-row overlaid style picture, wasn't it?" his response was, "Well, I suppose

that could be the case." Takahashi didn't say to himself, "Right! I'm going to create a new form of expression!" but that is what he did.

Regardless of whether or not other artists of the time were conscious of the changes underway, it is clear that Takahashi Macoto's *Beyond the Storm* was a definitive crossroads at which shōjo manga acquired not merely themes and subject matter that differed from those in shōnen manga but a *style of expression* and a path of development entirely distinct from shōnen manga.

A TRANSITION IN TAKAHASHI MACOTO'S STARRY EYES

There is another distinctive feature of shōjo manga I would like to touch on: "starry eyes." No one would deny that the large, long-lashed eyes filled with glittering stars, which appeared in the wildly popular illustrations of Takahashi Macoto in the 1960s and early 1970s, were a classic example of this phenomenon. But there were not always stars glittering in the eyes drawn by Takahashi. The eyes of the characters he drew in his earliest rental-market manga were relatively narrow, and when eyes were drawn in any detail, they contained nebulous shapes which, when magnified, can be seen to be a fairly realistic portrayal of what one sees in actual human eyes (Figure 30).

In "The Cursed Coppéllia" and *Beyond the Storm,* the eyes are much larger and there are more eyelashes, but inside the eye itself is only a single white dot representing the pupil (Figures 1–4). In the second chapter of *Tokyo–Paris* (*Shōjo,* August 1958–November 1959), published in the September 1958 issue of *Shōjo,* Takahashi added a second small dot (Figure 31), and, starting with the August 1959 chapter, these dots are transformed into stars (Figure 32).

In the first two chapters of *Princess Anne* (*Shōjo,* December 1959–December 1960), the stars become dots once again, but in episode 3 (February 1960), the stars return. In the May 1960 chapter, after some apparent vacillation over the exact placement of the stars, we finally see, in a close-up of the heroine, something very close to the eyes that would become the signature of Takahashi's work: beneath a white dot, a cross-shaped star shines, surrounded by more very small points of light (Figure 33).

It may be worth noting that some six months later, in the first chapter of the popular shōjo manga artist Maki Miyako's series *Girls* (*Shōjo,* December 1960), little stars began glittering that had never been seen before in the eyes of Maki's characters. Clearly, prior to Takahashi's *Princess Anne,* such complexly glittering starry eyes had never appeared in manga of any kind.

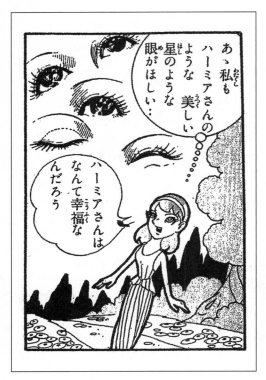

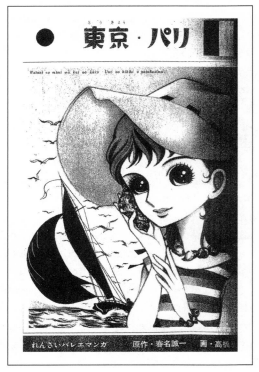

FIGURE 30 (LEFT). Takahashi Macoto, *Otome no yume* (The maiden's dream) (Tokyo: Akashiya Shobō Publishing, 1957), 30.

FIGURE 31 (BELOW). Takahashi Macoto, *Tōkyō–Pari* (Tokyo–Paris), *Shōjo,* July 1959, part of the frontispiece.

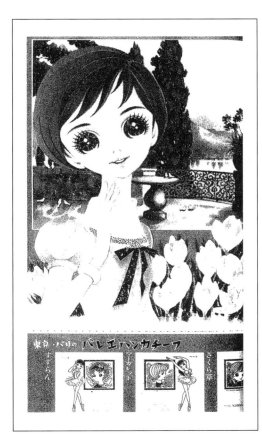

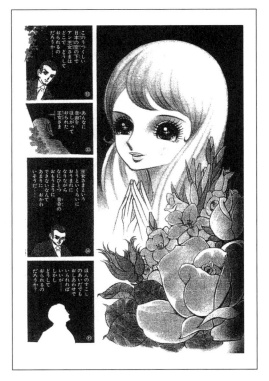

FIGURE 32 (LEFT). Takahashi Macoto, *Tōkyō–Pari* (Tokyo–Paris), *Shōjo*, August 1959, part of the frontispiece. The introduction of small stars.

FIGURE 33 (BELOW). Takahashi Macoto, *Purinsesu An* (Princess Anne), *Shōjo*, May 1960 (partial). The basic pattern in its final form.

Earlier "Starry Eyes"

Still, any account of starry eyes depends entirely on how exactly one defines them. According to the Shōjo Manga Discussion Group, the first example of starry eyes is Ishimori (later Ishinomori) Shōtarō's *Second-Rate Angel*. To be sure, literal five-pointed stars appear in the eyes of the protagonist in chapter two of *Second-Rate Angel* (Figure 34). This may, in fact, be the first example of stars appearing in the eyes of a manga character. However, since the protagonist is an angel, and chapter six includes an explanation of "my special eyes" (*Manga Shōnen,* June 1955), it seems highly likely that these "stars" are a manifestation of the protagonist's "special power." Incidentally, there are no stars in the first chapter.

There are cross-shaped stars to be found in the eyes of the heroine of *Ghost Girl* (*Shōjo Club,* September 1956–October 1957) (Figure 35), but this technique was used by many artists (e.g., Nagashima Shinji, Yokoyama Mitsuteru, Matsumoto Akira [later Leiji]). At this point, it is still a question for further research to determine whether or not this technique originated with Ishimori Shōtarō. In any event, all of these artists experimented with highlighting widely, trying out large dots, small dots, cross-shaped stars, and so on.

CLOSURE

After presenting the above findings to a joint meeting of the Manga History Study Group and the Shōjo Manga Section of the Japan Society for Studies in Cartoons and Comics, an audience member suggested that I might want to reread Yonezawa Yoshihiro's *History of Postwar Shōjo Manga*. On doing so, I discovered that Yonezawa had already made most of the same observations I made in Part 1 regarding Takahashi Macoto; that is, that Takahashi was the true "reformer of shōjo manga," and that this was made possible by his incorporation into shōjo manga of the techniques of both *emonogatari* and illustrated girls' novels. Allow me to quote Yonezawa at length:

> His style itself could be said to be a manga-esque development of the then-declining genres of *emonogatari* and the illustrations for girls' novels. . . .
> One could say that artists in the Tezuka Osamu tradition drew pictures in little panels for the purpose of advancing the story . . . and the cinematic technique of which Tezuka spoke, as drawn at the time, failed to express

FIGURE 34. Star in eyes in Ishinomori Shōtarō, *Nikyū tenshi* (Second-rate angel), *Manga shōnen*, February 1955.

FIGURE 35. Cross-shaped star in eyes in Ishinomori Shōtarō, *Yūrei shōjo* (Ghost girl), *Shōjo Club*, November 1956.

beautiful moods and psychological images. The speedy flow of panels was conceived to suit fighting and action, and could not be applied to shōjo manga without modification. . . . Takahashi's manga—which pushed mood and fashion and the beauty of the drawing to the fore, were composed as motionless "picturesque scenes," had few speech balloons, and made extensive use of expository narration—would have been labeled "shōjo *emonogatari*" just a few years earlier.

What I have achieved in this paper is to provide empirical, corroborative evidence for observations Yonezawa had made based on his own lived experience. I would like to express here my respect for Yonezawa's groundbreaking work; to pray that his soul, taken all too quickly on October 1, 2006, may rest in peace; and to reaffirm my own commitment to carrying on his research.

ATSUKO SAKAKI

The Face in the Shadow of the Camera: Corporeality of the Photographer in Kanai Mieko's Narratives

The photographer realizes that she is confined to her limited "vision," or to a part, and yet, precisely because of it, she aspires to encapsulate the whole. It is also an attempt at overcoming vision itself.

—Taki Kōji, "Me to me narazaru mono" (1970, The eye and that which is not), in *Shashinron shūsei* (Compendium of essays on photography)

We stand between the two impulses: to entirely become an "eye," and to become "that which is not an eye."

—Taki Kōji, "Me to me narazaru mono"

In the opening scene of Edward Sedgwick's silent film *The Cameraman* (1928), the protagonist, played by Buster Keaton, then a tintype photographer who takes portraits for passersby, proves to be physically susceptible to the dynamic flux of masses of people as they participate in and witness ongoing events on the street (Figure 1). As a means of approaching the woman of his dreams, Keaton's character replaces his tintype camera, capable only of representing static images of posing models, with a more up-to-date newsreel camera. With this new equipment he ends up capturing two events of documentary

PHOTOGRAPHERS CAN BE HIGHLY VISIBLE IN PUBLIC IN THE ACT OF TAKING PICTURES, WHICH DOES NOT NECESSARILY CONFORM TO NORMAL EVERYDAY BEHAVIOR; WITH THEIR CONSPICUOUS EQUIPMENT, THEY BECOME SPECTACLES THEMSELVES.

value—street fighting and a boating accident—in long and dramatic sequences, fully encapsulating the actions of entire bodies engaged in a struggle for survival. In the process he garners both professional success and personal happiness (the latter because his film inadvertently proves he has saved his sweetheart's life). The subtext is a celebration of motion pictures, as opposed to comparably inert and lifeless photographs.

Susan Sontag cites this film in her book *On Photography* in the context of discussing the myth that the camera never misses the mark:

> Unlike the fine-art objects of pre-democratic eras, photographs don't seem deeply beholden to the intentions of an artist. Rather, they owe their existence to loose cooperation (quasi-magical, quasi-accidental) between photographer and subject—mediated by an ever simpler and more automated machine, which is tireless, and which even when capricious can produce a result that is interesting and never entirely wrong. (The sales pitch for the first Kodak, in 1888, was: "You press the button, we do the rest." The purchaser was guaranteed that the picture would be "without any mistake.") In the fairy tale of photography the magic box insures veracity and banishes error, compensates for inexperience and rewards innocence.
>
> The myth is tenderly parodied in a 1928 silent film, *The Cameraman,* which has an inept dreamy Buster Keaton vainly struggling with his dilapidated apparatus, knocking out windows and doors whenever he picks up his tripod, never managing to take one decent picture, yet finally getting some great footage (a photojournalist scoop of a tong war in New York's Chinatown)—by inadvertence. It is the hero's pet monkey who loads the camera with film and operates it in part of the time.[1]

Though the camera that Keaton struggles with, "knocking out windows and doors," is not one for photographing but rather for filming, *The Cameraman*—the way Sontag frames it—still confirms the prominence of the photographer's own physical presence. The awkwardness and out-of-place-ness of being there with the object—of photographing "here and now"—is acutely felt as the photographer's body, too, is made into a spectacle. As Roland Barthes puts it: "The Photographer's 'second sight' does not consist in 'seeing' but in being there."[2] Photographers can be highly visible in public in the act of taking

FIGURE 1. Keaton struggles with a camera in *The Cameraman.*

pictures, which does not necessarily conform to normal everyday behavior; with their conspicuous equipment, they become spectacles themselves. Some of the points Sontag makes in this passage resonate with the concerns of Kanai Mieko (b. 1947), a poet turned novelist and visual arts critic, with regard to the contrast between the intentionality and contingency of the act of photographing, and the coordination (or lack thereof) between the body and the machine during this act.

In this essay I will consider cases in which text registers moments when the photographer's body manifests itself as visible or tangible, rather than being conceptually reduced to a transparent and immaterial container of the eye, as in the Cartesian regime of visuality. The reminder of the photographer's corporeal engagement in a series of actions taking place during photographic production—preparing and placing the equipment, releasing the shutter, developing the negatives, editing images, and producing prints—serves to compensate for the photography's perceived placidity and inefficacy. By helping to theorize the dialectics of seer and seen (beyond factual references to inconsequential and banal circumstances), photography overcomes the status of mediocrity that has often been ascribed to the medium. My procedure is

to take into account references made to photography by Kanai Mieko and discourses by her and others on one of the most celebrated Japanese photographers (himself a photo critic), Kuwabara Kineo (1913–2007),[3] whom Kanai reviewed and even quoted in a work of fiction. Kanai and Kuwabara both reveal sensibilities that lean toward corporeal and spatial projections into the otherwise flat images, similar to those of Maurice Merleau-Ponty and Walter Benjamin, whom both even occasionally cite.

As both Kanai and Kuwabara published their works, mostly in journals and then in books, their premise of image/text production and consumption is bound by the terms of print culture, wherein image and text are literally and figuratively flattened, appearing on two-dimensional pages, with their material presence reduced to the negligible. Both creators, however, have effectively challenged the common modern perception of prose and photography as transparent mediums of representation. One of their strategies is to foreground the creator's body (rather than their mind) and to urge the reader/spectator to become aware of traces of the body's active presence in the process of production. This awareness reactivates the archive of information as the time-space of performance. Released from the imagined community of consumer culture, readers/spectators are expected to find themselves in the here and now of the author/photographer's engagement with participants in their art—the engagement that is more physical than metaphysical.

WHY PHOTOGRAPHY?
BETWEEN PAINTING AND CINEMA

Kanai has been active as a film critic (with two collections of film essays as well as many reviews of films, prescreening lectures, and interviews of international directors to her credit) and as a cinematically inspired novelist who liberally alludes to films by Jean Renoir, Fritz Lang, Luis Buñuel, Robert Bresson, Naruse Mikio, and Eric Rohmer, among many others. Her sister Kumiko is a famed visual artist who frequently contributes to her publications as designer. A lesser-known yet equally formative exposure to photography is manifest in Kanai's reviews of photographic exhibitions and in a substantial essay on photography entitled "Han imeeji-ron" (1992–93, On anti-image),[4] and also in her engagement with photography in her fiction, ranging from her early short stories to the full-length novels that she concentrates on today. Her attention to photography relates to the concerns of influential critics of the medium, including Susan Sontag, Roland Barthes, Mary Ann Doane, and Victor Burgin.

As I have discussed elsewhere, Kanai's short story "Windows" (1976, "Mado") relates the male narrator-protagonist's frustration with the disconnect from his mother, portrayed as a young girl in an old photograph, while Barthes similarly tells us of the shock (which he famously terms "*punctum*") that he experiences upon encountering his mother in a portrait from her youth as someone he has never known.[5] Kanai's engagement with photography thus transcends the boundaries among media and is inescapably conceptual.

Throughout its history, photography has been defined in terms of what it is not: it is not fine art on the one hand (as in the above Sontag passage) and not cinema/film on the other. Its reproducibility, affordability, and perceived contingency of production have resulted in it receiving the ambiguous label "middle-brow art" (as in Bourdieu's formative book) and being considered inferior to "fine" art—deemed highbrow, irreplaceable, and invaluable, created intentionally by an author of genius.[6] On the other hand, photography, interpreted as imposing death upon the object that would otherwise be alive and mobile, has earned a reputation for inefficacy compared with cinema. As Burgin relates:

> Photography, sharing the static image with *painting,* the camera with *film,* tends to be placed "between" these two mediums, but it is encountered in a fundamentally different way from either of them. For the majority, paintings and films are only seen as the result of a voluntary act which quite clearly entails an expenditure of time and/or money. Although photographs may be shown in art galleries and sold in book form, most photographs are not seen by deliberate choice, they have no special space or time allotted to them, they are *apparently* (an important qualification) provided free of charge—photographs offer themselves *gratuitously*; whereas paintings and films readily present themselves to critical attention as objects, photographs are received rather as an environment.[7]

Having touched upon a hierarchical consciousness of the painter and photographer in her essay "Fotogurafu oboegaki: Ugoku mono to ugokanai mono no kyori" (2001, "Notes on photography: The distance between the mobile and the immobile"), Kanai addresses one of Doane's major concerns5, namely, photography's negotiations with movement that the medium is normally considered unable to render:[8]

> It should be indecent to indicate the release of the shutter by stop motion. There are many methods to show the photographs taken by characters in

films. For example, in Godard's *Masculin, féminin,* Jean-Pierre Léaud, who posed the camera to take a picture of his girlfriend on a rooftop, walks backward to encase her within the frame of the finder as he sees fit, to the extent that he falls from the rooftop of the building with the camera. [9]

By such commentaries on the cinematic representation of the photographer, who necessarily becomes corporeal, Kanai succeeds in drawing our attention to the photographic process rather than the images as photography's final product. Kanai considers the body of the photographer in Jean-Luc Godard's film *Masculin, féminin: 15 faits précis* (1966), the body in this case being sacrificed for the very act of photographing. It is appropriate that Kanai cites the actor Jean-Pierre Léaud rather than the character, Paul, to suggest the corporeality in a fashion that is as physical and as unmediated as possible, although the Godard film in its currently distributed DVD format lacks the scene she describes (the accident is recounted by witnesses afterward). The imaginative excess of Kanai's account of the film may be attributed to her keen interest in the involvement of the body that manipulates the camera behind the scene.

AGAINST THE MYTH OF MECHANICAL REPRODUCTION

In her article on Jeff Wall's work of digital photography in tribute to a woodblock print by Katsushika Hokusai, Laura Mulvey suggests that Hokusai's *ukiyoe* print "was modern not only in its subject matter, but in its process of production," as his work "was transformed into a marketable commodity through the collaboration of engravers and printers, depending on the investment of a publisher to ensure mass circulation. . . . The citation of Hokusai seems to bracket the life of photography, from the mass-produced wood print to Wall's complex, computer generated image designed for the museum, gallery, or collector." [10]

The history of photography according to Mulvey may also be effectively bracketed by manga, a medium that, in the age of mechanical reproduction and mass distribution, complicates the artist's body in relation to the spectacle and spectator of his art. Traces of the artist's body, such as brush strokes and autographs, stay within the frame and are fetishized by the audience, while authorial control may be lost in the process of reproduction and distribution. Between the vanishing and the haunting persistence of the author's presence, manga qualifies anonymity, objectivity, and universality—definitive

qualities of conventional photography complicit with the Cartesian visual framework—much as *ukiyoe* does. While the specters of manga artists command the space between manually produced pictures and reproducible prints, the photographer's identity has been obscure. The photographer's body is usually withdrawn from the image, as photographs purport to be anonymous, objective, and universal.[11]

Kanai and Kuwabara are among those who challenge the purported transparency and neutrality of photography, and aspire to restore the photographer's corporeal presence in the medium. In so doing, they do not proclaim the authorial intent of the photographer but call our attention to her physical grappling with technology and the environment—an experience shared with manga creators.

THE PHOTOGRAPHER WITHOUT VOICE

Kanai, in a 1981 review of the film *The Cameraman* for the literary journal *Bungei,* points out that "the spectators [of films] tend to forget the cameraman's existence" and that "the camera and cameraman are the only things that the camera could not capture."[12] She may then have had in mind the film, or Sontag's commentary on it, when she calls Kuwabara "a cameraman" ("kyameraman") and Araki Nobuyoshi a "journalist" ("jaanarisuto") in her review of the two photographers' collaborative exhibition, *Love You Tokyo! The Photography of Kineo Kuwabara and Nobuyoshi Araki;*[13] she speaks favorably of the lack of authorial intention in Kuwabara's photographs, and of the corporeal coordination of eye and finger that renders his work "ethical."[14]

Kanai's interpretation of Kuwabara resembles that of French literature scholar Okamura Tamio, who articulates the way Kuwabara's body moves among the people whom he photographs, rather than the way his mind works to incorporate and organize them in a preordained vision. Okamura begins his essay "Tsūkasha no manazashi" (The gaze of the passer-by) with another film–photography comparison, lamenting that film sacrificed the *flâneur*'s gaze in order to narrate stories:

> The gaze of the passer-by in a city, which Baudelaire registered in poetry in
> the mid-nineteenth century, was recorded in film by the Lumière brothers
> at the end of the century, after the Impressionists' canvases. However, cin-
> ema sacrificed this treasure, exchanging it for acquisition of the narrative.
> Before the rediscovery of the passer-by's gaze by the New Wave cineastes,

> BEING A SELF-ADMITTED *FLÂNEUR*, KUWABARA REFUSES TO GIVE ANY MEANING TO THE VISUAL, WHILE FRANK COULD NOT BEAR THE DISCONNECT BETWEEN THE PHOTOGRAPHER AND PHOTOGRAPHED AND CONVERTED TO FILM TO TELL A STORY OF THE LATTER.

photographers with Leicas in their hands assumed the responsibility of registering it. Kuwabara Kineo (b. 1913) and Robert Frank (b. 1924) must be identified as representative photographers of this kind.

Both prefer photographing figures temporarily on the street (just as the two of them are): passers-by, street venders, street performers, and things that wink at the glances of passers-by, such as signs, posters, and merchandise. . . . The charm of their photographs of urban landscape lies in the instantaneous encapsulation of incidental structures on the streets, where encounters and parting, or formation and dissolution, are inseparable. It is not even "a decisive moment" but "a moment" that cannot form a theme, a moment that settles, which only the camera could foreground. For Kuwabara and Frank, "streets" are not only their site of work, but also the principle of photography.[15]

Okamura is in sync with Kanai in his assessment of the nonnarrative orientation of Kuwabara's photography. While Kanai explicitly contrasts Kuwabara with Araki, an eager storyteller (Figure 2), Okamura obviously draws a contrast with Henri Cartier-Bresson, for whom capturing a moment that has a "decisive" meaning was an ultimate goal.[16] Another implicit comparison is to Eugène Atget, for whom, as we shall see later, streets were first and foremost the "site of work," whereas streets permit Kuwabara to share with passers-by the contingency of physical exploration of space. Beyond a reference, beyond a metaphor, urban space is formative and definitive for Kuwabara's photography.[17] In it materializes a conundrum, involving conventionally contradictory qualities such as anonymity, celebrity, obscurity, and visibility of the photographed and the photographer. Okamura suggests, "Kuwabara is conscious of the coercive nature of photography and yet is immune to melancholy."[18] Melancholy, in Kanai's terminology, comes from narrativity, a quality absent in Kuwabara's photography. The photographic rejection of the narrative—or of the commentary on image—is ultimately the reason that Frank, whom Okamura finds analogous to Kuwabara, left photography for film. Kuwabara contrasts himself with Frank on this account:

> I would spend a certain amount of time photographing those poverty-stricken streets *without thinking of them as such*. It was the activity of a

FIGURE 2. From Araki Nobuyoshi, *Subway,* in *Love You Tokyo.* Courtesy of Setagaya Art Museum, Tokyo.

> slow-witted person with no use or value in society. They say that Robert
> Frank quit photography and turned to film, stating, "I cannot afford to be a
> lonely observer who would look away from his subject right after releasing
> the shutter," but I shamelessly continued to photograph as a solitary ob-
> server, or to put it precisely, *a mere passer-by.*[19]

Kuwabara gains a perspective from which to define the environment he used
to photograph as "poverty-stricken," though he did not "think of it as such"
while taking the pictures. He had not formed a narrative to account for the se-
ries of images prior to the release of the shutter. Being a self-admitted *flâneur,*
Kuwabara refuses to give any meaning to the visual, while Frank could not
bear the disconnect between the photographer and photographed and con-
verted to film to tell a story of the latter. Instead of becoming an omniscient
narrator, or an embodiment of the bird's-eye view, Kuwabara remained "a
mere passer-by," whose involvement with the subject is by default transient
and conditioned by physical limitations.

The contrast drawn between Frank and Kuwabara seems to parallel the
one between Eugene Smith and William Klein, submitted by Taki Kōji, a re-
nowned critic of visual arts and a photographer himself, who among others

"rescued" from obscurity Kuwabara, who had transitioned from photographer to photographic journal editor after World War II:[20]

> As for Klein, he does not gaze at the huge space of New York City from a fixed viewpoint—*he does not try to look at it from outside or above.* New York is the world he interacts with skin to skin, the world that actively comes to touch him and at the same time is soaked by his sensibilities. We can sense a "gazing eye" in Eugene Smith, while there is *a consciousness of "being within," so to speak, in Klein.* New York exists as *something that is not only to look at but also to be looked at by, as something infinitely ambiguous, impossible to form a complete picture of, and actively variable.* . . . Its originary method was sought *in the flux and amorphous structure encompassing a subject and its environs.*[21]

To borrow from Taki's polarization of Smith and Klein, Kuwabara is someone whose "consciousness of 'being within'" comes through in his work, as he does not see urban landscape either "from outside or above." His streets are "ambiguous, impossible to form a complete picture of, and actively variable." And thus, unlike Cartier-Bresson's or Atget's pictures, Kuwabara's photographs reveal the "flux and amorphous structure encompassing a subject and its environs."

PHOTOGRAPHY AS CORPOREAL ART

In Kanai's short story "Windows," the narrator-protagonist relates his early practice of photography, in which his awareness of the physicality of his presence surfaces:

> This is what photos are like, said my father. You should take pictures of whatever you feel like—it's very simple. And he showed me how to use that small lens-shutter camera. Take any photos you feel like, he had said; but I had as yet no idea of the connections among my own gaze, the body, the camera, and the images caught on film, so I was content for some time to simply hold in my hands the empty camera, with no film in it, and look through the finder. The scenes and objects carved into the shape of the little finder-window seemed to take on a special radiance. The finder was, in fact, dark and hard to look through, and since I had to keep one eye shut for a long time, the muscles on the left side of my face, being scrunched up in an unnatural way, developed a slight twitch and became quite stiff. Still, the

world became brighter when viewed within the steady finder, exposing its clear outlines.[22]

It is evident that the narrator-protagonist is conscious that his own body limits the "inexhaustible" possibilities that are often imagined in photo taking—the liberty, or automatism,

> THE FACE IS NOT FLAT BUT THREE-DIMENSIONAL, COMPOSED OF NOT ONLY SKIN BUT ALSO FLESH AND MUSCLES THAT AROUSE TACTILE SENSATIONS.

that was praised in the Kodak advertisement quoted by Sontag, and the ease that in effect helped to condemn photography to a second-class status below fine art. The face that concerns "I" here is not that of a spectacle but a part of the spectator's body. Although his own face is fixed to the lens and thus remains invisible to him, its physical presence is painfully felt in coordination with other parts of his body. The face is not flat but three-dimensional, composed of not only skin but also flesh and muscles that arouse tactile sensations.

Kanai's narrator-protagonist then addresses the unmanageability of the (physical) act of photographing, further invalidating the purported ease with which the camera should be maneuvered—the lure of the machine that caught Sontag's attention, as we saw earlier:

> My father said I should just take a picture of something, anything, I liked, but I didn't know what it was I should take a picture of, so my heart was heavy, since I knew the simple act of clicking the shutter to expose an object on film to be immensely important. By pressing a cylindrical, dull-silver-colored piece of metal about the size of an adzuki bean down by a few millimeters, one could peel away a sliver from the radiance of the world of matter and time, I thought.[23]

The narrator expresses further frustration with the lack of continuum between the image his eyes see and the one the camera lens could frame, as well as between the landscape he saw with his own eyes and the one imprinted in the picture:

> In fact the first photo I tried to take was of the ruins of the army depot, but it was too big and would not fit into the finder of my toy camera. If I wanted to include it all, I would have needed to take it from far away; so, unable to take the photo from the angle and point of view I wanted, I had to be content with as much as would fit into the little finder. When the film was developed and the photo printed, the scene was completely different

from the actual scene—or rather, from the scene I had viewed. In my vision it had had a definite sense of existence and clear outlines, but in the photo, everything was lost, transformed into a muddy, ash-colored lump, dreary and disordered.[24]

While Kanai's photographer, unlike Godard's ill-fated one in *Masculin, féminin,* complies with the limited physical conditions and thus avoids catastrophe, he must endure dissatisfaction with the outcome of the compromise. The above passage effectively undoes the myth of the automatism of camera work, first by identifying the obstacles lying in the process of photographic (re)production, and then by revealing the disjuncture between the picture registered by his eye, the camera's telescopic vision, and the resulting photographic image. What emerges from this unsuccessful procedure is the rhetoricity of photography; he fails to either transcend it or translate into the language of photography the image captured by the eye. Photography thus does not consist of a transparent representation of what you see but an adaptation thereof within the delimiting, if equally enabling, material framework that the medium requires.

Taki expounds on the crucial involvement of the specific physical conditions, beyond the optical faculty, that help to form images:

> As I stopped the car and posed the camera, I realized that the sensation stirred in my body while driving was no more. No longer in the mood for releasing the shutter, I returned to the car. As the car drove away, I felt that things were not static, and that they disappeared from the scope of my vision in a moment. I was on the site where mobile vision was the only thing at stake. My eyes that move could constitute the world, but as soon as they stopped moving, I felt as though the world I saw had retreated and hidden itself beyond my power to organize. I was incorporated within the world while I was on the move—incorporated and at the same time able to incorporate the world. In other words, I had discovered a body in action, and this body of mine (and not my eyes) constituted the world.[25]

Taki encapsulates the "being-within-the-world-ness" of the photographer's entire body, in a reciprocally formative relationship with the world. While the eye—along with the mind, of which the eye is considered a window—has long been taken for granted as neutral and intangible, recognized only for its function of surveying and registering things it sees, the body is itself a part of the world and thus occupies a certain amount of space, moves around, and can be looked at and touched. And it is the body, rather than the eye, that

produces the image. As Maurice Merleau-Ponty declares in "Eye and Mind" (1964, *L'oeil et l'esprit*):

> The painter "takes his body with him," says Valéry. Indeed we cannot imagine how a *mind* could paint. It is by lending his body to the world that the artist changes the world into paintings. To understand these transubstantiations we must go back to the working, actual body—not the body as a chunk of space or a bundle of functions but that body which is an intertwining of vision and movement. I have only to see something to know how to reach it and deal with it, even if I do not know how this happens in the nervous machine. My mobile body makes a difference in the visible world, being a part of it; that is why I can steer it through the visible. Moreover, it is also true that vision is attached to movement. We see only what we look at. What would vision be without eye movement?[26]

How, then, does Kuwabara position himself vis-à-vis other persons or things that he photographs? The photo critic Nishii Kazuo's colophon to Kuwabara's book *Tokyo 1934–1993* is mocked by Kanai in her novel *Karui memai* (1997, Vague vertigo) for its unabashed and uncritical outpouring of nostalgia, as Nishii concludes the text with the proclamation that Kuwabara's photographs remind him of a Tokyo now vanished. Despite falling back on a nostalgia that Kanai and Okamura do not think Kuwabara evokes or capitalizes on, Nishii approximates Kanai in another part of the same text, where he articulates Kuwabara's stance vis-à-vis the people he photographs. Nishii stresses Kuwabara's seeming distance from the subject as opposed to Atget's strategic approach to photography, manifest in his method of painting out a map of Paris block by block to check the area that he had photographed.[27] In this light Atget's photography is not a product of *flânerie* but a cartographic enterprise, which accords perfectly with his self-definition as "author-producer" (*auteur-éditeur*). In contrast, Kuwabara's photographs manifest no authorial intent according to Kanai, as we saw above.

THE PHOTOGRAPHER IN RELATION TO THE PHOTOGRAPHED

Nishii further illustrates Kuwabara's positioning of his own body as follows. Kuwabara tends to take photos of people from behind as he is passing by, especially if the person is a woman with long hair (Figure 3). Whether this

practice deserves the name of voyeurism or courtesy—"shyness or considerateness"—he chooses to "stand in silence beside or behind the object."[28]

While Araki Nobuyoshi, who is known to photograph women while having sexual intercourse with them, cannot help but strike up a "conversation" with the object, face to face, Kuwabara maintains a distance that permits him to stand slightly apart from and yet look at the object without issuing a word. As another critic, Suzuki Shiroyasu, puts it, Kuwabara does not "assault" the people he photographs but "flees" them.[29] This might account for Kuwabara's tendency to photograph children, who neither reject nor ignore the camera, as well as mannequins and visual representations of human faces in posters or on television screens (Figure 4). It is as though he were deliberately avoiding interaction with people who might react to the fact they are being photographed, as Barthes says he is:

> Now, once I feel myself observed by the lens, everything changes: I constitute myself in the process of "posing," I instantaneously make another body for myself, I transform myself in advance into an image. This transformation is an active one: I feel that the Photograph creates my body or mortifies it, according to its caprice.[30]

Children look back at the cameraman inquisitively or simply do not notice him, engrossed in their own activities. Adults, on the other hand, tend either to pose for a camera or pretend not to notice it. They make an implicit effort to define a relationship with a photographer one way or another: as an accomplice or as an unwitting victim of voyeurism, in which the photographer remains anonymous and ostensibly inconspicuous or invisible.

Kuwabara illustrates the awkward relationship between the photographer and the photographic object as follows:

> Then, a mistress in kimono with hair undone hastened out of a store. I released the shutter, then the next moment, she shouted: "Don't take my picture. Stop it! I hate being photographed!" It was awkward even to apologize, so I turned around as though nothing had happened and turned right at the corner of the next alley. When I took another look at the mistress, she

FIGURE 3. A woman from the back. Kuwabara Kineo, in *Love You Tokyo*. Courtesy of Setagaya Art Museum, Tokyo.

FIGURE 4. Children. Kuwabara Kineo, in *Love You Tokyo*. Courtesy of Setagaya Art Museum, Tokyo.

THE FACE IN THE SHADOW OF THE CAMERA **71**

was engrossed in a chat with a female customer, as though she had forgotten shouting at me. It was I, the photographer, who was unable to overcome the lingering discomfort. *The relationship between the subject and object of photographing has its own conflicts and contradictions for each*, which generates photographs. *To me, taking photographs continues to involve nothing but embarrassment and hesitation.*[31]

Kuwabara is painfully aware of the conundrum of the seer–seen relationship, and yet instead of resolving it, he capitalizes on the tension and contradiction to produce photographs, at the cost of complicating his interpersonal relationships.

While Kuwabara naturally experiences embarrassment, hesitation, or displeasure from behind the camera, Kanai theorizes the response from those in front of the camera, using another photographer as a point of reference: Tamura Shigeru (b. 1947, also called Tamura Akihide), who is perhaps best known to the Western audience through a book of portraits of Kurosawa Akira. The specific photograph Kanai explicates is called "Yume no hoteru de no beigun Betonamu kikyūhei" (An American soldier on furlough from Vietnam, at a dream hotel).[32] When the picture and several others first appeared in the photographic journal *Asahi kamera* in 1970, the photographer related the circumstances under which the photographs were taken:

> The way that jet planes blurred in the shimmering heat haze, it was *more delightful to look at through the keyhole than to produce a photograph out of it.* Since it was impossible to hold the one-meter-length telephoto lens myself while photographing, *I had my friend shoulder the equipment so that I could take pictures.* I felt trepidation, fear that the U.S. military's air patrol might pick up on us. But the patrol car passed by without [the officer inside] even turning back to see us, which left me with a kind of disappointment that my expectation had not been met.[33]

Tamura's account succinctly mediates the physical experience of the objects, the employment of his body as well as his friend's in maneuvering the equipment, and the anxiety that sustained the tension in the act of photographing. What is missing from his narrative, however, is how the objects reacted to his camera. Kanai cuts into the scene by addressing the very question:

> What was the gaze of the soldier and the girl, turned toward the photographer who hid half of his face with the camera, which had become the gaze of

his body? They look as though nothing had been on their minds. One cannot be sure whether their apparent stare is just a glance as they twist their necks, or whether they entertain some ineradicable prejudice or menace toward the photographer. The gaze of the person who looks at the camera always concerns me. At that moment, the photographer moves via the camera eye, while being looked at (what they are looking at is none other than the unique body of the photographer who is engaged in the movement of photographing) and does not see anything except through the act of photographing. Miyakawa Atsushi has pointed out that the man who turns his back to the audience in Brueghel's paintings is the painter himself. Photography, a genre that is most objective and represents unmediated truth, does not require the author's figure showing the back: instead, *the rectangular frame itself manages to materialize the gaze of the photographer.*[34]

Kanai suggests above that the frame of a photograph is a material condition that forms the product, and that the presence of the photographer's body is confirmed without being shown within the frame. Instead of the sight of the back of the "author," Kanai imagines the sight of the photographer from the front, reflected in the eyes of the object being seen and photographed—the face in the shadow of the camera, with one eye fixed to the lens, with the other side of the face being squeezed so that one eye may be kept closed while photographing, just as experienced (but not portrayed as seen) in "Windows." His body also takes an unusual posture, maneuvering the camera placed on his friend's shoulder. Indeed, it is a "unique body" that is engaged in a very visible and notable if not awkward and unsightly action—and this engagement in the specific action forbids him to see things other than through the lens. In other words, the photographer exposes his unique body to the others who exist for him only as spectacles, even while reducing himself to the eye, subordinating the other faculties to the vision that they support. The seen/photographed must have turned their faces to the photographer, with curiosity at least, to return what Victor Burgin calls the fourth look, "the look the actor may direct to the camera."[35]

The interface involving those designated by the photographer as spectacles (who nonetheless look back at him and turn him into a spectacle) and the photographer (whose consciousness takes minimal note of his body beyond the eye) must inform the process of photographing, including the production of the final print. Perhaps what transpires from the process is the generation of the aura, as Walter Benjamin argues:

What was inevitably felt to be inhuman, one might even say deadly, in da-guerreotype was the (prolonged) looking into the camera, since the camera records our likeness without returning our gaze. But looking at someone carries the implicit expectation that our look will be returned by the object of our gaze. Where this expectation is met (which, in the case of thought processes, can apply equally to the look of the eye of the mind and to a glance pure and simple), there is an experience of the aura to the fullest extent. "Perceptibility," as Novalis puts it, "is a kind of attentiveness." The perceptibility he has in mind is none other than that of the aura. Experience of the aura thus rests on the transposition of a response common in human relationships to the relationship between the inanimate or natural object and man. *The person we look at, or who feels he is being looked at, looks at us in turn.* To perceive the aura of an object we look at means to invest it with the ability to look at us in return.[36]

Whether the photographer's body is within the picture or without, beside the object or behind the camera, facing the object or avoiding eye contact with it, the photographer's physical presence disturbs and dictates the scene at the same time. In the constant struggle to overcome incidentals, the photographer photographs, while seen as no less corporeal than the photographed, playing the game within his or her own frame.

..

Notes

Earlier versions of this paper were presented at "The City, the Body, and the Text in Modern Japanese Literature," a conference at the University of Toronto (2005); the Association for Asian Studies Annual Meeting (San Francisco, 2006); the Asian Studies Conference Japan (Tokyo, 2009); and the Jackman Humanities Institute at the University of Toronto (2010). I am thankful for these opportunities and the insightful comments given by participants. Research on this topic has been supported by a Social Sciences and Humanities Research Council of Canada standard research grant and a Jackman Humanities Institute faculty research fellowship. I am grateful to Baryon Tensor Posadas, Michelle Smith, Martin Townsend, and Jing Wang for their help with various stages of writing.
 1. Susan Sontag, *On Photography* (New York: Picador, 1977), 53.
 2. Roland Barthes, *Camera Lucida: Reflections on Photography,* trans. Richard Howard (New York: Hill and Wang, 1981), 47.
 3. Kuwabara was featured in *Creatis* 15 (1981): 12–18.
 4. Serialized in the photographic journal *Asahi kamera,* this essay was then collected in Kanai Mieko, *Hon o kaku hito yomanu hito tokaku kono yo wa mamanaranu* (What on earth to do with writers who don't read?), part 2 (Tokyo: Nihon Bungeisha, 1993), 317–71.
 5. Kanai Mieko, "Windows," in *The Word Book,* trans. Paul McCarthy (Champaign, Ill.:

Dalkey Archive Press, 2009), 11–22. For Kanai's remarks on the uncanny similarity and the nonetheless irrevocable discrepancy between the sentiments the mother's old photographs evoke in Barthes and "Windows," see Atsuko Sakaki, "Breezes through Rooms with Light: Kanai Mieko by Roland Barthes by Kanai Mieko," *Proceedings of the Association for Japanese Literary Studies* 10 (Summer 2009): 204–19.

6. Pierre Bourdieu, *Photography: A Middle-brow Art,* trans. Shaun Whiteside (Stanford, Calif.: Stanford University Press, 1990).

7. Victor Burgin, "Looking at Photographs," in *Thinking Photography,* ed. Victor Burgin (Hampshire, U.K.: MacMillan, 1982), 142–43; emphasis in the original.

8. Mary Ann Doane, *The Emergence of Cinematic Time: Modernity, Contingency, the Archive* (Cambridge, Mass.: Harvard University Press, 2002).

9. Kanai Mieko, "Fotogurafu oboegaki: Ugoku mono to ugokanai mo no kyori," *Gendai shisō* 29, no. 1 (September 2001): 130.

10. Laura Mulvey, "A Sudden Gust of Wind (after Hokusai): From After to Before the Photograph," *Oxford Art Journal* 30, no. 1 (2007): 36–37.

11. Many contemporary photographers have de-neutralized their own physical presence: David Hockney, who famously lets the tips of his shoes slip into the frame of his photographs; Ernestine Ruben, who provides commentaries on her own hands; and Onodera Yuki, who entitles one of her works *Jūichibanme no yubi* (The eleventh finger), alerting us to the presence of her finger on the shutter button.

12. Kanai Mieko, "Kozaru no yō na kameraman no shōzō: *Kiiton no kameraman*" (A portrait of a photographer like a baby monkey: *The Cameraman by Keaton*) in *Eiga yawarakai hada* (Cinema: La Peau douche/The soft skin) (Tokyo: Kawade Shobō Shinsha, 1983), 66, 73.

13. Kanai, "Kussetsu to rinri" (Reflection and ethic), *déjà-vu: a photographic quarterly* 14 (Autumn 1993): 139. The exhibition took place at Setagaya Art Museum, Tokyo, July 17–September 5, 1993. For an English-language review, see Dana Friis-Hansen, "Kineo Kuwabara and Nobuyoshi Araki at the Setagaya Art Museum–Photography–Tokyo, Japan–Review of Exhibitions," in *Art in America* 82, no. 1 (January 1994): 114.

14. Atsuko Sakaki, "Materializing Narratology: Kanai Mieko's Corporeal Narrative," *Proceedings of the Association for Japanese Literary Studies* 5 (Summer 2004): 223–24. Quotations are from Kanai, *Karui memai* (Vague vertigo) (Tokyo: Kōdansha, 1997), 148–67, though they are originally from "Kussetsu to rinri" and "Hikari no ima ushi to mishi yo" (The present of light: The life I was ready to renounce) in Kuwabara Kineo, *Kuwabara Kineo shashinten Tōkyō Shōwa modan* (Tokyo: Higashi Nihon Tetsudō Bunka Zaidan, 1995), 156–57.

15. Okamura Tamio, "Kuwabara Kineo to Robaato Furanku: Tsūkasha tachi" (Kuwabara Kineo and Robert Frank: The gaze of the passer-by), in *Shashin/Bodi sukōpu: Hikari, rogosu, kioku* (Photography/bodyscope: Light, logos, memory), *Kokubungaku kaishaku to kyōzai no kenkyū* 44, no. 10 (August 1999): 116.

16. According to Imahashi Eiko, however, the concept of the "decisive moment" originates from a mistranslation into English, rather than Cartier-Bresson's own words. His stress was on the fugitive nature of photo taking, which indeed may parallel Kuwabara's attitude to be elaborated later in this essay. See Imahashi, *Pari-shashin no seiki* (The century of Paris photography) (Tokyo: Hakusuisha, 2003), 415–26.

17. Kuwabara Kineo's expressed preference for the Benjaminian "*flâneur*" who has "not formed a self-consciousness as a photographer" and for Garry Winogrand's view that "I photograph to find out what something will look like photographed" ("Understanding Still Photographs," 1974; quoted in Sontag, *On Photography*, 197, which, translated into Japanese in 1977, made the statement famous in Japan) suggests the lack of a preordained scheme in his photographs. See Kuwabara, "Hashigaki" (Preface), in *Tokyo 1934–1993* (Tokyo: Shinchōsha, 1995), 3–5, a collection of his works cited in Kanai's *Karui memai*.

18. Okamura, "Kuwabara Kineo to Robaato Furanku," 119.

19. Kuwabara, "Shashin o toru mono no fukō" (The misfortune of a cameraman), *Shashin hihyō* 2 (1973): 95–96 (emphasis added).

20. Taki Kōji, "Kodoku na ningen no ushiro sugata" (1973, The back of a loner), in Kuwabara Kineo, *Tōkyō Shōwa 11nen* (Tokyo, the eleventh year of Shōwa) (Tokyo: Shōbunsha, 1974), 223–26.

21. Taki Kōji, "Me to me narazaru mono," 38 (emphasis added).

22. Kanai, "Windows," 16–17.

23. Ibid., 18.

24. Ibid., 19.

25. Taki, "Me to me narazaru mono," 50.

26. Maurice Merleau-Ponty, "Eye and Mind," trans. Michael B. Smith, in *The Merleau-Ponty Aesthetics Reader: Philosophy and Painting,* ed. Galen A. Johnson (Evanston, Ill.: Northwestern University Press, 1993), 123–24.

27. Nishii Kazuo, "Yosoyososhiku tatazumu: Yume no machi no shashinka" (Lingering on, as though indifferent: The photographer in a dream town), in Kuwabara Kineo, *Tokyo 1934–1993,* 553.

28. Nishii, "Yosoyososhiku tatazumu," 552.

29. Suzuki Shiroyasu, "Nichijōsei no gyakusetsu: Kuwabara Kineo ron" (The paradox of everydayness: On Kuwabara Kineo), in Kuwabara Kineo, *Tōkyō chōjitsu,* vol. 15 of *Sonorama shashin sensho* (Sonorama photography compendium) (Tokyo: Asahi Sonorama, 1978), n.p..

30. Roland Barthes, *Camera Lucida,* 10–11.

31. Kuwabara Kineo, "Torarekata no rekishi" (The history of how to be photographed), in *Watakushi no shashinshi* (My history of photography) (Tokyo: Shōbunsha, 1976), 149 (emphasis added).

32. Tamura Shigeru [Akihide], "Shiroi fensu no mukō: Beigun kichi," no. 9 of "Shashin kiroku 1970" (Photo documentaries 1970), *Asahi kamera* 55, no. 9 (September 1970): 119–20.

33. Tamura, "Shiroi fensu no mukō," 150; emphasis added.

34. Kanai Mieko, "Mirumono no nikutai wa doko de chokuritsu suruka: Aruiwa shashin ni mukatte ippo zenshin niho kōtai" (Where does the observer's body stand upright? Or, toward photography, one step forward, two steps backward) *Kikan shashin eizō* 6 (Autumn 1970): 179 (emphasis added).

35. Burgin, "Looking at Photographs," 148.

36. Walter Benjamin, "On Some Motifs in Baudelaire," in *Illuminations,* trans. Harry Zohn, ed. Hannah Arendt (New York: Schoken, 1969), 187–88 (emphasis added).

SHARALYN ORBAUGH

Kamishibai and the Art of the Interval

The Cartesian search for truth . . . is posed as the problem of relating the external world to the interiority of a pure mind divested of all emotion, sensuality and corporeality.

—Scott McQuire, *Visions of Modernity*

The system of perspective is not just a form of representation, not just a representational device, but is rather a representational device that also possesses a thematic content. . . . It is an expression of a desire to order the world in a certain way: to make incoherence coherent, objectify subjective points.

—Michael Ann Holly, *Past Looking: Historical Imagination and the Rhetoric of the Image*

Kamishibai is a performance art that was popular in Japan from the late 1920s to the 1960s and today lives on in nostalgia venues such as the International Manga Museum in Kyoto and the Shitamachi Museum in Tokyo. Most simply, a *kamishibai* play is a set of pictures used by a performer to tell a story to an audience, usually of children aged four to twelve. During Japan's Fifteen Year War (1931–1945), however, *kamishibai* was a crucial medium for the

dissemination of propaganda to a variety of audiences, adults as well as children.[1] The questions driving this study are: How did the characteristics of *kamishibai* function in the context of prowar, imperialist propaganda to make that propaganda effective (or not)? And do the Cartesian or anti-Cartesian elements of *kamishibai* plays have any influence on the propaganda effect?

For my purposes here Cartesianism boils down to three major elements: (1) the split between the mind and body, with the mind considered primary; (2) rationalism—a belief in science as the standard for truth; and (3) a conceptualization of the human self as stable and enclosed, separate from the world, and able to observe and judge the world in a detached, objective, rational manner.[2] As in the second epigraph above, I take Cartesian perspectivalism in the visual aspects of *kamishibai*—the illustrations—as more than simply a neutral choice of representational style: it indicates a desire to "order the [*kamishibai*] world in a certain way" that could convince viewers to understand and respond to their own world in similar terms. When considering the effectiveness of any tool of propaganda, the question arises: what kind of "subject" is being interpellated by a particular propaganda text? Here I will specifically consider the ways that Cartesian perspectivalism—in both a visual-culture and phenomenological sense—was used in propaganda *kamishibai* to construct particular kinds of subjects, and also the ways that certain characteristics of the medium seem to resist aspects of Cartesianism.

Kamishibai may be best known today as one of the direct precursors of postwar manga and anime,[3] but over its forty-year heyday it enjoyed enormous popularity, at times eclipsing rival entertainment media for children such as movies or radio (in the 1930s and early 1940s) and manga (in the 1950s). It was only the rise of television—tellingly known as *denki kamishibai* (electric *kamishibai*) in its early years—that finally brought about its demise.

Looking backward, *kamishibai*'s roots clearly lie in a host of what J. L. Anderson calls "commingled media" in Japan—*etoki* from the Heian period; *nozoki karakuri,* magic lanterns, and *utsushie* from the Edo period—as well as being influenced by Meiji-period performance forms such as *rakugo* and *yose*.[4] Rather than tracing *kamishibai*'s debt to these older forms, however, in this project I will concentrate on its relationship with the cinema, still developing in the late 1920s and early 1930s when *kamishibai* was born. In fact, it was cinema's transition from silent films to the talkies that helped ensure *kamishibai*'s success, as we shall see.[5]

One characteristic to be noted immediately, however, is the *intensely* commingled nature of *kamishibai,* even when compared to other Japanese commingled media: *kamishibai* consisted in every context and every time period

of three integral parts: pictures, story (sometimes in the form of a printed script), and performance.

In the next section we turn to the structure and techniques of *kamishibai,* which comes in two forms: *gaitō* (street-corner), referring to performances on the street by a professional, with children as the audience; and *kyōiku* (educational) or *insatsu* (printed), referring to performances in a variety of educational or religious venues. It was the latter form that was adapted during the war for use in conveying propaganda to a wide range of audiences. In order to comprehend the media characteristics that made *kamishibai* suitable (or not) for wartime propaganda messages, it is necessary to understand its prewar origins and the material realities of its typical deployment.

GAITŌ KAMISHIBAI

A form of street theatre, *gaitō kamishibai* appealed particularly to children of the urban laboring classes, who could derive affordable entertainment from the daily visit of the *kamishibai no ojisan* (literally "uncle kamishibai," the kamishibai performer)[6] to their neighborhoods with the latest installment of a serial narrative. A performer would travel on a specially equipped bicycle and, on arriving at one of his usual stopping-places, he would announce his presence with *hyōshigi* (wooden clappers) or other musical instruments. Children would instantly gather from all directions, some of them carrying even smaller children on their backs. The performer would first sell them cheap candy or snacks, and then, while the children crowded together in front of the stage eating the treats, would relate a set of three short narratives: a slapstick cartoon for the smallest children in the audience (with flat, cartoonish visuals), a melodrama for the older girls, and an adventure story for the older boys (in more realistic visual styles). Both the melodrama and the adventure story would be one episode of a serial narrative; a single story might go on for months or even years, with the children running out to consume each day's installment.

One play (one episode) would consist of ten to fifteen cards, about ten inches by sixteen inches, each of which had a hand-painted picture on one side. On the few prewar *gaitō kamishibai* play cards that are extant, we usually find the script hand-written on the other side.[7] But in their first uses the prewar play cards typically had nothing written on the backs at all. The performers would have the general storyline explained to them each day when they came to pick up the new set of picture cards at the *kashimoto* (production agents; see below). Beyond keeping to the general plot and the painted

images, they were completely free to invent or embellish as they wished. This practice only held true for the performers attached to the *kashimoto*'s headquarters, however. As the play cards were sent out to the *kashimoto*'s subsidiaries in the suburbs and beyond, the recommended narration and/or dialog for each picture would be added on the back of each card, which is why we now find them on the extant cards.[8] After the war, when *kashimoto* turned to lithography

> MOST SUCH MEDIA WERE CREATED BY ADULTS WITH THE AIM OF "IMPROVING" OR "TEACHING" CHILDREN; IN CONTRAST *KAMISHIBAI* PLAYS WERE NEARLY UNIQUE IN HAVING NO PRETENSE OF PROVIDING EDUCATIONAL CONTENT: WHATEVER THE CHILDREN LIKED, THEY GOT MORE OF.

to produce the cards, scripts were printed on the back of each. *Gaitō* performers were nonetheless still free to change or embellish the script at will.

For the performance the picture cards were placed all together in the stage-frame and then pulled out one after another to reveal the next scene, with the *ojisan* performing the narration and dialog in a variety of voices. Performers also added sound effects with musical instruments, they threw in jokes, songs, references to other popular media, and so on. The three commingled elements of *kamishibai*—the pictures, the script, and the performance— might work in harmony, or might be used to play off each other, depending primarily on the whim of the performer. The point to note here is that the emphasis in *gaitō kamishibai* was on the visual and performance aspects of a play, not on a fixed script.

The production and distribution of street-corner *kamishibai* was handled by production agents, known as *kashimoto* (literally "lenders") who would commission stories and their hand-painted illustrations from professional scriptwriters and painters, often employing a stable of in-house writers and artists for this purpose. Each day a writer would come up with the next segment of the serial narrative currently under production, and a set of between ten and fifteen illustrations for that episode would be designed by the lead artist. Then multiple copies of each set would be hand-painted, and sometimes a sketch of the plot or suggested dialogue would be written on the back of each card. The completed story card sets were then rented out to *kamishibai* performers, together with a bicycle equipped with a small stage, and a storage area for holding the plays and the candy the performers sold to make money. The profit for the *kashimoto* came from the rental fee they charged the performers for the story cards, candy, and equipment; the performers made their profit from the volume of candy they sold to the children at a small mark-up. Because the performers and producers of street-corner *kamishibai* made their

money from the volume of candy sales, they gave the children whatever they wanted in terms of plot and picture, in order to attract the largest possible audience. The 1910s through 1930s in Japan saw the construction of the concept of "childhood" as a distinct developmental phase, and the concomitant rise of both educational and entertainment media meant to appeal to this new demographic group.[9] But most such media were created by adults with the aim of "improving" or "teaching" children; in contrast *kamishibai* plays were nearly unique in having no pretense of providing educational content: whatever the children liked, they got more of.

And what they liked was a healthy dose of the fantastic or gruesome, in the form of adventure stories featuring monsters, demons, ghosts, and the like, and heartrending melodrama that dealt with issues of concern to children: unkind stepmothers or bullies terrorizing innocent girls, evil men and women disrupting happy families, and so on.[10] Many educators claimed that such stories were not natural fare for children, not what they would choose to consume if they had a choice. But *kamishibai* performers had an unmediated experience of children's tastes and happily served up the horror and melodrama the children obviously preferred.

Street-corner *kamishibai* became wildly popular very quickly. It originated about 1929, and by 1933 there were already at least two thousand performers in Tokyo alone.[11] By 1937 there were some thirty thousand street-corner *kamishibai* performers across Japan,[12] performing for an estimated minimum of one million children daily.[13]

The sudden rise and phenomenal success of *kamishibai* was conditioned by the development of various other popular-culture media in the prewar period, but here I will concentrate on its relationship with the cinema. Film technology, in the form of Edison's Kinetoscope, for example, was imported from the United States in 1896; by 1897 films were shown publicly in Japan accompanied by a *katsudō benshi* (a live narrator who performed the dialog and narration for silent films; often shortened to *katsuben* or *benshi*). The first Japanese films were made in 1899, and the first Japanese film company, Nikkatsu, was started in 1912. By 1920, Shōchiku studio had also been established, and film production standards in Japan were impressive.[14] In 1921 urban Japanese people listed the movies as their favorite form of entertainment. In the 1930s film remained extremely popular but was too expensive for children, particularly those of the working class, to view frequently. In contrast, even most working class children could afford the daily one-*sen* charge for the *kamishibai* man's candy.[15] Moreover, since *kamishibai* came to one's neighborhood, unlike movies that had to be viewed in theaters, children who

had chores or child minding to do after school could easily find a few moments to enjoy a performance.

Whether imported or domestic, the movies in the 1920s were, of course, silent films, so the new profession of *katsuben* flourished throughout the 1920s. In 1929, however, Japan produced its first talkie, and the popularity of the silents faded, gradually driving all the *katsuben* out of work.[16] Historians suggest that many of them turned for work to the newly emerging medium of *kamishibai*.[17] The skill at performing dialog that the *katsuben* brought to their *kamishibai* performances may in turn have greatly contributed to its quick rise in popularity.

KYŌIKU KAMISHIBAI

As soon as street-corner *kamishibai*'s popularity was established in the early 1930s, voices of concern and criticism were raised. Professional educators and parents' groups were quick to find fault with street-corner *kamishibai,* often publishing the results of their meetings in newspapers and magazines. But some educators countered by emphasizing the *instructive* potential of the medium. In the mid-1930s, for example, the progressive Christian educator Imai Yone (1897–1968) promoted the use of *kamishibai* for bringing wholesome messages to children of the urban poor. She pointed to *kamishibai*'s ease of production, distribution, and performance: with a few cheap materials anyone could make a set of play cards, which were light and easy to carry and could be performed by anyone able to read the script.

She was also enthusiastic about what she saw as the medium's *senden-ryoku,* its unique persuasive power—one of the "faults" repeatedly cited by *kamishibai*'s critics. She acknowledged that it was not a medium suited to high art or expressions of the sublime, but because in *kamishibai* "the hearts of the performer and the viewers are unified," it was a perfect medium for conveying messages to downtrodden or outcast people, particularly children, who were often suspicious of or resistant to other, more "elitist" educational media.[18]

Another influential promoter of educational *kamishibai* was Matsunaga Ken'ya (1907–1946), who had become involved with settlement work during his student days at Tokyo Imperial University ("Tōdai"), beginning in 1931. The well-known "Tōdai Settlement" group helped poor people by supporting and carrying out material improvements in the slum areas of town and by promoting education for poor children. Although his Tōdai friends disparaged *kamishibai* as vulgar and devoid of cultural value, Matsunaga, influenced

by Imai, saw educational potential in the medium. His first experience with *kamishibai* occurred when one of Imai's colleagues demonstrated a Christian play for the settlement group. Even though the performer was shy and soft-spoken, Matsunaga was reportedly powerfully impressed by the potential he saw in *kamishibai* as an educational medium.[19]

Matsunaga was similarly impressed by *Jinsei annai* (A guide for life), the first Soviet talkie to play in Tokyo, in 1932. The film was about a boy who ends up on the streets as a result of war and revolution, but who survives and pulls himself out of destitution through hard work. In cooperation with his colleagues in the Tōdai Settlement group, Matsunaga created the first nonreligious educational *kamishibai,* based on this film and with the same title, in January 1933.[20] Throughout the 1930s—or at least until government censorship became too oppressive late in the decade—educational *kamishibai* plays were used by people like Imai and Matsunaga to promote various populist, mostly leftist causes, among audiences of people who were, in various ways, disempowered or outcast.

KAMISHIBAI AS A MEDIUM

At this point let me summarize the salient aspects of *kamishibai* as a medium. First, it is significant that in prewar *kamishibai* plays the images were more central than the script. The privileging of the visual might seem to accord with Cartesian modernity, in which vision is the primary, most rational sensory mode, but the other crucial element of prewar *kamishibai* was performance, which supplemented or at times contested the meanings suggested by the pictures displayed.

Another crucial element of *gaitō kamishibai* was that it offered multiple sensory paths of comprehension and enjoyment: the visual pleasure of the pictures and the antics of the performer himself; the taste and smell of the candy; the sound effects from drums, whistles, and other musical instruments, and of course the voice of the performer; and the touch of the other children's bodies as they crowded around the small stage, which offered a restricted viewing angle of about 120 degrees. Educational *kamishibai* often dispensed with the candy but made maximum use of *kamishibai*'s other sensory possibilities, adding songs (Matsunaga reportedly sang the anthem of the Soviet Union's Young Pioneers Association when he performed *Jinsei annai,* for example),[21] and taking great care that the pictures were colorful and appealing. This contrasts sharply with Cartesian modes of knowing, in which

bodily sensation was to be suppressed, as in the first epigraph above. In his First Meditation, Descartes describes the proper way to think: "I will consider myself as having no hands, no eyes, no flesh, no blood, nor any senses."[22]

One might argue that children were not involved in thinking or learning while watching *kamishibai,* so the radically interactive, sensual, and embodied nature of their experience is irrelevant. But Suzuki Tsunekatsu argues, on the basis of extensive interviews with people who remember viewing *gaitō kamishibai* in their youth, that children learned many life lessons from the *ojisan.* He quotes one woman as saying that "the moral lessons imparted by the *kamishibai no ojisan* were far more vivid than my teachers' lectures."[23] The interaction between the *ojisan* and the children was an integral element of the children's enjoyment, and they took pleasure in a bond with the familiar *ojisan* that was unlike that with any other adult. They could question him, argue with him, exchange teasing banter, all without risk of getting in trouble. In Suzuki's words, "the *kamishibai* man was an adult but had the same point of view (*mesen*) as the children."[24] As a result, he argues, children trusted and learned from their local *kamishibai* performers in myriad ways in a safe space that allowed them to *critique* adult society.[25] He underscores the fact that "both the *kamishibai* man and the children lived on the fringes of the social order."[26]

> CHILDREN TRUSTED AND LEARNED FROM THEIR LOCAL *KAMISHIBAI* PERFORMERS IN MYRIAD WAYS IN A SAFE SPACE THAT ALLOWED THEM TO *CRITIQUE* ADULT SOCIETY.

In sum, *kamishibai* was characterized by unfettered creativity and spontaneity (in its performance), sensory abundance (in its consumption), heterogeneity (in the interplay of picture, script, and performance), and marginality—a feature that progressive educators such as Imai and Matsunaga used to appeal to disempowered audiences who tended to be wary of other instructional media.

THE VISUAL CHARACTERISTICS OF *KAMISHIBAI*

When compared to the continuous visual motion of a medium such as cinema, *kamishibai* seems on first consideration to be very static, relying as it does on the display of still pictures. But several kinds of movement were, in fact, routinely incorporated into the performance of a play. First, the panels themselves, pulled out one after another, provided movement from scene to

scene. Performers often pulled a panel out only halfway as they continued their narration, revealing a tantalizing bit of the next scene to raise suspense, and then suddenly revealing the rest. Decisions about the speed (fast or slow), the vigor (violently, gently, or smoothly), and the rhythm (halfway stop, slow revelation; quick revelation, etc.) with which the panels were pulled out of the frame was one of the most important skills for the professional performer to master. (Later, in propaganda *kamishibai,* such "stage directions" were printed on the play itself to aid the amateur performer.) Another kind of movement could be introduced by the performer shaking the stage or moving the picture card itself up and down within the limits of the frame, simulating violent diagetic motion.

And finally, *kamishibai* makes use of one "special effect" to enhance the impression of continuity and fluid motion: the *sashikomi* (literally, an insert). Some panels are made in two parts: the base panel that shows the second part of the movement, and a half-size panel (*sashikomi*) that sits snuggly over it. The picture on the half-size panel melds perfectly with that on the base panel so that the join is not visible, and shows the first stage of the movement. When the half-size panel is pulled rapidly aside and the full base panel is revealed, it appears that the background has remained unchanged while the foreground figure has moved from one place/state to another. An example can be seen in the wartime play *Okome to heitai* (1941, Rice and soldiers), in which the first view (with *sashikomi* in place) shows a soldier walking toward his commander to volunteer for a dangerous task, and then the second view (with *sashikomi* removed and the base panel fully revealed) shows the same soldier lying on the ground, having been shot by the enemy (Figures 1 and 2). This is the most common type of *sashikomi,* but inserts with different shapes could give the impression of a train moving across a landscape, or a balloon moving up and down, and so on.

The *sashikomi* allowed for visual continuity in the depiction of movement in special cases, but in fact the visuals of *kamishibai* relied even more strongly on discontinuity between panels. The basic structural nature of *kamishibai* is montage, a visual technique that was enormously popular in modern(ist) consumer culture and much theorized in cinema and art in the 1920s and 1930s.[27] Kata Kōji, one of *kamishibai*'s pioneers as both a practitioner and theorist, reports that in the 1930s, as the medium was developing on both the *gaitō* and *kyōiku* fronts, he and his cohort studied the work of filmmakers to improve *kamishibai*'s effectiveness as a visual/narrative medium. In particular he cites the work of Sergei Eisenstein (1898–1948) and Vsevolod Pudovkin (1893–1953) on montage in cinema.[28] The "interval" between one picture and the next could

be used to produce a variety of visual and narrative effects through such cinema-inspired techniques as continuity (making one picture flow naturally into the next) or disjunction (as in montage); "panning shots" or "close-ups"; changes in point of view; or distinctive changes in dominant colors or visual styles. The result, though inspired by motion pictures, differs from cinematic flow, even cinematic montage. *Kamishibai* presents a unique balance of stillness and motion, fragmentation and continuity, with the *interval*—the space in between one panel and the next—a crucial element in the storytelling technique.

Taking all these characteristics together, we can see that *kamishibai* was a very modernist medium (in Miriam Silverberg's terms), one that disrupted Cartesianism in a variety of ways, and it is perhaps not surprising, therefore, that it was used extensively by those *resistant* to the dominant discourses and power structures of the time.

FIGURE 1. From *Okome to heitai* (1941, Rice and soldiers), with *sashikomi* in place: soldier volunteering for duty.

FIGURE 2. From *Okome to heitai* (1941, Rice and soldiers), with *sashikomi* removed to show the base panel: soldier shot.

KAMISHIBAI IN THE FIFTEEN-YEAR WAR

Nonetheless, like all artistic or expressive media in Japan, as the (unofficial) war in China gained momentum in the mid- to late 1930s, *kamishibai* was coopted into the service of the government. *Gaitō* performers and producers were increasingly drafted into military or labor service, and *kyōiku* producers were bullied (or cajoled) into ceasing their progressive, educational ("leftist") activities and turning their talents to the production of prowar, pro-imperialist propaganda *kamishibai*.

The Japanese word for "propaganda" is *senden* ("advertisement," "persuasion"), the root of the word used by Imai Yone to describe *kamishibai*'s greatest virtue: its *sendenryoku,* persuasive power. Given this quality, it is no surprise that the government should turn to *kamishibai* for the dissemination

> THE WILDLY CREATIVE, SPONTANEOUS, AND HETEROGENEOUS NATURE OF *KAMISHIBAI* WAS RECOGNIZED AS DANGEROUS BY THOSE WHO WISHED TO PROMOTE ONE CLEAR AUTHORITATIVE MESSAGE, AND THOSE ELEMENTS OF *KAMISHIBAI* PERFORMANCE WERE SUPPRESSED.

of its messages. Considered superficially, *kamishibai* would seem to provide a terrific mechanism for instilling propagandistic ideas: a series of still pictures, accompanied by a static script, viewed by a willing audience—these elements would produce a phenomenological structure featuring a stable and seemingly natural relationship between viewer, viewed, and message, as in Cartesian perspectivalism. And, as in the second epigraph above, that phenomenological relationship would have epistemological consequences, making even the most unpleasant, illogical, and subjective government messages seem coherent and objective. Particularly after 1937, when the war in China became official, the government began working to tweak the characteristics of *kamishibai* to maximize its usefulness to the state.

When propaganda became the goal, the story content of *kamishibai* plays took on an increased importance and new techniques were devised to try to make the pictorial and performance aspects of the medium conform to the needs of the script. The scripts were now printed on the back of each picture card and a series of municipal ordinances were put in place to ensure that the script was always performed exactly as printed.[29] The presence of the performer, adding life and warmth to the story, and the multiple sensory pathways that characterize the consumption of *kamishibai* were recognized as elements that increased audience engagement with the material, so these were retained, but now within strictly monitored limits. The wildly creative, spontaneous, and heterogeneous nature of *kamishibai* was recognized as dangerous by those who wished to promote one clear authoritative message, and those elements of *kamishibai* performance were suppressed.

Because so many professional performers were drafted and unavailable, wartime *kamishibai* plays were performed primarily by amateurs: teachers, neighborhood association leaders, factory foremen, and young women specifically recruited for the purpose. A large number of manuals and magazine articles appeared, explaining proper performance techniques for the benefit of these amateurs. They were advised to:

1. stand behind the stage so as not to distract from the play (*gaitō* performers, in contrast, stood to the side and became part of the "show");

2. adhere closely to the script, never ad lib, and certainly don't add jokes (nor were they even supposed to smile);

3. efface themselves as far as possible, inviting no unscripted inter-action with the audience;

4. read the stage directions carefully to understand how best to transition from one panel to the next, the emotional tone to give to each scene, and so on.

Despite this new focus on the script, however, a well-known example of this kind of instruction shows that promoters continued to recognize the primacy of *kamishibai*'s visual elements: "First find a script that deals with your chosen topic. Then, without reading the explanations on the back at all, just look at each of the pictures one by one. *Kamishibai* are also sometimes called '*gekiga*' [dramatic pictures] and from looking at the pictures you will come to understand your script's special characteristics. . . . From the point of view of the audience, they get their emotional impact first from the pictures and then from the words."[30] As we shall see, the creators of wartime *kamishibai* understood clearly the importance of the pictures, as different visual techniques were used to support the presentation of different kinds of propaganda messages.

Propaganda *kamishibai* also differed from earlier forms in the sense that each card set was a complete story, rather than being one installment in a serial narrative, and, on average, twenty cards would be allotted for a single story, as opposed to the ten or fifteen common for one episode of *gaitō kamishibai*. So the question arises: how did the writers and artists of propaganda *kamishibai* take a government message or a complex narrative and convey it in a mere twenty images/scenes? Here we turn to specific examples of visual techniques used in propaganda *kamishibai*.

There are many possible ways of categorizing the multitude of propaganda plays produced during the Fifteen Year War. Here I focus on the rhetorical function of the plays, and identify three major types: information, exhortation, and emulation. There are specific visual tropes that seem to characterize each.[31]

The first type provided factual *information* about real events, or gave how-to information, such as how to build a bomb shelter.[32] Examples include *Umi no tatakai* (1941, Naval battles), *Rondon daibakugeki* (1941, The great air raid on London [i.e. The Blitz]), and *Maree oki kaisen* (1943, The naval battle of the Malay Strait). The first two consist entirely of photographs (Figure 3), and

the third of realistically painted scenes of battle, using careful perspective. In Figures 4 and 5, from *Maree oki kaisen,* we see cinematically inspired shots: first a view of a Japanese airplane in the sky and then the view *from* that plane down onto the ships it is about to bomb.

It is not surprising that this genre of play should make use of photographs or of paintings done in classic perspectivalism, as its purpose is to present "reality" in a believable, scientific, and authoritative manner. In the case of the "how-to" version of the genre, diagrams and other "scientific" visual tools are also common.

The second type, the *exhortation* play, is intended to convince the audience to do something specific—buy war bonds, eschew the black market, participate in neighborhood watch groups, and so on—using direct pleas and arguments. Usually these are structured in the form of a very loose narrative—a young boy asking his grandfather naïve questions, for example, to which he receives exhortatory answers (in *Bakudan jiisan* [1942, Explosive grandpa]). Other examples include *Jissen fujin* (1942, Practical wife), about a woman who bullies her family and neighbors into proper wartime behavior; *Taisei yokusan* (1940, Imperial relief assistance), an early play that lectures viewers about the consequences of not shifting to a wartime lifestyle; and *Tamago-mura* (1946, Egg village), an interesting example of a play produced after the war by the Allied Occupation government to try to discourage people from trading on the black market.

In all these exhortation plays the visual style is at the opposite end of the spectrum from the information plays: utterly flat and cartoonish (Figures 6, 7, and 8). In the pictures, there is little or no attempt to reproduce a Cartesian "realism," perhaps in order to make the characters as generic as possible. Because they are visually generic and flat, anyone can recognize these character "types," such as the aged but feisty and wise Grandpa, and can easily identify with the social order they represent. The humor of the visuals also, no doubt, helped to soften the hectoring tone of the scripts.

The third type of play was meant to encourage *emulation* of the heroic behaviors dramatized therein. Emulation plays differ from the exhortation plays in that there is never any direct mention of proper behavior. These were complex narratives with interesting, sympathetic characters, coping gallantly with hardship and/or loss. Viewers were meant to be moved by the self-sacrifice and discipline of these attractive characters (often hard-working mothers) and thereby inspired to emulate them. Examples include *Tengu no hata* (1942, The tengu flag), a story aimed at school-age children; *Teki kudaru hi made* (1943, Until the day the enemy crumbles), aimed at male shopkeepers;

FIGURE 3 (TOP). From *Umi no tatakai* (1941, Naval battles).

FIGURE 4 (MIDDLE). From *Maree oki kaisen* (1943, The naval battle of the Malay Strait): Cartesian perspective.

FIGURE 5 (RIGHT). From *Maree oki kaisen* (1943, The naval battle of the Malay Strait): Cartesian perspective.

FIGURE 6 (TOP). From *Bakudan jiisan* (1942, Explosive grandpa): relatively flat, cartoonish.

FIGURE 7 (MIDDLE). From *Jissen fujin* (1942, Practical wife): flat, cartoonish.

FIGURE 8 (RIGHT). From *Tamago mura* (1946, Egg village): flat, cartoonish.

Gunshin no haha (1942, Mother of a war god), and *Mumei no haha* (1944, The unsung mother), both of which feature perfect self-sacrificing mothers who produce perfect self-sacrificing sons (who die heroically in battle).

These plays are by far the most visually interesting of the three types described here. Because of the brevity of these plays (only twenty very short scenes) and the nature of *kamishibai* as a medium, the characterization that was so key to their success had to be achieved through the visuals as much as or more than through the script itself. A number of extremely talented artists contributed to the popularity of wartime *kamishibai* plays, notably Nishi Masayoshi, Koyano Hanji, and Nonoguchi Shigeru.[33] Each was capable of working in a variety of styles, suiting the visual style and color scheme to the play's content.[34] In almost all cases, however, the illustrations of these plays exhibit an intriguing combination of flatness and roundness (three-dimensionality), "realism" and stylization/abstraction—that is, they combine both Cartesian and anti-Cartesian visual elements.

For example, in Figure 9, from *Mumei no haha* (pictures by Nishi Masayoshi), we see faces that are round, detailed and warm looking contrasted with flat and rough depictions of clothing, against a background that is also flat (though beautifully colored). This flatness is often mitigated by a haloing effect, making the human figures "pop out" from the flat background, as we see in Figure 10, from *Gunshin no haha* (pictures by Nonoguchi Shigeru). This haloing technique is similar to the multiplanar character that Thomas Lamarre identifies as a feature of much Japanese animation, though here, of course, the planes do not move.[35] Its effect in *kamishibai* is to highlight the human, particularly the human face, emphasizing the affective elements of the picture.

These emulation plays are also notable for pictures that represent an apotheosis—a representation of a character's admirable perfection. Figures 9 and 10 are both examples of this, showing the audience the image that the loving sons carry in their minds of their adored mothers. Figures 11 and 12 are further examples from the same plays, this time highlighting the literal apotheosis of each of the heroically dead sons, as he becomes a god enshrined at Yasukuni. These apotheosis pictures use the halo effect not simply to produce a sense of depth through the suggestion of multiple planes, but to elevate, in *psychological* terms, the representation of these admirable characters.

Another common feature is a picture that encapsulates a character's psychological confusion or torment, as in Figures 13 and 14 (from *Teki kudaru hi made* and *Tengu no hata*, respectively). Objective realism here is (at least partly) abandoned to convey the impact of a disturbing psychological state.

FIGURE 9. From *Mumei no haha* (1944, The unsung mother): round face, roughly depicted clothing, flat background.

FIGURE 10. From *Gunshin no haha* (1942, Mother of a war god): halo effect around human figure.

Perspective is also frequently abandoned for the sake of psychological verity, as in Figure 15 (from *Tengu no hata*). In this play, intended to inspire *children* to patriotic fervor, the visual style is *as if drawn by a child,* with somewhat crude and clumsy depictions of trees and ponds, and a child's disregard for proper perspective.

"Realistic" depiction is sometimes featured in emulation plays as well, however. In *Mumei no haha,* the visual style veers back and forth (as in film montage) between lushly colored pictures depicting home and the eponymous mother, in the mixture of flat and rounded styles described above (Figure 9), and monochrome (dark green and white) depictions of the battlefield (Figure 16), which are more hard-edged and realistic looking (although not to the extent of the "photorealist" painting style we find in some informational plays).

In other words, propaganda plays display a range of faithfulness to Cartesianism, with the information plays the most "scientific," "rational," and perspectival in their visual styles; the emulation plays a mix of realist/rational and antirealist/psychological, and often multiplanar rather than perspectival; and the exhortation plays deliberately antirealist/humorous and almost completely flat, with very little use of Cartesian perspective.

I would argue that the emulation plays were the most effective and important type of propaganda *kamishibai*.[36] They were intended to rouse the viewers' emotions and inspire conscious or unconscious imitation of the heroic behaviors depicted. The quality of the *kamishibai* medium, touted by Imai Yone, in which "the *hearts* of the performers and the viewers are unified," was particularly important and effective in the context of propaganda, and it was the emulation plays that relentlessly pulled on the heartstrings. The

seeming iconicity of Cartesian perspectivalism frequently used in the visuals for these plays was, therefore, a key element in constructing a narrative world that was *believable* and would therefore have the desired effect on the viewers. We see here Cartesian visual rationalism used in the service of evoking (irrational) emotion.

I would argue, however, that the effect of the emulation plays was not nearly so straightforward. For one thing, in all types of *kamishibai* plays the *interval* between one panel and the next forces the viewer to actively construct continuity in order to make the narrative make sense. In cinema, only special techniques such as montage or abrupt scene changes produce the same level of disjunction between one image and the next that is the fundamental nature of *kamishibai*. The viewers of wartime *kamishibai* were, therefore, far from passive, as they (albeit unconsciously) bridged the interval between panels to make sense of the plot.

In the case of the emulation plays this effect was often heightened by the sophisticated mix of visual styles in a single work, which sometimes changed drastically in the interval between one panel and the next, as we have seen in the

FIGURE 11. From *Gunshin no haha* (1942, Mother of a war god): halo effect highlights son's apotheosis.

FIGURE 12. From *Mumei no haha* (1944, The unsung mother): son's apotheosis.

case of *Mumei no haha* (Figures 9 and 16).[37] Despite *kamishibai*'s pull on the heartstrings and the radically embodied nature of its consumption, in these plays the connection between world, representation, and viewer is far from unitary or simple, far from straightforwardly Cartesian, and therefore the viewing subjects interpellated by the emulation plays were also not unitary or simple. Ironically, however, it may have been precisely the psychological complexity and multiple subject positions characteristic of these plays that made them effective.

It is impossible to gauge the actual effectiveness of *kamishibai* plays as

FIGURE 13 (TOP). From *Teki kudaru hi made* (1943, Until the day the enemy crumbles): anti-Cartesian effect to highlight character's confusion.

FIGURE 14 (MIDDLE). From *Tengu no hata* (1942, The tengu flag): anti-realism to highlight character's agitation.

FIGURE 15 (RIGHT). From *Tengu no hata* (1942, The tengu flag): "incorrect" perspective, to mimic child's drawing.

FIGURE 16. From *Mumei no haha* (1944, The unsung mother): battlefield scenes depicted in stark monochrome.

propaganda in the Fifteen Year War. *Something* inspired the Japanese people to go on working hard even in the absence of much hope of victory, as they did in the final years of the war, and perhaps *kamishibai* plays contributed to that inspiration. And we do have evidence that audiences found specific plays to be moving or appealing—*kamishibai* plays, even propaganda, were perennially popular throughout the war. But, given the general characteristics of *kamishibai* as a medium—such as its multisensory and group-oriented nature—and the intensive use of montage and interval to enhance the artistry of many wartime plays, I doubt they appealed effectively to the rational, conscious level of viewers' minds. They provided entertainment and beautiful, intensely colorful visuals, which no doubt provided a sort of mental relief from the oppressive atmosphere of "total war." But beyond that I suspect that it was precisely the anti-Cartesian, heterogeneous, and commingled aspects of *kamishibai* that made wartime plays *emotionally* powerful, and therefore effective at motivating their audiences to continue the fight.

Notes

1. A full 70 percent of wartime *kamishibai* were for adult or mixed-age audiences. Kamichi Chizuko, *Kamishibai no rekishi* (The history of *kamishibai*) (Tokyo: Kyūzansha, 1997), 74.

2. I follow Susan Bordo, here, in her description of the object of a feminist critique of Cartesianism: "it is the dominant cultural and historical renderings of Cartesianism" that concern me, "not Decartes 'himself.'" Susan Bordo, "Introduction," in *Feminist Interpretations of René Descartes,* ed. Susan Bordo (University Park: Penn State Press, 1999), 2.

3. Famous examples of *kamishibai* artists turned manga artists include Mizuki Shigeru (creator of *Gegege no Kitarō*) and Shirato Sanpei, whose best-known work is *Kamui den* (The Legend of Kamui).

4. "Commingled media" describes various Japanese arts characterized by an "aesthetic tendency [toward] extreme complexity with heterogeneous, often redundant elements brought together to form a work." J. L. Anderson, "Spoken Silents in the Japanese Cinema; or, Talking to Pictures: Essaying the *Katsuben,* Contexturalizing [sic] the Texts," in *Reframing Japanese Cinema: Authorship, Genre, History,* ed. Arthur Nolletti Jr. and David Desser (Bloomington: Indiana University Press, 1992), 261–62.

5. The rise of *kamishibai* was also, of course, conditioned by a number of other new media in Taishō and early Shōwa Japan: new mass-audience newspapers and the serialized popular literature and manga they featured, radio, magazines targeted at children, and so on. For more on these connections see Sharalyn Orbaugh, "Kamishibai as Entertainment and Propaganda," in the *Transactions of the Asiatic Society of Japan,* fourth series, vol. 19 (December 2005): 21–58.

6. In the prewar period there were very few female performers of street-corner *kamishibai*: *kamishibai no obasan* ("auntie *kamishibai*"). A 1935 survey of 565 *kamishibai* performers and producers in Tokyo turned up only two female performers. Tōkyō Shiyakusho, *Kamishibai ni kansuru chōsa* (1935), 42, 39.

7. Few play cards from the prewar period survive because they were not considered valuable, as each day's new cards superseded the ones from the previous day. Made of cheap cardboard, many were damaged or burnt over the years, especially during the war.

8. "Koko ni mo shintaisei" (Here, too, the new order: Roundtable discussion on *kamishibai*). In *Shūkan Asahi,* January 1941, 122.

9. See, for example, L. Halliday Piel, "Loyal Dogs and Meiji Boys: The Controversy over Japan's First Children's Story, *Koganemaru* (1891), *Children's Literature* 38 (2010): 218–19; or Kawahara Kazue, *Kodomokan no kindai: Akai tori to 'dōshin' no risō* (Children's modernity: *Akai tori* and the ideal of childish innocence) (Tokyo: Chūōkōronsha, 1998).

10. For numerous examples of *gaitō kamishibai* plays, see Eric Nash, *Manga Kamishibai: The Art of Japanese Paper Theater* (New York: Abrams Comicarts, 2010).

11. Kamichi, *Kamishibai no rekishi,* 34.

12. Saitama-ken Heiwa Shiryōkan, *Sensō to kamishibai* (The war and *kamishibai*), exhibition catalogue (Saitama: Saitama-ken Heiwa Shiryōkan, 1997), 8.

13. According to Imai Yone, the official surveys failed to count the full number of *kamishibai* performers, underestimating their numbers by at least half. It is possible, therefore, that there were really closer to 60,000 performers in the 1930s, performing for two million children daily. Imai Yone, *Yomiuri Shinbun,* January 11, 1934, 4 (no title or headline).

14. Yamamoto Taketoshi, *Kamishibai: Machikado no media* (*Kamishibai*: The medium of the street corner) (Tokyo: Yoshikawa Kōbunkan, 2000), 17–18.

15. Although candy prices varied over the decade and from place to place and varied

depending on the type of candy purchased, the general rule was that viewing *kamishibai*—that is, buying the candy that allowed you to view it—cost one *sen*.

16. J. L. Anderson explains that *katsuben* hung on in Japan after the introduction of talkies much longer than in other countries. Anderson, "Spoken Silents," 261, 270, 291.

17. Yamamoto, *Kamishibai*, 18, 26–27; Saitama-ken Heiwa Shiryōkan, *Sensō to kamishibai*, 5.

18. Suzuki Tsunekatsu, *Media to shite no kamishibai* (*Kamishibai* as a medium) (Tokyo: Kyūzansha, 2005), 49.

19. Ibid., 52.

20. Ibid.

21. Ibid.

22. Quoted in Leslie Heywood, "When Descartes Met the Fitness Babe: Academic Cartesianism and the Late Twentieth Century Cult of the Body," in Bordo, ed., *Feminist Interpretations of René Descartes,* 267.

23. Suzuki, *Media to shite no kamishibai,* 8.

24. Ibid., 45.

25. Ibid., 47.

26. Ibid.

27. See Miriam Silverberg, *Erotic Grotesque Nonsense: The Mass Culture of Japanese Modern Times* (Berkeley and Los Angeles: University of California Press, 2006), especially 30–35, for an insightful examination of montage in the arts and culture of this period.

28. Kata Kōji. "Shikaku no bunkaron: Etoki kara gekiga made" (A cultural study of vision: from *etoki* to *gekiga*), in *Etoku: Kamishibai/nozokikarakuri/utsushie no sekai* (Reading pictures: The world of *kamishibai/nozokikarakuri/utsushie*), ed. Nagai and Ozawa (Tokyo: Hakusuisha, 1982), 31–32.

29. Kang Jun, *Kamishibai to "bukimi na mono"-tachi no kindai* (*Kamishibai* and the modernity of "uncanny creatures") (Tokyo: Seikyūsha, 2007), 71–74; Ishiyama Yukihiro, *Kamishibai no bunkashi: Shiryō de yomitoku kamishibai no rekishi* (The cultural history of *kamishibai*: The history of *kamishibai* understood through archival information) (Tokyo: Hōbun Shorin, 2008), 74–75.

30. "Kamishibai no enjikata" (How to perform *kamishibai*), reprinted in *Seinen* (August 1942), 54–59.

31. Unlike *gaitō kamishibai* plays, propaganda plays were mechanically printed and distributed in large numbers. Although many propaganda play cards were destroyed in wartime bombing raids and others were destroyed after the war by the Allied Occupation authorities, a fair number still survive. I have collected more than seventy such plays and have read another fifty or so; the information here comes from that database. I began by dividing the plays according to visual technique and only afterward noticed the rhetorical functions that appear to characterize each visual type.

32. *Kamishibai* plays about real events were very much like the film newsreels available in the theaters but were, of course, much cheaper to produce and disseminate.

33. Talented though they were, these artists are not famous, probably because *kamishibai* was looked down on as a vulgar medium. It has been difficult to get information about their lives or other artistic activities. Of the sixty-four plays that I own that were produced during the Fifteen Year War, Nishi Masayoshi provided the pictures for fourteen.

Nishi died with his entire family in the firebombing of Tokyo in 1944. Koyano did the pictures for ten of the plays I own, and Nonoguchi Shigeru another five.

34. Nishi Masayoshi, for example, excels in producing lushly colored landscapes that look like watercolor washes, or, for a different mood, using stylistic elements drawn from folk-art woodblock prints in Japan, or from German expressionism. But he could also produce photorealist-type visuals, such as a very recognizable portrait of Prime Minister Tōjō in *Teki kudaru hi made*.

35. Thomas Lamarre, "The Multiplanar Image," *Mechademia 1* (2006): 120–44.

36. I base this contention on the substantive mentions of *kamishibai* viewings that appear in wartime memoirs, *all* of which refer to plays I would classify as the emulation type. Additionally, as the war progressed, it appears that the number of emulation plays increased, together with how-to plays providing practical information about bomb shelters and fire prevention; in contrast, the exhortation plays decreased.

37. We also find examples in which the artist has provided a deeply sad, disheartening picture for what the script presents as an uplifting moment, suggesting another way in which the commingled character of *kamishibai* allowed for contestation of the propagandistic party line.

Worlds in Perspective

TIMON SCREECH

Hokusai's Lines of Sight

Hokusai is among the best-known names in Japanese art, and it may be thought that only a deficiency of imagination could lead to more writing on him. Many other artists of his period have been entirely neglected in the contemporary literature. But in fact, there is still more to be said, and this short essay will attempt to introduce some ideas that are probably unknown even to specialists.

Hokusai has come to be thought of internationally as the Japanese artist par excellence, and his "Great Wave off Kanagawa," from the series *Thirty-Six Views of Mount Fuji* (*Fugaku sanjūrokkei*), can lay claim to being one of the world's most widely recognized works (Figure 1). However, Hokusai is not just the Japanese artist that foreigners love to love. In his own day he was widely regarded, and the *Thirty-Six Views* series just mentioned, which began in 1826, was finally brought to a close only in 1833, ultimately comprising forty-six designs. The extra ten can only have been created in response to clamor from the market.

The realization that Hokusai has been recognized in the West from more or less his own day up until now, however, has undoubtedly added to his status in Japan. Hokusai forms part of the narrative of self-validation that is

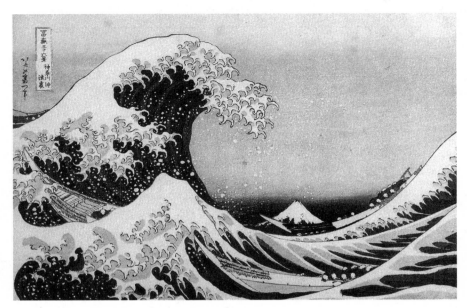

FIGURE 1. Katsushika Hokusai, "Great Wave of Kanagawa," multicolored woodblock print, from the series *Thirty-Six Views of Mt. Fuji*, 1826–33.

the country's "opening," modernization, and equalization with Europe and North America. Trains steamed to, and ships steamed on from Yokohama, and Western critics praised Hokusai as among the greatest masters of all time. (He died in 1849.) While chinoiserie is often considered a trivializing, decorative mode, japonisme fits snugly within the rhetoric of Japan's powerful impact on the outside world; japonisme is certainly not just a branch of Orientalism. Hokusai also seemed to show, at just the right time, that Japan was not just a borrowing nation but an originating one, too, as Impressionist and Post-Impressionist artists lined up to aver that in him they found an entirely new way of representing the world, and even, indeed, of *seeing* it.

A century later, in 1983, Tokyo Disneyland was opened. On what grounds we can only wonder, but the name "Hokusai" was chosen for its Japanese restaurant (Figure 2). Surely it was not the case that Hokusai represented Japan, but rather that he represented a robustness for Japan within a space likely to be dominated by the foreign. Hokusai symbolizes a Japan as valued and then singled out for praise by foreigners, but then as replanted back into Japan. His international standing is meaningful because it has been brought home, under the imprimatur of both a self and an other. With its faux U.S. colonial exterior and a faux Japanese "traditional" interior, the restaurant encapsulates a Japan pulsating between the two, not to be colonized and never to be

caught; indeed, it is "America" that is colonized. *Hokusai* makes little sense as the name of a Japanese restaurant in Florida's Disney World or California's Disneyland. But where it makes perfect sense is in *Tokyo* Disneyland.

Hokusai is adduced as a figure of mirrors. It is interesting in this regard that his father is thought to have been a mirror maker of rather high standing. (Some say he was even mirror maker to the shogun.) Born in 1760 in the Katsushika district of Edo (modern Tokyo), Hokusai, then called Tokitarō, would have seen his father at work. He did not however inherit the business, and it has been speculated that he was the son of a mistress. Had he become a literal man of mirrors, Hokusai would not have been sent out to work in a lending library, or moved from there to become a block carver, and thence metamorphose into a professional artist. As it was, he became, in a different sense, a *reflective* person.

The year 1760 was also when Tokugawa Ieharu took over as the tenth Tokugawa shogun. It was a relatively free time and would become more so after Tanuma Okitsugu assumed the chief ministership in 1772. That was the same year in which Hokusai entered the lending library. International exchange was especially vigorous in this period, and although the Dutch East India Company (sole official importer of European things) complained about the market, and indeed made ever less money in Japan, it did a good trade in looking glasses (as distinct from the East Asian burnished metallic mirrors). There was also a sideline in items useful as bribes and gifts, or as "private trade" by the Company's employees, and principal among these were prints and illustrated books.

FIGURE 2. Hokusai Restaurant, Tokyo Disneyland. Photograph by Chris Calabrese (tdrfan.com).

The East India Company's station (or "factory") in Japan was far away in Nagasaki, but it had an Edo lodging, used on its annual trips to pay respect at the shogunal court. Hokusai included a view of this place in a book of Edo's famous sites, *Azuma asobi* (*Leisure Time in the East*), published in 1799. This was despite the fact that the lodging was not really one of Edo's established spots, and moreover, the Company, having fallen on hard times, had been permitted to stop its annual trips to Edo shortly before. Hokusai had some special interest in

FIGURE 3. Katsushika Hokusai, "Nagasaki-ya," multicolored woodblock print from the book *Ehon azuma asobi*, 1803.

this place—though his publisher would also have had a role in the decisions of what sites to include. They even retained the view in the reissue of his book in 1803, radically pared down to just a few places of significance, but issued in color (Figure 3).

As the Company came to Edo (or used to come) at the invitation of the shogun himself, protocol required that commoners could not write about it or depict it, though they might watch the exotic retinue passing: overseas matters remained something that the shogunate kept control of, especially where they overlapped with politics. Hokusai's two views therefore (identical, except for the color) were the first anyone had ever had the temerity to make illustrating the place where the Company lodged in Edo. Perhaps the fact that the building was no longer in use (the annual visits having tapered off) made this possible, but of all the images in *Azuma asobi*, this alone is unlabelled. Every other site has its location clearly inscribed on the scene. The reader knows where this place is, but the image also has a plausible deniability, should it be required, and of the building, nothing specific is given away.

This same year, 1803, Hokusai was induced to provide the pictures for a work of popular fiction by the writer Kanwatei Onitake. It came out in the urban-ephemera genre of *kibyōshi* ("yellow cover"), where text is superimposed on the images, giving the latter considerable stature. (They are not "illustrations," but an integral part of the compilation.) The punning title given to this work was *Wakanran zatsuwa*, literally "Compendium on Japan, China, and Holland, Europe," but eliding into *wakaran zatsu wa*, or "I haven't a clue, it's such a mess."

Hokusai provided the pictures for other such books, but it was far from his major activity. (Illustrating Edo sites was his major activity—or one of them.) He must have agreed here because he liked the story's theme. It tells of a Nagasaki courtesan who is propositioned by a Chinese and a Dutchman. In order to further their suits they make her gifts deemed to be typical of their respective cultures. The Chinese gives sage-lore and wizardry, while the Dutchman gives mechanical devices, including a hot-air balloon and a telescope (Figure 4). Issues of how foreigners *look* and *represent* are to the fore.

FIGURE 4. Monochrome woodblock printed page from Kanwatei Onitake's *Wakanran zatsuwa*, 1799, illustrated by Katsushika Hokusai.

Hokusai's lines of sight—in, out, around, up, and down—play out in others of his works, and his concern with the changing valances of sight that sprang from imported things is apparent. His famous *Manga* (Random drawings), begun in 1814 and continued over decades, includes, among its host of diverse items, a study in perspective (Figure 5). Though it is not often pointed out, "The Great Wave off Kanagawa" also uses perspective in a way that any Japanese viewer would have found thoroughly Western—and the deep blue pigment would have been imported too.

Twenty years later, in 1834, Hokusai published his enormous project, *One Hundred Views of Mount Fuji (Fugaku hyakkei),* in three volumes. The endless inventiveness of the series makes many designs worth commenting on, but it is striking how the set does not just take up the topography and history of the mountain but also considers acts of looking, representing, and indeed reflecting it. Two of the one hundred may be selected for short comment here.

In one, we see a man pointing to a hanging scroll of Fuji with its famous Fujimi ("Fuji-view") Bridge below, indicating that we are looking from the Edo side (Figure 6). A second man reacts with exaggerated surprise, while the title reads "invention (or 'trigger') of hanging scrolls" (*kakimono no hattan*). The standing man has removed the paper screen in his hand, to reveal Fuji outside, *looking as if* it were in a painting. We see, therefore, a picture within

FIGURE 5. Katsushika Hokusai, perspective study, monochrome woodblock printed page from *Manga,* after 1814.

a picture that, in terms of the picture itself, is actually reality within a picture and only seeming to be a picture. Conventions ricochet against each other.

The second example brings us in touch with imported phenomena (Figure 7). Entitled "Fushiana no Fuji" (Fuji of the knothole), a servant-like figure is seen demonstrating a *camera obscura* effect to two amazed visitors. He is clearly abreast of the phenomenon, and perhaps shows it off at a temple or inn for a fee. The two men are unable to comprehend. There is no lens in the knothole and the paper serving as a screen cannot be moved forward and back, so that the image appears upside-down and unfocused, with its penumbra visible. The effect is perhaps a fluke, but it would not be long before the *camera obscura* was developed in Japan, for the purpose of viewing fun (as here) and as a means of making functional pictures.

Hokusai shows us Fuji seen as an incipient Japanese picture (original of hanging scrolls), and an incipient Western one (once an imported lens is used). Fuji has become a world mountain.

FIGURE 6 (LEFT). Katsushika Hokusai, 'The Origin of Pictures," monochrome woodblock printed page from the series *One Hundred Views of Mt. Fuji*, 1834–35.

FIGURE 7 (BELOW). Katsushika Hokusai, "Fuji of the Knothole," monochrome woodblock printed page from the series *One Hundred Views of Mt. Fuji*, 1834–35.

WAIYEE LOH •••

Superflat and the Postmodern Gothic: Images of Western Modernity in *Kuroshitsuji*

In 2007, Toboso Yana began publishing *Kuroshitsuji* (*Black Butler*), a manga series set in late Victorian England about a beautiful butler named Sebastian, who is actually a devil in disguise, and his young master, Count Ciel Phantomhive. With its Western European setting, its aestheticization of the demonic and the deathly, and its penchant for roses, Rococo motifs, and the color black, *Kuroshitsuji* exemplifies a type of "Gothic" style that has become popular in postwar Japanese shōjo culture since Hagio Moto's classic vampire manga *Pō no ichizoku* (1972–76, The clan of Poe).[1] Through a reading of *Kuroshitsuji* as a representative case study, I examine this shōjo Gothic style and its relation to Japanese national identity in the age of postmodern globalization and postcolonial reevaluations of the legacy of nineteenth-century Western imperialism.[2] In the first part of the essay, I consider the relationship between the superflat visual aesthetic and the postmodern condition of simulation, which the shōjo Gothic style makes explicit. I then discuss how the shōjo Gothic style, as a postmodern and postcolonial practice of enunciation, simulates, recontextualizes, and reinvents a Western European past in order to articulate the enduring desire of the contemporary Japanese nation for an idealized "Western modernity," characterized by "tasteful" consumption. In the last

THE SHŌJO GOTHIC STYLE IN *KUROSHITSUJI* EXPRESSES THE PROFOUND AMBIVALENCE OF POSTCOLONIAL JAPANESE NATIONAL IDENTITY VIS-À-VIS THE WEST IN THE TWENTY-FIRST CENTURY.

part of the essay, I argue that *Kuroshitsuji,* through its Gothic style, paradoxically intervenes in its own idealization of Western modernity to celebrate contemporary Japan's ability to hybridize different cultures and to disseminate its hybrid cultural commodities around the world as a cultural superpower in the age of postmodern globalization. The shōjo Gothic style in *Kuroshitsuji* thus expresses the profound ambivalence of postcolonial Japanese national identity vis-à-vis the West in the twenty-first century. Through reinscribing the signs of a Western European past, *Kuroshitsuji* articulates the split in the Japanese "Self" between the endless striving for the ideal of "Western" modernity and the nationalistic affirmation of an empowered "Japanese" (post)modernity, while eliding the inherent cultural hybridity of the shōjo Gothic style and of the national identity articulated through this style. Lastly, it is important to note that Japan was (and is) a (neo)colonial power in Asia, and I touch on the significance of this double postcolonial relationship at the end of the essay.

Murakami Takashi first introduced the concept of "superflat" within the context of an art exhibition titled *Super Flat,* which was presented in 2000 at the PARCO department store gallery. He later developed the concept through two more exhibitions: *Coloriage* (2002) and *Little Boy: The Arts of Japan's Exploding Subculture* (2005). Murakami and several other critics, including Azuma Hiroki and Sawaragi Noi, interpret superflatness as a visual manifestation of the postmodern collapse of hierarchies and the fragmentation of the modern Cartesian subject.[3] In this essay, I will argue that the shōjo Gothic style points to a connection between superflatness and another principal element of the postmodern condition: simulation. In "Postmodernism, or The Cultural Logic of Late Capitalism" (1984), Fredric Jameson reads the formal planarity of Andy Warhol's *Diamond Dust Shoes* as a symbolic expression of "the emergence of a new kind of flatness or depthlessness, a new kind of superficiality" in our world where objects "now become a set of texts or simulacra."[4] Likewise, the shōjo Gothic style suggests that the superflat visual aesthetic implies a particular postmodern mode of vision and knowledge—a "way of seeing" (John Berger) or "scopic regime" (Martin Jay)—that "flattens" all "real" phenomena in the world into hyperreal signifiers "without origin or reality."[5] *Kuroshitsuji* illustrates this connection between literal and figurative flattening through its depiction of the Undertaker's shop. In Figure 1, the façade of the shop is depicted in a highly planar, nongeometric perspectival

FIGURE 1. The Undertaker's Shop. *Kuroshitsuji,* volume 2, by Toboso Yana (Tokyo: Square Enix, 2008).

style. The figures of the characters, the door of the shop, and the coffin and tombstones flanking the door are positioned in a highly linear arrangement, and the speech bubbles add to the planarity through their superimposition, also in a linear fashion, over the picture of the characters and the shop entrance. This horizontal composition directs the reader's gaze to move across the flat "layers" of the panel, taking in visual and verbal information from one side to the other, instead of moving toward a vanishing point in a Cartesian illusion of depth. The flatness of the image is further emphasized by the high black-and-white contrast and a minimal use of shading, which tends to diminish the sense of three-dimensionality in the objects depicted.

This literal planarity coincides in Figure 1 with the figurative superficiality of the traditional motifs of Gothic horror, here presented in an exaggerated, campy form, which bathetically reduces these motifs to pure clichés devoid of any deeper, "real" meaning. The Undertaker's shop, with its coffins, cobwebs, and general dilapidated condition, is a "blank parody"[6] of the Gothic trope of the haunted house: the signboard of the shop is embellished with a giant

> THE SHŌJO GOTHIC STYLE
> PARADOXICALLY SIMULATES AND
> REINVENTS PRE-TWENTIETH-
> CENTURY WESTERN EUROPEAN
> AND ENGLISH CULTURE TO
> ARTICULATE THE CONTEMPORARY
> JAPANESE NATION'S CONTINUING
> DESIRE FOR THE COLONIAL IDEAL
> OF "TASTEFUL" CONSUMPTION
> IN "WESTERN MODERNITY."

death's-head, and a string of garlic hangs above the door as a decorative ornament, deprived of its former function as a guard against vampires in a place that already looks like a vampire's abode. This rendering banal of the Gothic illustrates a process of simulation, whereby Gothic tropes are stripped of their repressed, unconscious depth, and "flattened" out into superficial images that are more fantastic than frightening and that self-consciously evoke their own superficiality. As we can see from the example of the Undertaker's shop, the shōjo Gothic style exemplified in *Kuroshitsuji* draws a connection between the highly "flattened" visual form of superflat and the postmodern "flattening" mode of perception, which is brought to bear on all signs that claim to have a relation to a deeper reality (such as "the repressed") outside language. The shōjo Gothic style thereby supports Azuma Hiroki's contention that the emergence of superflat-style manga, anime, and video games in Japan is not the unique and groundbreaking historical development that Murakami and like-minded otaku nationalist commentators have claimed it to be; it is merely part of an ongoing worldwide trend of "postmodernization,"[7] which, in fact, exceeds the superflat visual aesthetic. Apart from superflat, the shōjo Gothic style actually uses other modes of composition and rendering as well, but these modes nonetheless imply the same postmodern condition of simulation. I will return to this issue later in my argument.

As a symbolic expression of postmodern "flatness," the Gothic style in *Kuroshitsuji* and in contemporary Japanese shōjo culture is both part of and distinct from the genre of the (Euro-American) "postmodern Gothic." According to Fred Botting, with the normalization of irrational, excessive consumption and the circulation of "undead" images in late twentieth-century mass culture, the Gothic has become thoroughly commodified and "flattened" into a mere simulation of itself.[8] For Botting, Gothic tropes and figures have "become too familiar after two centuries of repetitive mutation and see[m] incapable of shocking anew."[9] Almost devoid of its formerly uncanny affect, the superficial, clichéd Gothic sign cannot function as a locus for the location and expulsion of anxieties about the absence of any "sacred, final Meaning" within the postmodern condition; it can only hint obliquely at the "black hole" that continues to lurk beneath it.[10] As Gothic monsters become banal symbols of the "black hole" of meaning, the postmodern Gothic, Botting argues, struggles

to reinstitute boundaries and realities,[11] while paradoxically celebrating their loss.[12] The shōjo Gothic style can be included in the genre of the postmodern Gothic as it self-reflexively recognizes that the Gothic is now a commodified simulacrum—it is significant that the Gothic trope of the haunted house is transformed through pastiche into an undertaker's shop in *Kuroshitsuji*—and that contemporary Japan participates in the global consumption of the Euro-American Gothic (both traditional and postmodern) through transnational "flows" of media and commodities. However, unlike the Euro-American post-modern Gothic texts Botting considers,[13] the shōjo Gothic style exhibits much less anxiety about the "horror of textuality."[14] As an alternative variant of the postmodern Gothic that stands both inside and outside the rubric delimited by Botting, shōjo Gothic playfully deploys the "black hole" of meaning to di-vest the signs of the Euro-American Gothic (traditional and postmodern), and of a Western European past in general, of their historical and cultural refer-ents (including the "horror of textuality"), and to reinscribe them in terms of a postcolonial politics of consumption.

As mentioned above, despite its Japanese context of production, the shōjo Gothic style "flattens" and reinvents the meanings of historical signs drawn from an identifiably "Western European" past (including those of the Gothic) instead of a "Japanese" past. This cross-cultural dimension implies that the shōjo Gothic style is not only a postmodern practice of appropria-tion, recontextualization and re-inscription through consumption but is also a postcolonial practice of cultural hybridity concerned with undermining and yet affirming hierarchies of consumption. In *The Location of Culture,* Homi Bhabha draws on postmodern theories of the semiotic nature of culture to argue that cultural hybridity is a process of "translation" whereby the signs of a foreign culture are iterated, divested of their received meanings, and re-inscribed with alternative meanings as simulacra in a different cultural context of enunciation.[15] Bhabha suggests that this subversive practice of cultural hybridity returns a measure of agency to postcolonial subjects and enables them to transform their colonial inheritance into a new hybrid culture that is emancipatory.[16] However, as a postmodern and postcolonial practice of enunciation, the shōjo Gothic style paradoxically simulates and reinvents pre-twentieth-century Western European and English culture to articulate the contemporary Japanese nation's continuing desire for the colonial ideal of "tasteful" consumption in "Western modernity."

In *Kuroshitsuji,* the setting of the narrative in late Victorian England forms the premise for a nostalgic simulation, recontextualization and reinscription of seventeenth-, eighteenth-, and nineteenth-century Western European

and English architecture, food, and dress. Postmodern nostalgia, as defined by Jameson, is the collective social desire to appropriate an idealized past through aesthetic representation or, to use Baudrillard's term, simulation.[17] It involves emptying signs of the past of their historical referents, and re-inscribing these signs with connotations of a vague "pastness" that construct Barthesian "mythologies" of the past as a "privileged lost object of desire" while effectively effacing "real history."[18] The shōjo Gothic style in *Kuroshitsuji* performs this postmodern nostalgic simulation: the signs of Western European and English culture are "flattened" out, stripped of their historical referents, and transformed into idealized hyperreal images of an impeccably elegant and beautiful late Victorian aristocratic lifestyle. For example, the first volume of the manga opens with an introduction to Count Ciel Phantomhive's country manor (Figure 2). The narrator in the exposition guides the reader toward the manor: "At a short distance from London, as you leave the forest covered with mist, a well-maintained manor house appears before you." The reader is greeted with an image of the neoclassical front entrance of a mansion that is imbued with a romantic air. The mansion is depicted in soft focus, with beams of sunlight falling gently across its façade and the lush greenery in the foreground, and so it indeed seems to be appearing before the reader out of the misty forest like a magical castle in a fairytale land. Here, the country manor loses its historical associations with feudal aristocratic rule and instead becomes a signifier of a retrospectively romanticized aristocratic "style" of living.

Like the trope of the country manor, pre-twentieth-century Western European and English dress, diet, and dining practices function in the manga as simulacra that connote an imaginary and idealized late Victorian aristocratic lifestyle that is not entirely historically accurate. For example, although the narrative is set in the late 1880s, anachronistic design elements and accessories—such as lace cravats from the Restoration period (1660–80) and crinoline silhouettes from the mid-Victorian period (1844–68)—are jumbled together in the manner of pastiche to form the elaborate outfits Ciel and other aristocratic characters wear. Despite their historical inaccuracy, simulations of Western European and English food and fashion in the text are portrayed in a meticulously detailed manner that clearly foregrounds the issue of aesthetics. Furthermore, the text's employment of non-superflat modes of composition and rendering implies that superflatness is only part of the general trend of postmodern simulation that gives rise to multiple kinds of visual aesthetics. Cartesian or photorealistic modes of visuality happily coexist with superflat ones within the larger framework of hyperreality.[19] The front cover of volume

一杯の紅茶から始まる

ロンドン首都から少し離れ霧けぶる森を抜けると手入れの行き届いた屋敷があらわれる

その屋敷に住まう名門貴族ファントムハイヴ家当主の朝は

FIGURE 2. The main entrance of the Phantomhive country manor. *Kuroshitsuji,* volume 1, by Toboso Yana (Tokyo: Square Enix, 2007).

2 of the manga depicts Ciel's butler, Sebastian, carrying an intricately carved three-tier pewter tray with a wide assortment of dainty cakes, scones, macaroons, and cream-filled fancy biscuits arranged neatly on it (Figure 3). The food is rendered in a highly detailed and realistic style and in vibrant colors, and this gives the food a three-dimensional appearance that differentiates it from the rest of the image (which is rendered in a more conventionally superflat visual style) and makes it appear very attractive and appetizing. The act of serving the food is depicted in a highly aesthetic manner as well. In Figure 3, Sebastian is shown balancing the tray expertly on one hand and turning back slightly to smile at the reader as he presumably makes his way to serve afternoon tea to his young master. This image and many others like it in the manga collectively conjure up a fantasy of a luxurious late Victorian aristocratic lifestyle where aesthetics are paramount, where the food and drink are of exquisite quality, where the cutlery is stylish, and where elaborately dressed ladies and gentlemen are served by a butler well-trained in the complicated conventions of fine dining. In other words, these highly aestheticized simulations of the past connote an idealized aristocratic lifestyle that expresses what Pierre Bourdieu calls "the aesthetic disposition" or "legitimate taste": the ability of the "cultural nobility" to consume and appreciate cultural objects and practices for their aesthetic form rather than for their practical function.[20]

FIGURE 3. Sebastian carrying a tray of delectable tea-time pastries. Front cover of *Kuroshitsuji*, volume 2, by Toboso Yana (Tokyo: Square Enix, 2008).

As we can see from the discussion thus far, the shōjo Gothic style in *Kuro-shitsuji* nostalgically simulates pre-twentieth-century Western European and English culture, and reinscribes the simulations of this culture to construct a myth of a romanticized late Victorian aristocratic lifestyle and of the aesthetic disposition this lifestyle manifests. This myth connoted is actually a synecdoche of a larger mythology that privileges "Western modernity" as an ideal toward which the Japanese nation is compelled to continue to strive in the present.[21] Although the manga overtly characterizes itself as "Gothic" through its repetition of the familiar tropes of the Gothic tradition, its representation of late Victorian England could not be more different from that found in fin-de-siècle British Gothic fiction. Toward the end of the nineteenth century, the mood in late Victorian England was clearly one of gloom and uncertainty as the much-vaunted phenomenon of Western modernity was increasingly put into question. The Enlightenment ideals of rationality, order, and progress were increasingly perceived as hollow, as theories of evolution sparked off fears of atavism,[22] and Western civilization was condemned for its hypocrisy (by Oscar Wilde) and alienation (by Karl Marx and Friedrich Engels). These and many other social anxieties were expressed in the Gothic fiction of the period, which reinvented the signs of the feudal past to hold up a mirror to the hidden ugliness and corruption at the heart of Western modernity in the late Victorian present. *Kuroshitsuji,* in contrast, holds up a very different mirror through its nostalgic reinscription of the signs of a pre-twentieth-century Western European past. Like the mirror in Jacques Lacan's theory of the "mirror stage" in ego formation, the manga's romanticized portrayal of late Victorian aristocratic culture represents the historical phenomenon of Western modernity as an "ideal-I,"[23] a vision of a perfect Self that interpellates the contemporary Japanese nation and compels it to identify with and aspire to this state of perfection. The bright, cheery neoclassical façade of the Phantomhive country manor not only alludes to but also affirms the neoclassical ideals of rationality, order, and progress. The simulations of stylish fashion and elegant fine dining, however, implicitly valorize another important aspect of Western modernity: namely, the emergence of a capitalist consumer culture in the nineteenth century and the corresponding development of the aesthetic disposition that the consumer needed to possess in order to consume commodities in the "proper" way. In the text, Ciel's aristocratic lifestyle is deeply implicated in the growth of a culture of consumption stimulated by industrialization in nineteenth-century Europe. Significantly, Ciel's meals and clothing are bought with capital that comes not from land rents, the traditional source of the nobility's income, but from the profits his company earns

from the mass production of toys and sweets marketed to the children of the rising middle classes. Besides manufacturing commodities for consumption by others, Ciel himself engages in the consumption of commodities as a connoisseur. In volume 1, the story begins with Ciel in the act of enjoying a fragrant early morning cup of Royal Dorton Ceylon tea served in a finely-crafted Wedgwood china tea set, and later in the story, he is shown collecting a custom-made walking stick with an elaborately carved handle from a shop in London. In *Kuroshitsuji,* these simulations of "aristocratic" food and fashion collectively evoke a positive, sunny image of nineteenth-century Western modernity where "civilization" refers not so much to philosophical Enlightenment ideals but to the possession of both Western commodities and the Western aesthetic disposition or "taste" required to consume and appreciate the aesthetic form of these commodities.

It is this cultural form of Western modernity that is represented in *Kuroshitsuji* as an ideal that contemporary Japan, despite its postwar economic achievements, has yet to attain. In other words, the shōjo Gothic style exemplified in *Kuroshitsuji* articulates a paradoxical nostalgia that demands that Japan look back to the past in order to look forward to the future. In the second story of the series, Ciel discovers that the mastermind behind a series of murders is a wealthy businessman called Harold West. Despite his name, Harold West is a caricature of the familiar Japanese archetype of the "brand-lover" (in fact, Ciel uses the Japanese epithet *"burando-zuki"* to refer to the character, West, in the text). West indulges in conspicuous consumption: in one scene, he comically takes pains to inform the reader of the brand names of his household goods even as they are being inadvertently destroyed by his own hired assassin. In contrast to the criminal-minded and crass West, for whom the exchange value of commodities is a direct equivalent to social status, Ciel shows little interest in the brand names of his tea and of the vessels in which the tea is served. The manga thus encourages the Japanese reader to reject identification with the "Japanese" and middle class West, and to identify instead with the English and aristocratic Ciel, who knows how to consume and appreciate his branded tea and teacups as art objects rather than as opportunities to flaunt his wealth.[24] Through this privileging of Ciel and his aristocratic taste and lifestyle as the "ideal-I" of the Japanese reader/nation, hierarchies of social class and cultural distinction take on a postcolonial inflection in the manga. The text implies that although Japan has in recent decades achieved parity with the West in terms of economic capital and is now a prosperous "middle class" nation, it has not yet quite attained the ideal of "modernity" because it remains inferior to the West in the realm of "aristocratic" cultural capital.[25]

This idealization of Western cultural modernity in *Kuroshitsuji* (and in other postwar Japanese popular culture texts that manifest the shōjo Gothic style) articulates the enduring desire of contemporary Japan to "catch up" with the West and become fully "modern" in Western terms. This desire can be traced back to the final Tokugawa years (1853–67) and the Meiji era (1868–1912), which constituted the turning point in Japan's history when the country first came into contact with Western imperial power in the latter half of the nineteenth century. In the years before and during the Meiji era, Western artifacts and customs, and the aesthetic disposition or "taste" these artifacts and customs implied, became objects of idolization. According to Kitahara Michio, this "Europeanization fever" (*ōkanetsu*) was the cultural expression of Japan's Oedipal identification with the West in response to the "shock" of possible colonization (which Kitahara reads as castration) engendered by the arrival of Commodore Perry's warships in 1853 and, I would argue, by the increasing awareness of the realities of international geopolitics in the years that followed.[26] The Japanese public's almost fanatic desire to possess both Western goods and the Western knowledge needed to consume and appreciate these goods led to intense interest in Western languages, art, apparel, hairstyles, and even the eating of beef.[27] The Meiji writer Natsume Sōseki observed that "men would show off by dangling gold watches, wearing Western dress, growing beards, and interjecting English phrases when speaking ordinary Japanese."[28] Japanese art and culture, on the other hand, were seen as inferior and treated with contempt. For example, woodblock prints by prominent artists were used to wrap fish and vegetables.[29] As I have shown, Japanese identification with Western cultural modernity as a national "ideal-I" first arose out of Japan's traumatic historical encounter with Western imperialism just before and during the Meiji period; as the product of that traumatic encounter, it has arguably become rooted in the collective unconscious of the Japanese nation and finds expression today in *Kuroshitsuji* and other shōjo Gothic texts.

The shōjo Gothic style, as we have seen, is a signifying practice that involves a number of paradoxes. As a *postmodern* practice of simulation, recontextualization and reinscription, the shōjo Gothic style ironically idealizes the *modern*. It nostalgically fictionalizes a Western European *past* in order to articulate the continuing desire of the Japanese nation in the *present* for the historical phenomenon of Western modernity projected into the *future* as an ideal to which to aspire. As a particular expression of the shōjo Gothic style, *Kuroshitsuji* suggests that there may be two more paradoxes to explore. As a shōjo Gothic text, *Kuroshitsuji* appropriates and reinvents the signs of a Western European past not only to fetishize an idealized Western European aristocratic taste and

> THE SHŌJO GOTHIC STYLE IN
> *KUROSHITSUJI* INTERVENES
> IN ITS OWN IDEALIZATION OF
> WESTERN CULTURAL MODERNITY
> TO CELEBRATE CONTEMPORARY
> JAPAN'S POSSESSION OF THIS
> FORM OF CULTURAL CAPITAL.

lifestyle and the ideal of Western cultural modernity the former symbolizes. It does so also for the counterhegemonic purpose of articulating and affirming a "Japanese" form of (post)modernity that emerges out of capitalist globalization, the formation of a global consumer culture, and the consequent privileging of a different form of cultural capital: namely, the ability to hybridize different cultures that "flow" across national boundaries through the processes of simulation, recontextualization, and reinscription, and to export these hybrid cultural commodities for global consumption. In other words, the shōjo Gothic style in *Kuroshitsuji* intervenes in its own idealization of Western cultural modernity to celebrate contemporary Japan's possession of this form of cultural capital that is manifested in the shōjo Gothic style itself. However, in doing so, it participates in *Nihonjinron* discourses and superflat theory's jingoistic affirmation of the Japanese "Self" as unique, essential, proto-postmodern, and superior to the Western "Other,"[30] while neglecting to recognize that the shōjo Gothic style is an enunciative practice of cultural hybridity that, in its construction of postcolonial Japanese national identity, actually subverts the Japan/West binary opposition. As Bhabha argues in *The Location of Culture,* the act of "translating" the signs of a foreign culture changes the boundaries of both the translated and the translating cultures, thereby producing a liminal hybrid that eludes the polarization of "East" and "West," "Self" and "Other."[31]

Despite the setting of the narrative in late Victorian England, the butler Sebastian (who, as I have mentioned earlier, is a devil in disguise) functions as an allegory of the contemporary Japanese nation's ability to hybridize the various cultures that "flow" into Japan to create hybrid cultural products. In a bid to win a curry-cooking competition, Sebastian introduces several culinary innovations. He first adds chocolate to traditional Indian curry, and then he deliberately overboils the curry so he can seal the thickened mixture within a small mound of dough that looks like a cross between Indian *naan* and English bread. Instead of using a *tandooru* or an oven to bake the dough, he deep-fries it in oil. This act of cooking is in fact an act of cultural "translation": Sebastian repeats the signs of both English and Indian cuisine, divests them of their established meanings, and re-inscribes them with new meanings, and the end result of this process of simulation and transformation is an English–Indian hybrid that is none other than the "curry bun" (*karii pan*), a popular twentieth-century Japanese invention (Figure 4).[32] Remarkably,

the supernatural figure of Sebastian does not simply affirm contemporary Japan's ability to hybridize different cultures. The fact that Sebastian is endowed with a supernatural aptitude for hybridization symbolically represents Japan's capacity for hybridization as a unique and innate talent that, as the manga proceeds to claim, positions Japan at the forefront of the hybridization and export of cross-cultural commodities in the postmodern globalizing world.

In the nineteenth century, hybridization and dissemination were the exclusive prerogative of imperial England. The historical Victorian England anglicized Indian curry because it "felt itself to be far superior to any other nation in the world, and that like Ancient Rome before it, could steal with impunity any idea or culture it thought desirable."[33] It also possessed the power to spread its culture, including its culinary practices, around the world, even to countries such as Japan that were not formally colonized. However, in the simulated late Victorian world of the manga, it is the "Japanese" Sebastian who wins the curry-cooking competition with his unique and innate flair for hybridization. Sebastian defeats the English chefs who use bland store-bought Anglo-Indian curry powder, and who therefore fail at hybridization; he also

FIGURE 4. Sebastian presents his "invention," the "curry bun" (*karii pan*), to the panel of judges at the curry-cooking competition. *Kuroshitsuji,* volume 5, by Toboso Yana (Tokyo: Square Enix, 2008).

defeats the Indian chef, Agni, who cooks a delicious but traditional curry, and who therefore fails even to attempt hybridization. Moreover, the competition is held in the Crystal Palace in conjunction with an exhibition on Indian culture and British achievements and industries in the colonies. As the location of the 1851 Great Exhibition, the Crystal Palace symbolized the power of Victorian England to bring the various cultures of the world to its doorstep, to hybridize the cultures it deemed desirable, and, as the fictional exhibition in the manga illustrates, to disseminate its hybrid culture to the rest of the world. With this historical context in mind, we can read Sebastian's culinary victory in the Crystal Palace as a Japanese postcolonial response to the cultural imperial power of Victorian England, the cultural superpower of the nineteenth century. Sebastian's triumph over the "incompetent" English chefs and the conservative Indian chef implies that Japan is inherently superior to both East and West in hybridizing the different cultures that "flow" into Japan, and in reversing the "flow" and disseminating its hybrid cultural commodities around the world. This triumph implies that Japan, with its native talent for hybridization, has supplanted Victorian England as the preeminent "hybridizer" and exporter of cross-cultural commodities, and is the new cultural superpower of the twenty-first century.

In conclusion, we can see that Victorian England, the shining emblem of Western cultural modernity, is simulated and transformed in *Kuroshitsuji* into a symbol of a Japanese cultural (post)modernity predicated on the emergence of a global consumer culture and characterized by the possession of a very different kind of cultural capital: the supposedly unique and innate Japanese genius for cultural hybridization and global dissemination. At the end of *The Location of Culture*, Bhabha argues that "modernity" is not only an a priori epochal event or idea but is also a sign that is constantly being negotiated and redefined in the present context of enunciation.[34] Postcolonial (post)modernity is, therefore, a "post-European" hybrid that cannot be classified as either purely "Western" or "Japanese."[35] However, as we can see from this essay's discussion of the shōjo Gothic style, contemporary Japanese texts such as *Kuroshitsuji* reinterpret the signs of a Western European past not merely to idealize the historical phenomenon of Western modernity but also to reinterpret that phenomenon to construct and celebrate a dehistoricized "Japanese" form of (post)modernity in the present. This shows us that the ability to simulate, recontextualize, and re-inscribe does not necessarily translate into an emancipatory postcolonial politics and that this enunciative modality can be deployed to produce and to perpetuate cultural essentialism and exceptionalism instead. In fact, the nationalistic self-affirmation of

Japanese cultural hybridity in the shōjo Gothic echoes the "trans/national-ism" discourses predominant in Japan in the 1990s, as discussed by Iwabuchi Kōichi in *Recentering Globalization*.[36]

In an attempt to reconcile the notion of a Japanese "national essence" with increasing transnational cultural "flows" in the 1990s, the state, the media, the private sector, and academic and social commentators posited the capacity for hybridization as a distinctive and inherent trait of the Japanese nation.[37] Commentators similarly claimed that Japan's ability to hybridize Western culture into forms suitable for dissemination in Asia justified Japan's position as the (neo)colonial leader of Asia.[38] Given the popular perception of Japan as the economic and cultural role model of Asia, *Kuroshitsuji* and other shōjo Gothic texts may be consumed by other Asian nations to articulate their desire for Japanese (post)modernity. Nevertheless, the enunciative modality manifested in the shōjo Gothic style reminds the reader that hybrid Japanese cultural commodities can just as well be, and are currently being "appropriated, translated, rehistoricized, and read anew"[39] by Asian audiences to construct new postcolonial identities for themselves.

..

Notes

I would like to thank my editor and the reviewers for their insightful comments and suggestions, which have helped me improve this essay tremendously. I would also like to thank Professor Valerie Wee, Professor Ryan Bishop, Dr. Shun-liang Chao, and my friends Adeline Koh, Lin Li, and Christine Chong for their invaluable advice and support in the earlier stages of writing the essay.

1. There are certainly many Japanese novels, films, manga, and anime that exhibit Gothic influences (such as the works of Yokomizo Seishi, Edogawa Ranpō, and Suehiro Maruo) but in this essay I want to focus on a particular variant of the Gothic in Japan that intersects with shōjo culture. This "prettified" shōjo Gothic style can be seen in other shōjo culture texts such as Yuki Kaori's manga *Cain Saga* (1992–94, *Hakushaku Kain*) and *Ludwig Revolution* (2004–7, *Rūdovihhi kakumei*), and Shurei Kōyu's manga *Alichino* (1998–2001, Arikiino), and in the Gothic Lolita and Visual Kei subcultures. However, due to space constraints, I will not be discussing the gendered dimension of shōjo Gothic in this essay.

2. As serialization of *Kuroshitsuji* is still ongoing at the time of writing, my analyses in this paper are limited to volumes 1-9 of the manga, published 2007-10. Serialized installments of *Kuroshitsuji* are published in a monthly manga magazine, *G-Fantasy*, before they are published in the form of single-series volumes (*tankōbon*), but I have decided to use the *tankōbon* as my primary texts instead because they contain the finalized version of the manga.

3. See Murakami Takashi, "A Theory of Super Flat Japanese Art," in *Super Flat,* ed. Murakami Takashi, 8–25 (Tokyo: Madra, 2000); Azuma Hiroki, "Super Flat Speculation,"

in *Super Flat,* ed. Murakami Takashi, 138–51; Sawaragi Noi, quoted in Murakami Takashi, "Superflat Trilogy: Greetings, You Are Alive," in *Little Boy: The Arts of Japan's Exploding Sub-culture,* ed. Murakami Takashi, 151–61 (New Haven, Conn.: Yale University Press, 2005); and Michael Darling, "Plumbing the Depths of Superflatness," in *Art Journal* 60, no. 3 (2001): 77–89. Thomas Lamarre offers a critical overview of superflat theory in chapter 10 of *The Anime Machine: A Media Theory of Animation* (Minneapolis: University of Minnesota Press, 2009), 110–23.

4. Fredric Jameson, "Postmodernism, or the Cultural Logic of Late Capitalism," in *The Jameson Reader,* eds. Michael Hardt and Kathi Weeks, 195–96 (Oxford: Blackwell, 1995).

5. Jean Baudrillard, *Simulacra and Simulation,* trans. Sheila Faria Glaser (Ann Arbor: University of Michigan Press, 1994), 1. See also Martin Jay, "Scopic Regimes of Modernity," in *Visions and Visuality*, 3–23 (Seattle: Bay Press, 1988) and John Berger, *Ways of Seeing* (London: Penguin, 1972).

6. Jameson, "Postmodernism," 202.

7. Azuma Hiroki, *Dōbutsukasuru posutomodan: Otaku kara mita Nihon shakai* (Tokyo: Kōdansha Gendai Shinsho, 2001), 10, 18–19; trans. Jonathan E. Abel and Shion Kono as *Otaku: Japan's Database Animals* (Minneapolis: University of Minnesota Press, 2009).

8. Fred Botting, *Gothic Romanced: Consumption, Gender, and Technology in Contemporary Fictions* (London: Routledge, 2008), 66–75.

9. Fred Botting, "Aftergothic: Consumption, Machines, and Black Holes," in *The Cambridge Companion to Gothic Fiction,* ed. Jerrold E. Hogle (Cambridge: Cambridge University Press, 2002), 298.

10. Ibid., 292–96.

11. Botting, *Gothic Romanced,* 75.

12. Fred Botting, *Gothic* (London: Routledge, 1996), 172.

13. The texts Botting considers under the rubric of the "postmodern Gothic" include the Goth music subculture, the computer game *Doom,* Ridley Scott's *Alien* films, Umberto Eco's *The Name of the Rose,* and Francis Ford Coppola's *Bram Stoker's Dracula.*

14. Botting, *Gothic,* 171.

15. Homi K. Bhabha, *The Location of Culture* (London: Routledge, 1994), 34-37.

16. Ibid., 38.

17. Jameson, "Postmodernism," 203–4.

18. Ibid., 203–7.

19. The highly detailed and realist visual aesthetic employed in *Kuroshitsuji* is akin to British heritage cinema's fetishization of period detail in the latter's simulation of the English past as empty visual spectacle. See Andrew Higson, "Re-Presenting the National Past: Nostalgia and Pastiche in the Heritage Film," in *Fires Were Started: British Cinema and Thatcherism,* 2nd ed., ed. Lester Friedman (London: Wallflower Press, 2006), 91–109.

20. Pierre Bourdieu, *Distinction: A Social Critique of the Judgement of Taste,* trans. Richard Nice (London: Routledge and Kegan Paul, 1984), 16, 28, 42.

21. It seems paradoxical that *Kuroshitsuji* associates Western modernity with the aristocracy, which is a predominantly premodern social formation. However, the manga treats "aristocracy" less as a social caste and more as a lifestyle that became less contingent on birth and more dependent on the economic power to consume commodities with the

advent of capitalist modernity. Therefore, the text's adoption of the aristocracy as a symbol of Western modernity is not ultimately contradictory.

22. Kelly Hurley, *The Gothic Body: Sexuality, Materialism, and Degeneration at the Fin-de-Siècle* (New York: Cambridge University Press, 1997), 5.

23. Jacques Lacan, *Ecrits: A Selection,* trans. Bruce Fink (New York: W. W. Norton, 2002), 4-6.

24. Remarkably, the text does not encourage the reader to read Ciel as "English" by attributing stereotypical "Western" qualities to the character. Ciel seems to symbolize the West because of his ethnicity in the text and, more important, because of the opposition the text sets up between him and the other characters, who are either obvious racial caricatures (such as Lau, the inscrutable Chinese trader–cum–opium den operator, and the superstitious Prince Sōma and his servant Agni from India) or disguised stereotypes (Harold West). The text thus positions Ciel/the West as the "norm," which is defined in relation to stereotyped racial Others while avoiding stereotyping itself.

25. It is often said that postwar Japanese society perceives itself to be homogeneously "middle class." More than 75 percent of Japanese people identified themselves as "middle class" in a national survey conducted in 1996. See Duncan McCargo, *Contemporary Japan,* 2nd ed. (Hampshire: Palgrave Macmillan, 2004), 90.

26. Kitahara Michio, "Popular Culture in Japan: A Psychoanalytic Interpretation," *Journal of Popular Culture* 17, no. 1 (1983): 103.

27. Hane Mikiso, *Modern Japan: A Historical Survey,* 3rd ed. (Boulder, Colo.: Westview, 2001), 116.

28. Quoted in Hirakawa Sukehiro, *Japan's Love-Hate Relationship with the West* (Kent, UK: Global Oriental, 2005), 120.

29. Hane, *Modern Japan,* 116.

30. Thomas Lamarre, *The Anime Machine: A Media Theory of Animation* (Minneapolis: University of Minnesota Press, 2009), 113–14.

31. Bhabha, *Location of Culture,* 37–39.

32. According to the ANA Sky Web website, a bakery in Tokyo called Cattlea (Katoreya) claims to have invented the "curry bun" in 1927 as a "Western cuisine-bread" (*yōshoku pan*). ANA, "Ganso karee pan no mise! Shitamachi no panyasan 'Katoreya' Tokyo, Morishita," ANA Sky Web website, https://tabidachi.ana.co.jp/topic/3213 (accessed October 25, 2010).

33. Colin Spencer, *British Food: An Extraordinary Thousand Years of History* (New York: Columbia University Press, 2002), 280–81.

34. Bhabha, *Location of Culture,* 242–47.

35. Rey Chow, "The Old/New Question of Comparison in Literary Studies: A Post-European Perspective," *ELH* 71, no. 2 (2004): 298–300.

36. Iwabuchi Kōichi, *Recentering Globalization: Popular Culture and Japanese Transnationalism* (Durham, N.C.: Duke University Press, 2002), 52.

37. Ibid., 53.

38. Ibid., 59–69.

39. Bhabha, *Location of Culture,* 37.

DAVID BEYNON

• • •

From Techno-cute to Superflat:
Robots and Asian
Architectural Futures

It may surprise some of you when I say that I first began to acquire a knowledge of Buddhism through a study of robots, in which I am still engaged today. It may surprise you even more when I add that I believe that robots have Buddha-nature within them— that is, the potential for attaining Buddhahood.

—Mori Masahiro, *The Buddha in the Robot: A Robot Engineer's Thoughts on Science and Religion*

THE ROBOT

The Thai architect Sumet Jumsai's former Bank of Asia building (now United Overseas Bank) is one of the most distinctive sights on the Bangkok skyline. Approaching its twenty-story bulk along Sathorn Road, the building looms as a stack of giant cubic forms (Figure 1, *left*). However on closer inspection, it becomes clear that this stack of cubes is actually a giant robot. The building's tripartite vertical division can be distinguished as "legs," "body," and "head," each articulated by strips of curtain walling (Figure 1, *right*). On each side of the "legs," ground floor openings are surrounded by canopies that mimic robot tank-track feet (Figure 2, *left*). Oversized "bolts" emerge from higher

129

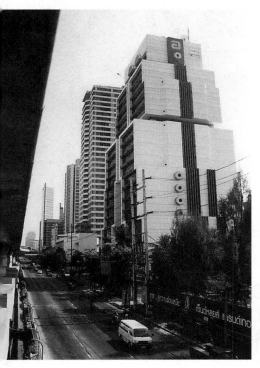
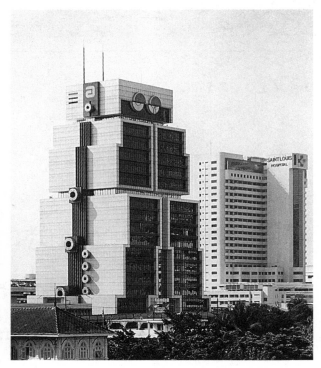

FIGURE 1. Former Bank of Asia building (now United Overseas Bank), Bangkok. *Left*: View along Sathorn Road. *Right*: View of front. Photographs by the author.

up (Figure 2, *right*), while at the front of the head facing the street, there are reflective glass "eyeballs" partially covered by louvered "eyelids" and twin antennae. While all this is quite startling in a bank building, in a sense, the use of mechanistic imagery is not so strange. The bank was completed in 1986, the same year as Richard Rogers's Lloyds Bank and Norman Foster's Hong Kong Shanghai Bank buildings. However, while the Bank of Asia's technologically based imagery might be broadly comparable to these other banks, it lacks their coldly mechanistic representation of ducts, struts, and pipes. Instead, Jumsai's robot is unashamedly anthropomorphic in its expression of technology. Its robot "eyelids" were even intended to "wink" at night, accompanied by lighting that pulsated to the rhythm of "The Robot Symphony," a piece by a local composer.[1]

By anthropomorphizing the robot, the Bank of Asia blends humanity and technology in a manner similar to the Japanese toy robots from which its imagery is derived, and so renders explicit notions about technology that are quite different from its British high-tech contemporaries. It looks forward to a future in which the information age will be friendly and anthropomorphic. There is no sense of humanity's alienation from high technology. Moreover,

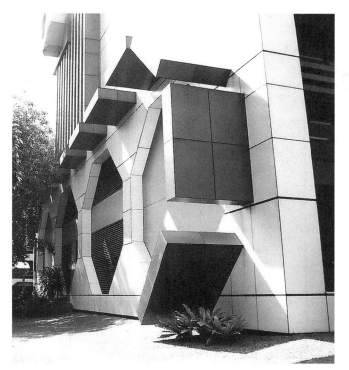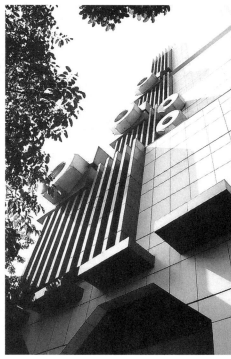

FIGURE 2. Former Bank of Asia building (now United Overseas Bank), Bangkok. *Left*: "Caterpillar tracks" on side of building. *Right*: "Bolts" on side of building. Photographs by the author.

the robot's expression is strangely endearing, even cute, a curious attribute for the twenty-story headquarters of a major financial institution. The robot identity of the building is only skin-deep, especially now that the original foyer, adorned with rather anthropotechnical sculptures of Thaveechai Nitiprabha, has been replaced by something more conventionally bland. The robot identity is now confined to the skin of the building. Underneath its techno-cute packaging, the business that is the Bank of Asia is presumably no more endearing than any other financial institution. Yet the layering of such apparently contradictory expressions and attributes in Jumsai's design make it a fascinating subject, particularly if we place it in the context of more recent developments. Jumsai's Japanese-derived robot is now over twenty years old, and, since its completion, three characteristics of the building—its machine/animist identity, its portrayal of this identity as endearing, and its reference to a specifically Japanese popular culture—have all become more globalized phenomena. Because of this, it is worth examining the interconnections between these three characteristics. In the postwar period, Japan was a land known in the West first for its clever imitation and then its enhancement of Western products—as Iwabuchi Kōichi describes them, "culturally odorless"

technological advancements such as Walkmans and karaoke.[2] More recently, however, more overtly Japanese products such as manga and anime have become popular outside Japan itself, and so the symbolic use of a Japanese robot in a Southeast Asian work of architecture raises the question of whether the robot is a symbol of Japanese influence or an expression of a more diffused "Asian" modernity.

WHY THE ROBOT?

In the Bank of Asia, Jumsai demonstrates a particular attitude toward technology and its relation with humanity. He describes his design in the following terms:

> But first, machine as we know it in this century has to be exorcised. It must no longer remain a separate entity or elevated on a pedestal to worship. This exorcism has been completed in the Sathorn Robot. Now the machine, this robot, is no longer a "big deal": it has become part of our daily lives, a friend, ourselves. It has entered the first phase of the 21st century revolution.[3]

This idea of the machine being not only a friend but "ourselves" is a critical point in Jumsai's exorcism of the machine. In the unthreatening anthropomorphic guise of the robot, technology—so overwhelming and sublimely menacing in high-tech—is blended into the world of humanity. At the risk of essentializing, this is quite different from the Western preconceptions about robots. Whereas the friendly robot exists within Western popular culture, from the clowning Robot from *Lost in Space,* to C-3PO from *Star Wars,* they are definitively not human, no matter how much they emulate human behavior. Mixtures of human and machine exist but are rarely as friendly. They may be on the side of good, like Arnold Schwarzenegger's Terminator in the second and third films of that series, but they retain a sense of menacing and disconcerting otherness.[4] More often, like the Borg in *Star Trek: The Next Generation,* they represent the implacable horror of subsumption into the Other, into the imagined undifferentiatedness outside (Western) humanity.[5] Taking this point further, identification of the cyborg with the automaton, and via the analogy of the doll with the feminine, gives a misogynistic undercurrent to this fear of the human-machine. A further discussion of the Borg, with their hive mind and bee-like queen, is certainly suggestive of this idea. Donna Haraway has outlined from a feminist viewpoint how the machine has been

identified within Western culture as being op-
posed more specifically to masculine human-
ity. She counters this idea with the argument
that the reality of existence is that we are all
really cyborgs—part animal, part machine—

and sees the figure of the cyborg as possibly redemptive in its disassociation
from traditional structures: "a cyborg world might be about social and bodily
realities in which people are not afraid of their joint kinship with animals and
machines."[6] Rey Chow's elaboration of this argument provides an interesting
interpretation of the robot building:

> Being "automatized" means being subjected to social exploitation whose ori-
> gins are beyond one's individual grasp, but it also means becoming a spec-
> tacle whose "aesthetic" power increases with one's increasing awkwardness
> and helplessness.[7]

The Bank of Asia robot, in its anthropomorphism of the automaton,
seems to do precisely this. Its visual impact is both tame and powerful, its
expression of the technological future distilling the massive bulk of financial
construction to a singular and personable image. We are intended to feel em-
pathy with the building, to connect with its techno-animist spirit. In this, the
building aligns with a tradition of empathetic Japanese robots. As Timothy
Hornyak relates, the Japanese interest in robots has deep roots.[8] He notes the
existence of an amusement park in Osaka in 1662 that featured apparently
self-automated puppets, as well as *Karakuri zui* (Automaton figures), a 1796
treatise that details how to make automated *karakuri* puppets.[9] Such puppets
were widely popular, especially *chahakobi ningyō,* a wind-up boy-puppet who
could serve tea. The poet Kobayashi Issa's haiku captured its appeal:

> Such coolness by the gate
> as the tea-serving doll
> brings another cup[10]

From Aibo™ the robot dog to Asimo™ the robot humanoid, there have been
great efforts in Japan to create personable and empathetic robots. There is
even, conflating cuteness and cyborg technology to its extreme, Hello Kitty
ROBO™ and the Therapeutic Robot: Paro™, a baby robot seal.[11] Japanese pop-
ular culture also abounds with human characters augmented by technology.
Anime from *Mobile Suit Gundam* (1979, *Kidō senshi Gandamu*) to *Bubblegum*

Crisis Tokyo 2040 (1998, *Baburugamu kuraishisu TOKYO 2040*) have protagonists who merge with machines in a manner portrayed as both technologically spectacular and, in the context of their narratives, quite normal. While there are other pathologies within the genre, this easy acceptance of the infiltration of the machinic into the human contrasts with the dread with which such hybrids are held in their equivalents in the West. This contrast leads to an attitude that Ueno Toshiya has termed techno-Orientalism—the way in which, through Western eyes, the Japanese eagerness to embrace the robot is symptomatic of their intrinsic repression of human individuality.[12] He sees in current Western depictions of Japan in particular and East Asia in general an echo of the Orientalist attitudes of their colonialist forebears as eloquently delineated by Edward Said. In this framing, Japanese are Japanoids, cyborgs with or without their robot suits and dogs. Conversely, as Mori Masahiro, a Japanese robotics engineer writing on Buddhism, has suggested, such a conjoining of human and machine is no less natural than any other phenomenon, and the idea of a distinction or opposition between humanity and machines— as between humanity and nature—is only a construct that obscures the acceptance of the Buddha-hood present not just in the human but also in the cyborg and the robot.[13]

This anthropomorphizing of the robot brings us back to Jumsai's bank, for as he states, the exorcising of the machine involves seeing it as a mirror of the self, a portrait in a different medium. The robot is literally animated, endowed with a life force that, drawing on the animist origins of Asian beliefs, lies inherent in all things. While the Thai context is in many ways quite different to Japan, there are some shared or parallel aspects of East and Southeast Asian cultures that may explain the empathetic robot's cross-cultural appeal. In Thai culture, the landscape is inhabited by *phi* (spirits), which coexist with Thai Buddhist practice in a way that combines indigenous animist beliefs with Hindu-Buddhist cosmology. Kirsch uses the example of the *phi-thewada* (*phi* + Hindu-Buddhist deity) to illustrate this aspect of the traditional Thai belief system.[14] These spirits have their equivalents in other Asian cultures. For instance in Malaysia, despite the quite different theological overlay of Islam, belief in *keramat* (spirits) remains strong, manifesting in both animate and inanimate objects. Even Chinese property developers in Malaysia sometimes perform rituals of propitiation to *keramat,* demonstrating the degree to which such beliefs remain potent in contemporary life.[15] In Japan, *kami* are intrinsic elements in Shinto. Inherently formless entities, *kami* may manifest in objects such as trees or stones and have the power to influence human affairs favorably or unfavorably, depending on their ritual treatment. The worship of *kami*

is a folk tradition, but as Shinto has integrated with imperial institutions, they, like Thai *phi,* have become as deities. The *kami,* Amaterasu-Ōmikami, for example, is both the sun goddess and the ancestress of Japan's imperial family.[16] Despite these identifications, a landscape of *kami* is nonhierarchal, fragmented, as each locality is influenced by its own combination of spirits.

Allied with a Japanese history of frequent natural disasters, such as fires and earthquakes, which have contributed to the conception of buildings as temporary and replaceable, the Shinto/Buddhist sensibility has led to a particular set of attitudes toward urban environments and to what may seem to Western eyes to be inanimate objects within them. To return to Thailand, Brian McGrath's description of Bangkok is strikingly similar:

> Thai Buddhist social order employs this world-view to synthesise vastly different forms of knowledge and practices. Cities here are ecumenical and tolerant, heterogeneous and cosmopolitan, populated with a vast diversity of ghostly and living creatures within heavenly and hellish realms, and all that lies between. This polystructured and complexly layered ecology historically accommodated Bodhisattvas, spirits and gods of Buddhism, Animism, and Brahmanism as well as traders and missionaries from Japan to Holland.[17]

These attitudes might also apply to the future where new and often intangible technologies contribute to the transformable nature of spirit; hence Mori's comment on the Buddha-potential of robots. However, the deliberately endearing means of representing this quality draws in another pervasive aspect of Japanese pop culture, and one that also disconcerts the cultural commentators of the West (as it does some in the East)—the realm of the cute. This aspect of popular culture is by now a regional and almost a global phenomenon. In utilizing an endearing image, the bank joins a multitude of other corporate and institutional entities in East and Southeast Asia that project a cute image, often by the means of a cuddly cartoon creature. The reasons for this are complex. The Japanese term for cute, *kawaii*—which has itself become as internationalized as its content—contains an older meaning, *kawaisō* (pitiful), which raises the question as to why an aesthetic of cuteness should be so popular.[18] One explanation is that the cult of cuteness is a desire to extend (early) childhood, a reaction to the inevitable drudgery of (particularly female) adulthood in societies that traditionally have had very strict social structures and hierarchies, but are now offering the ways and means to avoid or subvert them. A more pathological interpretation highlights the sometimes creepy juxtaposition of cheerily bland flatness and bodily deformity in cute characters,

hinting at, if not blatantly expressing, the abjection and angst behind the apparently smiling innocent exterior, like that of a roused Pokémon, that swiftly turns from apparently inane happiness to startling fury.[19] More prosaically, in East and Southeast Asian societies, assertiveness and directness are generally valued less than smiling deference. More specifically in relation to the robot building's Thai context, Philip Cornwel-Smith, in his survey of Thai popular culture, suggests that "*na rak* (cute) resonates with several core Thai values: *sanuk* (fun sensibility), *suay* (beauty), *sabai* (contentment), and *kreng jai* (deferential consideration)."[20] The Bank of Asia's winking robot arguably embodies all of these qualities, and as Cornwel-Smith continues, "It is also urban, plastic, and commercial, and thus pop. That suits another aspiration: looking *dern* (modern)."[21] While the imagery of the robot might be considered akin to the multitude of endearing characters used in the logos, mascots, and other public, corporate imagery, cuteness is not something commonly attributed to buildings themselves. In the West, architecture is usually considered to be too big, too permanent, and too serious to be regarded as cute, though in East and Southeast Asia, this is not necessarily the case. In conjunction with the Tokyo Institute of Technology, the Japanese architecture studio Atelier Bow-Wow has categorized some of the many buildings on tiny, marginal sites in Tokyo as "Pet Architecture." They argue that architecturally, such buildings occupy a place in relation to the larger surrounding buildings analogous to pets in relation to people, and so, whatever their physical characteristics, they are "small, humorous, and charming," offering visual approachability due not just to their size but also to the lack of design or technical sophistication in their composition.[22] While the robot bank has no lack of design, technical sophistication is not part of its expression, subordinated in favor of the animated image.

SURFACE AND ESSENCE

The use of the robot also raises the question of the use of artifice more generally. At first glance the Bank of Asia's enormous bolts and fake caterpillar-tracks appear to correlate with the contemporaneous wave of oversized Po-Mo pediments and candy columns that were appliquéd to the buildings of the 1980s. Jumsai, however, has clearly outlined a stance quite contrary to Postmodern Classicism as well as to High-Tech, and one that correlates with more recent developments in Asian art and architecture. His first point is that while the use of Classical pediments, capitals, and columns looks backward into the past—a specifically *Western* past—the robot looks toward the future, an

Eastern future. Jumsai sees the use of revivalist Classicism in Asia as symptomatic of the legacy of Western cultural paternalism. That new faux-temple apartments are still as prevalent in contemporary Thailand as they were in 1986 indicates the persistence of this legacy, but the difference in choice of decorative elements is not the only thing that distinguishes the robot from its 1980s contemporaries. Taking up the argument that the robot image has little to do with the purpose of the building, Jumsai suggests that the robot wrapping has a certain transformative power:

> It need not be a robot. It could be a host of other metamorphoses as long
> as they act as agents to free the spirit from the present intellectual impasse
> and propel it forwards into the next century.[23]

That the surface should have this power suggests a relationship between image and content that is quite removed from Western ideas of superficiality and essence—ideas that have discredited Western Postmodernist architecture. Instead, its exuberant surface recalls the sometimes intensely decorative but highly symbolic skins of traditional Thai *chedi* (stupas) that are encrusted with the symbolic meanings of Theravada Buddhism (Figure 3).[24] Additionally—and Jumsai is explicit in his opinions about the possibilities of architectural connections between Southeast Asia and Japan[25]—the robot image is connected with the ongoing Japanese interest in the power of the surface.

The word *superficial* describes the literal and ontological emptiness of something whose surface hides a lack within. It is indicative of the modern Western view that the surface, be it wrapping, skin, or container, is merely the covering of the essential thing inside it. The surface, in this estimation, may be truthful, obscurant, or deceitful about its contents, but not productive. However in both traditional and contemporary Japanese terms, the surface is considerably more intrinsic to the thing that it wraps or contains. From the ritual roping of rocks in sacred Shinto places, to the elaborate wrapping of even ordinary retail items; from the artful plating of *kaiseki* meals to the presence of uniformed greeters in department stores; there is a belief that the image, impression, or surface of a thing contributes to, if not helps to determine, its content. The quintessential Japanese garment, the kimono, illustrates this. Kimono are renowned for their exquisite designs, displayed to best effect by being hung flat, unlike a tailored garment, which requires a body underneath it to reveal its proper form. As Liza Dalby describes it, the flat nature of the kimono serves to "shift the issue of fashion away from shape to the areas of color, pattern, and decorative detail."[26] A kimono is made up of

FIGURE 3. Royal Palace, Bangkok. *Left*: *Chedi* in palace grounds. *Right*: Close-up of *chedi* surface. Photographs by the author.

straight lengths of fabric, upon which designs are often nonsequential. On a body they often seem like fragments of a larger design, the center of which is beyond its boundaries. Unlike a tailored garment that is molded around the form of the body, a kimono instead modifies the body, in form and in action, to suit the cylindrical shape determined by its two-dimensionality. Waists are padded, breasts are compressed and legs restricted, so that the kimono's fabric, when wrapped round the body, forms a perfect cylinder. The kimono is, arguably, a 2.5-dimensional garment. Even when wrapped around the obvious three-dimensionality of the body, it is essentially a flat surface.

This interest in the surface also has a specific history in Japanese art, traceable through traditions of painting and drawing, to contemporary popular media such as manga and anime. Conjecture about meanings, such as whether the emphasis on surface or container meaningfully contributes to, or merely represses, what it represents or contains, have been debated in relation to these media. However, what is consistently argued is that depth and surface share a different relationship seen through Japanese perceptions of their meaning.[27] Japanese animated filmmakers, for instance, unlike makers of recent Disney or Pixar animations, have resisted the illusion of three-dimensionality offered via computer-generated imagery, retaining a visual style that has been described as "almost in denial of their impulse

to 'animate.'"[28] In art, these meanings have recently been made explicit by Murakami Takashi in his promotion of the superflat movement, led by himself, Aoshima Chiho, Nara Yoshitomo, and other artists. The term *superflat* was coined by Murakami to describe the aesthetic that is by its nature two-dimensional, but instead of alluding to depth, emphasizes its intrinsic flatness.[29] Azuma Hiroki describes Murakami's own art in the following terms:

> Resolutely planar, his works prevent the construction of visual depth. This is what Murakami means by Super Flat. That he occasionally refers to even his three-dimensional sculptural work as Super Flat provides testament to the consistency of his sensibility. Murakami not only rejects the spatial in the planar, he sees space itself as an assemblage of planes.[30]

A way of seeing is required that involves a steady, moving gaze across a scene. Thus, while the overall effect might be curiously flat from a single perspectival viewpoint, its hierarchy of elements based on actual size and perceived importance becomes apparent as the viewer moves across it. One of Murakami's points of reference is the woodcuts known popularly as *ukiyo-e*. Translated as "a composite term: *uki* (floating), *yo* (world), and *e* (pictures)," of which *ukiyo* refers to the Buddhist concept of the illusory nature of the experiential world,[31] *ukiyo-e* art was the product of a Japan that was beginning to take notice of the West. Traditionally, Japanese artists worked in a Chinese-derived tradition, where isometry had been developed to simulate depth. They drew on particular representational conventions, in which landscape elements of similar size were taken closer to the viewer if they were lower in the composition. This was effective in elongated, vertical scroll paintings, where distant mountains at the top of the image were equal in size to closer ones below. In Takahashi Sōhei's *Pure View of Stream and Hills,* the distant trees at the tops of the highest hills are no smaller than the trees overhanging the small boat in the bottom of the picture. It was also effective in landscapes portrayed on Japanese folding screens. An isometric view meant that the viewer could perceive whatever was illustrated—pavilions, natural features, courtyards, castles—equally, without having to stand in a particular position. This image was best experienced by moving in front of the screen, with the image (literally) unfolding as one moved. This unfolding was made not just literal but physical in Japanese handscrolls. Dating back to the twelfth century CE, handscrolls contained a mixture of narrative

> TRADITIONALLY, JAPANESE ARTISTS WORKED IN A CHINESE-DERIVED TRADITION, WHERE ISOMETRY HAD BEEN DEVELOPED TO SIMULATE DEPTH.

painting and text, designed to be held and slowly unrolled by the viewer.[32] All these forms of painting, as Murakami argues, "control the speed of its observer's gaze,"[33] a perceptual device employed by contemporary Japanese media such as manga, anime, and his own superflat art.

However, in portraying landscapes within the truncated proportions of the woodblock print, this method was much less effective. Because of this, *ukiyo-e* artists began to use different methods to portray built environments and landscapes, combining traditional methods with new techniques from the West. For depicting landscapes, the foremost among these was single-point perspective, the first examples of which appear in the mid- to late 1700s in the work of Okumura Masanobu and Utagawa Toyoharu.[34] Their landscapes were characterized as *uki-e,* or perspective prints, referring to the influence of Western copperplate prints and Western texts on perspective, which became available after the relaxation of trade restrictions in the early eighteenth century.[35] By the eighteenth century, Katsushika Hokusai and Andō Hiroshige and other *ukiyo-e* artists were commonly using single-point perspective in their landscape views. With the viewer's eye unable to drift upward or sideways for any distance, Western perspective was much more effective in representing background depth. However, in the foreground, isometric methods of projecting buildings and interiors maintained a level of immediacy and familiarity. Hokusai's *A Treasury of Loyalty* series illustrates this combination of isometric and perspectival projection in several examples. In *Act 6,* an outdoor background is depicted in Western perspective while, in the foreground, the interior is done in isometric projection. In *Act 10,* Hokusai combines two: an outdoor scene in Western perspective and an indoor scene, which is shown with the building's walls and roof removed, a traditional way of viewing detail from above. Perspectival techniques were also combined with other criteria in *ukiyo-e* landscapes. Thomas Looser describes how, in Hiroshige's *Landspar at Tango* and *The Ryogaku Bridge Riverbank,* perspective is used to position some elements, while others are portrayed within the same picture as being within a depthlessly flat space, their importance overriding any conformity to perspectival rules.[36] This mixture of techniques suggests that *ukiyo-e* art was not all about perceptual flatness, which in turn leads some to question Murakami's assertions.[37] However, this mixture also gives some basis to Murakami's idea that "'Super flatness' is an original concept of Japanese who have been completely

> ANY "REAL" ARCHITECTURE IS SO COVERED IN LIGHTS, SIGNS, IMAGES, AND OTHER ACCRETIONS THAT ITS FORMAL QUALITIES ARE HIDDEN AND, PERCEPTUALLY, ONLY THE SURFACE REMAINS.

Westernized."[38] Moreover, *ukiyo-e* artists' methods of portraying depth in different ways and combining the perception of depth with depthless flat surfaces within the same composition suggest the potential for architectural explorations into dimensionality.

SUPERFLATNESS IN ARCHITECTURE

The architectural implications of such a sensibility have not been ignored by Japanese architects, as they, too, grapple with the entwined legacy of Western modernity and Japanese traditions. As Igarashi Tarō relates, the current generation of younger Japanese architects such as Aoki Jun, Sejima Kazuyo, and the founders of Atelier Bow-Wow (Kajima Momoyo and Tsukamoto Yoshiharu) grew up with the first generation of manga such as the popular *Astro Boy* (1963–66, *Tetsuwan Atomu*) and more recent anime such as *Akira* (1988) and *Neon Genesis Evangelion* (1995–96, *Shinseiki evangerion*).[39] As Igarashi also argues, the Japanese urban landscape of repetitive, nonhierarchal elements strewn along roadsides has itself a sense of depthlessness; forms are blurred or superimposed over each other with no discernible order, until from the point of the observer, they form a continuous surface, obscuring the purpose and nature of any spaces behind. The resultant landscape has been described by the architect Ashihara Yoshinobu as an *ameeba-toshi* (amoeba city).[40] Elements are arrayed in a floating, almost isographic environment, where perceptions of relative importance depend on the observer's movement across the image. As Itō Toyō describes it, signs are transformed into space. Any "real" architecture is so covered in lights, signs, images, and other accretions that its formal qualities are hidden and, perceptually, only the surface remains.[41] Design, as traditionally conceived in the West as form and spatial substance, is barely apparent, dissolved into a plethora of other competing stimuli. The connection between physical and cultural flatness can refer to a culturally specific relationship between surface and skin, but also to the shift between the two- and the three-dimensional in architectural space, akin to the combining of isometric and Western perspective in *ukie* landscapes.

One approach to planarity and flatness can be identified in the architecture of SANAA, the duo Sejima Kazuyo and Nishizawa Ryūe (Figure 4). Their 21st Century Museum of Contemporary Art in Kanazawa is in plan a perfect circle, within which are placed cubic, rectangular, and other circular spaces of different areas on a single plane (there is also a basement gallery). Each of these internal volumes is separated completely from the others. There is

FIGURE 4. 21st Century Museum of Contemporary Art, Kanazawa, Japan. *Left*: Exterior view, looking at glass wall. *Right*: Interior view, looking at glass wall. Photographs by the author.

no obvious hierarchy or sequential arrangement, either of volumes or of the spaces between them. From the outside what can be seen is a virtually unbroken curving glass plane, sitting within a flat park landscape. Any structure supporting this perimeter is hidden. Behind this glass wall can be seen the protruding cubic forms of some of the gallery spaces. These are also flat unbroken surfaces, this time white and opaque. Both inside and outside, there is no expression of structure, only the minimal articulation between planar sections. Like Murakami's art, this elimination of all but flat surfaces as the constituent parts of architecture posits space as an assemblage of planes. The focus of these buildings, the skins of which are essentially the wrapping around large multinationally branded boutiques, also alludes to the consumerist aspects of Murakami's superflat art, where Japaneseness is not so much expressed as folded into an apparently globalized image.

A number of recent buildings built for boutiques, including Itō Toyō's Tod's and Mikimoto Buildings, and Aoki's Louis Vuitton stores in Tokyo's exclusive Aoyama district, are emblematic of a superflat approach to skin and content. Each of them treats the exterior surface as independent of the form and layout within. The Tod's store is clad with a skin of concrete and glass formed to suggest a tree in winter, with concrete elements tapering and diminishing toward the top of the building and wrapping around its L-shaped plan (Figure 5). In this flat treatment there is no articulation of the corners; like paper, the tapering two-dimensional forms merely fold around each corner. There is no reference to either the plan layout of the building or

FIGURE 5. Tod's store, Aoyama, Tokyo. *Left*: Close-up view of exterior wall. *Right*: View of side and rear façades, showing corner. Photographs by the author.

the expensive but rather bland products it contains. The building is its skin.

Itō's Matsumoto Performing Arts Centre is formally quite different to the Kanazawa Museum but demonstrates a similar relationship between surface and space, and a similar subsumption of structure. Its treatment of surface and content is also analogous to the kimono, in that the building's materiality is not entirely elided but concentrated into graphic techniques applied to its skin. The building's amoebic plan form is delineated by an exterior wall, which itself is punctuated by small blob-shaped areas of translucent, and occasionally transparent, glass (Figure 6, *left*). This forms a thin curved skin, as glass sections are flush-mounted both inside and outside to negate any sense of thickness.

Perceptually, the wall is simply a screen-like surface, and from within, what is most apparent are blobs of light within blackness, rather than any structure. On the outside, the walls of the concert hall are lightly embossed with looping curvilinear patterns that, as the building has no external corners, seem to continue endlessly around it. Inside, the floors, ceilings, and balustrades form distinct continuous surfaces; the joints between them are hidden, as is the structure, apart from a few thin white columns. Perceptual games are played, highlighting the way surfaces dominate the building's architectural expression. For instance, blob-shaped benches appear to cast a curiously pale shadow on the floor, but this is actually a color gradation dyed into the carpet (Figure 6, *right*). The overall effect is more like a computer rendering brought to life than a constructed space.

FIGURE 6. Performing Arts Center, Matsumoto. *Left*: View of foyer showing translucent wall. *Right*: View of seating and carpet. Photographs by the author.

THE FUTURE OF THE ROBOT— THE ROBOT IN THE FUTURE

The process started by the robot is continued with Jumsai's Nation Newspaper headquarters, in a more abstracted (and literally flat) manner. Designed as the headquarters of the Nation Multimedia Group, the building shares with the Bank of Asia an anthropomorphic composition. Its overall form is described by the architect as being "like a 'head' with cut-outs for 'eyes' that peer over the road below."[42] Compositionally, it is a vertical sandwich, with two flat façades that are delineated with a graphic treatment derived from the architect's idea of a "built painting." As a painting, the building alludes to a number of possible sources for its content:

> Other fleeting thoughts came at this point: "the profile of the chief editor working on a word processor, or perhaps a graphic artist working on a page layout, sitting on a stool; electronic circuitries surfacing here and there" as well as references to the robot and cubist painting.[43]

These buildings, while pointing toward the twenty-first century in expressive terms, wrap their content in a manner calculated to flatten other meanings. In their design, the former Bank of Asia and the Nation Building selectively represent and project an image of a pan-Asian future. In portraying a cute, playful surface image, they are, in a way, pioneers of a forward-looking

architecture that is both deliberately non-Western and nontraditional. They also key into the idea of the future as Asian, a notion that is already a well-used trope:

> When the architect Lee Ho-yin saw the sci-fi thriller *Blade Runner* in the mid-nineties, he was surprised about the film reviews that he read. "A gloomy vision of a big-city future" was the tenor of the American newspapers, because the film was set in dark alleyways between glittering skyscrapers, crowds of people pushed past vegetable stands and collections of disembowelled electrical appliances, raindrops fell from leaky canvas covers, flickering neon lights bathed the passers-by in greenish-grey light. And Lee Ho-yin thought to himself. Future? Vision? This is the future and I am living in it. It is called Hong Kong.[44]

This broader cultural resonance connects with the dual notions of "Asianness" and modernity and how they can be represented within a country like Thailand. From being a Western construct, the notion of Asia is now widely used within the region to define attributes that are seen to be culturally embedded. Reference to "Asian values," especially by authoritarian governments in the region, is illustrative of this idea. In *Recentering Globalization,* Iwabuchi specifically discusses the exportation of Japanese technology and pop culture, but more broadly describes the late twentieth-century realization that Asia is no longer the passive recipient of globalized culture, but now rather actively produces and exports it.[45] However, while this production of recentered culture draws on shared characteristics, as Iwabuchi, Muecke, and Thomas argue; "what has become more prominent . . . is the emergence of popular Asianism and Asian dialogues whose main feature is not Asian values or traditional culture but capitalist consumer/popular culture."[46] In this, the dimensionality (arguably a culturally embedded way of seeing), the animism, and the pop-culture aspects of superflat art and architecture are combined. The overt use of cute imagery may wane, as suggested by the 2011 exhibition *Bye Bye Kitty!!!* and its associated lecture "Cordoning the Child, Killing the *Kawaii*." The intention here is explicitly to banish the specter of cuteness from Japanese contemporary art, and includes Nara Yoshitomo's photograph of Hello Kitty's gravestone.[47] However, the interest in dimensionality (and within a Japanese context, the referencing of *uki-e* landscapes) remains, most notably in Yamaguchi Akira's *Narita International Airport: View of Flourishing South Wing,* which applies intense detail to its architectural subject in floating isometric perspective.[48] Perhaps the future of this combination will be a world like that

portrayed in the art of superflat artist Aoshima Chiho, integrating not only the endearingly anthropomorphic and the machinic but also the natural. In her computer generated cityscape image *City Glow,* Aoshima brings Haraway's cyborgs to life as buildings with sweetly feminine faces, merging with an Arcadian landscape that has similar characteristics.[49] Both graphically flat and luxuriantly alive, the continuum of human–building–landscape in the artwork is suggestive of a sensual, technological, and ecological future. The animist belief in the life force within all things is brought to its logical posthuman conclusion.

..

Notes

1. Sumet Jumsai, "Bank of Asia, Bangkok," *MIMAR: Architecture in Development* 23 (March 1987): 77.

2. Iwabuchi Kōichi, *Recentering Globalization: Popular Culture and Japanese Transnationalism* (Durham, N.C.: Duke University Press, 2002), 27.

3. Sumet Jumsai, "Why the Robot?" *MIMAR: Architecture in Development* 23 (March 1987): 79–80.

4. "To put it simply, the difference between Mighty Atom and the Terminator shows the difference between how Japanese and Westerners view robots." Suematsu Yoshikazu, quoted in Timothy N. Hornyak, *Loving the Machine: The Art and Science of Japanese Robots* (Tokyo: Kōdansha International, 2006), 25.

5. Christine Wertheim, "*Star Trek: First Contact*: The Hybrid, the Whore, and the Machine," in *Aliens R Us: The Other in Science Fiction Cinema,* ed. Ziauddin Sardar and Sean Cubitt, 74–93 (London: Pluto, 2004).

6. Donna Haraway, *Simians, Cyborgs, and Women: The Reinvention of Nature* (London: Routledge, 1990), 154.

7. Rey Chow, "Postmodern Automatons," in *Writing Diaspora: Tactics of Intervention in Contemporary Cultural Studies* (Bloomington: Indiana University Press, 1993), 61.

8. Hornyak, *Loving the Machine.*

9. Ibid., 17.

10. Ibid., 21.

11. Hello Kitty ROBO™ http://www.business-design.co.jp; Therapeutic Robot: Paro™ http://paro.jp.

12. Ueno Toshiya, "Japanimation: Techno-Orientalism and Media Tribalism: On Japanese Animation and Rave Culture," *Third Text* (1999): 95–106.

13. Mori *Masahiro, The Buddha in the Robot: A Robot Engineer's Thoughts on Science and Religion* (Tokyo: Kosei Publishing Company, 1989).

14. A. Thomas Kirsch, "Complexity in the Thai Religious System: An Interpretation," *Journal of Asian Studies* 36, no. 2 (1977): 241.

15. Beng-Lan Goh, "Malay-Muslim Spirits and Malaysian Capitalist Modernity: A Study of Keramat Propitiation among Property Developers in Penang," *Asia Pacific Viewpoint* 46, no. 3 (December 2005), 307–8.

16. Sarah Thal, "Redefining the Gods: Politics and Survival in the Creation of Modern Kami," *Japanese Journal of Religious Studies*, 29, no. 3/4 (Fall 2002): 383.

17. Brian McGrath, "Bangkok: Liquid Perception," *Architectural Design* 73, no. 5 (2003): 78–85.

18. Matsui Midori, "Beyond the Pleasure Room to a Chaotic Street: Transformations of Cute Subculture in the Art of the Japanese Nineties," in *Little Boy: The Arts of Japan's Exploding Subculture,* ed. Murakami Takashi (New York: The Japan Society, 2005), 210.

19. Kurt Brereton, *Hyper Taiwan: Art, Design, Culture* (Taipei: Art and Collection Group, 2005), 107.

20. Philip Cornwel-Smith, *Very Thai: Everyday Popular Culture* (Bangkok: River, 2005), 120.

21. Ibid.

22. Tsukamoto Yoshiharu, "How to utilize PET ARCHITECTURE," in Tokyo Institute of Technology Tsukamoto Architectural Laboratory and Atelier Bow-Wow, *Petto aakitekuchaa gaidobukku* (Pet architecture guide book) (Tokyo: World Photo Press, 2002), 1.

23. Jumsai, "Why the Robot?" 79.

24. McGrath, "Bangkok: Liquid Perception," 79.

25. Sumet Jumsai, "The West Pacific Region versus Punk Architecture," *MIMAR: Architecture in Development* 19 (1986): 22–23.

26. Liza Dalby, *Kimono: Fashioning Culture* (Seattle: University of Washington Press, 2001), 18.

27. Philip Brophy, *100 Anime* (London: British Film Institute, 2006), 14–15.

28. Ibid., 3.

29. Murakami Takashi, "The Super Flat Manifesto," in *Supaafuratto = Superflat*, (Tokyo: Madora Shuppan, 2000), 5.

30. Azuma Hiroki, "Super Flat Speculation," in *Supaafuratto = Superflat* (Tokyo: Madora Shuppan, 2000), 147.

31. Yoko Woodson, "Hokusai and Hiroshige: Landscape Prints of the *Ukiyo-e* School," in *Hokusai and Hiroshige: Great Japanese Prints from the James A Michener Collection, Honolulu Academy of Arts* (San Francisco, Calif.: The Asian Art Museum of San Francisco in association with the Honolulu Academy of Arts and University of Washington Press, 1998), 32.

32. Tsuji Nobuo, "Early Medieval Picture Scrolls as Ancestors of Anime and Manga," in *Births and Rebirths in Japanese Art: Essays Celebrating the Inauguration of the Sainsbury Institute for the Study of Japanese Arts and Cultures,* ed. Nicole Coolidge Rousmaniere (Leiden: Hotei Publishing, 2001), 55.

33. Murakami, "The Super Flat Manifesto," 9.

34. Woodson, "Hokusai and Hiroshige," 38.

35. Takahashi Seiichirō, *Traditional Woodblock Prints of Japan,* trans. Richard Stanley-Baker (New York: Weatherhill, 1972), 104; Jane Messenger, *Japanese Prints: Images from the Floating World: The Brian and Barbara Crisp Collection* (Adelaide: Art Gallery of South Australia, 2004).

36. Thomas Looser, "Superflat and the Layers of Image and History in 1990s Japan," *Mechademia* 1, (2006): 92–109.

37. Marc Steinberg, "*Otaku* Consumption, Superflat Art and the Return to Edo," *Japan Forum* 16, no. 3 (2004): 449–71.

38. Murakami, "The Super Flat Manifesto," 5.

39. Igarashi Tarō, "Superflat Architecture and Japanese Subculture," in Japan: *Towards Totalscape: Contemporary Japanese Architecture, Urban Planning, and Landscape*, ed. Moriko Kira and Mariko Terada (Rotterdam: NAI Publishers, 2000), 98–101.

40. Ashihara Yoshinobu, *The Hidden Order: Tokyo through the Twentieth Century* (Tokyo: Kodansha International, 1989), 58.

41. Itō Toyō, "A Garden of Microchips," in *Toyo Ito: Works, Projects, Writings,* ed. Andrea Maffei (Milan: Electa Architecture, 2001), 338.

42. Sumet Jumsai, "Memories of the Future," in *Asian Architects 1*, *ed.* Tan Kok Meng (Singapore: Select Books, 2000), 62.

43. Ibid., 65.

44. Florian Hanig, "Neon Cities," in *Neon Tigers: Photographs of Asian Megacities,* by Peter Bialobrzeski (Ostfildern-Ruit: Hatje Cantz, 2004), 12.

45. Iwabuchi, *Recentering Globalization.*

46. Iwabuchi Kōichi, Stephen Muecke, and Mandy Thomas, "Introduction: Siting Asian Cultural Flows," in *Rogue Flows: Trans-Asian Cultural Traffic,* ed. Iwabuchi Kōichi, Stephen Muecke, and Mandy Thomas (Hong Kong: Hong Kong University Press, 2004), 1.

47. Japan Society Presents BYE BYE KITTY!!!, http://www.byebyekittyart.org /artists.htm#yoshitomo_nara.

48. Japan Society Presents BYE BYE KITTY!!!, http://www.byebyekittyart.org /artists.htm#yanaguchi_akira.

49. Matsui, "Beyond the Pleasure Room," 210.

REGINALD JACKSON

Dying in Two Dimensions: *Genji emaki* and the Wages of Depth Perception

The Gotō Museum's "Yomigaeru *Genji monogatari emaki*" exhibit of 2005–6 was an ambitious attempt to "resurrect" (*yomigaeru*) the museum's legendary illustrated handscrolls of *The Tale of Genji* (the *Genji monogatari emaki*) by analyzing the flaking, faded twelfth-century scrolls scientifically and having artists paint a series of new, more polished and more vibrant but ostensibly "faithful" copies to be exhibited alongside the originals. In its apparent attempt to make the scrolls more accessible and appealing to modern audiences, the exhibit was nothing less than an attempt to produce a contemporary viewing public in relation to art of the Heian period (794–1185).[1] But such a desire to consolidate the audience's impressions of the artwork does away with facets of the scrolls that might endanger the construction of a unified viewership. In particular, the refabrication of the scrolls strategically excludes the narrative calligraphic *kotobagaki* sections that in fact compose the lion's share of the extant *Genji* scrolls, effectively severing an intimate bond between narrative text and narrative image. Even more significantly, the redacted reproduction fails to account for the calligraphic performance of dying that figures so prominently in the climatic deathbed scenes of the *Tale of Genji* protagonists Kashiwagi and Murasaki no Ue. In this article, I would like to consider some of the potential

implications of this omission. My primary goal will be to think through the spatial and temporal dimensions of artistic representations of death in relation to the composition—and decomposition—of the *Genji emaki*. Specifically, I want to examine some of the consequences involved in "resurrecting" the twelfth-century scrolls within the context of the twenty-first-century gallery in order to critique a contemporary insistence on the flatness of images and the displacement of text that results.

Murasaki Shikibu's *The Tale of Genji* (1008, *Genji monogatari*) is commonly regarded as the highest achievement within the canon of Japanese literature and stands as a powerful icon of Japanese cultural identity. *Genji* comprises fifty-four chapters and centers primarily on the affairs of the title character, a preternaturally talented courtier of the Heian period. It holds the reputation of being a paragon of classical literature and can be said to symbolize a peak of Japanese cultural achievement in the premodern era. The *Genji monogatari emaki* (ca. 1140, Illustrated handscrolls of *The Tale of Genji*), which represent the oldest surviving copy of the *Genji* text, have thus by association earned the status of a sacred relic to be enshrined and "resurrected" in order to preserve or renew a sense of national pride. The "Yomigaeru" exhibition works to bolster this sentiment not by restoring the bleak, deteriorated paintings but by *replacing* them with entirely new, dazzling, repainted versions.

The *Genji monogatari emaki* are a set of illustrated handscrolls composed in an alternating text and painting format in which the *Genji* scenes deemed most compelling by five groups of artists were excerpted from the narrative and rendered in incredibly lavish, deeply interrelated, calligraphic and pictorial forms. Most of the scroll sections have been lost, but it is thought that at one time, sections that corresponded to each of *The Tale of Genji*'s fifty-four chapters existed. Each scroll section consists of a painted interpretation of one scene from a particular chapter from *Genji*. Each of these is preceded by a calligraphic preface, or "*kotobagaki*," excerpted from the *Genji* narrative that relates the scene depicted in the painting. These *kotobagaki* were done in five different hands, with the most skilled calligrapher writing for the most famous scenes.[2] Sponsored by competing aristocrats, groups of artists worked closely as ensembles to produce the scrolls in an elaborate "built-picture," or "*tsukurie*," system of artistic production, based on the layering of planes of ink and color to build up the painting in distinct stages. A head artist would see to the *shitagaki* or "under-sketch" for each scene (basically an outline of characters and architectural shapes), and then other painters proceeded to successively overlay the pigments (e.g. crushed-shell white, malachite green, ferrous red, etc.).[3] There were also craftsmen who designed various ornate

> THE WAY IN WHICH THE EXHIBIT UNDERSCORES THE TWO-DIMENSIONAL PROPERTIES OF THE IMAGES DISPLAYED SPEAKS DIRECTLY TO THE EXTENT TO WHICH THE MOST GRAPHIC TRACES OF DEATH HAVE BEEN REMOVED FROM VIEW.

papers upon which the calligraphy for each scene would be choreographed.

These papers could involve special dying techniques with substances such as pomegranate juice or indigo, and often included striking overlays of mica powder, or sprinklings of cut gold or silver foil, "wild hairs" (*noge*), or silver dust, which oxidizes to an ominously gray color. These materials were coordinated to suit the thematic and emotional tenor of the chapter (as decided by the artists), and could be likened to the visual equivalent of a movie soundtrack[4]—nondiegetic but still crucial for setting the visual mood of the calligraphy and conveying meaning in ways more diffuse and less linearly communicative than the calligraphic script itself.

Each painting in the *Genji emaki* was originally preceded by a *kotobagaki,* and each *kotobagaki* provided a framing narrative to contextualize and foreshadow the scene depicted in the painting.[5] The textual portions were excerpted by the craftsmen's patrons for their emotional interest, entertainment value, and poetic or aesthetic appeal, and then the principal artisan would decide on how best to render in pictorial form the scene described in the writing.[6] The patron would also select a particular calligrapher to write the text.

Under sponsorship from rival aristocratic factions, the groups of artists worked collaboratively, but in competition with other similarly funded groups, to produce graphic interpretations of the *Genji* narrative that were both familiar to the Heian elite and yet striking in their own right as creative translations of the narrative into a more spectacular context. An important result of this transposition of the narrative excerpts into the *emaki* format is that the narrative is unrolled by the viewer and read progressively from right-to-left, moving forward through the narrative arc of each section as one moves leftward along the scroll's horizontal axis. There are, however, particularly captivating moments at which this standard narrative flow appears to shift dramatically, even seeming to break down. These are the instances of *midaregaki* calligraphy, or "tangled script," that I will discuss later in the essay.

One of the things I would like to argue is that the exhibition of the resurrected scrolls insists upon a two-dimensionality in order to ensure the smoothest identification possible on the part of the contemporary Japanese audience. This two-dimensional emphasis stems from a desire to streamline the scrolls for public consumption. Moreover, this desire to promote through *Genji* an aesthetic sense of Heian culture sets the ground for a systematic

reconfiguration of the scrolls' shape and significance. I would posit, first, that the triumphal "resurrection" proclaimed by the exhibit's title privileges a certain flatness—in both the reproduced paintings themselves and the imaging technologies that contribute to the precision of those reproductions. Furthermore, I would argue that the way in which the exhibit underscores the two-dimensional properties of the images displayed speaks directly to the extent to which the most graphic traces of death have been removed from view. These traces take the form of calligraphic performances of dying characterized by a columnar overlap, velocity, and centripetal torsion that combine to give an otherwise flat surface of inscription a distinct three-dimensional contour, as seen in the *midaregaki* passages. In the exhibit this calligraphy is given much less prominence than the scroll paintings. Despite comprising roughly 80 percent of the extant scrolls, the calligraphy appears more as a decorative addendum to the exhibition, with only a handful of sheets being displayed among the more than seventy that survive. This marginalization carries over to the exhibition catalog, where the calligraphy debuts only on the 138th of 157 pages, and then only as computer graphics or CG renderings rather than handmade artworks. By contrast, every one of the nineteen extant paintings confirmed to have been part of the original set of scrolls had the flaked, drained pigments of their deteriorated surfaces redressed by an ensemble of technologists and painters, and every one of them was displayed alongside its "original" incarnation in the gallery. As a consequence of this process, any residual coarseness present in either the *text or the image* that might skew the impression of Heian constancy endorsed by the exhibit had been scraped away.

By examining closely the aesthetic and political implications of this removal, I hope to present a reading of depth in Heian-period illustrated handscrolls that might also contribute a helpful analytical perspective to broader discussions of narrative art in modern genres such as manga and anime. Indeed, we might see the exhibition as being just one particularly elaborate example of a broader recent desire to reinvigorate premodern illustrated handscrolls by recasting them as the natural ancestors of contemporary Japanese comics and animation. Books like Studio Ghibli director Takahata Isao's *Jūni seiki animeeshon* (Twelfth-century animation), published in 1999, and a 2002 issue of *Nihon no bi o meguru* called "The Beginnings of Anime," which posits the famous *Chōjū giga* scrolls (Comic illustrations of birds and animals) as a twelfth-century anime prototype, both exemplify this phenomenon.[7] More significantly, the Takahata publication ignores entirely the textual written elements of illustrated handscrolls in lieu of the pictures. This forms part

of a larger project to force a twenty-first-century anime template onto the twelfth-century illustrated handscrolls, which results in gross oversimplifications being made about the primacy of images in illustrated handscrolls, and questionable equivalencies being drawn between the two media. It would seem that such a reductive account overlooks the narrative *kotobagaki* writing as a matter of convenience. To incorporate the text into a discussion of the specific narrative strategies employed in narrative scrolls might well necessitate a revision of the transhistorical catchphrase "twelfth-century animation," if not a reevaluation of the boundaries of "animation" itself. Rather than risk such a disruptive rethinking, Takahata's volume opts instead to merely recast the premodern textual peculiarities of illustrated handscrolls within the confines of a contemporary lexicon that, while vivid, is nonetheless ill equipped to render fully the intricacies of the twelfth-century productions.

In contrast to this trend, I will emphasize the importance of understanding text and image as intimately intertwined, if not inseparable. While I will focus here on the *Genji emaki,* I believe that many of the points I'll make concerning the symbiotic relation between text and image and the techniques through which the appearance of two- or three-dimensionality is produced artistically will also engage those interested in contemporary visual culture. Insofar as I develop my critique of an idealized flatness enforced in the twenty-first century out of a particular instance of three-dimensional writing produced in the twelfth century, the approach put forth here is meant to challenge notions of flatness that elide more textured historical and material considerations of the artwork.

QUALITY CONTROL AND THE PROBLEM OF PERSPECTIVE

The Gotō Museum's "Resurrected Genji Scrolls" exhibit aimed to flatten any potentially disruptive visual elements. Smoothness of the image intimates a refinement of execution at both the scientific and artisanal levels: the patent lack of any roughness marks the overall quality of the reproduction as extraordinarily high. More specifically, the planar uniformity of the images reflects the aims of legibility, accessibility, and enjoyment that pervade both the exhibit's didactic tenor as well as its unabashedly rich palette. The focus on popular accessibility and marketability bears directly upon how the art object is shaped for display within the space of the modern museum. Admittedly, the handscroll format is in many ways ill suited to the presentational demands of

the standard rectangular, encased, exhibition protocol. In the case of the *Genji monogatari emaki,* specifically, they are too long for their own good, which is to say that their length might make them difficult to segment and arrange pragmatically within the Gotō's gallery space. Their lopsided ratio of sheets of calligraphy to paintings—the latter being both far fewer in number and yet recognized far more legibly and desirably as "art" proper—makes them less attractive from a curatorial perspective that privileges a vibrant image over an unwieldy text.[8]

FIGURE 1. Yūgiri's visit to Kashiwagi's deathbed. "Yomigaeru *Genji monogatari emaki*" (Resurrected Illustrated handscrolls of the *Tale of Genji*) exhibition catalog, "Kashiwagi 2." Painting detail. Artist: Katō Junko. Courtesy of Japan Broadcasting Corporation, Tokyo.

In considering the problem of perspective as a problem of both institutional priorities and disciplinary proclivities, it is helpful to note briefly two important contributions to theorizing perspective within the context of premodern Japanese narrative and art: Takahashi Tōru's concept of "psycho-perspective" (*shinteki enkinhō*) and Sano Midori's notion of "pluralistic perspective" (*tagenteki na shiten*). In elaborating his concept of psycho-perspective, Takahashi outlines a narrative perspective that avoids both Cartesian and diametrically anti-Cartesian poles. By introducing the concept of a "*mononoke no yō na*" viewpoint, a narrative perspective that roves the tale "like a possessing spirit"—untethered to a single consciousness or fixed site of enunciation—Takahashi provides an intervention that loosens the hold of Cartesian principles on our understanding of how premodern narratives function.[9] The value of Takahashi's critique should be understood in relation to a broader politics of reading that resists capitulating to either a purely Cartesian sensibility or to a similarly extreme "native" Heian mode of composition.[10]

Sano Midori develops her own concept toward related ends and focuses attention on the spatial design of pictorial narratives in her discussion of the *Genji emaki.* Approaching similar narrative phenomena from an art historical standpoint, Sano's notion of "pluralistic perspective," too, dislodges any sense of absolute perspectival certainty. Sano also points out the impression of instability caused by the absence of a horizon line and the diagonal arrangement of the architecture in the "Yadorigi 3" section to stress the lack

of centralized linear perspective as an organizing spatial design principle within the *Genji emaki,* in particular.[11] Moreover, we can read her discussion of "zero-focalization" as suggesting a kind of flatness insofar as it implies a normalization of pictorial elements into a visual field undifferentiated by either modulated planes of color or the stabilized focus that a single vanishing point might establish.

Rather than think of the handscroll as being merely a static art object, I would like to conceptualize it as an interactive spatial and temporal site within which subjectivity is negotiated through corporeal contact. Distinctions between viewing, reading, and feeling—distinctions whose stability depends in large part on the ways in which one understands a notion of spectacle and the overlapping haptic and affective labors it involves—become especially porous at such a site. Through the redaction of the handscroll format to a set of individuated frames, the malleable temporality once coupled to the viewer's tactile interface with the object is replaced by a fixed temporality that is less beholden to the motions of the reading body. The "Yomigaeru" exhibit thus reprises the cuts made more than a century before, when the scrolls were remounted, and later, when they were split again to protect them during the Pacific War. This abridgment amounts to a translation of the objects' material format that marks a shift from the semi-private, viscerally *haptic,* space of reading to a more expansive public sphere of viewing. We could posit that within such a space, a more somatically immediate rapport between an individual reader and the text they seek to apprehend might interfere with the promotion of an anodyne condition of collective viewership. Members of the audience are united as consumers by their shared inability to handle the texts, coupled with their equalized access to retooled images of the paintings.

The modern project of affirming the delicacy and the ephemerality of Heian culture serves as a rationale for preserving its images and for supervising the location, rate, mode, and extent of their representation, reproduction, and sale. The images produced are radically flattened for public consumption by means of the x-rays, infrared scans, and other technological apparatuses of detection and imaging used to analyze and reproduce the paintings. This translation continues past the backlit cases into the Gotō Museum gift shop, where catalogs, bookmarks, stationery, and postcards all extend the proliferation of commodified images instigated by microscopic scans. Specifically, the "Yomigaeru *Genji monogatari emaki*" exhibit showcases technology's capacity to disclose the internal mysteries of the Heian cultural artifact and to recuperate its withered appearance. The process of assaying the scrolls results in images thoroughly evacuated of the aura tethered to premodern mystery, but are

images that nevertheless remain infused with a magnified sensation of awe that could only emerge from the alchemical amalgam of safflower pulp and infrared lenses.[12] In contrast to Walter Benjamin's account of the consequences of the technological reproducibility of artworks, in which the art object's prehistoric cult value loses out to the exhibition value

> RATHER THAN THINK OF THE HANDSCROLL AS BEING MERELY A STATIC ART OBJECT, I WOULD LIKE TO CONCEPTUALIZE IT AS AN INTERACTIVE SPATIAL AND TEMPORAL SITE WITHIN WHICH SUBJECTIVITY IS NEGOTIATED THROUGH CORPOREAL CONTACT.

favored by modern mass culture, my sense is that the "Yomigaeru" exhibit strikes a balance between these two values.[13] On the one hand, it optimizes their respective proportions such that the technological and artisanal components of the recomposed scrolls are aligned; on the other hand, it effectively splits the difference between the values so that the cult value of the work can be preserved without compromising an efficient distribution of its exhibition value among spectators.

AURA AND ITS ASYMMETRIES

We should think about how the more palpably performative aspects of experiencing the scrolls are amputated in order to preserve a perspective that fuses the recessionary present to a halcyon past.[14] One thing to point out is that the intimately physical experience of engaging with the handscroll—unrolling it, holding it before one's eyes, carefully spooling the narrative forward or backward through time within one's hands at a span of approximately a torso-width at a time—has vanished. This modern version offers a far less haptic experience for the viewer, as the capacity to touch the narrative is withheld. Even if we account for the reasonable insistence that ancient works of art should not be molested by spectators, one still has to wonder about the decision to abandon the handscroll format for the new reproductions. By ditching the "*maki*" (scroll) of *emaki* and keeping just the "*e*" (picture), the images take on a veneer of self-sufficiency that belies the illustrated narrative's once palpable attachment to the human body. Another point to mention is that without the calligraphic text to accompany the new images, the embodied interaction of vocalizing the narrative excerpts interposed between paintings is also blocked. In the communal context of a Heian-period salon, different participants could read aloud as listeners pitched their own comments to supplement the story; this form of Heian entertainment, along with any modern

> THESE TECHNOLOGIES GENERATE IMAGES BY DECODING THE PAINTINGS THROUGH CALIBRATED EMISSIONS OF INFRARED AND X-RAY WAVELENGTHS THAT FORCE THE SECRETS OF THEIR COMPOSITION TO LIGHT.

analogue, is effectively foreclosed as the format and focus narrow to extol the paintings at the calligraphy's expense. Together, these changes combine to push into the background the precarious physical contingency that attends these elements of the illustrated narrative handscroll.

I would like to suggest here that the exhibit privileges certain lines of sight above others, both in terms of the type of narrative it promotes and in terms of the ways in which the material forms of the objects displayed attest to a radical compression of the depth of the visual field. This compression, I would argue, references a historical materiality through imaging technologies, but does so to only a superficial degree and only insofar as those diagnostic images try, in their empiricist zeal, to recoup some measure of the paintings' dwindled aura. The exhibit traffics in a two-dimensionality linked directly to the technological imaging apparatus used to probe the scroll paintings. In fact, the infrared scans and x-ray photographs epitomize the exhibit's insistence on a two-dimensional plane. While this might seem counterintuitive, since one normally thinks of x-rays as allowing a three-dimensional insight into the object examined, it is important to note that in this context, these technologies (1) collaborate to veil the natural (if inadmissibly grotesque) topography of the heavily flaked scroll surface and (2) focus singularly on the goal of penetrating the paintings in order to rid their reproductions of any debris that might tarnish an optimally smooth façade.

The resurrected scrolls look flatter because the wholly repainted images erase signs of the extensive blistering borne by the time-ravaged originals. One consequence of this is that visual elements that were once hidden below the topmost painted layer but later exposed to view as the scrolls deteriorated (such as stray lines of the under-drawing for a character's head or even scribbled directions noting the placement of pictorial elements like pieces of furniture or a garden) are swept away. Along the same lines, the provisional traces of the multiple twelfth-century artists who worked on different aspects of the scroll sections have been distilled to the hand of a single artist who repaints the scene, executing the design deduced and prescribed by the hi-tech sensors. By the same token, the diagnostic images' conspicuous presence within the exhibition attests to a desire to showcase a set of images that might serve a compensatory function in supplementing any deficit of aura caused by the removal of the scrolls' coarsest remnants.

These technologies generate images by decoding the paintings through calibrated emissions of infrared and x-ray wavelengths that force the secrets of their composition to light. This production of knowledge relies not on a preservation of premodern remnants but instead on a host of cutting-edge images designed to call forth for the viewing public an *idealized optical impression of premodern fidelity.* It is this matrix of images that will serve as a virtual proxy for the original scrolls' *tsukurie* ("built-picture") process, whose aura and palimpsestic depth are deserted by the reproduced images.[15]

If the aura, as described by Benjamin, is a "strange tissue of space and time: the unique apparition of a distance, however near it may be," then the reproductive process carried out in this context might be said to normalize unevenness in the tissue's surface to extinguish the breadth of this interval.[16] In a sense, the resurrected scroll paintings collectively represent an image that refuses the status of a palimpsest. Indeed, given that the *tsukurie* process is a defining feature of the twelfth-century paintings, this refusal of a similar degree of tiered depth—which I would argue reduces the three-dimensional quality of the image and thus produces an accentuated two-dimensional appearance—represents a suppression of the material vagaries that had accrued to give the painting its distinct historical form: a three-dimensional texture stemming as much from calligraphic overlap as from the decrepit paintings' peeling surface. While the new paintings appear to retain

FIGURE 2. A portable x-ray machine being used to scan the handscroll painting, from the "Yomigaeru *Genji monogatari emaki*" exhibition catalog. Photograph courtesy of Japan Broadcasting Corporation, Tokyo.

FIGURE 3. Infrared (*above*) and X-ray (*below*) diagnostic photos of twelfth-century scroll paintings depicting autumn grasses and Genji cradling Kashiwagi's son, Kaoru, respectively. Photo courtesy of National Research Institute for Cultural Properties, Tokyo.

the precise chemical composition of the original pigments, they nonetheless redact the *system* of composition by collapsing the multiple layers of inscription into a single uniform plane. Consequently, what had been a field stratified unevenly by applications—and successive, conflicting, *reapplications*—of ink and color, has in this case been cleared to secure a more tractable, valuable vision of the Heian past within the recessionary present.

By stressing the primacy of the two-dimensional pictorial plane, the most benign and most mimetic properties of the artwork are emphasized such that attendees of the exhibit might identify more readily with the bygone image of Heian Japan coveted by the recuperative project. This emphasis entails an enforcement of a particular mode of viewing. The main way this happens is through the use of imaging technologies that are designed to penetrate the topmost layer of the paintings in order to expose the precise composition of their stratified pigments. The coloration of clothing and architectural appointments are important, but arguably they matter only insofar as they contrast in hue with the white faces of the protagonists. As others have argued, these faces, with their remarkable uniformity of depiction, might have allowed premodern viewers to identify more readily with the fictional characters: to see themselves reflected in the shell-white paint and more easily project their own desires upon the protagonists portrayed, as though facing a mirror.[17]

The exhibit works to protract (and protect) a vector of filiation that connects the twelfth-and twenty-first-century artworks, and goes further: to project a futurity that has been technologically secured by the "Yomigaeru" exhibit's gloss of Heian culture. The "Yomigaeru" exhibition treats the painting as an organism to be reconstituted and propagated. We should note, though, that this expansion, which proceeds alongside a rise in exhibition value, also advances a mythic legacy for public consumption. Each iteration of images produced recapitulates, in the same instant, the remoteness of the original objects as well as the facsimiles' sleek modernity. To the extent that both of these qualities are underscored simultaneously, a continuum is drawn. In this regard, the presentational logic of the exhibition, which juxtaposes past and present images, plots the iconic points between which an unwavering transhistorical lineage can be traced. I would point out, however, that this metaphorical line's horizontal extension contrasts with the static placement of the actual images within the exhibition.

The images of the twelfth-century paintings are cut and placed side by side with the newly "resurrected" *Genji* paintings to install a spatial syntax that conveys an equivalence between the images. The complementary orientation of the past and present paintings invites the viewer to look back and forth

between the images to establish (freely, for themselves) a commonsensical—if not geometrical—correlation between them. This manner of presentation effectively holds out the promise of being able to not only redeem the decrepit image and restore its luster but, moreover, to successfully reproduce in the present a history more vibrant and attractive than the original. Such an arrangement lends an air of natural correspondence between the fabricated artistic products, a correspondence that the calligraphy would most likely perturb.

This arrangement of reproductions dispels with its compensatory vibrancy the insistent but unsavory truth that all art atrophies with time. It is arguably this deterioration that carries with it the potential disclosure of the image's material, and *corporeal,* depth. Along these lines, I think immediately of the painting of Onna San no Miya in the "Suzumushi" section. The textual memos to the artists specifying where to paint architectural and landscape elements that can be seen where the pigments have worn away attest not only to the presence of another plane of inscription below the painted surface, *but index an entire hierarchal network of artisanal labor* as well. The flaking mineral pigments divulge the presence of strata initially orchestrated in such a way as to understate (but not necessarily erase) the painting's impression of depth.

Substratum elements such as these, which help scaffold the surface of the image, are exteriorized and arrayed as separate diagnostic images, with the result that they can then be consulted to consolidate a more streamlined impression of Heian luxury. This exteriorization treats the multiple contingencies of sketched guidelines and scribbled notes found throughout the twelfth-century scrolls, which were fundamental aspects of their composition, as debris to be swept away in order to usher in an unblemished pictorial façade. The *tsukurie* process of layered inscription of a single painting by multiple artists has been leveled in favor of a single painter's hand emulating a computer-assisted projection. This decision effaces a central feature of the original *emaki*: the provisional tenor underwriting the painting's surface. Consequently it also undercuts what I would term the interrogative capacity of the scrolls. Indeed, it is this interrogative capacity—the scrolls' potential to pose (and interpose) questions about the politics of their formation and framing by dint of their medium's material composition—that the change in format suppresses. I consider this interrogative potential to be a quality that is brought to the foreground in the three-dimensional overlap of the *midaregaki* calligraphy.[18]

IMPRESSIONS OF DEPTH AND DEAD LINES

The other manner in which the exhibition's two-dimensional insistence takes shape is through the suppression of calligraphic elements. The question of discipline enters the scene here, as well, insofar as the presentational logic of the exhibition entails the systematic displacement of disruptive visual elements in order to foreground qualities of order, linearity, and a clarity borne of high-resolution imaging. Even if this impression of uniformity is in practice cast less as a production than as a preservation, it becomes immediately apparent that what is allegedly preserved, or "resurrected," is not the actual twelfth-century object but rather the *sense* of it: a kind of essence, conveyed by the affective impression the image is fashioned to transmit. The *midaregaki* writing, however, embodies a three-dimensional capacity at odds with the flattened portrayal of Heian culture endorsed by the exhibition. The particular type of two-dimensional plane established by the "Yomigaeru" paintings, then, might be interpreted as a space of quarantine that shields the exhumed image from contagion by a morbid calligraphic hand.

Five calligraphic hands have been identified in the *Genji emaki,* and both the "Minori" and the three "Kashiwagi" sections are categorized together as having been done by the same person—considered by scholars like Akiyama Terukazu to have been the most skilled (and most staunchly traditional) calligrapher of the group.[19] The sections "Kashiwagi" and "Minori" stand out for the *midaregaki,* or "tangled-script," that occupies their final sheets. This special type of writing, characterized by extremely rapid brushwork in which the brush rarely leaves the paper to create long sequences of connected characters whose vertical columns overlap such that they seem to "tangle," represents a distinctive feature of the *Genji emaki.* While this mode of writing is employed in both the "Murasaki" and "Kashiwagi" sections of the scrolls, I will focus on the Kashiwagi section, named for the character whose death it depicts.

In the climax of the chapter, a frail and suffering Kashiwagi tries desperately to write a letter to his love, the Third Princess, with whom he has fathered an illegitimate child, Kaoru. Genji passes the child off as his own son, concealing the truth of the matter and causing Kashiwagi, his rival, even further grief. Sensing his final days drawing near, Kashiwagi tries to write to the Third Princess, but with his hand trembling and his will unsteadied by the visceral—and, it should be noted, *textual*—fact of his own mortality, his writing collapses. Seeing his own writing fractured there on the page before him only demoralizes Kashiwagi further, as he realizes that he cannot convey all that he wishes to his estranged lover; he dies soon after his failed writing attempt.

I have argued this point at length elsewhere,[20] but I'd like to revisit the language of this scene as a point of departure here: "[Kashiwagi's] tears flowed faster now, and he wrote his reply lying down, between bouts of weeping. The words made no sense and resembled the tracks of strange birds [koto no ha no tsuzuki mo nō, ayashiki tori no yō nite]. . . . He felt even worse after this confused effort at writing."[21] In a narrative utterly saturated with scenes of writing and reading, this instance, in which Kashiwagi confronts the brute materiality of his illegible script, still attains status as a primal scene. The description of the writing later in the narrative as "lumpy" or "pulpy"

FIGURE 4. Image from the twelfth-century *Genji monogatari emaki* (Illustrated handscrolls of *The Tale of Genji*) showing Yūgiri's visit to Kashiwagi's deathbed (Kashiwagi on left, Yūgiri on right). "Kashiwagi 2." Courtesy of the Tokugawa Museum, Nagoya.

("*tsubu-tsubu*") suggests a coagulation of script that lures the reader closer even as it bears ill portent. Such a description attests to the clotted texture of the writing, which in turn suggests to my mind a thickening materiality that exceeds a two-dimensional plane: something denser, indeed *chewier* (especially given Kaoru's indulgence in "gruel and steamed rice" as he visually consumes through the letters the traces of his dead father's hand).[22]

To the extent that the prefaces not only recount but calligraphically *perform* certain elements of the narrative, we can read in the phrasing a gesture toward a more dynamic form of writing. In one sense, to have no clear linear progression, no successive arrangement that would lend legible meaning to an arrangement of written characters, suggests an absence of order. But taken another way, this absence also marks a repletion insofar as it opens possibilities for other configurations, other modes of writing, reading, and viewing to take shape. When considered in conjunction with the calligraphic performance of overlapping columns, we can understand the phrasing as referencing a lack of succession along a horizontal plane, in particular. While this might imply a kind of disarray along the horizontal axis of the sheet, it does not however appear to preclude an altered arrangement of script along the front-to-rear or *z* axis.

This altered mode of inscription takes shape as *midaregaki,* or "tangled-

FIGURE 5. An image of *midare-gaki* calligraphy from the "Kashi-wagi 2" section of the *Genji monogatari emaki*, not reproduced as part of the "Yomigaeru *Genji Monogatari Emaki*" exhibition. "Kashiwagi 2," sheet 8, detail. Courtesy of the Tokugawa Museum, Nagoya.

script," which enters the frame at the climatic death scenes of Kashiwagi and Genji's beloved, Murasaki no Ue. At these charged junctures, in which ill characters palpably approach the limits of mortality, the inexorable question of what comes next visibly galls the protagonists, even as it amplifies the drama of *Genji*'s deathbed portrayals. In this sense, the lack of a clear succession connects with the interruption in the standard spatiotemporal progression of Kashiwagi's failed letter, a communicative misfire that should also be read as disrupting the broader system of patriarchal lineage within which the protagonists subsist and make meaning. But in addition to this, the description of the broken script also marks a break in the handscroll's narrational schema and in the steady leftward spatial movement synced to that narrative development.

That the standard linear progression of the scroll should come to be interrupted by death is no surprise when we consider the tenor of finality death carries. What deserves our attention, however, is the way in which what I term the calligraphic performance of dying visibly transforms the surface of the scroll and thus refracts standard vectors of viewing. I would argue that the calligraphic performance of dying in the "Kashiwagi" and "Minori" sections transfigures the narrative *kotobagaki,* moves against the normative spatial and temporal framework of the scroll format, and, more significantly, can be said to gesture beyond that format's standard two-dimensional principle of linear writing. Call it a striation of the once-smooth space of narration, or a swell of energy that roils the sheet's surface.[23] I read this *midare* movement as a pulsion that produces a fissure along which the calligraphy constricts against the grounding plane to take on a conical inclination. The sheer speed of the script, the contraction of columns' width across the sheet, and the graduated superimposition of columns, all accrue to lend a torsion to the writing—as though the topmost stratum of writing buckled to embed deeper currents of inscription.[24]

This mode of writing produces an effect of calligraphic depth, not between planes of inscription in which decorated paper merely grounds calligraphic writing, but an effect of depth wrought by *the successive superimposition of calligraphic columns alone.* This layering of script represents a juncture at which writing's movement does more than merely narrate: it reworks the standard

grid of lineation and exploits the modulation of ink tone to knead the two-dimensional surface toward a three-dimensional contour. It is at this focused point that the *midaregaki* exceeds the task of simply portraying the deathbed scenes to instead perform kinesthetically the labor of trying to outstrip death's hold on the body straining to write.[25]

We could interpret this performance's intensity as potentially magnifying the Heian viewer's affective investment in the portrayal: for instance, does it incur sympathy or disgust on behalf of the abject protagonists? The choreographed modulation of the writing along the z axis might well be read—which is to

FIGURE 6. An image of *midaregaki* from the "Minori" section of the *Genji monogatari emaki*. "Minori," sheet 5. Courtesy of the Gotō Museum, Tokyo.

say here, "misread"—to figure some simple depth of feeling. But I do not think this mode of calligraphic writing should be subsumed by the discourse of pure feeling, which has a habit of casting the more violent and politically charged aspects of Heian society in a superficial light. While feeling might be said to matter to these calligraphic scenes of dying, our critical engagement with the art objects would be served far better by concentrating our energy—much as the scroll sections themselves do—on the sites at which the *performative materiality* of the script intersects the affective inducement to look more closely.

In my reading, what the writing Kashiwagi produces and the *midaregaki* sections of the scrolls have in common is that they both represent challenges to reading in habituated ways. That Kashiwagi's writing is described as having no *tsuzuki*, or "continuous line," signifies that it makes no sense because it does not proceed along a linear vector that would presumably ensure its comprehensibility. What this lack of *tsuzuki* might imply, then, is that Kashiwagi's writing, in its splintered, "pulpy" form, also has no history—that it possesses nothing *but* a present in its deviation from a teleological alignment of future and past. In this sense, his "senseless" writing becomes radically present precisely to the extent that, in its grotesque materiality, it exceeds a normative

framing of time. It seems to stand outside of history insofar as it perforates such a strict temporal frame. The writing manifests a punctum, in the terms of Barthes's *Camera Lucida,* puncturing the field of representation with a performative force that prompts the onlooker to contend, in a more corporeally invested way, with the textural poignancy of the object.[26]

The medium through which the viewer encounters the punctum shapes its emergence. As such, the force of the calligraphic hand manifests itself differently in the handscroll format than in the photograph. If, for Barthes, the punctum pricks up past the surface of the photo, then we might understand the calligraphic punctum as materializing here with a less explicitly vertical aspect: not necessarily as an individuated perceptual peak rising off of the image's flat surface *but rather as a fold that reworks the planar, two-dimensional orientation of the inscribed sheet.* The calligraphic gesture I am most interested in here materializes as a persistent but tremulous hand, denied both the cultural status and central physical placement granted the paintings within the exhibition. This irruption, which emits affective energy less predictably than the paintings, threatens to disarticulate the essentialist discourse underwriting the exhibit. (Perhaps it elicits a flinch from viewers or imparts a ripple to the surface of perception that perturbs the images' triumphal finish.)

By removing the calligraphy and accentuating the significance of the technologically aided "resurrections" of the *Genji* scroll paintings, the exhibit holds out the promise of a clean, clear link to the mythic Heian past from which, it is implied, modern Japanese rightfully and naturally derive their cultural inheritance. Painting is assigned a status above calligraphy because, unlike calligraphy, the images let this problematic rapport appear both valid and seamless. With their vivid colors, the juxtaposed reproductions appear to remedy the decrepitude of the Heian-era product; they effectively cast what is really a full-scale recreation as the proper, unadulterated incarnation of a long-lost original. In so doing, they satisfy a desire for historical and cultural unity by presenting in high-resolution a whole and straightforward version of a complex object whose multilayered, circuitous composition resists a superficial rendition.

CONCLUSION: DWELLING ON THE DEAD

The particular brand of two-dimensionality pursued by the "Yomigaeru" exhibit showcases a cleansed depiction of Heian cultural inheritance that is as stunning as it is insufficient. In terms of their dimensional depth, we

might say that the painted planes of-
fered for view—in their refurbished
incarnation—are too thin to encom-
pass the kind of embodied labor figured
by the *midaregaki*. This two-dimensional
emphasis is subsidized by desires for

WHAT WOULD IT MEAN TO ATTEMPT
TO APPREHEND—AS OPPOSED
TO TECHNO-SCIENTIFICALLY
ASCERTAIN—THE TRACES OF
DEAD FIGURES?

utter clarity in the heavily mediated, yet ostensibly stable, Heian-era image: a
vision that has been streamlined into its most serviceable incarnation. When
the artistic figuration of dying is limited to just two dimensions—as it is when
the painted image is highlighted in lieu of the calligraphic text—the visceral,
motile features of death's encroachment slip from view.

This suppression of potentially disruptive writing from the frame opti-
mizes the transmission of Heian opulence reanimated to offset the somber
reality of a prolonged recessionary present. This is a writing that I believe
prompts us to read more deeply, in the most figurative and literal of senses.
Moreover, in considering the relation between the twelfth-century version
and the twenty-first-century one, the performative movement of the calligra-
phy should encourage mistrust of any frame in which the two-dimensionality
of the artwork is concentrated to index historical fidelity and a fully recuper-
able materiality.[27]

At the heart of my larger project lies a concern with legibility's relation
to dying and the ways in which legibility is managed, enforced, or undercut
through the performative movement of writing. As I close this essay, then,
it is within this vein that I would like to put forward the notion of dwelling
on the dead as a kind of critical practice. What would it mean to attempt
to apprehend—as opposed to techno-scientifically ascertain—the traces of
dead figures? How should we view figurations of dying, particularly when they
beckon us to engage them both within and beyond a register of pure surface?
To "dwell on the dead" suggests a topographical relation as well as a durative
engagement with forms that have perished. It conforms to the spatiotemporal
schema of neither mourning nor melancholia; its critical gesture traces no
straightforward sequence toward release, nor does it circuitously defer the
acknowledgment of loss.

We should read the drive to substantiate the material truth of the scroll
via techno-scientific images as stemming from a fear that the artwork's pas-
sage into the space of the modern market has hollowed out its aura. As a
result, the imaging apparatus proposes an archival remedy to the problem of
a lapsed capacity to rouse feeling—even as the script unhinges its positivis-
tic bent. The technical probing exacts confessions from the paintings, sifting

through the slivers of their aura to fabricate an evacuated vista that strives to awe the viewer. This scientific inquisition narrows its focus to the vivid reproductions in order to institutionalize a practice of looking trained to furnish comfort through the medium of a depthless surface. To the extent that the exhibition marginalizes the *midaregaki* calligraphy and thus limits the depiction of dying to two pictorial dimensions, it censors an undesirable breed of feeling at the same time that it dilates a space for the painted images to be continually retouched—without being menaced by the calligraphic hand. By maintaining such an aperture, the exhibit calibrates the degree to which the mimesis of the paintings is allowed to overshadow the alterity embodied by the script, with the result that the calligraphy is barred almost entirely from entering the frame. Such an entrance would carry with it not just a more three-dimensional contour but, more suggestively, the promise of a kinesthetic contact too unsettlingly intimate to admit. If, as Michael Taussig claims, "The swallowing-up of contact we might say, by its copy, is what ensures the animation of the latter, its power to straddle us," then the resurrection of Heian images pledged by the "Yomigaeru" exhibit ostensibly succeeds in its reproductive efforts precisely to the extent that it consumes the troubling brushwork's most palpable residue.[28]

Within the calligraphic context I've discussed above, I would like to suggest finally that the wages of depth perception are death, by which I mean this: the process of perceiving the dimension of depth in these works entails an engagement with visceral figurations of dying, figurations whose gestures potentially interrupt routines of feeling and dislodge habituated readings. Indeed, the exhibit might in fact foreclose the potential to perceive certain depths *through* the calligraphic performance of dying, as a gestural medium with its own material, affective, and ethical investments. How should we theorize the relationship between desire, dying, and the materiality of art's affective work? In what ways might the cultivation of a depth of feeling literally undercut the material dimensions of an image? How might artistic figurations of dying not only alter the morphology of an image but, moreover, reshape our sense of the political stakes involved in reanimating lapsed aesthetic forms?

The ample kinesthetic charge of the *midaregaki* intensifies a precariousness of reading that tends to go unacknowledged. This performative energy has the potential to compel alternate modes of reading in response to its movement. As it calligraphically performs dying, the writing eludes the pictorial plane's enforced consistency (even as the script's conservative style betrays territorial ambitions of its own).[29] This tangled script might call upon us, in a certain way, to reckon with the coarser strands at work within the

overlapping gestures of literary and pictorial narration. To press further: it might inspire less myopic disciplinary approaches that lend more breadth to critical engagements with the material, affective, ethical dimensions of dying. *How, then, should we dwell upon the dead, as a crucial element of a more generative creative and critical practice?* In other words, how should we grasp not only dead hands and dead styles of writing or painting but also come to grips with decrepit paradigms? How to counter frames of thought and practices that were forged in the Cold War and in its wake still lie poised to be revived at a moment's notice?

Confronting these questions will pose a host of challenges—methodologically and ethically—for the frames through which we seek to secure our objects of study. Indeed, the path to any truly transformative answers will likely be barred by the debris of our own disciplinary investments: entrenched artifacts of analysis whose promise of efficiency and stability has allowed them to linger largely unchallenged. *How should we dwell critically upon the dead?* Our capacity to reshape conceptions of the critical work that an engagement with Japanese visual culture can and should perform might well hinge upon our capacity to embrace this morbid question's risks.

..

Notes

1. This exhibit was held at the Gotō Museum in Tokyo in 2006.

2. See Komatsu Shigemi, ed., *Kohitsu to emaki* (Ancient script and picture scrolls) (Tokyo: Yagi Shoten, 1994), 29–44, for a detailed account of the calligraphic groupings and stylistic traits of the script in relation to other Heian calligraphy.

3. For information on women's involvement in Heian painting and their possible role in the production of the *Genji emaki*, see Akiyama Terukazu, "Women Painters at the Heian Court," trans. Marybeth Graybill, in *Flowering in the Shadows: Women in the History of Chinese and Japanese Painting,* ed. Marsha Weidner, 172–76 (Honolulu: University of Hawai'i Press, 1990).

4. Egami Yasushi has emphasized the sonic qualities of the scrolls in his article "Genji monogatari emaki no ryōshi sōshoku to 'Genji monogatari' honbun" (Paper design of the Illustrated *Tale of Genji* handscrolls and the original *Tale of Genji* text), *Sophia International Review* 19 (1997): 1–29. Kevin Carr has also underscored the sonic qualities of the paper design in relation to the "Suzumushi" (Bell cricket) section in a personal communication. Yukio Lippit has likened the paper design to a cinematic soundtrack; see his "Figure and Facture in the Genji Scrolls," in *Envisioning the Tale of Genji: Media, Gender, and Cultural Production*, ed. Haruo Shirane (New York: Columbia University Press, 2008), 63.

5. Many of the *Genji Scroll kotobagaki* have been lost. Twenty-nine *kotobagaki* sections remain; ten of those are fragments, most of which were at some point culled from larger sections of the text and used as private calligraphy samples.

6. It is believed that nobles competed for the opportunity to choose which paper was most appropriate for a certain scene. See Akiyama Terukazu, *Nihon emakimono no kenkyū* (Research on Japanese picture scrolls), vol. 1 (Tokyo: Chūōkōron Bijutsu Shuppan, 2000), 90–93, and Sano Midori, *Chūsei Nihon no monogatari to ega* (Medieval Japanese narratives and paintings), (Tokyo: Hōsō Daigaku Shuppan, 2004), 87–100, for background on the production and composition of the scrolls. For more on the materials used to produce the *Genji emaki*, plus a filmed reenactment of particular aspects of their composition, see Video Champ's *The Illustrated Handscroll: Tale of Genji*, VHS (Films for the Humanities & Sciences, 1993).

7. *Anime no hajimari: Chōjū giga* (The beginnings of Anime: The Comic illustrations of birds and animals scroll), *Nihon no bi o meguru* 8/6 (Tokyo: Shōgakukan, 2002); Takahata Isao, *Jūni seiki no animeeshon: Kokuho emakimono ni miru eigateki, animeteki naru mono* (Twelfth-century animation: Film and anime elements in national treasure picture scrolls) (Tokyo: Tokuma Shoten, 1999).

8. It is difficult if not impossible to make a hard-and-fast distinction between these two categories, especially within the context of Heian inscription. My usage of the terms "image" and "text" here is provisional and only meant to designate broad and permeable categories along the following lines: "text" here refers to the calligraphic prefaces (*kotobagaki*) and "image" refers to the paintings. For an exhaustive account of the problems involved in delineating the boundaries of what constitutes an image, see James Elkins, *The Domain of Images* (Ithaca, N.Y.: Cornell University Press, 1999), especially 3–12, and 95–119.

9. See Takahashi Tōru, *Monogatari to e no enkinhō* (Perspective in narrative tales and painting) (Tokyo: Perikansha, 1991), 9-73.

10. For an in-depth discussion of the modern narratological history of Heian literature see Tomiko Yoda, *Gender and National Literature: Heian Texts and the Constructions of Japanese Modernity* (Durham, N.C.: Duke University Press, 2004), 146–53.

11. On this point, see also Watanabe Masako, "Narrative Framing in the *Tale of Genji Scroll*: Interior Space in the Compartmentalized *emaki*," *Artibus Asiae* 58, nos. 1–2 (1998): 115–46.

12. This image of the hands in safflower pulp represents but one symbolic instance of the fetishization of manual labor that recurs throughout the exhibition's materials. It seems to me noteworthy because of its juxtaposition to an X-ray analysis graph (and a lone safflower), reminding us of the natural connection that has been lost and yet rescued through this technological undertaking, and indicative of a nostalgia for a simpler, earthier mode of production. The value of this type of anachronistic labor increases precisely in relation to the accrual of a technological analytical apparatus surrounding it. We might add that this apparatus submits the more primitive labor to a rigorous program of scientific management and quality control.

13. In taking up the relation between cult and exhibition value here, I reference the following passage from Walter Benjamin: "The scope for exhibiting the work of art has increased so enormously with the various methods of technologically reproducing it that, as happened in prehistoric times, a quantitative shift between the two poles of the artwork has led to a qualitative transformation in its nature. Just as the work of art in prehistoric times, through the exclusive emphasis placed on its cult value, became first and foremost an instrument of magic which only later came to be recognized as a work of art,

so today, through the exclusive emphasis placed on its exhibition value, the work of art becomes a construct [*Gebilde*] with quite new functions." "The Work of Art in the Age of Its Technological Reproducibility: Second Version," in *Walter Benjamin: Selected Writings, Vol. 3, 1935–1938*, ed. Howard Eiland and Michael W. Jennings (Cambridge, Mass.: The Belknap Press of Harvard University Press, 2002), 106–7.

14. My sense of the representational and political implications attending "recessionary" Japanese culture is informed by Marilyn Ivy's essay, "Revenge and Recapitation in Recessionary Japan," in *Japan after Japan: Social and Cultural Life from the Recessionary 1990s to the Present,* ed. Tomiko Yoda and Harry Harootunian, 195–216 (Durham, N.C.: Duke University Press, 2006).

15. For a description of the *tsukurie* process see Yukio Lippit, "Figure and Facture in the Genji Scrolls," in *Envisioning the Tale of Genji: Media, Gender and Cultural Production*, ed. Haruo Shirane (New York: Columbia University Press, 2008), 49–80.

16. Benjamin, "The Work of Art in the Age of Its Technological Reproducibility: Second Version," 104–5.

17. For more on the theory of how painting techniques used for the faces of characters in the handscrolls promote viewers' ability to project their own feelings onto them, see Mitani Kuniaki and Mitamura Masako, *Genji monogatari emaki no nazo o yomitoku* (Solving the mysteries of the Illustrated Tale of Genji handscrolls) (Tokyo: Kadokawa Shoten, 1998), 22–28.

18. I detail this idea of recursive reading in my forthcoming manuscript, To Mourn the Legible: Calligraphic Performance, Mortality, and the Ethics of Reading.

19. The telling irony of this is that only the most skilled calligrapher was allowed to simulate such a maladroit hand as Kashiwagi's.

20. See Reginald Jackson, "Scripting the Moribund: The *Genji* Scrolls' Aesthetics of Decomposition," in *Reading the Tale of Genji: Its Picture Scrolls, Texts, and Romance,* ed. Richard Stanley-Baker et al., 3–36 (Kent, U.K.: Global Oriental, 2009).

21. The Japanese text reads as follows: " . . . いとど泣きまさりたまひて、御返り、臥しながらうち休みつつ書いたまふ。言の葉のつづきもなう、あやしき鳥の跡のやうにて . . . " Murasaki Shikibu, *Genji monogatari,* ed. Abe Akio et al., *Nihon koten bungaku zenshū* (Complete anthology of classical Japanese literature), vols. 12–17 (Tokyo: Shōgakukan, 1970–76), 15:286; translated by Royall Tyler as *The Tale of Genji,* 2 vols. (New York: Viking, 2001), 2:677.

22. The scene in which Kaoru finally has the opportunity to read his father's letters proceeds as follows: "The first thing he did when he got home was to inspect the bag. It was sewn from Chinese brocade and had 'For Her Highness' written on it. The knot of slender, braided cord that tied it shut bore his [Kashiwagi's] signature seal. To open it was terrifying [開くるも恐ろしうおほえたまふ]. Inside, he found sheets of paper in various colors, including five or six replies from his mother. In his hand there were five or six sheets of Michinokuni paper that evoked at length, in letters like the tracks of some strange bird, how extremely ill he was [病は重く限りになりにたるに]; how he could no longer get the slightest message to her, which only made him yearn for her the more; how he supposed that by now she must have assumed the guise of a nun; and other such sorrowful topics. . . . It was all quite untidy and it just seemed to stop [書きさしたるやうにいと乱りかはしうて]. On it was written 'To Kojijū.' The paper was now inhabited by silverfish and smelled of age and mold, but the writing was still there, as fresh as though just set down, and the

words stood out with perfect clarity [こまこまとさたかなるを見たまふ]. Yes, he thought, if this had ever gone astray . . . ; and he trembled and ached for them both." Murasaki, *The Tale of Genji*, 2:846; *Genji monogatari*, 16:156–57.

23. Deleuze and Guattari discuss the concepts of smooth and striated space within the context of their broader concept of nomadology. See Gilles Deleuze and Félix Guattari, *A Thousand Plateaus: Capitalism and Schizophrenia*, trans. Brian Massumi (Minneapolis: University of Minnesota Press, 1987), 474–500. For a reading of the properties of Heian paper and calligraphy that follows Deleuze and Guattari's notion of the smooth and striated, see Thomas Lamarre, *Uncovering Heian Japan: An Archaeology of Sensation and Inscription* (Durham, N.C.: Duke University Press, 2000), 93–101.

24. This written movement should be thought of as marking a spatial interior different from the kind established by the *fukinuki yatai*, or "blown-off roof" architecture.

25. For a fascinating reading the narrative depiction of Kashiwagi and the "bodily depth" (*mi no fukami*) he figures, see Matsui Kenji, "*Kashiwagi no juku to shintai: Fukamari-yuku mi, mi no fukami e*" (Kashiwagi's passion: Deepening bodies, deep into the body), in *Genji kenkyū* (*Genji* research), vol. 2, ed. Mitamura Masako et al., 60–71 (Tokyo: Kanrin Shobō, 1997). While an extended discussion of it exceeds the focus of this article, it is crucial to note the gap between the paintings' and calligraphic prefaces' respective depictions of bodies. I would argue that in the case of the *Genji emaki*, the most visceral portrayals of bodily phenomena, particularly in terms of physical strife, are actually provided in the *kotobagaki* sections, *not* the painted images.

26. See the discussion of punctum in Roland Barthes, *Camera Lucida* (New York: Hill and Wang, 1981): 26–27.

27. Compare Norbert Bolz's claim that "Modernity was an organized distrust of the senses. Today we are told by depthless surfaces to trust our senses again." As quoted in Janet Ward's *Weimar Surfaces: Urban Visual Culture in 1920s Germany* (London: University of California Press, 2002), 5.

28. The quotation appears in Michael Taussig, *Mimesis and Alterity: A Particular History of the Senses* (New York: Routledge, 1993), 22.

29. Sano Midori considers the calligraphy used for the *kotobagaki* of the "Minori" and "Kashiwagi" sections of the scrolls to be an archetypal example of the "*jōdai wayō*" style. She refers to it as "[a style] that has inherited the gracefully delicate classic Japanese style perfected by Fujiwara no Yukinari." Sano Midori, *Jikkuri mitai Genji monogatari emaki* (Looking closely at the Genji emaki) (Tokyo: Shōgakukan, 2000), 42.

STEFAN RIEKELES AND
THOMAS LAMARRE

Image Essay:
Mobile Worldviews

In cel animation and digital animation, the anime image is composed of layers. Compositing is the term commonly used to describe the process of establishing of relations between image layers. Much of our experience of movement in animation comes from compositing, and a variety of artists contribute to the mobile relations established between layers of the image. The usual point of departure and overall focus for discussions of compositing are the relations between characters and background, and there is a tendency to treat backgrounds as inert and static backdrops for action. Yet, production design in anime does not simply provide a passive space for action and emotions to be played out but plays an active role in orientating and qualifying all manner of movement, which is beautifully conveyed in the Japanese term used to describe the role of production design—*sekai-kan* or "worldview"—an incipient mobility that generates perspectives. Here, we propose to explore the layers of production of such "mobile worldviews," both to impart a better sense of the dynamics of animation and to acknowledge the range of artistic contributions to anime production.

BACKGROUND PAINTING AND DESIGN

A scene generally consists of several takes or shots, which in anime are also called "cuts." Each cut requires a background image. Usually, the background image is painted on a sheet of paper with watercolors or gouache on the basis of the layout and image board designs. In cel animation, the sheet of paper is generally larger in format than the transparent sheets on which characters and other figures are drawn, to allow for movement of the viewing position.

Patlabor—The Movie (1989, dir. Oshii Mamoru) brought new attention to background painting in anime production. Often in animation production greater attention is paid to the movement of characters, at the expense of the background. Of course, Miyazaki Hayao's films had already begun to employ beautifully painted backgrounds, but *Patlabor* introduces a new kind of focus and mobility into its design. This becomes especially apparent in a sequence in which the two detectives' investigation brings them to the old suburbs of Tokyo, which are being demolished to make way for islands of high-rise constructions. The abandoned wooden houses that are to be demolished stand in stark contrast to the sleek, white, soaring towers. It was a combination of talents that allowed this sequence to set new standards for animation. On the one hand, Oshii allows the background to come to fore: as our viewing position follows the two detectives, they hardly speak, and their silence, in conjunction with Kawai Kenji's music, heightens our focus on the background.

On the other hand, there are Ogura Hiromasa's paintings. Ogura uses high contrast to express the quality of light on a summer day in Tokyo, extending the contrast to the relation between the old wooden houses and the new ferro-concrete high-rises (Figure 1). The houses are rendered with thin lines in high detail, while the background high-rises are drawn schematically, and their vertical lines fade out, implying that there is nothing to see (Figure 2). Our attention thus settles on the wooden houses in the foreground, which effectively block the vanishing point, refusing to vanish. In sum, Ogura uses different degrees of detail in order to guide attention within the image, deploying one-point perspective only to undermine its ability to structure this worldview.

In his designs for the room in which the character Ayanami Rei was "born" in Anno Hideaki's digital rebuild *Evangelion 2.0: You Can (Not) Advance* (2009), Watabe Takashi first generated a three-dimensional computer model. While our viewing position adheres to one-point perspective, his wire-frame rendering of the space (Figure 3) builds in the possibility of looking at the central chamber from any point within the cylindrical room. As such, rather than a single fixed viewing point, we have a sense of mobile perspectivalism.

FIGURE 1. Ogura Hiromasa: background painting for *Patlabor—The Movie*, cut 382, watercolor and gouache on paper, 25 × 35.3 cm. Copyright 1989 HEADGEAR / BANDAI VISUAL / TOHOKUSHINSHA.

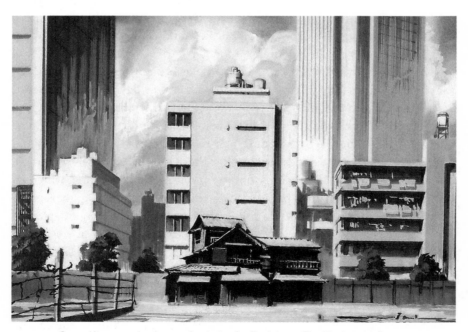

FIGURE 2. Ogura Hiromasa: background painting for *Patlabor—The Movie*, cut 382, watercolor and gouache on paper, 25 × 35.3 cm. Detail. Copyright 1989 HEADGEAR / BANDAI VISUAL / TOHOKUSHINSHA.

As we see in Figure 3, after printing the wire-frame rendering in red, Watabe added details and highlights in pencil. The drawing was then scanned again, and the red lines were replaced with black, resulting in a layout to be processed as a digital image for use in subsequent animation production.

In the final image (Figure 4), such details largely disappear, but Watabe's attention to meticulous detail nonetheless pays off. The detail visible in the illuminated portion of the image imparts a sense of the underlying structure of space allowing for viewing positions even from the recesses of the room, which enhances our sense of being able to enter the image and thus into the process of experimentation and creation.

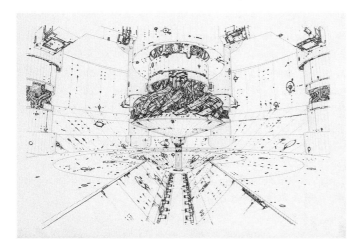

FIGURE 3. Watabe Takashi: layout for *Evangelion: 2.0 You Can (Not) Advance*, cut 710, computer printout and pencil on paper, 21 × 29.7 cm. Copyright 2009 khara.

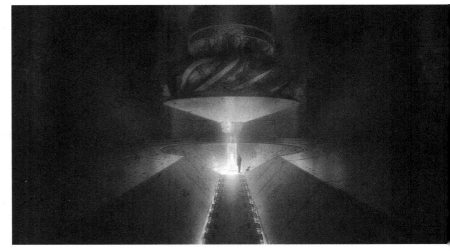

FIGURE 4. *Evangelion: 2.0 You Can (Not) Advance*, cut 710, still image. Copyright 2009 khara.

LAYOUT

Each background painting begins with a layout drawing. The layout is the separate construction sketch made for every image layer. There may be, for instance, background, middle ground, and foreground, and sometimes, additional layers within these. The layout defines the essential characteristics of the shot such as the composition and the framing. The layout is crucial for background painters and key animators. If the camera is to move over the background during a shot, the starting and ending points of the motion must be specified in the layout. The corresponding camera framings are usually marked with red frames. The cameraman subsequently decides at what speed and with which acceleration the movement will be animated.

Each layout is labeled with a scene and cut number. Together with the image board defining the color palette for a scene, the layout is used as the blueprint for the background painter. The production designer is in charge of this drawing and thus is responsible for decisions involving camera work. In anime production, the production designer is also referred to as the layout designer.

Watabe Takashi produced some of the layout drawings for Rintarō's 2001 animated film *Metropolis*. In his design for the set and the layout for an early scene in the film (scene 10), Watabe introduces the city of Metropolis and its architectures, arranging shots to highlight the urban world of the film as the main characters walk through the streets, discussing the adventure on which they are embarking.

Figure 5 shows the plaza in front of a theater, and in Figure 6, Watabe maps out the positions for other views on the architectures surrounding the plaza, as in cut 12 (Figure 7) and cut 19 (Figure 8). Thus Watabe generates an open and mobile perspectivalism allowing for a variety of orientations. In the final film, these architectures were digitally painted in brilliant colors. Because Watabe's layouts impart a strong sense of three-dimensionality, while the character design adhered to a more two-dimensional "cartoonish" look in keeping with Tezuka Osamu's original manga, the director Rintarō felt that high contrast and high saturation would aid in compositing the two layers of the anime image (Figure 9). The result is a brilliantly colored world in which motley characters navigate their way through disorienting pathways and disturbing events. Ultimately, appropriately enough in light of this solution to compositing Watabe's layouts together with Tezuka-inspired character designs, it is *iro* and *kokoro*—hue, color, or attraction and feeling—that are the "message" of this worldview striving to bring together the different worlds of humans and robots, as the film stressed in its promotional material (Figure 10).

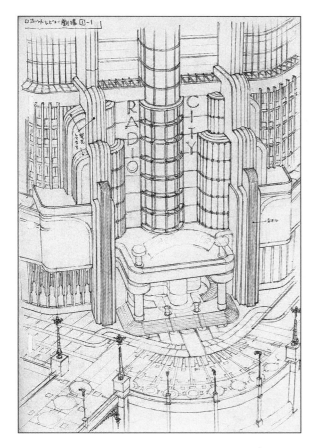

FIGURE 5. Watabe Takashi: layout for *Metropolis*, scene 10, pencil on paper, 23.4 × 35.8 cm. Copyright 2001 TEZUKA PRODUCTIONS / METROPOLIS COMMITTEE. All Rights Reserved. Licensed from Bandai Visual.

FIGURE 6 (BELOW). Watabe Takashi: map of the set for *Metropolis*, scene 10, pencil on paper, 23.4 × 35.8 cm. Translation of the annotations (from left to right): building in the center of cut 19; camera position for cut 12 and 19, both in front of the theater building (so called "robot revue"); building with triangular windows; close up of camera position of cut 21, the three protagonists directly in front of the camera. Copyright 2001 TEZUKA PRODUCTIONS / METROPOLIS COMMITTEE. All Rights Reserved. Licensed from Bandai Visual.

FIGURE 7. Watabe Takashi: layout for *Metropolis,* scene 10, cut 19, pencil on paper, 23.4 × 35.8 cm. Copyright 2001 TEZUKA PRODUCTIONS / METROPOLIS COMMITTEE. All Rights Reserved. Licensed from Bandai Visual.

FIGURE 8. Watabe Takashi: layout for *Metropolis,* scene 10, cut 21, pencil on paper, 23.4 × 35.8 cm. Copyright 2001 TEZUKA PRODUCTIONS / METROPOLIS COMMITTEE. All Rights Reserved. Licensed from Bandai Visual.

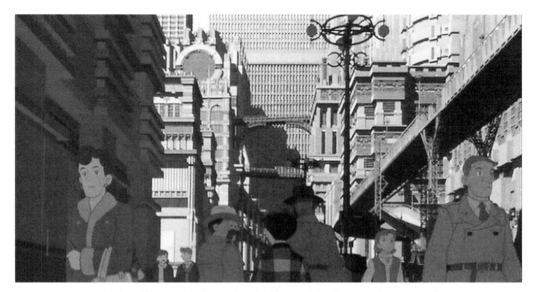

FIGURE 9. Screengrab from *Metropolis* showing Ken'ichi, his uncle, and a robot detective walking through the brilliant architectures of the city.

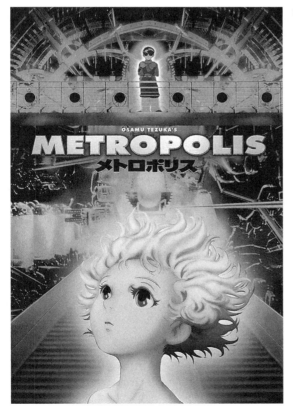

FIGURE 10. *Metropolis* DVD cover.

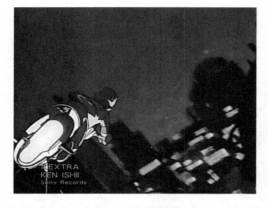

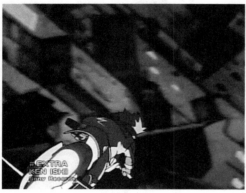

FIGURE 11. Sequence from *EXTRA* featuring layouts by Morimoto Koji.

Even when layout designs do not map out viewing positions, the actual design may signal them, as in Morimoto Kōji's layouts for cuts 28 and 55 of his music video for Ken Ishii's single *EXTRA* from his album *Jelly Tones* (1995). The music video, produced in 1996, is actually a short animated film, for which Morimoto produced all of the art himself, drawing the image boards, storyboards, layouts, key-frame animation, and the background. In cut 28, the hero soars over the nighttime city on a kind of flying motorcycle, and camera's viewing position follows his flight from the lower right across the sheet to the upper left. Rectangular marks indicate the framing for the shots. In cut 55, the final cut of the film, the hero looks down into the plaza in the lower portion of the image and then jumps into the void. In Figure 11, three moments of cut 28 from the music video show how Morimoto's layout anticipates and accommodates the movement of the flying motorcycle.

While the position of the animation camera implies at any moment a version of one-point perspective, the mobility imparted to this viewing position generates a sense of multiple perspectives, implying a radical perspectivalism. Already in the layout design, the "worldview" is constructed in accordance with three different vanishing points, making for a flexible and active world. Indeed, even in the sequences of *EXTRA* employing a sort of ballistic vision in which the viewing position is that of the motorcycle speeding into the vanishing point, the impression is one of the world rushing at us, now bending toward us, now leaning away. Rather than a purely instrumental vehicular perception, Morimoto's animation arrives at new form of depth through movement.

LAYERS IN MOTION

Backgrounds may also be composed of several layers to generate other effects of movement in animation. Such a design is often called a book cel, for the layers of the image are stacked like the pages of a book. Cel animation traditionally takes its shots through stacked sheets of celluloid, while in digital animation the layers of the image may be produced entirely on the computer, or produced on paper or celluloid and scanned into the computer, or some combination of the two processes. The background layer, most distant from the camera, is often painted on a large card, and the books on transparent celluloid. The layers of a book allow for a variety of effects. There are camera effects such as depth-of-field blur, in which the camera focuses on one layer while the other layers appear out of focus and thus blurred. The use of books also allows for effects based on the differential lighting of layers. Finally, books allow for distinctively animetic effects of movement. For instance, many of the backgrounds for *Ghost in the Shell* (1995, dir. Oshii Mamoru), which combined cel animation and digital animation, consisted of three layers: the background layer (Figure 12a) and two books, book 1 (Figure 12b) and book 2 (Figure 12c).

The use of a three-layer background allowed the animators to create a sense of depth in conjunction with a mobile viewing position, that is, camera movement over the background. To achieve such effects, the starting point and the endpoint for movement must be precisely indicated in the layout. What is more, in a traveling shot, the "deepest" layers must move at a different rate than those closer to the camera, if the animators wish to sustain a consistent sense of depth. This is commonly referred to as "parallax." For instance, when you look out the window of a train or car, the objects closer to you appear to move faster than those in the distance.

Thus, in the instance of these backgrounds from *Ghost in the Shell,* the direction of movement is indicated in the lower left-hand corner of the drawings. The background layer (Figure 12a) is to be pulled from point A to point B, while Book 1 (Figure 12b) is to be moved from point C to point D, and Book 2 (Figure 12c) from point E to point F. The speed of movement is indicated in millimeters per film frame. In this instance, the different rate of movement of the layers of the background allow for a sense of the camera moving both across and into the image.

As such an example shows, this technical set-up for producing a sense of movement in animation is stretched between polarized tendencies. At one end of the spectrum would be movement directly into depth, directly into the image, which may be glossed as "closed compositing" or "cinematism."

FIGURE 12. Watabe Takashi: layout, *Ghost in the Shell*, cut 477, pencil on paper, 25 × 35.3 cm. Copyright 1995 Shirow Masamune / KODANSHA BANDAI VISUAL MANGA ENTERTAINMENT Ltd.

At the other end would be purely lateral movement across the image, "open compositing" or "animetism." In this example from *Ghost in the Shell,* we see both tendencies: on the one hand, differential movement of layers allows an effect of the viewing position moving into the image; and on the other hand, as the viewing position moves into depth, the layers of the image become perceptible, imparting a sense of lateral movement of the underlying "mul- tiplanarity" of the image. Because in actual practice, animation is always a complex mixture of these polarized tendencies, much of the appeal and inter- est of animation lies in following its negotiation of them, its composition of forces. Parallax is one way of composing layers to negotiate relations of depth and movement. Needless to say, to produce an overall tendency toward either pole within a film would demand a great deal of finesse at every level of pro- duction, from background painting and design (line and color), layouts (map- ping orientations), and books (effects of depth), to character design, character animation, set-up, and story. As such, these negotiations become key to the overall worldview. In *Ghost in the Shell,* for instance, a negotiation of mobile effects of depth is central to its problematic: what kind of depth (ghost) does a cyborg (machine) accrue as it moves through world? Indeed, it is against this mobile background in cut 477 that we see Kusanagi Motoko reflecting on her identity, while in voice-over we hear her thoughts (Figure 13).

In Ōtomo Katsuhiro's *Steamboy* (2001), the negotiation between cin- ematism and animetism is already inscribed in its topological layout. Figure 14 shows the landscape seen from a train in an early scene in the movie in which the action unfolds around a group traveling into London. The landscape

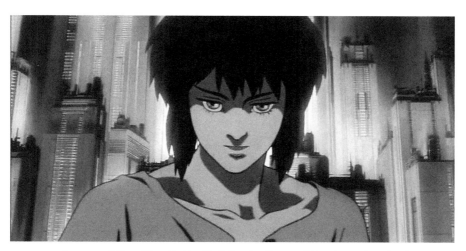

FIGURE 13. Screengrab from *Ghost in the Shell* showing Kusanagi Motoko against the cityscape.

FIGURE 14. Sequence from *Steamboy*.

is here laid out in a topology that combines a sense of layers to be composited (the clearly indicated planes of the landscape on which houses and trees are situated) and a seamlessly precomposited topology. Such a landscape begins with a digital layout in which the houses and trees are rendered with three-dimensional modeling. Thus this digital layout is already negotiating the two tendencies of movement and depth, allowing both for a kind of closed compositing and open compositing. When the digital layout is produced, it includes indications for the "character layer" and for the viewing position (simulated camera). The character layer (the layer with the characters in the train compartment) is produced separately and then is composited with the background layer. Note that the character layer is also composed of layers for

FIGURE 15. Sequence from *Steamboy*.

each character to move independently. Figure 14 shows the landscape to be seen from the train window under conditions of movement. The greater blur of the objects closer to the window impart a sense of parallax, and at the same time, the layers of the landscape become more perceptible. Similarly, when the background landscape and foreground train compartment are put together, the strong contrast between these differently layered layers highlights the planarity of the image. Finally, in the actual sequence in the film, the viewing position gradually moves closer to the window, framing the view of the landscape in the manner of a diorama (Figure 15). Even in this brief sequence, a number of different techniques of compositing are in evidence, implying a complex negotiation between different layers of the image and tendencies in depth and movement. The result is a worldview torn between tendencies, which plays out through sudden shifts between cinematism and animetism, and which affords an experience of the central problematic of technology in the film: will the invention of a highly sophisticated mode of energy production (the "steamball") lead inevitably to a world of high-tech ballistic militarism, or will it enable a different relation to energy and technology?

In sum, the production of a "worldview" through background painting, design, layout, and books is done with an eye toward depth under conditions of movement, and as such, this part of production is inseparable from the whole of animation.

...

Note

Some of the images in this essay are taken from *Proto Anime Cut Archive,* edited by Stefan Riekeles (Berlin: Kehrer Verlag, 2011) and reproduced with the kind permission of Les Jardins des Pilotes and the rights holders of the images. The book was published as a catalog accompanying the exhibition *Proto Anime Cut,* curated by Stefan Riekeles and David d'Heilly, which presents original drawings by the important directors and illustrators of Japanese animated films. The exhibition focuses on the development of arenas of action and narrative scenarios. Numerous background paintings, storyboards, drafts, photographs, and film excerpts provide insight into the working methods of the most successful animation artists of the past two decades. The publication includes works by Anno Hideaki (director, *Neon Genesis Evangelion*), Higami Haruhiko (photographer), Morimoto Koji (director, *Dimension Bomb*), Ogura Hiromasa (art director), Oshii Mamoru (director, *Patlabor, Ghost in the Shell*) and Watabe Takashi (layout). These artists have played key roles in the development of anime. Through their work in different production studios in Tokyo, they have imparted their distinctive signatures to many films.

Nonlocalizable Selves

CRAIG JACKSON

•••

Topologies of Identity in
Serial Experiments Lain

The problem or issue of human identity is a recurrent theme in anime, manga, and science fiction in general. From the dipolar identity of Dr. Jekyll and Mr. Hyde to the indefinite iterations of the Eternal Champion in the multiverse of Michael Moorcock, the precise nature of what constitutes a human, and the form in which that humanity is manifested, remains unsettled. The potential for human–machine interface provides an additional dimension to the problem. External memories and digital avatars allow for the possibility that a human might live in a machine.[1] Conversely, biomechanical hybridization and cybernetics imply that a machine might live in us.[2] This human–machine interface, in all its various forms and ramifications for human identity, is the frontier that many anime and manga series navigate. One particularly intriguing series in this vein is *Serial Experiments Lain* (1998).

Lain, the anime, is intriguing for its exploration of identity as a construct without a fixed or unambiguous location. As an entity, Lain, the character, is shown to simultaneously exist in many places—at home, at Cyberia, at Arisu's, in the Wired—and in many modes—diffident, ebullient, pernicious, assertive. Eventually, however, Lain becomes aware of these simultaneous identities. And they may, indeed, be viewed as simultaneous. They need not

result from a split identity, in the manner of a Dr. Jekyll one moment and a Mr. Hyde the next. Nor are they necessarily mere aspects of Lain, or more precisely, incomplete parts that only in sum constitute a whole. In one of Lain's trips to the Wired, Eiri Masami tells her, "Another you has always existed in the Wired."[3] This is difficult for Lain to accept, however: "I'm me, right? There's no other me but me, right?"[4] For Lain to believe otherwise would contradict the notion of a unitary localization of identity: namely, that at a specific point in time, human identity exists at a specific point in space. Identity, for Lain, needs distinct coordinates, a way to situate oneself uniquely among the gridlines of existence: "As long as I am aware of myself, my true self is inside me."[5]

It is hard to see this statement as anything other than a spatial corollary of the *cogito ergo sum,* to wit: "I think, therefore I am . . . at this precise time and place." This is Cartesian geometry applied to Cartesian philosophy, with Lain fixing her identity at the origin.

CIRCLES IN THE SKY

By any measurement, the analytical geometry of René Descartes must be counted among humanity's most enduring achievements. It is a system by which a single point, chosen arbitrarily, radiating measured orthogonal lines, suffices to coordinatize a space, turning continuous, amorphous curves and regions into discrete sets of equations. Coordinate geometry was the essential ingredient in the calculus of Isaac Newton and Gottfried Leibniz, and its usage today remains undiminished by time or fashion. From the trajectories of satellites to computer-generated imagery, the influence of Cartesian geometry is pervasive.

A by-product of Descartes's formalism, however, is the persistent, reinforced notion that all local properties of a universe may be extended globally. This notion assumes that, since any given locality may be situated within a Cartesian frame, then there must also exist a coordinate frame for the entire universe. I say "reinforced" because the notion of a universal unambiguous measurement of space relative to a solitary fixed point did not originate with Descartes. Indeed, the need for a linear ordering of our perception of the universe (and simultaneously, our position in its hierarchy) may be witnessed, for instance, in the concentric orbits of the Ptolemaic geocentric theory, developed nearly 1500 years before Descartes (Figure 1).

The cycles and epicycles of this system provide a universal order from Earth to Empyrean. It is a coordinate system for all creation.[6] But while the

Schema huius præmiſſæ diuiſionis Sphærarum.

FIGURE 1. The Primum Mobile as depicted in Peter Apian's *Cosmographia* (Antwerp 1539), reprinted in Edward Grant, "Celestial Orbs in the Latin Middle Ages," *Isis*, 78, no. 2 (June 1987): 152–73.

geocentric model eventually fell to heliocentrism, which in turn eventually fell to the view that the universe has no "center" whatsoever, the universal sense of certainty with respect to place that the geocentric model engendered persisted within the coordinate geometry of Descartes and the simple physical laws of Newton. Indeed, coordinate geometry not only allowed for precise measurement in space but also in time, for time was made to be just another coordinate.

From this confluence of Newtonian and Cartesian theories, there arose the notion of a deterministic universe: if the universe is such that the grid of a Cartesian system gives unique coordinates to all points in the universe, then a knowledge of the initial coordinates of all particles and their momenta, in combination with a handful of concise equations expressed in these coordinates, will give a complete knowledge of all future states of the universe.[7]

Leaving aside the philosophical ramifications of such determinism, we may nevertheless wonder: what if the universe was not coverable by a single, unambiguous Cartesian system? This is not, in fact, idle speculation. The question of the "shape of the universe" is far from settled. The universe might, indeed, continue on infinitely with perfect regularity, but it might also

HE WOULD LOOK OFF
INTO THE DISTANCE
AND SEE . . . HIMSELF.

curve back on itself in endlessly complicated ways, twisting into higher dimensions in such a way that no fixed origin will suffice to completely or unambiguously identify all points in space. That is to say, our local perception of our universe may not be globally extensible—and to imagine otherwise would be as mistaken as the proto-belief that the Earth is a flat disk.[8]

Topology is the branch of mathematics in which the issue of global versus local properties of a space is best understood. Topology should be distinguished from geometry in that topology considers only those properties of a space that are, in a sense, invariant under deformation. So, for instance, a sphere and a cube are topologically identical, whereas they are geometrically distinct.

Several examples-by-analogy present themselves in the form of early 2D arcade games. The universe of *Pac-man* (1980, *Pakkuman*), for instance, is a finite Cartesian patch with one set of opposite sides glued together. That is, passage through the left side of the screen leads to entrance from the right. This is accomplished without teleportation or other exotic forms of transportation.[9] From Pac-man's point of view, there is no distinction between the left edge and the right edge. They are identical. As such, the universe Pac-man inhabits is a cylinder (Figure 2). This identification, *left = right,* leads to ambiguity in any attempt to impose a Cartesian system on the *Pac-man* universe, since any single point must be identified by several (in fact infinitely many) distinct sets of coordinates.

The Atari game *Asteroids* (1979) is worse yet. In this bleak universe, both sets of parallel edges are joined: left-to-right and top-to-bottom. Who would have guessed that the little besieged ship inhabited a toroidal universe?[10] The question of perception in these non-Cartesian universes is an interesting one. Indeed, if Pac-man paused in his activity long enough to look through the corridor joining the left part of the screen to the right, his view would not open onto limitless space but rather onto the finite world he currently inhabits. As such, he would look off into the distance and see . . . himself. And further on there would be yet another image of himself, and so on. It is like the infinite multiplicity of identity created by situating oneself between two parallel mirrors, except that this multiplicity is an artifact of a finite universe rather than endless reflection. For the lonely Sisyphean cosmonaut of Atari's *Asteroids,* the view is even more chaotic. Any attempt to look any farther than her immediate vicinity, in any direction at all, will reveal limitless images of herself, from slightly different angles and at increasingly distant times.[11]

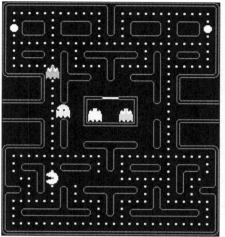

FIGURE 2. Screenshot from *Pac-man* (*Pakkuman*), Midway/Namco, 1980. The two-dimensional Pac-man universe is topologically a cylinder.

FIGURE 3. Screenshot from *Asteroids,* Atari, 1979. This universe is finite and unbounded in all directions. Topologically, it is a "torus" or doughnut.

Many higher dimensional analogues of these non-Cartesian spaces are known to exist, and the scientific community is actively seeking to discover if our universe is among them. Several satellites have been launched to map the cosmic background radiation that pervades the universe.[12] Images of this radiation represent a convergence of photons from all directions at a single "point" (the satellite's photo-receptor plate). Allowing time to run in reverse, these photons "expand" in a sphere of ever-increasing radius until they return to a state called the "surface of last scatter," roughly 380,000 years after the Big Bang, at which time the universe had cooled enough to allow matter and radiation to decouple. This surface of last scatter is a topological sphere. If the universe were finite (or non-Cartesian in a way similar to what has been described), and sufficiently small, then the surface of last scatter will self-intersect. This self-intersection would subsequently reveal itself,[13] a billion years later, as circles of radiation with identical temperature distribution in distinct parts of our sky.

INTERFERENCE PATTERNS

The topology of a finite, non-Cartesian universe precludes the use of unique coordinates to reference the position of its inhabitants. Indeed, the topology of such a universe invariably creates infinite virtual duplicates. In their

> COULD THERE BE A SENSE IN
> WHICH THESE COPIES OF LAIN
> ARE EXPLICABLE NOT AS
> INCOMPLETE SCRAPS OF A
> SINGLE FRAGMENTED IDENTITY
> BUT AS DISTORTED IMAGES
> OF HERSELF RECEIVED ACROSS
> A UNIVERSE OF NOISE?

scientific paper, "Circles in the Sky: Finding Topology with the Microwave Background Radiation," Cornish et al. discuss this potential phenomenon: "In a multiply connected universe, many null geodesics start from the position of an object and reach the present observer. Thus there will be many images of each object, often called ghosts."[14]

Of course, virtual duplicates ("ghosts") are also precisely what Lain encounters more and more frequently as she moves from reality into the Wired. As such, one wonders if there might be a topological aspect to this ambiguity of identity confronting Lain. Could there be a sense in which these copies of Lain are explicable not as incomplete scraps of a single fragmented identity but as distorted images of herself received across a universe of noise?

Or perhaps by moving from the real world to the Wired, from solitariness to increased socialization, Lain's expansion into her universe is actually bringing her into contact with herself. Like an expanding sphere of photons in a finite universe, self-intersection at the margins is inevitable. And with this self-intersection comes self-interaction. In one such self-interaction, Lain confronts her duplicate, saying, "Who are you? You're not me."[15] To which her image replies, "Hey, I'm Lain, aren't I?" Significantly, she does not say, "I am a part of Lain," or "I am like Lain," but rather, "I am Lain." Of course, this apparent contradiction is a source of anxiety. But it is a contradiction only insofar as Lain persists in holding on to a Cartesian view of her universe.

Lain's universe, however, becomes progressively less and less Cartesian. At one point we are shown an infinite regression of Lains, an infinite regression identical to what a far-sighted Pac-man would see (Figure 4). "What are these things?"[16] she asks. To which Eiri answers, "They are all you."

The multiplicity of identity is unmistakable in *Serial Experiments Lain,* and many authors have commented on it. One excellent example is the manga essay, "The Signal of Noise" by Adèle-Elise Prévost.[17] Prévost analyzes the multiple identities of Lain in terms of Lain-as-software. The multiple versions of Lain we see in the series are a "delocalization of identity," caused by the separability of the digits that make up the entirety of Lain's body and world. Lain-as-software is a computer program, broken into various packets, processed in parallel, which can only be considered whole or complete upon some future reassembly. As a fully digitized identity, Lain is susceptible to the bit-processes of all digital information: duplication, corruption, deletion.

FIGURE 4. Screenshots from *Serial Experiments Lain,* episode 8: "Rumors." Lain observes an endless regression of Lains.

This mode of analysis evokes, perhaps accidentally, a new topological paradigm of its own—namely, that of the network or graph: a finite set of nodes joined together by edges. This is an essentially discrete space that is non-Cartesian in the sense that there is no unambiguous notion of distance, even locally.[18] What matters most in such a space is the connectivity or nonconnectivity of nodes, and two nodes that might be very far apart by one route

can be very close by another. This is the discrete analog of a continuous space wrapping back around on itself. In a universe composed of nodes and wires, the difference between local and global topologies lies merely in the scale of their complexity. However, with increased complexity comes increased ambiguity with respect to distance. Widely distributed subroutines may eventually compete for the same resources. In this way, a digital being in a wired universe may unexpectedly collide with itself. Further, such self-collisions—if that is what Lain's multiple images actually are—must invariably give Lain the occasion to effectively change herself. Like a wave pattern that is allowed to self-overlap (as if dropping a pebble in a toroidal pond), superposition leads to constructive and destructive patterns of interference. Only, for Lain, given that she exists in a wired universe, the processes that lead to self-interference are digital: time sharing, queuing, stacking.

A wired universe is finite and must always be, but in a different way than the finite *Pac-man* universe. A discrete space is finite both in terms of distance and in terms of cardinality as well, because it is limited by the number of nodes available and by the clock cycle that regulates information sharing.[19] Indeed, in such a universe, there can be only a finite number of beings. And what distinguishes them from each other is not their content (0s and 1s), but some larger structure by which this content is arranged. Lain often finds herself wondering, "What's the other me doing?" Inside a digital universe, there are only a finite number of possibilities.

On the other hand, there is a sense in which the Cartesian notion of the singularity of identity may still be in effect in such a digital universe. This is because identity in such a universe, delocalized though it may be, can only be conceived in terms of permutations of digits. It is a universe whose beings are fragmented, formed of bits and pieces, but who nevertheless orbit a fixed, if unknown, origin.

TOPOLOGICAL COLLAPSE

In considering the ambiguity of identity depicted in *Serial Experiments Lain*, it is important to understand the nature of the universe in which these identities can be said to exist. Consequently, topological considerations can be useful for considering the nature of the identities themselves. *Lain* is not the only text that is amenable to such considerations. *Neon Genesis Evangelion* (1995, *Shin seiki evangerion*) also depicts characters with multiple simultaneous instantiations. In Episode 16, while trapped in the entry plug of his Eva,

Ikari Shinji confronts another version of himself who tells him, "There are many Ikari Shinjis. The one in your mind, the one in Katsuragi Misato's mind, the one in Soryu Asuka's mind, the one inside Ayanami Rei's mind . . . Each of them are different, but they're all Ikari Shinji."[20] Moreover, the Human Instrumentality Project at the end of the series is nothing short of a spectacular topological collapse of identity. The AT fields of all human beings are broken, allowing the physical essence of human identity to merge into a single field. With this, we witness the reduction of the entire universe of human identity to a topological space consisting of a single point: a degenerate Cartesian space of dimension zero.

For Lain, there are several ways in which a topological analysis can help in understanding and interpreting her apparent multiplicity of identity. By thinking of Lain as an expanding identity in a finite closed universe (discrete or continuous), we allow for instances of self-intersection. Additionally, in such universes, the existence of multiple geodesics joining two points together leads to distorted "ghost" images and singularities of apparent ambiguity. These topological considerations need not compete with the purely digital conception of identity presented by Prévost. Indeed, an analysis of identity in *Serial Experiments Lain* via artifacts of digitization naturally leads one to consider the topological implications of existence in a finite wired universe.

In the end, Lain's persistent question—"Where is the real me?"[21]—is answered, as in *Evangelion,* by locating identity in the minds of others: "There is no real me. I only exist inside those people who are aware of my existence."[22] And, in fact, Lain achieves her own version of topological collapse by subsuming her remaining images, removing herself from the world and the minds of her friends, leaving only a final grainy image of herself on a handheld Navi as evidence of her existence.

But, in fact, this final image is not the only evidence of Lain's existence. Arisu remembers Lain, if only instinctively. Hence, Arisu's final comment, "If you don't remember something, it never happened,"[23] is ultimately never completely put to the test.

The final topology of Lain's identity remains unclear. Has she retreated deep into the Wired, or to some other universe beyond the Wired? Is her final identity confined to a kernel of memory in Arisu's mind? Whatever the answer to these and other questions, we should keep in mind that when discussing the issues, problems, and representations of human identity, the spaces in which these discussions take place might be more complex than they seem.

Notes

1. Examples of both can be found, for example, in the *.hack* series, particularly the anime *.hack//Sign* (2002, dir. Mashimo Kōichi); 6 DVDs (Bandai, 2003–4), and the *Ghost in the Shell* series, beginning with the movie *Kōkaku kidōtai* (1995, dir. Oshii Mamoru); translated as *Ghost in the Shell*, DVD (Manga Entertainment, 1998).

2. See, for example, *Tekunoraizu* (2003, dir. Hamazaki Hiroshi); translated as *Texhnolyze*, 6 DVDs (Pioneer, 2004–5).

3. *Serial Experiments Lain,* dir. Nakamura Ryutarō, TV series, 13 episodes (1998); 4-DVD box set (Geneon [Pioneer], 2001), Ep. 8: "Rumors."

4. Ibid.

5. Ibid.

6. Although the theological implications of this ordering were vigorously pursued by the Catholic Church in the Middle Ages, the ordering itself is classical. See for example the sixth book of Cicero's *De re publica* (54–51 BCE, On the commonwealth) in which Scipio Aemilianus dreams of ascending through the heavens, observing the geometry of the celestial spheres, where, "in the center, the ninth of the spheres, is the Earth, never moving and at the bottom" (73). Marcus Tullius Cicero, *De re publica* VI.iv.3, in Macrobius, *Commentarii in Somnium Scipionis,* translated by William H. Stahl as *Commentary on the Dream of Scipio by Macrobius* (New York: Columbia University Press, 1952).

7. This view is elegantly summarized in Tom Stoppard's play, *Arcadia* (Boston: Faber & Faber, 1993): "If you could stop every atom in its position and direction, and if your mind could comprehend all the actions thus suspended, then if you were really, really good at algebra you could write the formula for all the future; and although nobody can be so clever as to do it, the formula must exist just as if one could" (9–10). In fact, if in this "formula for all the future" we replace t (time) with $-t$, we are able to run time backward and recover the past as well.

8. Many ancient cultures conceived of the Earth as flat. It is a widespread misconception, however, that this view lasted into the Middle Ages. In fact, the *Commentary on the Dream of Scipio* by Macrobius (see note 6) was a primary reference for medieval European scholars on many matters of cosmology.

9. Many advanced forms of transportation in science fiction are topological in nature: hyperspace, wormholes, singularities, and so-called tears in the "fabric of space." One in particular I find notable is the ability of the Guild Navigators, in Frank Herbert's novel *Dune* (Philadelphia: Chilton Books, 1965), to "fold space" and therefore "travel without moving."

10. For more current examples of creative use of topology in video games, see *Portal* and *Portal 2* (Bellevue, Wash.: Valve Corporation, 2007, 2011).

11. Since the speed of light is finite, all "distant" images will display past events.

12. Among these satellites is the Planck space observatory, launched in 2009 by the European Space Agency, and NASA's Wilkinson Microwave Anisotropy Probe (WMAP), launched in 2001.

13. For an accessible introduction to these topics, see Jeffrey Weeks, *The Shape of Space*, 2nd ed. (New York: CRC Press, 2002), especially 295–308. For a more detailed treatment, see the reference in the following note.

14. Neil J. Cornish, David N. Spergel, and Glenn D. Starkman, "Circles in the Sky: Finding Topology with the Microwave Background Radiation," *Classical and Quantum Gravity* 15 (1998): 2657–70, also available online at http://arxiv.org/abs/gr-qc/9602039. Moreover, the authors continue this paragraph with a discussion of the scientific ambiguity this phenomenon of "ghost" images leads to: "Many authors have sought to use this fact to limit the scale of the topology by searching for multiple images of recognizable objects. Unfortunately this approach is complicated by the fact that the different images will present the object at different epochs in its evolution, at different distances, at different redshifts, with different reddening factors, and from different perspectives. In all but a flat geometry, the images will also be stretched or compressed differently" (2).

15. *Serial Experiments Lain,* Ep. 8: "Rumors."

16. Ibid.

17. Adèle-Elise Prévost, "The Signal of Noise," illustrated by MUSEbasement, *Mechademia* 3 (2008): 173–88.

18. One can define the distance between two nodes as the length of the shortest path joining them together. However, this shortest-length path need not be unique.

19. There are, of course, infinite graphs. As a model universe for the Wired, however, the graph must be finite, as it is physically comprised of the sum of all human-manufactured electrical networks.

20. *Shin seiki evangerion,* dir. Anno Hideaki, TV series, 26 episodes (1995–96); translated as *Neon Genesis Evangelion: Platinum Collection,* 6-DVD box set (Gainax, 2005), Ep. 16: "Shi ni itaru yamai, soshite" (Sickness unto death, and . . .).

21. *Serial Experiments Lain,* Ep. 13: "Ego."

22. Ibid.

23. Ibid.

JINYING LI

From Superflat Windows to Facebook Walls: Mobility and Multiplicity of an Animated Shopping Gaze

In April 2009, Louis Vuitton released a new project with Takashi Murakami. The million-dollar collaboration between the French luxury brand and the Japanese artist produced a new collection of leather goods designed by Murakami, as well as a short animated video titled *Superflat First Love*. The romance story in this "first love" features a multicolor Panda who guides a teenage Japanese girl through a flood of LV monograms to meet young Louis Vuitton in the nineteenth-century France. Despite the title, *Superflat First Love* (2009) is actually the sequel to Murakami's 2003 video, *Superflat Monogram*, which, in a similar animation style, features the same cute Panda with big staring eyes, swimming in an ocean of the brand's multicolor monograms. And the moving images of both animated videos are deliberately flat, depthless, and floating, the signature visual style of what Takashi Murakami has famously defined and promoted as *superflat*.

Many have celebrated the distinctive visual sensibility of superflat art, which claims to be informed by Japanese visual cultures such as manga and anime, as a unique challenge to Western visual tradition of Renaissance perspective.[1] However, Murakami's superflat campaign for Louis Vuitton, as it turns out, is not alone in its fetishization of the luxury brand's graphic

trademarks with a depthless visual field. A simple Google search yields count-less user-created Louis Vuitton desktops, wallpapers, screensavers, and even a Louis Vuitton Facebook layout. These graphics, like Murakami's superflat art, all take the brand's now-iconic multicolor monograms as the visual cue for a deliberately flat surface. Unlike Murakami's, however, these depthless images are not for printed leather goods or video projectors but are for the screens of your personal computers. As a fashion blogger accurately commented: "Who needs skin, skateboards, or automobile bumpers when you can express your identity—or your brand obsession—by decorating your laptop?"[2] And "this paradoxical combination of individuality and corporate conformity," the blog-ger goes on, "works on any screen." Indeed, such a depthless image with over-flowing Louis Vuitton icons, like Murakami's superflat art, is the ideal format for any screen, from television to computer, from iPhone to iPad, whose ever flattened and enlarging surfaces are saturating our entire visual environment in this postcinematic age of the so-called media convergence.

What is more stunning about these depthless images is not just their ubiquity but their unnerving combination of personal identity with brand-name commodity or, to borrow that blogger's words, the "paradoxical combi-nation of individuality and corporate conformity."[3] When such combination is articulated through a flattened visual field, combination becomes equa-tion and interchangeability. In Murakami's superflat videos for Louis Vuit-ton, the brand's monograms are not just floating on the surface around the two-dimensional cartoon Panda but are also printed on its caricature body (Figure 1). This animated character is not just a consumer of the brand—it is the brand itself. And this cartoon Panda, with its staring, engaging eyes, as well as its smiling, posing, and camera-ready face (it poses for cellphone cam-eras on several occasions), is strikingly reminiscent of an anonymous female face that I encountered on the demo of the Louis Vuitton Facebook layout. That girl's face, like Murakami's Panda, smiling and self-displaying, floats on a flat surface saturated with Louis Vuitton monograms, and that surface is metaphorically—and aptly—defined by Facebook as the "wall." If the Face-book wall, as is marketed by this world-leading social network, is an articula-tion of your personal identity, then that wall in this case has nothing other than the abundance of a luxury icon.

Such flattened interchangeability between identity and commodity, between Facebook names and brand names, articulated through a depth-less visual mode called "superflat," evokes my questions in this essay. Since when, and how, have our individual identities become tie-in products of the brands we consume? And what are the roles of our changing modes of visual

perception, as well as subject formation, that are being played here informing, or informed by, this tendency toward increasing commodification of identity expression? Like Murakami's unnerving Panda who is continuously staring at us from the superflat surface flooded with Louis Vuitton logos, these questions will keep haunting us whenever we seek to decode such depthless visuality as a dramatic deviation from Renaissance perspective, whether we trace such deviation to premodern Edo paintings in Japan or postmodern surface play in America.

Moreover, such a nonperspective mode of visualization marks not just Murakami's superflat art or Japanese manga and anime but is increasingly dominating our entire visual culture, including cinema, television, video games, and the World Wide Web. The very ubiquity of such depthless visuality, from Murakami's superflat animation to Facebook layouts, suggests that what Murakami conceptualized as a unique Japanese artistic tradition has largely become an omnipresent and global visual mode. However, Murakami's notion of "superflat" still seems to be the best term to describe this trend of a nonperspective vision, despite the fact that the concept was originally coined within Japanese visual cultures. Therefore, borrowing Murakami's notion of superflat, this essay nevertheless seeks to reconceptualize and delineate superflat visuality away from Japanese visual traditions, and map it through

> THE VERY UBIQUITY OF SUCH DEPTHLESS VISUALITY, FROM MURAKAMI'S SUPERFLAT ANIMATION TO FACEBOOK LAYOUTS, SUGGESTS THAT WHAT MURAKAMI CONCEPTUALIZED AS A UNIQUE JAPANESE ARTISTIC TRADITION HAS LARGELY BECOME AN OMNIPRESENT AND GLOBAL VISUAL MODE.

the transforming landscape of computer technologies and new media, which, I will argue, are the defining forces in changing our modes of viewing, perceiving, and ultimately consuming. I will suggest that the so-called superflat should not be limited to a certain form of Japanese pop art but should rather be understood as a wide-ranging visual mode. It is not merely an inheritance from premodern Japanese traditions; nor is it simply a leftover from Andy Warhol's postmodern pop art. Instead, what is articulated through the encompassing superflat visuality is the still-transforming cultural logic of the cyber-age, marked by increasing mobility and multiplicity of screens, images, information, and gaze. Such a postperspective vision mobilized by cyber-technologies, I would further argue, implies a new spatial-temporal structure of subject position that is ultimately propagating and propagated by a heightened state of commodity experience. Therefore, by mapping the paradigm shift from Renaissance perspective to superflat vision, this essay hopes to address the technological nature behind the changing modes of perception and subject formation as a "new cultural logic" of the cyber-age consumer capitalism.

WHAT IS SUPERFLAT: MESSAGE OF THE MEDIUM OR LOGIC OF THE AGE?

Marshall McLuhan once famously said: "The medium is the message."[4] One cannot help but wonder: Is superflat an articulation of the message? The message of what medium? For Murakami, that medium is Japanese animation—often called "anime"—whose unique visual style of remarkable flatness and negation of depth is widely claimed to be the influence and inspiration of Murakami's notion of superflat. To be fair, the notion of flatness in anime cannot be simply interpreted as completely depthless. But instead, the sense of depth in anime, according to Thomas Lamarre, is rather "a strange depth," because anime organizes its images to create depth (or lack of it) in a manner dramatically different from the conventional photographic or pictorial illusion of depth.[5] Fashioning what Lamarre calls "superplanar" imagery, in which the image is densely packed with too many complex layers that all appear equal

and without hierarchy, anime's "flatness" is often marked by a crushed sense of "depth" that dramatically *lacks a unified linear perspective*. Unlike the perspective convention that holds a single viewpoint into a homogenous depth, the superflat imagery in anime rather fashions a *heterogeneous* space that often results in a radically different viewing experience.[6] Instead of looking into the three-dimensional depth toward a single vanishing point, the superflat imagery directs viewers to scan *across the surface*. Such a surface-oriented vision without a unified linear perspective probably best describes the superflat visuality that is celebrated by Murakami.

The superflat vision in anime is also reinforced through its overt emphasis on lateral movement. By preferring lateral sliding over motion-in-depth, anime tends to flatten movements and moving visions within the two-dimensional space on the surface. And this marks anime's dramatic departure from the visual convention of live-action cinema. Governed by Renaissance perspective, cinema since its very birth has largely preferred an in-depth view of motion. For instance, in the Lumière Brothers' *Arrival of a Train at La Ciotat* (1897), the camera is positioned at an oblique angle to create a sensational in-depth view of a moving train.[7] Such an astounding view of motion-in-depth served as an early cinematic spectacle in the "cinema of attraction"—such as the "Hale's Tours" series—which often positioned the camera to align with a train's direction to produce the viewing sensation of moving *into* the landscape.[8] Unlike cinema's obsession with an in-depth view of motion, however, anime fashions a totally different viewing sensation of a lateral movement across the field (instead of into it). As noticed by Lamarre, in many animes the vision from a moving vehicle is often portrayed by the lateral movement of background planes.[9] Such a vision of moving laterally often provides viewers an alternative sensation of speed and motion—a sense of floating and weightlessness, as if our viewpoint is flying across the landscape.[10]

The notion of flattened movements in anime, moreover, is also manifested by its unique way of creating movement within a single static image, which extends the notion of superflat visuality from *spatial orientation* to *temporal organization*. Animation artist Norman McLaren once famously said: "Animation is not the art of drawings-that-move, but rather the art of movements-that-are-drawn. What happens between each frame is more important than what happens on each frame."[11] As insightful as it is, however, McLaren's notion of "movements-that-are-drawn" is apparently not the only way to create animation. Contrary to McLaren's famous statement, anime not only tends to move drawings instead of drawing movements but also frequently creates movement precisely by "what happens on each frame" rather than "what

happens between each frame." And this is especially the case in anime when heightened emotions and violent actions are portrayed by still images with exaggerated facial expressions and body gestures. Instead of creating a stream of movement by "animating" a series of images, anime rather generates a "static movement" by using one single still frame as a moment-in-motion—it is essentially *a motion in an image* rather than *an animation between images*. Such a flattened motion within a static frame is very similar to Eadweard Muybridge's locomotion photography, which is arguably a reverse of the process of cinema and animation proper. Instead of creating an "illusion" of fluid movement through projecting sequential images, superflat anime, like Muybridge's photography, rather dissects a movement into individual stills. Such motion in stills implies a *dramatic transgression of temporality*. Like frozen frames in live-action cinema, the still motions in anime create a frozen moment, a flattened temporality that breaks linear progression into sudden timelessness.

If the superflat vision that I described above is the message of anime, then that message seems to be a direct antithesis to the message of another medium: live-action cinema. For "apparatus" film theorists, cinema is an ideological machine that genealogically inherits linear perspective from Renaissance paintings. The cinematic apparatus, in spite of occasional exceptions, consistently retains the convention of perspective through various means, including single-lens camera and projection that enforces a singular point-of-view (Jean-Louis Baudry), as well as linear narrative and continuous editing that disavows disjunctions and maintain a unified perspective (Stephen Heath and David Bordwell).[12] Although there has been some serious criticism of apparatus theories, the complex relations between Renaissance perspective and photographic cinema still largely remain the top subject of film critiques. With its flattened space, lateral slidings, and still-image motion, the superflat imagery in anime fashions itself as a dramatic paradigm shift from cinematic perspective. Its superplanar image and lateral movement challenge Renaissance convention's governing of *space* by providing multiple—instead of singular—viewpoints and subject locations, and its emphasis on the frozen motion in a single image—instead of sequential movement between images—further disrupts cinematic *temporality* that is also regulated by perspective conventions. Such a paradigm shift puts forward a new way of looking and perceiving, which implies multiple perspectives scanning across the surface instead of a singular viewpoint looking into a distant vanishing point. And this shift of perception fashions a highly mobilized gaze. As Murakami puts it, superflat should be characterized primarily in "the way that a picture controls the speed of its observer's gaze."[13]

For Murakami, the message that is articulated by superflat—a mobilized gaze that challenges linear perspective—is distinctively "Japanese." Tracing back to "ukiyo" paintings in Japan's Edo-era, superflat is regarded an essential part of what could be considered "Japaneseness." And superflat's intrinsic challenge to Western perspective, in Murakami's own words, is "a sensibility that has contributed to and continues to contribute to the construction of Japanese culture."[14] Murakami is actually not alone in his nationalist appropriation of superflat into Japaneseness. According to Thomas Lamarre, there is a whole school of "otaku discourse" that seeks to establish a linear genealogy of superflat visuality that continues from the premodern culture of Edo Japan to the postmodern culture of anime and manga.[15] Not unlike apparatus film theory that is comfortably settled with a direct teleology from Renaissance paintings to cinema, the otaku discourse is based on the assumption of a direct and unquestioned genealogical continuity from Edo paintings to superflat anime.

Of course, one can easily dismiss such a nationalist discourse of "Japaneseness" as nothing more than a valuable trademark—a "pop-exotica" of Japan that can be sold to a global market. As pointed out by Marc Steinberg, Edo exists for Murakami less as a real historical period than as a consumable "database of elements," and "the nationalist appeal to Japanese tradition—or a unique Japanese senility— is a marketing strategy, a selling point."[16] But what is at stake here is not simply to dismiss Murakami's nationalistic discourse but to realize that "superflat" as a visual aesthetics is not distinctively "Japanese." Nor is superflat's challenge to Renaissance perspective a unique message of anime. But instead, the superflat vision has increasingly become (or is becoming) a global cultural trend in the cyber-age, and its message is being articulated across various media that are rapidly converging. Among other things, the current revival of the comic-book culture in Hollywood is probably just one illuminating example of a blockbuster version of superflat "manga-films" or "animated comic strips."[17] Indeed, superflat is becoming (if it has not yet become) a global trend. As pointed out by Andrew Darley, the global mainstream visual culture nowadays "is largely given over to surface play and the production of imagery that lacks traditional depth cues."[18]

In fact, as early as the 1980s, the superflat aesthetics had already manifested in many American science fiction films. For instance, Ridley Scott's *Blade Runner* (1982), which was influenced by the dense visual style of the contemporary comic magazine *Heavy Metal* and by famous cartoonists such as Moebius, Angus Mckie, and Phillippe, exhibits spectacular visual complexity with dramatically transgressed scale and perspective.[19] The film's

stunning cityscape images largely echo the tightly packed superplanar imagery in anime and superflat arts. Indeed, put side by side, the superflat images in Murakami's artworks look strikingly similar to the visual density in *Blade Runner*—they are all "super-flattened" by complex and compacted layers and visual details. Such flattened and surface-oriented spatial density, which is displayed in many 1980s American films, is what Vivian Sobchack called "hyperspace"—a space that is "semantically described as a surface for play and dispersal."[20] Such a hyperspace could be either a "deflation of space" (e.g. the two-dimensionality and superficiality in *TRON* [1982]); or an "inflation of space" (e.g. the visual density and complexity in *Blade Runner*); or both (e.g. the "busy, eclectic, and decentered mise-en-scene" in *Liquid Sky* [1982] and *Repo Man* [1984]).[21] To a certain degree, the superflat imagery in Murakami and anime could be classified in Sobchack's third category of hyperspace. It is both a deflation of space by flattening it with an excess of surface and an inflation of space by saturating it with an excess of visual complexity, and the result is what Sobchack called "excess scenography":

> Elements of the mise-en-scene once arranged in space to represent depth now arrange themselves shallowly on and across space. . . . The effect is a material overload that exceeds visual grasp and gives everything, everyone, and every activity a certain non-hierarchy equivalence.[22]

Such a hyperspace popularized by the flattened spatial representation in American cinema, Japanese anime, and Murakami's superflat art, to some degree, is informing and informed by the transformation of real architectural space in postmodern cityscapes—Hong Kong, Tokyo, Los Angeles, and New York—that are all saturated with depthless surfaces of shining glasses and giant plasma screens. As Scott Bukatman says: "The new monument is no longer the substantial spatiality of the building, but the depthless surface of the screen. This is a transformation literalized in *Blade Runner* by the proliferation of walls which *are* screens."[23] Indeed, as Anne Friedberg observed, the transformation of imaginary space in cinema and television coincided with the transformation of the material reality of built space that is increasingly moving toward expansion and multiplicity of glasses, surfaces, and screens.[24] And the ultimate triumph of depthless surface in our physical space, not surprisingly, is also carried over to the now-flourishing cyberspace. Facebook's billion-dollar "wall" is probably just one indication.

From the imagery space in *Blade Runner* to the real space of Tokyo, from anime's surface-oriented superplanar to Facebook's more than 500 million

"walls," it seems that the visuality of superflat is not the specific message of one particular medium but rather points to a new cultural logic of our current age. Indeed, we should be reminded that before Murakami coined the term, "superflat" was in fact a well-advertised model name for Panasonic's flat-screen television. The sense of "superflatness" has become such a cultural norm in

the digital age that almost any design for consumer electronics—from LCD televisions to ultrathin cell phones— tries to evoke a cliché imagination of flatness and slimness. To a certain degree, the predominance of "superflat" almost renders its countercurrent— the increasing obsession with 3-D computer graphics in cinema and video games—seem like a reaction against the very loss of depth in contemporary visual cultures. The virtual "embodiment" in the 3-D imagery construction manifests the anxiety

> FROM THE IMAGERY SPACE IN *BLADE RUNNER* TO THE REAL SPACE OF TOKYO, FROM ANIME'S SURFACE-ORIENTED SUPERPLANAR TO FACEBOOK'S MORE THAN 500 MILLION "WALLS," IT SEEMS THAT THE VISUALITY OF SUPERFLAT IS NOT THE SPECIFIC MESSAGE OF ONE PARTICULAR MEDIUM BUT RATHER POINTS TO A NEW CULTURAL LOGIC OF OUR CURRENT AGE.

toward the very lack of bodily experience in superflat visuality, which is largely a disembodied vision mediated through new media technologies.

According to Sobchack, the prevalent visual flatness in our current cultural environment is a semantic response to electronic media, which is a system of simulation without the "original" and thus "has to attract spectator interest at the surface."[25] Such a reading of the "electronic simulacra" as the ontological base of visual flatness echoes with Thomas Looser's interpretation of superflat as "characteristics that are tied to digital as opposed to analog," because the digital operates in a system that lacks the "interior self" (the real) and thus "can be thought of as 'flat.'"[26] Sobchack and Looser are certainly right in pointing to new media technologies as the condition of superflat visions. However, their ontological reading of the digital/electronic as "simulacra" and thus "flat," though theoretically sound, seems reductively to assume a direct and unquestioned connection between semantic depthlessness (e.g. lack of interior or original) of digital media and actual visual flatness of images. What about the technological and cultural practices that render such a connection possible? How does the simulacra nature of digital media result in the widespread flatness in visual cultures?

Instead of the ontological relations between new media and visual depthlessness, I would argue that the prevalence of the superflat visuality in our

current age has more to do with the discursive and material realties of cyber-technologies, which have radically mobilized and fractured our gaze from Renaissance perspective to surface-oriented visions. In her groundbreaking book *The Virtual Window,* Anne Friedberg traces the visual history from single-point perspective in Leon Battista Alberti's famous Renaissance metaphor of the "window" to the fractured and multiplied vision in Microsoft's commodified "Windows" system on the personal computer. According to Friedberg, the centuries-long dominance of perspective, though constantly being challenged by various technologies, media, and art forms, still largely holds our vision to a single image in a single frame. In the current cyber-age, however, "perspective may have met its end on the computer desktop."[27] With multiple "windows" coexisting and overlapping, the "windows" trope on the computer screen fundamentally formed a new vernacular system of visuality that is emblematic of the collapse of Albertian perspective. Instead of a transparent "window" to look through into a distant vanishing point, the "Windows" in computers overlap, obscure, and disorientate—they are "windows" that we don't see through.[28] The "virtual window" of the computer age—a new logic of visuality—is precisely the message that is being articulated in the visual field of superflat. As rightly pointed out by critic Raphel Rubinstein, Murakami's superflat arts "owe as much to computer screens as they do to Edo screens."[29] Indeed, the densely packed, overlapping, and disorienting multiplanes in superflat images literalize those fractured frames in Microsoft's virtual windows, they articulate the very sense of visual mobility and multiplicity in the cyber-age. Like those monstrous eyes displayed in Murakami's famous work *Wink* (2001), the mobilized gaze manifested in superflat is, by and large, a posthuman gaze mediated and augmented by computer screens.

Such a mobilized, posthuman gaze also implies a new generation of spectators, who are now often called "users." As Lamarre points out, superflat images are not simply flat but are "complexly flat."[30] Viewing such tightly packed, overcrowded and remarkably disorienting images is like "orienting yourself in a densely packed distributive field—a sort of information field."[31] And such viewing experience implies a new type of viewers —"one more comfortable with scanning for information and stacked windows of data."[32] Indeed, if superflat imagery resembles our computer screens that have increasingly been overpacked by stacks of windows, piles of web pages, and countless pop-ups, then the superflat vision would certainly strike the current cyber-generation as akin to their daily experience of hours of websurfing, Twittering and Face-booking. Moreover, the emergence of this new generation of viewers, who are apparently "equipped" with a highly mobilized gaze, has become (or is

becoming) a global phenomenon; the mobilized vision in anime and superflat art is also evidently present in other popular cultures, especially Hollywood cinema. According to Dana Polan, the "cyber-age films" in Hollywood, ranging from *Pulp Fiction* (1994) to *The Matrix* (1999), often fashion a computer screen–like style, which seduces our eyes with countless minute visual details that requires "constant spectator alertness."[33] Similarly, in Hollywood's recent CGI films, Deborah Tudor noted a new aesthetic system that she called "array aesthetics." Exemplified by the use of split-screens, as in Mike Figgis's *Time Code* (2000), and the multilayer images resembling comic strips, as in Ang Lee's *The Hulk* (2003), the effect of array aesthetics "evokes computer arrays in the form of simultaneous open windows," which often constitute "a new configuration of space and time."[34] Like superflat, array aesthetics that resemble layers of computer windows also evoke a new type of viewers and viewing experiences. According to Tudor, array aesthetics is caters to a new generation of audiences who "are often quite comfortable working simultaneously with an array of multimedia devices," browsing computer windows while watching TV or listening to iPod.[35] To a large degree, array aesthetics are Hollywood's own version of superflat, with their fractured and multiplied layers (arrays, windows) of audiovisual information and mobilized multimedia experiences. Indeed, both array aesthetics in Hollywood and superflat in anime and Murakami imply a new generation of spectators, who are, in Friedberg's words, "beholders of multiple-screen 'windows,' . . . [who] see the world in spatially and temporally fractured frames, through 'virtual windows' that rely more on the multiple and simultaneous than on the singular and sequential."[36]

DECENTERED (AND DATABASED) SELF: POSTMODERN SUBJECT OR MOBILIZED CONSUMER?

Renaissance perspective has constantly been critiqued for its particular ideological function: constructing a unified modern subjectivity through its fixation of a singular viewpoint. The superflat vision, in contrast, with its lack of such a unified and hierarchized single point of depth, seems to radically challenge the system of modern subject formation. Thus, the superflat subjectivity, with its decentered and fractured "self," is often described as "postmodern."[37] Indeed, superflat's overt emphasis on the surface and depthlessness is dramatically in tune with the often-inflated discourses on postmodern, such as superficial simulacra (Baudrillard), decentered subjectivity (Derrida), and "a new depthlessness" with the disappearance of history

(Jameson).[38] Such discourses on postmodenity, as it turns out, are also extremely popular in Japan, a nation that has constantly been celebrated as essentially and uniquely postmodern. Thus, it is not surprising that language of the "postmodern" is precisely what Hiroki Azuma uses to analyze Murakami's superflat art.[39] But ironically, when Azuma charted a clean diagram illustrating a somewhat reductive genealogy that positions "postmodern" as a linear historical progression after "modern," he seemed to forget that the definition of "postmodern" often involves the very loss of history as such. In fact, as rightly noted by Anne Friedberg, the " 'p' word" has been overused, inflated, and destabilized to such a degree that the debates are often infused with "many epistemic assumptions that the theorists of postmodern themselves would challenge—the ontology of history, the denotative certainty of definition."[40] Indeed, as we are increasingly being positioned, in both popular and academic discourses, in the postmodern landscape of the postmodern age, the overarching notion, with its threatening totalization of everything and everywhere, starts to lose meaning. Furthermore, when the decentered superflat subjectivity is too easily coupled with the notion of postmodern, it forecloses all possibility of understanding the concrete material and discursive practices that popularize such superflat vision into so-called postmodernity. In other words, by reading superflat vision simply as a symptom of the postmodern condition, we ignore the fact that this vision may also be a contributing cause of such a condition.

But if not simply the "'p' word," then what is the best way to characterize the cultural condition of superflat subjectivity? As a highly mobilized gaze propagated by computer and digital technologies, the superflat vision, in fact, entails a heightened experience of consumerism, which renders superflat a unique cultural logic of cyber-age capitalism. It is in the cultural and technological relations between a mobilized gaze and consumer capitalism that superflat finds it entry into postmodernity. Indeed, as pointed out by Friedberg, the cultural condition of the postmodern can only be understood "in terms of virtual mobility of everyday life."[41] For Friedberg, the (post)modern condition—the decentered and detemporalized subjectivity—is the result of the increasing cultural centrality of a "mobilized 'virtual' gaze" that has always been imbued with the power of "commodity-experience"—the desire of shopping and consuming.[42] This virtual gaze, which used to be only partially mobilized by cinema and television, is now dramatically mobilized, multiplied, and fractured by the superflat vision of computers and the Internet. It is such a highly mobilized consuming gaze in the cyber-age that actually forms the cultural condition behind superflat's decentered subjectivity.

Such a mobilized, virtual gaze as subject construction for commodity-experience seems to be precisely what Murakami is implying in the aptly titled *Eye Love Superflat,* which is among the artworks he provided for Louis Vuitton (2003, Figure 2). Like his previous superflat artworks, Murakami uses floating, staring, and weightless eyes as a metaphor for a mobilized gaze. That gaze, as is suggested by the smart homophonic pun ("eye" as "I") in the title, is also a decentered subject. But the eyes (or "I"s) here are not just floating in an ambient space. They are happily swimming, together on the same sur-

FIGURE 2. *Eye Love SUPERFLAT,* 2003. Acrylic on canvas mounted on board, 100.0 × 100.0 cm. Copyright 2003 Takashi Murakami/Kaikai Kiki Co., Ltd. All Rights Reserved.

face, with equally afloat and weightless Louis Vuitton multicolor monograms. When the gaze is metaphorically represented by such flat and weightless but cute and seemingly innocent eyes, the gaze is not only mobilized but is also flattened and abstracted, both spatially and temporally; the superflat visuality projects the spectator into a depthless construction of spacelessness and timelesness. Or to borrow Friedberg's words, that floating eye in Murakami's superflat image is a mobilized virtual gaze from "elsewhere and elsewhen."[43] More importantly, when that gaze is put side by side, on the same surface, with the commodity at which it is supposed to be gazing, the look becomes the looked-at, the consumer becomes the consumed. Indeed, in Murakami's *Eye Love Superflat*, the color, size, and shape of the eyes are such a perfect match with LV icons that the eyes completely blend in with the surrounding monograms. The positions of the eyes are also positioned orderly within the monogram pattern. Upon first look, one might even mistake the eyes as round-shaped buttons sewed on Louis Vuitton leather goods. The "eyes"/ "I"s in Murakami's superflat vision, therefore, are an integral part of the commodity matrix. And the gaze (the "eye"/"I," the subject), though mobilized, is also confined within that well-ordered architecture of commodity experience (the perfect LV pattern). Just as Anne Friedberg described, "the shopper is dialectically both the observer and the observed, the transported and confined, the dioramic and the panoptic subject."[44]

The shoppers that Friedberg describes are the ones that still go to shopping malls. But increasingly that type of shopper is being replaced by the

virtual ones on the cyberspace. In the cyber shopping malls, from Amazon to eBay, from Yahoo to Google, from Facebook to Twitter, the mobilization of the gaze is pushed to a whole new level. Now, our vision is completely "free," and we are literally window-shopping every day and everywhere. Whenever we open our Internet browsers, we are bombarded with virtual displays of all kinds of consumer goods, from Chanel handbags to NongShim instant noodles. To borrow a now-classic quote from the anime film *Ghost in the Shell* (1995)—"the net is vast and infinite." What a perfect depiction of our cyber-malls! The flattened interchangeability between consumer identity and consumed commodity—as is articulated in Murakami's superflat images—is now celebrated as a new cultural norm, when our personal life is reduced to a set of data that is calculated, analyzed, and then delivered back to us as "personalized marketing," in which our identities are nothing more than a list of products that the computer, or the website, decides we'd like to purchase. Through the virtual shopping window of the Internet, our gaze and subjectivity is not just flattened and decentered, it is *databased and computerized*. And the widespread superflat vision in the cyber-age may well be a manifestation of such a databased self.

At the end of the twentieth century, Microsoft, the "corporate Goliath" in computer world, ultimately capitalized our fractured vision into its commodified "Windows."[45] Now in the new millennium, it is Facebook, the new Goliath of cyberspace, that has most successfully commercialized our databased gaze (and subjectivity) into a billion-dollar business, and it operates through a more-than-perfect metaphor: the wall. On the virtual walls of Facebook, which, not surprisingly, bear striking visual similarity to Murakami's superflat images, the postmodern subject is not just decentered and derealized into a spaceless and timeless gaze (e.g., flattened, floating eyes in Murakami's paintings; two-dimensional, digital "faces" on Facebook walls), but that subjectivity itself also becomes a sellable good. In Facebook, our databased selves—the sets of data documenting our private and personal lives—are valuable commodities that can be openly traded in the free-market economy. In that sense, the superflat visual field (the wall) in Facebook gains a new level of meaning. Our databased gaze in those posing, smiling, and self-displaying faces is just one of those commodities, being displayed and waiting to be purchased

in flattened cyberspace. Despite the much-publicized controversy over Facebook's infringement of privacy, our computerized, sellable, and displayed selves, in fact, are not alone on Facebook but are everywhere in every corner of the ever-expanding space of the Internet. As Zadie Smith said about Facebook:

> Maybe it will be like an intensified version of the Internet I already live in, where ads for dental services stalk me from pillar to post and I am continually urged to buy my own books. Or maybe the whole Internet will simply become like Facebook: falsely jolly, fake-friendly, self-promoting, slickly disingenuous.[46]

After all, Facebook is just one of those stacking windows on our computer screens. Friedberg's notion of a "virtual window," from Alberti's metaphor to Microsoft's product, is basically describing the apparatus that is organizing our gaze—from linear perspective in Renaissance paintings to multiplied and fractured vision on computer screens.[47] But when that gaze becomes a mobilized virtual gaze in the service of commodity experience, that "virtual window"— from cinema to television to computer—becomes a shopping window, or in Friedberg's words, a "spatial and temporal construction of consumerism."[48] And that "spatial and temporal construction," one is tempted to say, may have acheived perfection in the virtual architecture of the Facebook wall. The metaphorical transformation from Microsoft windows to Facebook wall vividly manifests a new level of paradigm shift that has further changed our ways of seeing and perceiving in less than twenty years. The "windows" trope in Microsoft, with its mixed metaphors of having both a "window" (which implies looking into) and a "desktop" (which implies overlapping above), maps a computer space that is "both deep and flat."[49] The "windows" may be overlapping, obscuring, and opaque, but they still invite us to imagine a space beyond them, if not see through them. But when the "window" is completely blocked and flattened into a "wall," we lost all sense of visual transparency and depth, and what is left is the ultimate darkness of the surface, and surface only, and nothing beyond the surface. Now there is nothing to see through, and the mobilized gaze can only go wandering on the superficial wall, like Murakami's floating eyes. And eventually, the floating, wandering gaze becomes nothing more than a commodity experience. Finally, the apparatus of the Facebook wall is a complete superflat construction of consumerism—weightless, timeless, and depthless.

To conclude this essay, let's go back to Murakami's artworks, the "original" superflat. For his collaboration with Louis Vuitton, Murakami created

two anime videos: *Superflat Monogram* (2003) and *Superflat First Love* (2009). Both have very similar visual styles and almost identical narratives. In both a teenage female shopper (the girl is always introduced in front of a Louis Vuitton store) is somehow "swallowed" by the Louis Vuitton Panda. Although this unnerving scene seems to suggest a dark vision of consumers' loss of identity to consumed goods, such anxiety is rather quickly dissolved by subsequent sequences featuring a cheerful journey, in which the girl is lead into a fantasy space flooded with loads of Louis Vuitton monograms. In the classical superflat style, the "dreamland" of Louis Vuitton is visualized as deliberately flat, depthless, and lacking a unitary perspective. The girl's flying motion, also in typical superflat fashion, is depicted as lateral and surface oriented, giving a strong visual pleasure of floating and weightlessness (Figure 3). As delightful as they are, however, both videos seem plagued with a sense of the uncanny and discomfort. When a YouTube viewer asked about the video: "Does the animation style bother anyone else?" quite a few viewers responded: "I'm bothered."[50] As one viewer puts it: "I don't get it. The girl got sucked into a weird monster fairy thing and she's smiling and pretending

FIGURE 3. Lateral and surface-oriented flying motion with a sense of floating and weightlessness, in *Superflat Monogram* (2003). Animated short video, 5 min. Copyright 2003 Takashi Murakami/Kaikai Kiki Co., Ltd. All Rights Reserved.

FIGURE 4. The female character, as well as her gaze, is framed within the shopping window of Louis Vuitton store, in *Superflat Monogram* (2003). Animated short video, 5 min. Copyright 2003 Takashi Murakami/Kaikai Kiki Co., Ltd. All Rights Reserved.

nothing happened. Plus when she popped out of the box she acted like 'oh look i'm 150 years in the past. cool. This is perfectly normal.' hmm . . ."[51] The viewers' comments suggest that those seemingly celebratory journeys in Murakami's superflat videos, in fact, are deeply ambiguous. The ambiguity can be seen from Murakami's uncanny framing choices. The girl—a shopper, a consumer, and ultimately a looker (her big eyes are always highlighted)—though seemingly "freed" into a fantasy land, her figure is often "prisoned" on the depthless surface within a certain frame—a door, a window, or a cellphone screen (Figure 4). These frames are precisely the "virtual windows" that Anne Friedberg is talking about, and these virtual windows, in Murakami's case, are also literalized as the shopping windows of a Louis Vuitton store. Murakami's superflat vision, therefore, seems to provide us a playful yet deeply alarming scenario about our mobilized subject/gaze in the cyber-age: by looking through the superflat virtual windows (Google, YouTube, Facebook), our vision is freed from the centuries-long governance of Renaissance perspective only to be captured by another century-long structure of the shopping window. That wonderland of elsewhere and elsewhen, toward which our gaze is happily mobilized, is nothing more than a "Garden of Louis Vuitton." Such a consumer-oriented, postperspective vision and subjectivity in the cyber-age is precisely what Zadie Smith is trying to warn us about in his comments on Facebook: "our denuded networked selves don't look more free, they just look more owned."[52]

Notes

1. Examples include: Michael Darling, "Plumbing the Depths of Superflatness," *Art Journal* 60, no. 3 (Autumn 2001): 77–89; Thomas Looser, "Superflat and the Layers of Images and History in 1990s Japan," in *Mechademia 1* (2006): 92–109; Kevin Dare, "Grinding Superflat—The Options," *Concrete* 39, no. 9 (September 2005): 28; Raphael Rubinstein, "In the Realm of the Superflat," *Art in America* 89, no. 6 (June 2001): 110.

2. Susan Scafidi, "Screen Scene," Counterfeit Chic web blog, November 17, 2008, http://www.counterfeitchic.com/culture_of_the_copy/ (accessed January 2 2001).

3. Ibid.

4. Marshall McLuhan and Quentin Fiore, *The Medium Is the Massage* (New York: Random House, 1967).

5. Thomas Lamarre, "The Multiplanar Image," in *Mechademia 1* (2006): 121.

6. Ibid.

7. David Bordwell noted that the film would lose all its dynamic energy if the scene were shot perpendicularly with another view of the train moving laterally across the screen. See David Bordwell and Kristin Thompson, *Film Art: An Introduction,* 8th ed. (New York: McGraw-Hill, 2006), 182.

8. T. Gunning, "The Cinema of Attractions," *Wide Angle* 8, no. 3–4 (1986): 63–70.

9. Thomas Lamarre, "The Multiplanar Image," 120–23.

10. Ibid.

11. Quoted in Charles Solomon, ed., *The Art of the Animated Image: An Anthology* (Los Angeles: American Film Institute, 1987), 11.

12. On apparatus film theory, see Jean-Louis Baudry, "Ideological Effects of the Basic Cinematographic Apparatus," trans. Alan Williams, *Film Quarterly* 28, no. 2 (Winter 1974–75): 39–47; first published in *Cinéthique*, nos. 7–8 (1970). On narrative and perspective, see Stephen Heath, "Narrative Space," *Screen* 17, no. 3 (Autumn 1976): 19–75; David Bordwell, *Narration in the Fictional Film* (Madison: University of Wisconsin Press, 1985). All of these essays have been reprinted in Philip Rosen, ed., *Narrative, Apparatus, Ideology: A Film Theory Reader* (New York: Columbia University Press, 1986).

13. Takashi Murakami, *Superflat* (Tokyo: Madora Shuppan, 2000), 9.

14. Ibid., 5.

15. Thomas Lamarre, "Otaku Movement," in *Japan after Japan: Social and Cultural Life from the Recessionary 1990s to the Present,* ed. Tomiko Yoda and Harry D. Harootunian, 358–94 (Durham, N.C.: Duke University Press, 2006).

16. Marc Steinberg, "Otaku Consumption, Superflat Art, and the Return to Edo," *Japan Forum* 16, no. 3 (2004): 467.

17. These two terms are often used to describe the superflat styles of anime; see Luca Raffaelli, "Disney, Warner Bros., and Japanese Animation: Three World Views," in *A Reader in Animation Studies*, ed. Jayne Pilling, 112–36 (London: John Libbey and Co., 1997).

18. Andrew Darley, *Visual Digital Culture: Surface Play and Spectacle in New Media Genres* (London: Routledge, 2000), 124.

19. See Scott Bukatman, *Terminal Identity: The Virtual Subject in Postmodern Science Fiction* (Durham, N.C.: Duke University Press, 1993), 132–34.

20. Vivian Carol Sobchack, *Screening Space: The American Science Fiction Film,* 2nd ed. (New Brunswick, N.J.: Rutgers University Press, 1997), 228.

21. Ibid., 255–72.

22. Ibid., 271.

23. Bukatman, *Terminal Identity,* 132.

24. Anne Friedberg, *The Virtual Window: From Alberti to Microsoft* (Cambridge, Mass.: MIT Press, 2006), 101–39.

25. Vivian Sobchack, "Toward a Phenomenology of Cinematic and Electronic Presence: The Scene of the Screen," *Post Script* 10, no. 1 (Fall 1990): 56–58.

26. Looser, "Superflat and the Layers of Images and History in 1990s Japan," 97–98.

27. Friedberg, *The Virtual Window,* 2.

28. Ibid., 229.

29. Rubinstein, "In the Realm of the Superflat," 115.

30. Lamarre, "The Multiplanar Image," 136.

31. Ibid., 137.

32. Ibid., 138.

33. Dana B. Polan, *Pulp Fiction*, BFI modern classics (London: BFI, 2000), 38.

34. Deborah Tudor, "The Eye of the Frog: Questions of Space in Films Using Digital Processes," *Cinema Journal* 48, no. 1 (2008): 96.

35. Ibid., 102.

36. Friedberg, *The Virtual Window,* 243.

37. Examples include: Steinberg, "Otaku Consumption, Superflat Art, and the Return to Edo"; Hiroki Azuma, *Otaku: Japan's Database Animals,* trans. Jonathan E. Abel and Shion Kono (Minneapolis: University of Minnesota Press, 2009).

38. Jean Baudrillard, *Simulacra and Simulation* (Ann Arbor: University of Michigan Press, 1994); Jacques Derrida, *Writing and Difference* (Chicago: University of Chicago Press, 1978); Fredric Jameson, *Postmodernism, or The Cultural Logic of Late Capitalism* (Durham, N.C.: Duke University Press, 1991).

39. Azuma, *Otaku.*

40. Anne Friedberg, *Window Shopping: Cinema and the Postmodern* (Berkeley and Los Angeles: University of California Press, 1994), 10–11.

41. Friedberg, *The Virtual Window,* 245.

42. Friedberg, *Window Shopping.*

43. Ibid.

44. Ibid., 115.

45. Friedberg, *The Virtual Window,* 3.

46. Smith, "Generation Why?"

47. Friedberg, *The Virtual Window.*

48. Friedberg, *Window Shopping.*

49. Friedberg, *The Virtual Window,* 227.

50. See users' comments on the YouTube post of Murakami's video: "Superflat First Love by Takashi Murakami for Louis Vuitton," YouTube website, http://www.youtube.com/watch?v=yqaXxSBZTZc&feature=related (accessed January 2, 2011).

51. Ibid.

52. Smith, "Generation Why?"

EMILY SOMERS

New Halves, Old Selves: Reincarnation and Transgender Identification in Ōshima Yumiko's *Tsurubara-tsurubara*

The cover illustration to Ōshima Yumiko's *Tsurubara-tsurubara* (1999, Rambling rose, rambling rose) depicts an androgynous child, in a nightgown, preparing for sleep.[1] Illustratively reminiscent of English literature's most famous gender-variant child, L. Frank Baum's Princess Ozma, Ōshima's drawing emphasizes the character's youthful naturalness in regard to gender ambiguity.[2] About to enter into a dream, the toddler's naïveté of conventional norms permits a freer expression of transgender tendency. This child is the boy Tsugio who will later, with the onset of pubescence, experience great distress as the socializing demand for culturally sanctioned forms of bodily performance casts shame and uncertainty on what had once seemed an instinctive tendency toward gender versatility.

Ōshima's *Tsurubara-tsurubara* (hereafter, *TS*) examines with an intimate lens the internal and external conflicts and tensions that a gender-variant child undergoes through the self-affirmation that occurs in the process of transition. Tsugio, who self-consciously identifies himself as female through the name of Tayoko, resists the external pressures of masculine conventionalization within Japanese society. While transgender phenomena have recently been the subject of several novels and television dramas in Japan,

TS uniquely emphasizes the intensely private world of identity formation in the constitution of trans-embodiment. Avoiding the more typical fixation on psychotherapeutic discourse common to most depictions of transgender phenomena, *TS* uses manga's imaginative mandate, as a genre that lends itself to visualization of paraphysical possibility, to elide medical presentations of sex reassignment. Instead of evolving as a pathological discourse of gender identity disorder—of hormones and orchiectomies—*TS* explores Tsugio's intuitive insistence on his/her multisubjectivity as both male and female at the level of consciousness. To emphasize the metaphysical nature of gender diversity, Ōshima situates Tsugio's gender variation within a vocabulary based on reincarnation: his transgender inclinations, as portrayed in *TS,* are not the result of a disordered psychological makeup, although the narrative raises this possibility. Instead, the text favors Tsugio's emphatic need to become Tayoko as directly connected to a sequence of past-life memories. Tsugio claims, from a young age, that he had previously existed as a woman, an existence that, because of karmic incompletion, requires him to be(come) Tayoko in the present lifetime. The persistence of Tayoko's memories enables the formation of a new subjectivity as a woman in his current life. Thus, *TS*, through a metaphysic in which past-life regressions intervene within the normative trajectory of gender acquisition, investigates how multiple subjectivities enable cross-gender identification. The process of transition, as Ōshima presents it, begins first as intensely cognitive, and only through this acceptance of internal diversity can the later external (bodily) adjustments be made in order to ease gender dysphoria. Enhanced by manga's capacity to present internal states of consciousness through illustration, *TS* takes a sympathetic interior view of Tsugio's developmental uncertainty as he experiments at transgender crossings until, ultimately, s/he undergoes a complete gender transformation in which the old self becomes his new half.

What makes *TS* so potent are its sets of related forces that inform the background to Tsugio's transition into Tayoko, in which both eventually coalesce as a spectrum of multiple-subject formation. Ōshima suggests, but does not insist on, the possibility for reincarnation as a catalyst for cross-gender identification, and that karma might act as a specific link in the chain of reincarnation. Yet, ultimately, she prefers to leave unresolved the meaning of telos through transition and transformation. Her depictions instead focus on tensions that resist easy categorization or explanation. Ōshima's illustrations explore consciousness as fluid and adaptive, rather than a basic metaphysical grounding of subjectivity. And, while she is not hostile to psychotherapy or in opposition to medical explanations for transgender identity, she evokes

a series of questions about gender and identity that undermine assumptions about the body as simply a physical grounding for the self-aware subject.

Ōshima's portrayals of transgender themes, published in the late 1980s in the shōjo magazine *ASUKA*, anticipated the growing visibility of GLBT issues in manga and anime. This trend has irritated conservative politicians. In December 2010, Ishihara Shintarō, the governor of Tokyo, spoke out against what he saw as a harmful proliferation of homosexuals readily turning up on television: "Gays are appearing nonchalantly on television, with no problem."[3] Ishihara's comments coincided with his support for the Revised Youth Ordinance Bill (*hijitsuzai seishōnen kisei*), a piece of legislation that would give various authorities the power to ban manga perceived to be harmful to youth.[4] Although the proposed bill seeks to confront the proliferation of X-rated sexuality—gay or straight—featured in manga, Ishihara directed his consternation at the increasing level of social acceptance within Japanese society for the GLBT community. This movement has acquired growing recognition, in part aided through popular (and educational) art forms such as music, television dramas, and manga. A particularly poignant moment of such visibility occurred during the 2007 *kōhaku uta gassen* (Japan's annual New Year Eve's singing contest). Prior to her performance of "Tomodachi no uta" ("A friendship song"), the transgender performer Nakamura Ataru— singing for the women's team—listened to a letter, written by her mother, read by one of the program's hosts. The letter briefly related an account of her mother's difficulties in understanding her son's—now daughter's—gender identity and eventual transition. The mother's sentiments concluded with a note of love, congratulations, and acceptance. Such a moment, through art and music, calls out for greater acknowledgment for all GLBT people in Japan. Given that the audience for *kōhaku* runs in the millions (being the premier annual time slot of Japanese television), the monumental level of awareness enabled through such personal and public witnessing cannot be ignored. Nakamura Ataru is not alone among transgender individuals across East Asia who speak openly about their transitions. Actresses such as Kawai Ikko in Japan and Harisu in Korea have undertaken a prominent form of activism by being out, active, and outspoken through their professional capacities. Harisu (Lee Kyung-eun), in fact, is one of a relatively few Koreans to have had their gender legally changed.

TS, THROUGH A METAPHYSIC IN WHICH PAST-LIFE REGRESSIONS INTERVENE WITHIN THE NORMATIVE TRAJECTORY OF GENDER ACQUISITION, INVESTIGATES HOW MULTIPLE SUBJECTIVITIES ENABLE CROSS-GENDER IDENTIFICATION.

Scholarship has at the same time provided additional attention to the particular social and political aspects to gay identities in East Asian cultures.[5] Wim Lunsing analyzes how, during the 1990s in Japan, an intensified interest in popular media circles brought about a "gay boom" in terms of appeal.[6] That transsexual issues have also received attention, both popular and scholarly, owes much to the advent of gay rights activism, particularly in Japan and Korea. Vera Mackie has provided a study of the emerging discourses surrounding transgender individuals in Japan, which include the legal, political, medical, and autobiographical.[7] Describing the enlarged mainstream interest for depictions of gender-variant experiences, Mackie explains, "Bringing transgendered narratives into the relatively mainstream spheres of mass market book publication and television has an important function in contributing to the recognition and of the belonging and citizenship of such individuals."[8] But Mackie's examples—most notably from a popular novel that was adapted for television: *Watashi ga watashi de aru tame ni* (2006, Because I am me)—have decidedly realistic and medicalistic approaches. While also deeply personal, such texts, written from a transgender perspective, focus on the practical implications of sex-reassignment: hormones, counseling, and other psycho-medical processes for transition. Although there is much educational benefit to such portrayals, as Mackie insightfully documents, there seems to be an elaborate fixation on surgical procedures in such portrayals of male-to-female transitioning, particularly in the West. Mainstream audiences are most curious about the external acts of transformation: the professional diagnosis and the becoming-procedures such as purchasing of gender-specific clothing or applying make-up, and the climactic hospital visit. Such presentations build a somatic narrative that ultimately requires pharmaceutical intervention to rationalize difficult journeys and painful adjustments. But transgender rights proponents have assessed that such prolonged attention to biomedical matters, in a way, can take on a somewhat lurid form of voyeurism. The narrative tends to become repetitive, as a curious public wants a surgeon's glance at the scientifically engineered resexing of a patient. Such a form of enquiry can shift attention away from the more difficult-to-quantify internal aspects of sex, self, identity, and subjectivity.

Ōshima's story, however, eschews the medicalization of gender reassignment by pursuing a more psycho-spiritual perspective. In this, she follows precedents from classical East Asian literature that at times invokes magical narratives that involve the changing of genders. Perhaps most famous of these is *Torikaebaya monogatari* (ca. twelfth century, *The Changelings*), in which two children—who both exhibit a preference for the social identities of

the opposite sex—are permitted to transition into the gender of their choosing.[9] In kabuki, the play *Sakura-hime azuma bunshō* (1817, *The Cherry Blossom Princess of Edo*) depicts homosexual eroticism as linked to a sequence of reincarnated spirits. Reminiscent of this play, a contemporary film about gay love and reincarnation recently premiered in Korea: *Bungee Jumping of Their Own* (2002, *Beonjijeompeureul hada*). From a manga perspective, *TS* examines a similar correlation between gender identity and reincarnation. Ōshima's illustrations do not dwell on the surgical aspects of gender transition, which is somewhat typical of most presentations of transindividuals, but rather explore the internal psychological profile of alternative gender identity acquisition in the constitution of physical transformation. Rather than fixate on the hormonal aspects of syringes or the cosmetics of electrolysis, *TS* develops—through the aesthetic possibilities for fantasia in manga—an ontology of reincarnation as enabling multiple selves, a pluralism that therefore effectively dismantles a fixed sense of binary gender formation. Tsugio's story of becoming Tayoko entails the confluence of old selves, new halves, in an interrelated process. Varying subjectivities, within the multilateral layers of consciousness, construct personal identities through a variegated sense of gender(s). Ōshima utilizes the illustrative power of manga to illustrate the internal and the external, thus documenting the increasing congruency between internal ideation and its interrelationship to physical presentation.

TS's metaphysical framework of reincarnation as circulating a network of multiple selves contrasts with the claims typical of a Cartesian singularity in the formation of personal identity. Emphasizing the indivisibility of the mind as an inherent unity, Descartes pursues a sense of self-conscious knowingness that lends itself to the art of autobiography in the singular. In terms of mind–body interaction, the subject animates its body, and in this relationship Descartes does not seem to permit any allowances for multiple personalities—as multiple subjects—that are capable of effecting different modes of control. From a perspective typical of European Enlightenment thinking, John Locke's analysis of the mind/body problem carefully distinguishes between *person* and *body*. With such distinctions in place, Locke assesses the intersections of mind and form as the mental and physical correlates in the performance of personhood. For Locke, importantly, memory engages reflexively with the field of consciousness in encountering those aggregates of thoughts and feelings to derive a sense of subject(s): "Nothing but consciousness can unite remote existences into the same person."[10] Yet, despite these mereological variables, Locke asserts that the body, as a static visual identifier, for the most part regulates not how an individual constructs an awareness of his or her

> IN PORTRAYING TSUGIO'S GROWTH FROM THIS PHASE OF BLISSFUL ACCEPTANCE INTO THE TRIBULATIONS OF PUBERTY, ŌSHIMA EMPHASIZES THAT TSUGIO, INHERENTLY, FINDS NOTHING WRONG ABOUT HIS SENSE OF GENDER IN THE PLURAL.

own person but how others identify said person through his or her body. In regard to his parable about a prince and cobbler swapping bodies, Locke acknowledges, after the transformation, "he would be the same cobbler to every one besides himself."[11] In the social world of appearances, as Locke claims, the body does much to make the man (or woman) as the prima facie marker. This is so much so, it seems, that consciousness goes along in regulated identification with the physical form: "Thus everyone finds that, whilst comprehended under that consciousness, the little finger is as much a part of himself as what is most so."[12] In his considerations, Locke even alludes to the possibility of reincarnation and multiple memories as potential modes for such a composition of personal identity out of the many. In referring to a man who claimed to be Socrates in a past life, Locke questions how, if a man claimed to have been Socrates previously, why then can he not recall Socrates' thoughts and actions? So, although appreciative of the diverging elements within consciousness, Locke tends to prefer a sense of mind/body that conforms to singularity: "But yet it is hard to conceive of Socrates, the same individual man, should be two persons."[13] Locke therefore concludes that it is "a contradiction that two or more should be one."[14]

Conversely, *TS*—through a phenomenology of reincarnation—argues for an irreducibility of the multiple senses that have the potential to form varying identities within consciousness; Ōshima explores this situation as a schema of gender fluidity and variety as experienced by some in the transgender community. Conventional gender, as an embodied discursivity enabled by carrot-and-stick social forces of recognition, bases itself on static parameters and on a dependability of set visual cues. But *TS*, with an anti-Delphic philosophy of *know thyselves*, dramatizes, through illustrations of the mental space as word and image of different voices, the complexity of gender identification as a dynamic, multiple process of selves-awareness. Tsugio/Tayoko depends on his/her own internal dimensions for an authoritative discourse that guides them through a process of gender crossing; in this case, s/he believes Tayoko to be his previous incarnation, and therefore a pre-presentation of a woman he still wishes to be in his current life. By illustratively sketching the plane of memory as including embodied experiences of (possibly) previous incarnations, Ōshima's manga diverges from more hyperrealistic depictions of gender-reassignment surgery by exposing the metaphysical dimensions of

multiplicity in the exploration of gender crossing. Tsugio seeks to become Tayoko, not only in thought and memory, as he first finds identification with her, but also in face and body. This need not lead to a unity of selves, a perfect changeover of one subject being erased to promote another. Rather, Tsugio/Tayoko must learn to trust in an intuitive sense of multiple persons within being, rather than seek psychological or medical authorization to diagnose some condition. *TS* employs the visual and textual lens of manga to peer into the transgender phenomena as subject (the preferential terms of gender self-reference), object (the necessary procedures for forming this transition in the body), and abject (the inevitable marginalization resulting from pursuing this transition).[15]

TS begins with a conversation between a very young Tsugio, perhaps only four years old, with his mother, who is involved in a typically domestic chore of hanging up the washing. Already keenly aware of a multigendered sense of himself, Tsugio describes to his mother a sequences of dreams he has in which, as a woman, he is also performing tasks around a house. The house, he understands, is a residual memory of an incarnated existence from before. Indirectly, Tsugio is also announcing to himself that he is in a kind of gendered stasis: although physically a boy, he has constant recall of a previous female embodiment, which seems to his mind as real as his current situation. Ōshima illustrates these impressions as floating images that enter into the frames of the physical world. Being so young, Tsugio is not constrained in his thinking by the biological and physiological realities of chromosomes, the rational realm of adulthood and its thoroughly entrenched semiotics of gender identities in which one, through binary dependency, must automatically exclude the other.

In portraying Tsugio's growth from this phase of blissful acceptance into the tribulations of puberty, Ōshima emphasizes that Tsugio, inherently, finds nothing wrong about his sense of gender in the plural. Only after he enters into the symbolic order of the great act of gender segregation—the Japanese school system—do his intuitive identities become a source of shame and then suicidal despair. On this point, Ōshima provides very blunt depictions of homophobic bullying (*ijime*) in Japan. In one particular instance, a group of boys leaves in Tsugio's shoe box (*getabako*) a second-hand girl's school uniform set: bra, socks, wig, and *seeraa-fuku* (girl's sailor-style uniform) (Figure 1). Rather than ignoring the clothes, Tsugio readily dons the skirt and middy blouse and attends classes that day, self-identifying as female with a look of both relief and complete comfort: as he tells himself, "Once I tried it on, it looked good on me."[16] Tsugio's classmates' varied response, emphasized through a

hallway sketch of faceless taunts, builds into a chorus: "Don't run away! You're human like us! New half! New half!"[17] They have suspected that Tsugio is gay. But even more scandalous to them now is that he is potentially a transsexual (nyūhaafu) who, given the first opportunity, would prefer to go through life presenting as a girl. In this case, being nyūhaafu is the more perverse breach of social norms.

Thomas J. Harper asks, in regards to the general level of tolerance for gender-variant behavior in contemporary Japan, "Where but in Japan would a weekly contest between respectable middle-class amateur transvestites, judged by professional transvestites, be broadcast on prime Saturday night family viewing time?"[18] However, as Judith Butler cautions, there has always been a general acceptance of counternormative gender behavior, so long as it is performed within a contextual framework that provides a legitimizing imprimatur: "Indeed, the sight of a transvestite onstage can compel pleasure and applause while the sight of the same transvestite on the seat next to us on the bus can compel fear, rage, even violence."[19] In this case, what might have been amusing if staged as a game show is a real-life example of gender variance that leads to bullying. Tsugio is not playacting; he's attempting to carve out a new gendered space as a girl in a Japanese high school. In popular Japanese argot, nyūhaafu describes a transitional space from one gender to the next, of a new half being fashioned as a counterpart to the old. The term can be empowering or derogatory, depending on its context. Tsugio insists that his transgender sense of himself is more than cosplay or josōshumi (a cross-dressing hobby). He wants to attend school as a girl, dressed as a girl, and be accepted as a girl, because he identifies as she. Only others insist on assigning an incorrect gender identity to him.[20]

Troubled by her son's intensifying inclinations, Tsugio's mother attempts to discredit Tsugio's transgender identification, as based on a sense of past lives and multiple selves, as a kind of neurotic defense mechanism. She tells Tsugio that his sense of being Tayoko, as derived from being a previous incarnation of Tayoko, is a diversion fantasy to avoid dealing with the psychosexual problem of his homosexuality. Put bluntly, she invalidates the Tsugio/Tayoko multiplicity by labeling this sense of multiple selves and past-life memories as an escapist way of legitimizing his homosexual orientation. Reminiscent of a moment explored in the Belgian film Ma Vie en Rose (1997, My Life in Pink), Tsugio's mother often wonders what is going on in her gender-variant child's mind. Tsugio identifies himself as having an internalized female identity, one that he seeks to embody; yet before his gender transition, he expresses same-sex attraction as his preference. Thus Mark McLelland notes accurately that,

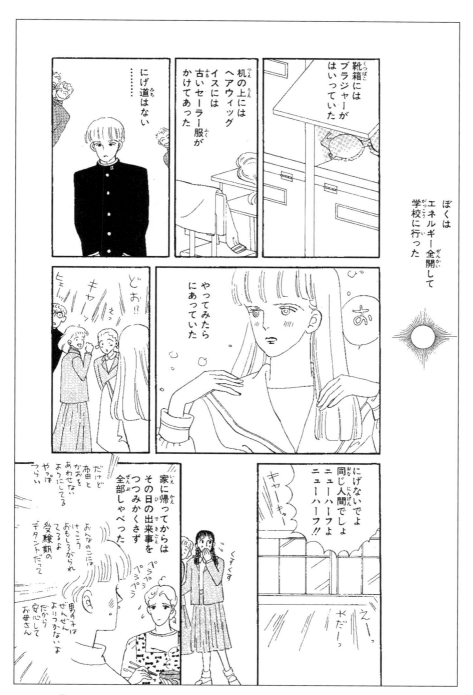

FIGURE 1. Tsugio asserts her gender identity, from *Tsurubara-tsurubara*. Copyright Hakusensha and Ōshima Yumiko.

although Japanese contains various terms for homosexuality and homosexual acts, "they all tend to conflate same-sex desire with transgenderism and transsexuality."[21]

The lack of understanding and acceptance, from within the home and without, proves to be emotionally unsustainable for Tsugio. Unable to continue comfortably presenting as male, but denying her wish to identify as female, Tsugio attempts suicide—a troubling incident that occurs frequently for transgender individuals. In a harrowing scene in which each box is inked in pure black, representing his efforts to erase his male body, Tsugio, as a teenager, tries to take his own life. As the manga's boxes shrink in a representation of a loss of consciousness, only an oxygen tube slowly penetrates the utter darkness of the page which lacks any illustration whatsoever, signifying that Tsugio's body is being resuscitated back into the symbolic world of rules and appearances (Figure 2).

Thus rescued, Tsugio spends a period of convalescence in hospital, but his/her problem has intensified, not diminished. Although sympathetic, Tsugio's mother attempts to analyze her child. Referring to Tsugio's sense of herself as Tayoko, through a previous incarnation, his mother most forcefully reiterates the claim that Tayoko is a psychosexual crutch: "It's your fantasy, I think. In order to justify your homosexuality, you've come up with this delusion in your head."[22] Emotionally vulnerable, this discrediting of his instinctual cross-identification with amateur psychologizing will insert continual self-doubt in Tsugio's mind, a doubt that will later resurface to threaten the completion of her transition as Tayoko.

But from the very beginning, Tsugio is emphatic about Tayoko's existence. In regard to his/her own self of multiple subjectivities in one body, the young Tsugio frequently describes the personalized presence of Tayoko as one of his halves whom he first encountered through forms of past-life recall (*zensei*) in dreams and memories. Most of Tsugio's initial encounters wherein he becomes Tayoko occur in the imaginative realms: by recollecting memories experientially produced in a previous incarnation as Tayoko, Tsugio recalls and reconstitutes a former subjectivity through dreams, recurrent hunches, and lingering postsentiments (*kako no shōjō*) of that lifetime. Gradually, Tsugio comes to identify more fully with Tayoko, at least in the sense that an approximation of Tayoko must be physically realized, embodied.

Although a paradigm of reincarnation—especially as Tsugio/Tayoko understands it—enables more than one sense of self to inhabit a single body, *TS* eschews any direct reference to Buddhist doctrines in order to situate its sense of reincarnation within a broader religious justification. On the contrary, *TS*

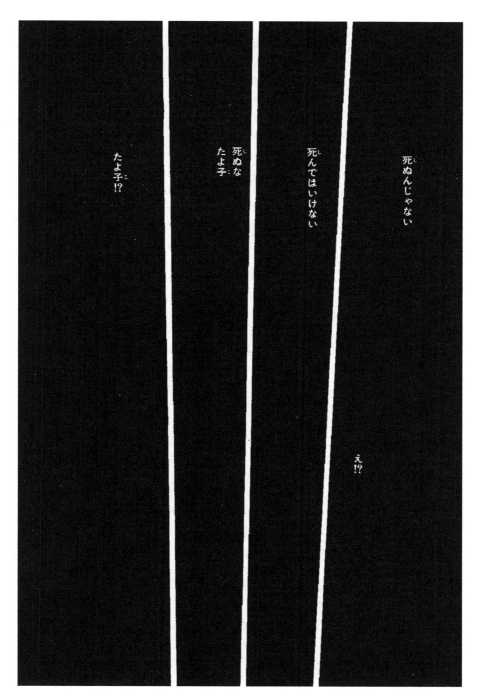

FIGURE 2. Tsugio attempts suicide, from *Tsurubara-tsurubara*. Copyright Hakusensha and Ōshima Yumiko.

emphasizes that Tsugio's intimations of having lived a previous existence as a woman and that a powerful remnant of that subjectivity is perpetuated into his current existence, occur through intense forms of intuition. Tsugio's transition to Tayoko is suggested to be from a catalyst of reincarnation, but Ōshima relates this possibility to Buddhist ontology in a very general way. Therefore, Ōshima resists employing religion as another form of discursive resolution—just as she eschews diagnostic psychology—in typecasting trans-gender phenomena. Ōshima, however, can rely on her Japanese readership to some sympathy, or least understanding, of reincarnation as a metaphysical possibility in interpreting Tsugio/Tayoko's condition. And eventually, rather than press for a rational explication, Tsugio's mother accepts that Tayoko's existence may well be a result of past-life regression. She does not require proof in order to see that this is Tsugio's interpretation of his condition, as a means of self-exploration of gender fluidity. His mother thus suggests that hypnotic treatment (*saimin ryōhō*) might uncover factors that, at that stage, more mainstream medication treatments had not accessed. Overall, neither mother or father act deliberately cruel to Tsugio. Rather, Ōshima's portrayal exposes the intrinsic difficulty in variant-gender performance and gender ac-ceptance, between the individual experiencing the inclination as natural and automatic, and his or her friends who perceive the behavior as unnatural and disordered.

Only in his late teenage years does Tsugio encounter a form of nonjudg-mental understanding that ultimately enables him to find the confidence to turn mental images into corporeal identities. Kanisawa, a young woman with whom Tsugio has a chaste friendship, augments Tsugio's desire to become Tayoko through her practice of unconditional acceptance of Tsugio's multiple selves. *TS* explores how, despite the intensely interior nature of alternative gender acquisition, at some stage the subject must either repress the instinc-tual desire for transition or else begin a difficult process of manifesting the desired gender identity in a performative, interpersonal way. Performance requires an audience, a receptive other who *reads* or accepts the new half as a force for validation and encouragement. This is very much what Kanisawa provides for Tsugio, relaying to him a therapeutic friendship as counterpoint to the horrors of his high school bullying. Kanisawa, in terms of feminine ap-pearance, has many of the stock characteristics of a shōjo heroine. In some ways, she is, as Toku Masami describes of shōjo portrayals, a "cute, innocent, and patient" girl in a conventional way.[23] Yet Kanisawa is revealed, emotion-ally, to be the most open-minded and accommodating individual in regard to Tsugio's sense of gender ambiguity and queer identity. Although references

to Tayoko never explicitly appears in their dialogue, the manga examines how their relationship—which involves frequent retreats for sky gazing—allows for an adjustment period in Tsugio's life in which he discovers the positive aspects in being honest and uncloseted. Their conversations are based on a purity of shared confidence and trust, as reciprocal acts of *shinrai* (confidence). Their mutual trust develops for each other a life-altering sense of openness and the possibility of unconditional acceptance. Rather than perceiving it as a source of shame, Kanisawa assumes Tsugio's unconventional identity to be entirely natural. Reflexively, this enables Tsugio to come to positive terms with his own internal sense of female authenticity. Thus, perhaps the most crucial moment in their brief companionship and the moment at which Tsugio determines to become Tayoko in body as well as spirit is when he tells Kanisawa, "So, at that very moment, I become neither Tsugio nor Tayoko."[24] In recognizing that neither fully exists, Tsugio realizes that both have the potential to exist, without one necessarily eliminating the other. With Kanisawa, he has the freedom to be variable. But through that freedom, he recognizes the particular subjective form as female-identified that he wishes to actualize. Tsugio has been *out* about his transgender identity since a young age, but through Kanisawa he finds the external confirmation necessary to make the exterior commitment to cross over, to transition, to make Tayoko physically apparent.

As many queer teens in the UK have discovered, London allows opportunities for coming out and being proud that provincial intimidation had precluded. Likewise, Tsugio departs for Tokyo from his hometown to begin his university studies. Once there, he quickly settles in Ginza, in its gay district, where he takes up employment at a bar—dressing as a woman and identifying as a woman, and eventually taking up a romance with a man. The narrative and illustrative atmosphere of *TS* notably opens up at this point—in image as well as word—as Tsugio now lives fulltime as Tayoko, which is the beginning of her formal, bodily transition.

The gay bar provides Tsugio/Tayoko a broader sympathetic audience through which he begins to encode his performance in terms of a sociocultural new-half, as marked feminine. This requires a kind of practice—or performative rehearsing, to use Butler's sense—of Japanese femininity. Given the critique that scholars have presented about woman's language and ideological performance in Japanese language usage, Tsugio's exploration—even as a rehearsal of the prescriptivist norms of feminine identity—would seem to require experimentation with the typical forms of woman's words for the purposes of presenting her authentic sense of herself.[25] Having adopted female clothing and other normative cultural signs of feminine gender, she begins

cognitively presenting herself through transgender self-reference by pronouns such as *atashi*. But rather than merely adopting a form of verbal drag, Tayoko's speech patterns function as sensitivity, as behaving according to the form of what is expected (*sekentei*). In this case, the *oneesan* style of speech she begins employing both suits the countercultural world of gay nightlife and the reaffirmation of her own process of committed transition. In Tsugio's transition into female subjectivity, in the new half of Tayoko, one would assume s/he would begin engaging in imitative presentations of socially normative female behavior. And thus, in terms of practical social engagements with the bar's patrons, Tayoko adjusts her language in accordance with whom she is speaking. Semiotic adjustments help to smooth over the crossing, as well as establish her own self-confidence: clothes, words, and make-up augment—rather than define—trans identity.

In describing the importance of Tayoko's use of *atashi* for the purposes of self-identifying, I do not mean to overlook the critiques of gender construction and discursive regulations of *joseigo* (woman's speech). Inoue Miyako, in particular, has emphasized how the assumption that *joseigo* is a natural element of the Japanese language is erroneous. Instead, such feminized linguistic patterns are "a mode of social formation and of the constitution of the subject": in this case, an imaginary subject conjured up for the purposes of consumer persuasion and national sentiment.[26] This is particularly so in the creation of cultural capital; magazines and television provide ample manifestations of the invented episteme of contemporary Japanese femininity. Mindful of Inoue's corrective analysis as to how woman's speech came to be instituted as a mode of discourse, gendered language nonetheless facilitates Tsugio's transformation into Tayoko. The illustrations reflect a process of gender transition that is gradual, as mind and body interact to form a sense of congruence. But Tsugio never engages in a kind of shallow mimesis, of imitating heroines from J-dramas. Clearly, Tayoko finds psychological relief and comfort in being *read* as female, and her friends in the night town of Ginza offer her receptive feedback and support. Embodying socially determined female signifiers—such as clothing and linguistic markers—helps to reaffirm a chosen transition despite the obvious potential for abuse and rejection from broader Japanese society, as her body retains characteristics of being born male. So, to assert the power of self-definition, in one of her most deliberate employments of feminized speech, Tayoko appears briefly on a local television program to discuss her real name (*honmyō*). Staring directly into the camera, she announces: "I'm Tayoko! I'm here! I died once, but I'm here!"[27] Through such stylized female speech, some might argue that Tsugio—as indicative of a

transsexual conundrum in general—merely reinforces the categorical impera-
tive of normative gender by assimilating as much as possible the conventions
of the other. Yet Tayoko's facial characteristics, although generically feminine,
still retain a certain degree of the masculine (Figure 3).[28] The effect of *atashi,*
self-identified through the speech as a trans person on television, emphasizes
her right to gender identity and expression within the public space.[29] In such
a combination of spoken word and physical appearance, Tayoko finds another
element in bringing congruency between mind, body, and presentation. She
has taken a publicized step of coming out, of breaching the discursive cordon-
ing off of gays and transsexuals, ghettoized into the gay district of Ginza, into
the realm of social visibility.

Ōshima is careful to remind the reader that being transgender entails a
more complex process than simply switching from one standardized self to
another. Much of the graphical layout of this manga, with its figurative boxes
that narrow or broaden according to Tayoko's comfort level, emphasizes the
problematic nature of conforming to reductive patterns of gendered subjec-
tivity. Tayoko/Tsugio continually struggles with a need for personal satisfac-
tion balanced against the necessary sacrifices to somewhat meet discursive
expectations of cultural norms. The visual content of Ōshima's manga var-
ies considerably in width, directly corresponding to the sense of freedom or
constraint that Tsugio/Tayoko's experiences in terms of mental and bodily
congruency. When Tsugio sets out for Tokyo, the bottom of the page opens up
into a series of lateral pathways, forming a maze-like structure with many po-
tential roads and no obvious exit. Such visual cues reiterate the psychological
patterns that occur for a trans person, whose quest for identification includes
the uncertainty in the changeover from one gender to another, of the spaces
in between, and of the ultimate unreliability for any single path to encapsulate
the multiplicity of identities within and transitions without.

Tellingly, Tayoko's appearance on television was immediately preceded by
an encounter with her parents, who failed initially to recognize their daughter
after her transition. Only when Tayoko readily readopts the stereotypically
male pronoun *boku,* which suggests a former subjectivity of being Tsugio,
do her parents register the confluence of identities in the transformed body.
A similar moment also occurs later in the story. Tsugio's father—now with
dimmed eyesight—does not notice Tayoko when she passes him in the street.
In order to verify identity and establish familiarity, Tayoko invokes the dis-
course of her previously assigned male subjectivity. She acquiesces to—but
also reassures—her father by saying, "OK, you always say so. Yes, indeed, I'm
Tsugio."[30] Thus, only when Tayoko partially restores Tsugio through *boku* does

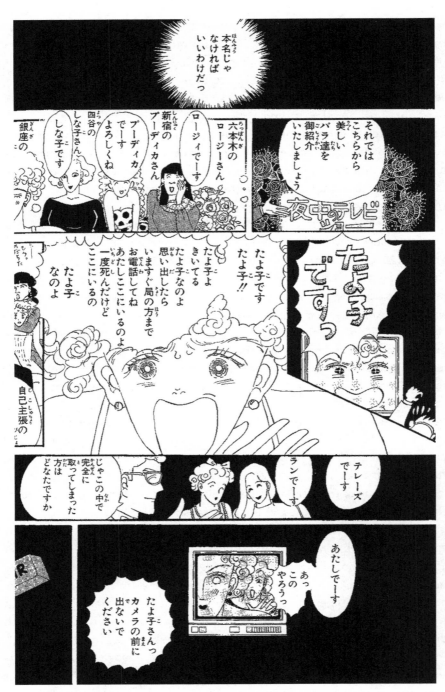

FIGURE 3. Tsugio, now fully transitioned as Tayoko, appears on television, from *Tsurubara-tsurubara*. Copyright Hakusensha and Ōshima Yumiko.

the father perceive the subject he previously distinguished as Tsugio. Tsugio continues to exist, in a fashion, although in a different physical form.

But Tsugio/Tayoko is not angry about having to retreat into a former module of identity in order to restore acquaintance with her father. Rather, Tayoko encourages her father not to dwell on terms of Cartesian singularity, of thinking of one mind interjecting through one body, of singular gender norms, but in terms of multiplicity and variability. She consoles him by insisting that her transition, and sense of multiple selves, does not fragment the shared continuity that is the history of their relationship. Instead of rebuke or confrontation or asserting that one subjectivity has erased another, Tayoko acknowledges that, in both her and her father's calculations, an ongoing remnant of Tsugio remains. In this remnant, Tayoko remembers her own past, and her father retains an ongoing presence of his son that allows him to accept the emergence of his daughter.

Nonetheless, this awkward encounter with her father causes Tayoko, shortly afterward, to experience something of a panic attack. Worried about her increasing age and generally fatigued from the emotional exhaustion of her adjustments, Tayoko briefly faints among the crowds of a humid Japan city. The strain in her body coincides with moments of internal self-reproach and self-doubt about the authenticity of transitioning, as well as the validity of her identification as a woman. Tayoko, repeating the accusation she heard from her mother as a child, critiques her own mental health as well as the legitimacy of *Tayoko*: "It's just like my mom told me before: it's probably only a crutch I just made up for myself."[31] In this instance, Tayoko/Tsugio reverts to *boku* as a way of retreating into a conventional norm of Tsugio, who is biologically, socially, and inescapably assigned as male at birth. And, rather than use a pronoun to refer to his feminine sense of subjectivity, *tsue* (crutch) here demotes Tayoko to the status of nonentity. *Tsue* had previously been his mother's term to pathologize Tsugio's sense of being a woman as being a fantasy, a kind of prop. Therefore, this climatic scene presents the most compelling moment of self-interrogation, self-authorship, and self-confirmation in the story. Tsugio now most directly asks his/herself not what Tayoko *means* but who she *is*: is the name of a former self of a past life, a psychical gimmick, or a vain delusion to satisfy his aberrant tendencies; or is it a name for who s/he truly is? In response to these questions, rather than seeking some kind of resolving rationalization, Tayoko/Tsugio allows the field of consciousness to be filled with dreams, reflections, and impressions of both lives. The manga's imagery depicts a vista of selves operating in different places, at different times. Reflecting on this multitemporal and multispatial panorama of desire

and fulfillment, being and identity, Tayoko/Tsugio accepts selfhood as a constellation of impressions that present themselves in various ways, rather than as a static, permanent self; the panic and dysphoria are overcome.

She reflects on the indeterminate nature of singular subjectivity by observing the various faces she (and he) has worn and been known by, saying to them all, "This and that, this and that . . ."[32] In this moment, Ōshima illustrates the osmosis of consciousness by positioning diversity and chance within floating forms of blended manga frames.

Indeed, much of this manga provides examples of what Itō Gō analyzes as the indeterminacy of the frame.[33] Ōshima allows mental impressions of gender identity to pass through the gaps between the frames, evidencing in a visual way the multilayering of selves, memories, and presentations. In this moment of self-authorship, in which images cross over from frame to frame, Tayoko/Tsugio realizes that the imaginative possibilities contained within the field of consciousness need not be categorized rationally or reified into a single subject or label. Ōshima's selfhood, rather than being a singular Cartesian *cogito* (Latin, "I think"), operates through variable identifications that constitute *cogitamus* ("we think"), a plurality. The premonitory dreams Tsugio had of previously being Tayoko have enabled him to visualize the form through which he could become Tayoko. And, therefore, the visions produced by his own creative imagination, whatever they might actually be ontologically, are nonetheless as real and valid as the generalized conventions conjured up by broader society that pressured the creation of Tsugio. Ōshima's metaphysical depiction, abetted through the visual dynamic of manga, enacts Sartre's analysis that "we may therefore conclude that the imagination is not an empirical power added to consciousness, but it is the whole of consciousness as it realizes its freedom."[34] Through the visual variability of manga, its transitions from internal to external figurations, Ōshima can enacts what Sartre implies.

Reincarnation, as a philosophical possibility, enables a sense of indeterminate framing of subjectivity, gender, and identity. But much of *TS*'s narrative deliberately leaves open the possibility as to whether Tayoko really emerges as some life-essence carried on from one incarnation to the next. There is no ultimate proof provided. Perhaps she is a psychological mechanism that Tsugio develops in order to name a new subjectivity for him, as a means to actualize his genderqueer identification. In the conclusion of the story, shortly after the panic attack in Tokyo, Tayoko fortuitously discovers the stone steps and rambling roses of the homestead that Tsugio had long since anticipated in childhood dreams. At this moment, the visual cues that had been illustrated as internal memories become realized, in a physical way, as external events,

just as Tsugio's notion of Tayoko has also become a social reality. However, the man who lives there, whom Tayoko presumes to be her husband from a previous incarnation, does not offer any specific confirmation, and thus the theory of reincarnation remains unresolved. Through discussion with Tayoko, the man reveals that Tsugio was born on the day he lost his wife, and that Tsugio's favorite food—honey tea and waffles—had also been enjoyed by his spouse. But there is no absolute resolution as to where Tayoko originates. The extent to which Tsugio's dreams of Tayoko had been either pre-presentations of his own gender transition or specters of past-life regression remain unknown. In this way, the text leaves open the question as to whether the reincarnation model somehow solves the reasons for the transgender phenomena. Importantly, the concept enables Tayoko to first address and understand her situation, but, ultimately, it is not required to somehow justify her transgender existence. The most important confirmation exhibited here is not whether Tayoko actually existed but that the Tayoko who must exist—Tsugio as female identified—does exist.

Therefore, Tayoko, in the final line of the story, employs *boku* one final time: "And I decided to perform in the next act."[35] *Boku*, at this instance, seems both natural and understandable, but at the same time illogical, since Tayoko seems most fully comfortable being herself. *Boku* implies that Tsugio remains a constitutive element of Tayoko, that he is still inside of her, and that they, in a fashion, dwell in physical form together in continuum. Ōshima is implying that, at least at the level of personal identity, gender is not a singularity in the scheme of genderqueering reincarnation. As the theatrical metaphor *maku* implies—of a curtain rising and closing on a stage—subjects are reborn many times, again and again. Ōshima illustrates how they do not need to be reduced to a single integration. Many identities exist within, and consciousness directs which version of identity should be articulated and made apparent; this process of formulation can be versatile, changing, and indeterminate.

Tayoko/Tsugio engages in the conscious selection of a female identity, augmented by gendered patterns, as a way of authentic and preferred self-presentation as the non-birth sex. However, this is not meant to delegitimize Tayoko as some form of cosplay fancy. On the contrary, the text demonstrates throughout the existential freedom to create one's own *honmyō* (true name) out of the varied schemata that fill consciousness. But *TS* also addresses the problematic gap between internal sensibilities and the manifestations of those feelings through the discursivities of words and bodies in the social world. In presenting Tsugio/Tayoko as inseparably linked in the production of queer identity, Ōshima illustrates how such attached labels of masculine and

feminine are, as Jacques Derrida describes in regards to the act of naming, "the trace of this wounded writing that bears the stigmata of its own proper inadequation."[36] Tsugio and Tayoko, as written in kanji, both contain markers that specifically denote a male (*o*) or female (*ko*) subject, and therefore are representative of orthodox masculinities and femininities determined by socialized biology and affirmed through conventionalized linguistics. Names like Tsugio or Tayoko in this way may be reductionistic for the sake of consistency. But they fail to provide a gestalt of the plural identities that *TS* portrays, a process of multitemporal and multilateral subject formation.

The title *Tsurubara* (rambling rose) provides a more dynamic account of the nonstatic variability that is Ōshima's philosophy of personal identity. As well as referring to the emblematic rose that bedecked the household of Tayoko's former life, the rambling rose suggests the process of crossing both in terms of gender and time. *Tsurubara,* a word not easily recognizable to Japanese readers, is actually a coinage (*zōgo*) of Tsugio's father. As a joke, he combines the words *tsuru* (crane) with *kame* (turtle), both traditional symbols of good luck and longevity. He crosses and interpolates these into the portmanteau phrase *tsurukame*, linked to the Shinto mantra *kuwabara kuwabara* (knock on wood), thus producing *tsurubara-tsurubara*. This blending of different creatures and magical words of power more suggestively alludes to Tsugio/Tayoko's multiplicity of blended identities.

TS confirms that, at the functional level, society predicates itself on fixed protocols for the assigned gender binary. Tsugio/Tayoko constantly struggles with intuitive sensations, of terrifying impressions of being assigned an inappropriate body (male) but having memories of being in the suitable one (female). In engaging in transgender identification and male-to-female transition, Tsugio shows awareness for the possibility that he, in becoming she, is repeating encoded illusions of a socially constructed femaleness. Like Gertie MacDowell in James Joyce's *Ulysses* (1922), the format of feminine subjectivity to some extent derives from advertisements, female novels, and so forth, in constructing a consumer demographic of *woman. Women's speech* and women's identities in Japan indeed result from such pressures, much as Joyce saw in Ireland. It is not easy to rest with the assumption that transformation automatically leads to empowerment. But, especially in terms of the GLBT community, it is equally discomfiting to dismiss Tsugio (and transgender people in general) as fantasists infatuated with a nationalized anima or animus of a pseudo-essentialist man or woman with whom they falsely attach themselves. This kind of dismissal resembles the rhetorical claim that homosexuals were mis-imprinted during puberty and can be *fixed* or *changed* with

the right form of cognitive therapy. Ōshima's portrayals of Tsugio's suicide attempts, as well as his rejection by various social realms, are reminders of the painful consequences of transgender lives. Although *TS* does not explore the enormous financial and physical costs of gender transition, its psychological intensity suggests that transgender folk often make enormous sacrifices at the personal and professional level, and surely these must be made for something other than a delusion or—in Tsugio's mother's terms—a crutch.

TS's unique contribution to queer writing is its combination of a somewhat linear timeframe—Tsugio's maturation into Tayoko—with the convergent frames of illustration that show the relationship of multiple identities. Genderqueering takes place in a dimension of something outside of time. In examining transgender identity formation through the paraphysical platform of reincarnation, Ōshima suggests that singular labels for gender will never really be accurate, since memories and ideas are reborn many times, again and again, and they do not necessarily integrate into a singular entity. *TS*, therefore, examines how an individual body may, in fact, have variable identities within, as a natural consequence of consciousness. The illustrated framework of this manga shifts from internal portraits of Tsugio's self-identification to external presentation, as new corporeal characteristics emerge through transition. This shift demonstrates how fluid and varied is the intuitive self-consciousness that determines which identity—and how much of that identity—is imagined, materialized, and individualized. The challenge for Tsugio/Tayoko is in the actualization of his/her life as a personally authentic exploration of these multiple possibilities, as arising from and enabled by the old selves and new halves.

Notes

1. My citations of *Tsurubara-tsurubara* (hereafter abbreviated *TS*) refer to the widely available paperback edition (Tokyo: Hakusensha, 1999). Much of Ōshima's work first appeared in the magazine *ASUKA* in the late 1980s. Originally, *Tsurubara-tsurubara* was serialized in magazine format in 1988. To my knowledge, little of Ōshima's manga is readily available in English, so all translations are my own. I would like to state my appreciation to Kaneda Emi for introducing me to Ōshima, and for our discussions about the philosophy underlying her stories. I also express my gratitude to the anonymous reviewers for their comments, and to Thomas D. Looser for his editorial suggestions.

2. Princess Ozma is a recurring character in L. Frank Baum's *Land of Oz* series, first appearing in *The Marvelous Land of Oz* (1904).

3. "Terebi nanka ni mo dōseiaisha ga heiki de deru deshō." *Mainichi shinbun*, December, 10 2010, http://mainichi.jp/area/tokyo/news/20101204ddlk13010267000c.html.

4. In response to the proposed bill, leading publishers such as Kōdansha and Shūeisha threatened to boycott the 2011 Tokyo International Anime Fair, which was eventually cancelled after the March 2011 Tōhoku earthquake. The legislation passed the Tokyo Assembly in December 2010, and there was a measure of public sympathy for the bill's efforts to restrict what some see as the excessive amount of X-rated content generally available in manga that becomes accessible to minors; how the vaguely worded bill will affect freedom of speech, authorial style, and what constitutes *harmful* subjects in manga remains to be seen.

5. See, for example, Chris Berry, "Asian Values, Family Values: Film, Video, and Lesbian and Gay Identities," *Journal of Homosexuality* 40 (2001): 211–31. For a comprehensive study on gay issues specific to Japan, see Mark J. McLelland, *Male Homosexuality in Modern Japan* (London: Routledge, 2000).

6. Wim Lunsing, "'Gay Boom' in Japan: Changing Views of Homosexuality," *Thamrys* 4, no. 2 (1997): 267.

7. Vera Mackie, "How to Be a Girl: Mainstream Media Portrayals of Transgendered Lives in Japan," *Asian Studies Review* 32 (2008): 411–23.

8. Ibid., 420.

9. For an English translation of this story, see Rosette Willig, trans., *The Changelings* (Stanford, Calif.: Stanford University Press, 1983). For an edition translated into modern Japanese, see Kuwabara Hiroshi, trans., *Torikaebaya monogatari* (Tokyo: Kōdansha, 1978). It is important to note that themes of cross-dressing and gender-shifting in this classical text arise from deeply seated imperatives within the characters rather than acting in a more Elizabethan mode of mistaken identities or intrigue conspiracies. Ōshima's focus on trans-identified people also differs considerably from manga such as Akahori Satoru and Katsura Yukimaru's *Kashimashi: Girl Meets Girl* (5 vols; Tokyo: Media Works, 2004–7) in which gender transformation is accidental, fantastically induced, and a cause for comedic interludes.

10. John Locke, *An Essay Concerning Human Understanding* (Middlesex: Echo Library, 2006), 227.

11. Ibid., 225.

12. Ibid.

13. Ibid., 209.

14. Ibid., 218.

15. The contentious relationship between internal senses of identity and subjectivity and their corporeal manifestations is a common theme is Ōshima's works. Her stories often portray forms of bodily dysphoria through the fantasia of paranormal manga. For example, *Daietto* (1988, The diet) satirizes the obsession with thinness and phenomenological interpretations of size. *Natsu no yoru no baku* (1988, A tapir in the summer's night) explores a Kafkaesque series of zoomorphic transformations. And *Mainichi ga natsuyasumi* (1989, Every day is summer vacation) playfully presents an alternate universe in which a person's physical age directly correlates to his or her level of spiritual maturity. Hence, a forty-year-old corporate megalomaniac regresses to infancy through the course of the story while still maintaining a selfishly adult consciousness.

16. "Yatte mitara niatte ita." *TS*, 31.

17. "Nigenai de yō! Onaji ningen deshō! Nyūhaafu! Nyūhaafu!" *TS*, 31.

18. Thomas J. Harper, "Review: *The Changelings*," *Monumenta Nipponica* 39, no. 4 (Winter 1984), 455–57.

19. Judith Butler, "Performative Acts and Gender Constitution," *Theatre Journal* 40, no. 4 (December 1988), 519–31.

20. Japan, unlike many Western countries, does not generally have gender unspecific school uniforms. There have been a number of recent court cases in which parents, on behalf of a child exhibiting transgender identification, have sought to enroll their son or daughter in school as the opposite sex as part of the process in transitioning. See the following link for a recent news story, in Japanese, about such an occurrence in Saitama: http://news.livedoor.com/article/detail/4643499/. There was also a similar case in Okinawa in 2009: http://ryukyushimpo.jp/news/storyid-142815-storytopic-1.html. Notably, these petitions have included both male-to-female and female-to-male examples. A child with transgender inclinations will frequently and emphatically be insistent on a preference for wearing the school uniform of the nonbirth sex. Such behavior can begin asserting itself at an early age, and such individuals express extreme psychological discomfort if their request is denied or discredited.

21. Mark J. McLelland, "Is There a Japanese 'Gay' Identity?" *Culture, Health, and Sexuality* 2, no. 4 (October 2000): 460.

22. "Sore wa ne, Tsugio no mōsō da to omou wa. Jibun no dōseiai o seitōkasuru tame ni, anta no atama no okubukai tokoro de enshutsushita mono yo." *TS*, 28.

23. Toku Masami, "Shōjo Manga! Girls' Comics! A Mirror of Girls' Dreams," *Mechademia* 2 (2007): 19–32.

24. "Soshite sono shunkan ni boku wa Tayoko demo Tsugio demo nakunatte iru no da." *TS*, 36.

25. Tayoko during this stage begins sprinkling her conversations with elements of *onee-san* speech, which critics have seen as a deliberate subversion of conventionally *feminine* Japanese speech when used in such a way by gay men. For a discussion on this style of language and its social coding within Japanese gay subculture, see McLelland, "Is There a Japanese 'Gay' Identity?" 47.

26. Inoue Miyako, *Vicarious Language: Gender and Linguistic Modernity in Japan* (Berkeley and Los Angeles: University of California Press, 2006), 15.

27. "Tayoko desu! Atashi koko ni iru no yo! Ichido shinda kedo koko ni iru," 58.

28. Although Japanese film and television feature many positive portrayals of trans-identified people, there are problematic and insulting depictions as well. Generally speaking, especially for male-to-female transgender individuals, one's ability to *pass* determines what sort of treatment a trans person receives in the media. For example, passing as a trans woman means the ability to conform to prevalent ideals about female beauty. For those who do not achieve such an idealized feminine presentation, because of secondary male sex characteristics such as voice, build, or facial structure, the reception can be one of outright ridicule, as in the *Mr. Lady* stereotype of a hulking cross dresser, or as comedic entertainment, such as is often the case with Matsuko Deluxe.

29. Digital social networks can be devastating for at-risk queer youths, as revealed by the 2010 suicide of Tyler Clementi at Rutgers University in New Jersey. Clementi took his own life after a private moment with a lover was illicitly broadcast on the Internet by his roommate. In the wake of this tragedy, however, social networking expert Dan Savage encouraged the GLBT community to take back the Internet: he called on queers worldwide to post personal videos that offered support and encouragement through the acclamation

that "it gets better." Videos made as part of this project, by celebrities and ordinary people alike, can be viewed at itgetsbetter.org. Notably, the film *Departures* (2008, *Okuribito*) begins with the main character sympathetically tending to the body of a trans woman who took her own life by carbon monoxide poisoning (*rentan jisatsu*).

30. "Itsumo sō iu ne. Sō da yo. Tsugio da yo." *TS*, 61.

31. "Mukashi, haha ga itta yō ni, kore wa boku no tsukutta boku jishin no tsue datta no kamo shirenai." *TS*, 66.

32. "Kore mo are mo kore mo are mo . . ." TS, 66.

33. Itō Gō, *Tezuka Is Dead: Postmodernist and Modernist Approaches to Japanese Manga* (Tokyo: NTT Shuppan, 2005).

34. Jean-Paul Sartre, *The Imaginary,* trans. Jonathan Webber (London: Routledge, 2006), 186.

35. "Soshite boku wa tsugi no maku o ageru koto ni shita." *TS*, 71. This phrase is a more positive revision of a statement made earlier by Tsugio, who had described his adolescent suicide attempt as the closing of the curtain. As he stated at that moment, "*Maku o orosō, jinsei no maku o*" (Let the curtain fall, fall on life) (23).

36. Jacques Derrida, *On the Name,* trans. David Wood, John P. Leavey, and Ian McLeod (Stanford, Calif.: Stanford University Press, 1995), 61.

Energetic Matter

YURIKO FURUHATA

Audiovisual Redundancy and Remediation in *Ninja bugeichō*

The 1950s and the 1960s saw a sudden proliferation of the term *eizō* ("image") among film and media criticism in Japan. Although the term *eizō* is often translated as "moving image," it also encompasses the still image medium of photography. The semantic parameter of *eizō* hence is much larger than the moving image. Nonetheless, it is also much more specific than the image in general. This has to do with the fundamental definition or presupposition of *eizō* as a mechanically produced image, mediated by technological apparatuses such as the camera and the screen. This mechanical connotation of *eizō* had been in place long before the 1950s. Interestingly, however, many influential critics and filmmakers, including Imamura Taihei, Matsumoto Toshio, and Okada Susumu, claim that they are the ones who first introduced or gave critical significance to this term in the 1950s.[1] In other words, there was a collective understanding among the Japanese film critics and theorists that a new definition of *eizō* was developed in the postwar period. This claim to newness is indeed tied up with the changing media environment, and the increased currency of this term in the 1950s and 1960s points to a symptomatic oscillation between the desire to define cinema exclusively in terms of its medium specificity and the desire to theorize cinema through its relation to other media, including television.

Consequently, the familiar paradigm of medium specificity saw a strong resurgence during this period, though concern with the specificity of cinema was inseparable from an imminent threat of its disappearance. If the semantic parameter of the word *eizō* shifted, as Imamura, Matsumoto, Okada, and others claim it did in the 1950s and 1960s, then it did so precisely because of the increased difficulty of isolating cinema from other forms of visual media. This was the time when cinema lost its privileged position as a hegemonic medium of the moving image and became just one type of the *eizō* or image-based media. Cinematic experiments of this period suggest that this concern with the medium specificity of cinema was particularly strong in the avant-garde filmmaking milieu. This essay will look at an exemplary case of such experiment undertaken by Ōshima Nagisa in the 1967 film *Ninja bugeichō* (Band of Ninja) in order to shed light on how this tension around the medium specificity of cinema in the age of multiple *eizō* or image-based media played out in actual filmmaking practice. This essay's focus on the formal characteristics of redundancy and intermediality in *Ninja bugeichō* and its resonance with the theory of avant-garde documentary will complement Miryam Sas's in-depth analysis, published in this volume, of the film's engagement with the problematic of violence.

INTERMEDIALITY AND AUDIOVISUAL REDUNDANCY

The film *Ninja bugeichō* premiered at the legendary Shinjuku Bunka theater in Tokyo on February 25, 1967. It was screened as a double bill with Ōshima's earlier controversial work *Night and Fog in Japan* (1960, *Nihon no yoru to kiri*).[2] Based on the comic writer Shirato Sanpei's 1959–62 *gekiga* with the same title, the film *Ninja bugeichō* is a meticulously filmed and edited version of the original *gekiga* that sits somewhat uncomfortably between comic book and animation. Set in the feudal era of the sixteenth century, *Ninja bugeichō* presents an epic narrative about a series of peasant revolts aided by an anonymous band of ninja called the "Shadow Clan" (*Kage ichizoku*). As the title suggests, the focus of the narrative is on the activities of this enigmatic Shadow Clan, who stealthily incite mass insurgencies against the feudal lords. Unlike mainstream manga, which caters to children, *gekiga,* which primarily targets a young adult readership, emphasizes dramatic (and often violent) actions and complex plot structures. This genre emerged and developed in the late 1950s as a kind of underground art form, though it quickly became commercialized. At first, promoters presented this genre as a grown-up alternative to

mainstream manga.³ Shirato Sanpei was one of the leading *gekiga* artists who not only made this genre popular but also, in the words of Ōshima, offered "an alternative model of activism and philosophy" to politically conscious left-wing students.⁴ In other words, the primary readers of *gekiga* during the 1950s and 1960s were mainly students and young workers. Given Shirato Sanpei's underground and left-leaning background, it is not surprising that Ōshima turned to Shirato's work at the time when he was deeply interested in politicizing cinema.⁵

What is interesting about this film is how Ōshima uses a technique of direct appropriation or remediation to highlight the recognizability and presence of the original medium of *gekiga*.⁶ Ōshima developed this technique through the making of his 1965 experimental short, *Yunbogi no nikki* (Diary of Yunbogi) (Figure 1). The film is composed entirely of still photographs. As one may recognize from the production date of this work, Ōshima's experiment with still photography came right after Matsumoto Toshio's comparable remediation of still photography in his 1963 film, *Ishi no uta (The Song of Stone)* (Figure 2). These two films are strikingly similar in their exclusive use of still photographs. However, this emphasis on stillness is not limited to these particular works. For instance, they resonate strongly with contemporaneous experiments undertaken by European filmmakers such as Chris Marker's 1962 film *La Jettée* or Agnès Varda's 1963 film *Salut les cubains*. In fact, the affinity and contemporaneity of these works is something that Matsumoto himself addresses in his 1967 essay, titled "Experiments with Forms of Expression" ("Hyōgen keishiki no jikken").⁷ The experience of having worked in the field of documentary filmmaking, which historically has made great use of still images, perhaps helped these filmmakers to directly remediate still photography into cinema. Also, one could argue that Ōshima's decision to directly film Shirato's comic book without translating it into cel animation is based on economics: it is much cheaper and less labor-intensive to rephotograph comic book frames rather than to redraw them. But I think there was something else at stake in his decision to shoot *Ninja bugeichō* in this manner, a reason that cannot be simply reduced to economic factors or to the conventions of documentary filmmaking.

There are two reasons to believe this. First, Ōshima regarded *Ninja bugeichō* as his major accomplishment, and he even compared his undertaking of this project to Eisenstein's unrealized project of creating a filmed version of Marx's *Das Kapital*. Much like Marx's *Das Kapital*, Ōshima argues in one of his memoirs that "making a filmic version of Shirato's *gekiga* was considered to be impossible at the time."⁸ He also notes that he wanted to make an

FIGURE 1. *Diary of Yunbogi* (1965, *Yunbogi no nikki*, dir. Ōshima Nagisa).

FIGURE 2. *The Song of Stone* (1963, *Ishi no uta*, dir. Matsumoto Toshio).

adaptation of Shirato's *gekiga* as early as 1962, but it was only after he made *Diary of Yunbogi* that he discovered the method necessary to realize his dream. This method, as I mentioned earlier, is remediation, a practice in which the aesthetics or formal traits of one medium are incorporated

into another medium. The second reason to believe that Ōshima's deployment of remediation was not simply economically driven comes from his use of a strange neologism to describe this film. When advertising this film, Ōshima made use of an awkward expression, *chōhen firumu gekiga* (which might be translated as "feature-length film-dramatic comic book") (Figures 3 and 4). This awkward coinage indicates Ōshima's desire to foreground the coexistence of two distinct media forms. Because of the combination of the words "film" and "comic book," this neologism explicitly draws our attention to the intermedial nature of the work.

The inventiveness of *Ninja bugeichō* indeed lies in its refusal to mimic the standard form of cel animation. Strictly speaking, none of the figures that appear in this film are animated. There is no attempt to create an illusion of movement emanating directly from the drawings. Instead, the only movements that appear on screen are generated by the camera, and these movements are extrinsic to the drawings.[9] Ōshima refused to redraw comic panels onto cels or to draw extra frames to supplement missing motions. Instead, he opted for the method of remediation, directly filming Shirato's original drawings frame by frame using not a professional animation stand but a makeshift device. Ōshima and his crew placed the original drawings against a board set in the living room of his home, and filmed over 10,000 images drawn with paper and ink. Since they were not filming transparent cels, they had to use high-key lighting and overexposure to emphasize the whiteness of the paper and to suppress smudges, extraneous pencil lines, and uneven brushstrokes.[10]

Nevertheless, the finished film still retains some of these traces and attests to the materiality of the original medium of the comic book. Tactile textures of paper, ink, and pencil not only come through in Ōshima's remediated version but semiotic markers of the comic book medium (such as word bubbles, speed lines, onomatopoetic words) are also present on screen. The presence of these visual elements—highly irregular from the perspective of the mainstream practice of animation at the time—contributes to the distinctively intermedial look of the film. To use the expression of Noël Burch, *Ninja bugeichō* is essentially "an exercise in dynamizing still pictures."[11] But what

FIGURE 3. The cover of the *Ninja bugeichō* (1967, Ōshima Nagisa) brochure.

FIGURE 4. The inside spread of the *Ninja bugeichō* brochure.

does it mean to say "dynamizing still pictures"? Is not all animation based on the process of dynamizing still pictures? Here, it is useful to compare the style of *Ninja bugeichō* to the standard practice of limited cel animation, which became dominant in Japanese television in the 1960s.[12] A crucial difference between the animation style of *Ninja bugeichō* and the conventional style of limited cel animation has to do with Ōshima's method of remediation.

First, Ōshima does not try to compensate for the lack of movement in the original drawings by adding extra drawings. Instead of concealing this lack of movement, he highlights it. For instance, the film has no "in-between" frames. The standard practice of animation requires drawing two kinds of images: first, you need the "key frames" that serve as a reference point for onscreen movements of characters or objects; and second, the so-called "in-between" frames that fill in the missing trajectories of these movements. Because these "in-betweens" generate the overall sensation of movement in animation, we might say that *Ninja bugeichō* is solely based on the sequence of key frames.

The resulting effect is curious. The film draws our attention to the material gap or dissonance between cinema and comic book. Hence, what is at stake here is not the complete absorption of one medium by another but their coexistence that creates a sense of "intermediality."[13] But, the intermedial

outlook of *Ninja bugeichō* is not only determined by the lack of in-between frames. There is something more, which I would like to call audiovisual redundancy. That is to say, the film contains redundant elements that are usually minimized in the animated adaptation of a comic book.

The first and perhaps most obvious example is the film's inclusion of word bubbles and onomatopoetic words. For instance, we often *read* onomatopoetic words on the margins of the panel as we *hear* sound effects corresponding to these words. This creates a strong sense of audiovisual redundancy. In Figures 5 and 6, for instance, we can read the onomatopoetic words for the sound of a galloping horse and the sound of a peasant breathing heavily. This redundancy again heightens the material gap between the film and the original comic book. The preservation of word bubbles contributes to this sense as well. While we hear the voice-over speech

FIGURE 5. An onomatopoetic word for the sound of a galloping horse ("paka paka") legible in *Ninja bugeichō*.

FIGURE 6. An onomatopoetic word for the sound of heavy breathing ("haa haa") legible in *Ninja bugeichō*.

of characters, we often see the remnants of word bubbles above or next to the drawn characters (Figures 7 and 8). In the standard practice of Japanese television anime, which often adapted popular manga, these graphic elements of the comic book were eliminated at the production stage. The animators usually do not reproduce word bubbles and onomatopoetic words on cels, because they want to generate a sense of movement in the three-dimensional space. Such graphic elements would draw attention to the two-dimensionality of the image. In fact, having moving characters or objects next to static word bubbles and onomatopoetic words would heighten a visual dissonance between multiple layers of the cel animation and thus undermine the unity of the diegetic or narrative space. In other words, word bubbles and onomatopoetic words would undermine the life of animation: the illusion of movement. As graphically rendered semiotic signs, word bubbles and onomatopoetic words signify

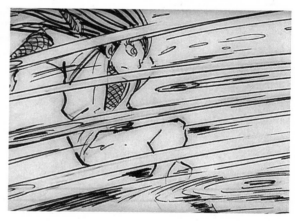

FIGURE 7 (ABOVE, LEFT). A word bubble signifying a battle cry in *Ninja bugeichō*.

FIGURE 8 (ABOVE, RIGHT). A word bubble signifying a character's speech ("Die") in *Ninja bugeichō*.

FIGURE 9 (RIGHT). Speed lines signifying the movements of the character and flying objects in *Ninja bugeichō*.

the silent and motionless medium of the comic book; these are elements that attest to its medium specificity.

Hence, it is not surprising that television animation eliminated these graphic elements as a standard practice and replaced them with voice-overs and sound effects. Another graphic element often erased from the animated comic book adaptation was the speed line. Speed lines also function as a semiotic code that signifies the velocity of a moving object or character. Shirato's original drawings are indeed filled with these speed lines and Ōshima faithfully preserves them instead of erasing and replacing them with animated movements (Figure 9). The result is a particular kind of pictorial dynamism, which is quite different from the dynamism of television animation.[14] By preserving these elements of audiovisual redundancy, Ōshima's film heightens the material and semiotic differences between cinema and the comic book, all the while allowing these two media forms to coexist in the same visual space.

AVANT-GARDE DOCUMENTARY FILMMAKING
AND THE PROCESS OF REMEDIATION

The sense of intermediality in question here is inseparable from the strategic use of remediation, in which the form of one medium is incorporated into another medium. When used consciously, this technique of remediation heightens one's awareness of the supposed specificities of different media forms. As I noted earlier, this question of medium specificity was central to the discourse on *eizō* or the image that arose in the 1960s. Ōshima's experiment with the comic book in *Ninja bugeichō,* in this sense, was not an isolated event. Rather, it was part of the larger cultural, medial, and discursive transformations taking place during this decade. At the heart of these transformations was a tension between the desire to preserve cinema's medium specificity and the desire to absorb it into a general category of *eizō* media. In order to further contextualize *Ninja bugeichō* in relation to the discourse on eizō, let me turn to the preceding work of Matsumoto in this concluding section.

Matsumoto's theorization of avant-garde documentary filmmaking in the late 1950s anticipates some of the experiments undertaken by Ōshima and Matsumoto himself in the 1960s. Here, it is helpful to turn briefly to Matsumoto's theorization of avant-garde documentary filmmaking in his 1958 essay "On the Method of the Avant-Garde Documentary Film" ("Zen'ei kiroku eiga no hōhō ni tsuite"). This classic essay merits our attention for two reasons: first, it is here that Matsumoto introduces his idea of the dialectical synthesis of avant-garde and documentary, which he borrows from Marxist critic Hanada Kiyoteru; second and more important for the present discussion, this essay shows how the question of remediation was integral to his idea of avant-garde documentary filmmaking.

Matsumoto finds an inspirational model of avant-garde documentary filmmaking in the work of Alain Resnais. More precisely, he finds it in Resnais's treatment of Pablo Picasso's painting *Guernica* in his documentary film of the same name. In this film, Matsumoto argues, the camera constantly crops, fragments, and pans over immobile objects (mostly paintings but also newspaper headlines and sculptures).[15] According to Matsumoto, Resnais's refusal to reproduce Picasso's painting in full view indicates his willingness to become a visionary, a seer who refuses to take what is visible and self-evident. Instead of simply using the camera to record and reproduce Picasso's painting in its entirety, Resnais uses the camera to fragment it. His willingness to inflict violence on the original painting in this manner is an indication of his desire to see beyond what is already visible. Matsumoto writes:

While Alain Resnais takes Picasso's *Guernica* as its object, he does not de-
pend on the strength of this material alone. Of course, the image presented
in each shot is always some part of Picasso's painting. Yet, what these im-
ages embody is no longer Picasso's painting; they embody the "Picasso seen
by Resnais" or the "Resnais seeing Picasso." . . . Here, the naïve idea of docu-
mentation has already been negated.[16]

Matsumoto thus locates the central significance of the film in Resnais's will-
ingness to sacrifice the integrity of the original painting. The decision to frag-
ment and undermine the painting's organic unity as an artwork indicates a
shift away from recording the surface of reality to recording the very process
of seeing beyond that surface.

Matsumoto interprets Resnais's gesture, his avoidance of showing Pi-
casso's painting in full view, as an indication of his will "to *see* Picasso's paint-
ing, but not to simply *show* it."[17] This privileging of an interrogative mode of
seeing resonates with Matsumoto's own filmmaking practice. From *Security
Treaty* (1960, *ANPO jōyaku*) to *Nishijin* (1961, The weavers of Nishijin) and
to *The Song of Stone* (1963), his documentary works are equally character-
ized by his refusal to show the object of investigation in full view. Through
his reading of *Guernica,* Matsumoto is thus able to articulate his own ideal
of avant-garde documentary filmmaking. It is indeed striking how much of
Matsumoto's argument about Resnais's *Guernica* is applicable to his own
works. To take the example of *The Song of Stone,* Matsumoto's treatment of
Ernest Satow's photographs through constant cropping, rotation, solariza-
tion, zoom, and superimposition clearly echoes Resnais's treatment of Pi-
casso's paintings in *Guernica*. What connects the two is the creation of a new
cinematic work through the process of remediating a work originally created
in another medium.[18]

In order to put Matsumoto's argument into perspective, we may turn to
André Bazin's comparable analysis of Resnais's treatment of Picasso's paint-
ing. In the famous essay "Painting and Cinema," Bazin appraises Resnais's
effort to offer new perspectives on the work of Picasso by inflicting a certain
violence upon the original paintings:

Films of paintings are not animation films. What is paradoxical about them
is that they use an already completed work sufficient unto itself. But it is
precisely because it substitutes for the painting a work one degree removed
from it, proceeding from something already aesthetically formulated, that it
throws a new light on the original. It is perhaps to the extent that the film *is*

a complete work and as such, seems therefore to betray the painting most, that it renders it in reality the greater service.[19]

The seeming "betrayal" of the original artwork is necessary, since it is "in pulling the work apart, in breaking up its component parts, in making an assault on its very essence that the film compels it to deliver up some of its hidden powers."[20] In other words, it is through the betrayal and the destruction of the original painting that the work of cinematic remediation can make visible what remains invisible in the original and do "the greater service." The key phrase here is "a work one degree removed from [the original]." It is this sense of removal or distance from the original that the practice of remediation generates. Returning once again to Matsumoto's reading of *Guernica,* we may surmise that the purpose of avant-garde documentary filmmaking lies in going beyond the visible surface of reality. On this point Bazin and Matsumoto are in agreement. For them, cinema is more than an indexical medium that faithfully records traces of reality; it is a visionary medium that reveals what remains inaccessible beneath the surface of immediacy.

Of relevance here is that the original work that gets remediated and defamiliarized is an already finished work done in a medium other than cinema. What the camera documents is not a boundless reality but a self-sufficient work. This is why the process of remediation is *second-order image making* that entails violent fragmentation and negation of the integrity of the original work, which then gives rise to effects of intermediality.

Understood in this light, the affinity between films such as *Guernica, The Song of Stone, Diary of Yunbogi,* and *Ninja bugeichō* becomes clearer. All are works of remediation that highlight the tension between the cinematic medium and the noncinematic media: painting, still photography, and the comic book, respectively. As I mentioned earlier, it is precisely this tension between cinema and other media forms that became pronounced in the discourse on *eizō* that flourished in the 1960s. The emergence of intermedial experiments is thus intertwined with this discursive rise of *eizō* as a dominant problematic in Japanese film and media discourses. This essay cannot fully address the development of the *eizō* discourse of the 1960s, but we can glimpse the increased currency of the term *eizō* by the sheer number of publications on the topic. For instance, Matsumoto's essay "On the Method of the Avant-Garde Documentary Film" was collected in the first book to bear the word "image" in its title: *Eizō no hakken: Avangyarudo to dokyumentarii* (1963, Discovery of the image: avant-garde and documentary). Other titles that became central to the discourse on *eizō* in the 1960s include Matsumoto's *Hyōgen no sekai* (1967,

The world of expression); Okada Susumu's *Hekiga kara terebi made: eiga no ata-rashii ronri* (1959, From cave painting to television: A new logic of cinema) and *Gendai eizōron* (1965, A contemporary theory of the image); Hani Susumu's *Kamera to maiku: Gendai geijutsu no hōhō* (1960, Camera and microphone: The method of modern art); and the anthology *Eizō to wa nani ka* (1966, What is image?).[21] Furthermore, in 1964 the journal *Eizō Geijutsu* (Image arts) was launched. Its publication accompanied the establishment of another artist collective, *Eizō geijutsu no kai* (The association of image arts), spearheaded by Matsumoto and documentary filmmaker Noda Shinkichi.

Ōshima's *Ninja bugeichō* appears right at the moment when the heated debates on the similarities and differences among various media that commonly share the element of *eizō* ("image") were unfolding. As I discussed in this essay, *Ninja bugeichō* not only exemplifies an intermedial tendency in cinematic experiments of the time but also intersects with a growing theoretical concern with cinema's medium specificity. Indeed, the emergent category of *eizō* media or image-based media, which encompassed cinema, television, video, and photography, forced many filmmakers and critics to rethink their assumptions regarding the specificity of each medium. The rise of intermedial experiments that transgress prescribed boundaries between media and the discourse on *eizō* that often subsumed various forms of media under the umbrella category of "image-based media" are hence complementary. Understood in this light, Ōshima's gesture to differentiate *Ninja bugeichō* from television animation all the while remediating the comic book medium is symptomatic of the anxiety generated by this changing media environment. Indeed, the tension between the desire to maintain cinema's specificity and to dissolve that specificity into the generic category of the *eizō* or image-based media would only grow stronger throughout the 1960s.

...

Notes

1. See, for instance, Okada Susumu, "Eizō no ronri to gengo no ronri," *Gendai geijutsu* 3 (1959): 100; and Matsumoto, "Saihan ni yosete," *Eizō no hakken: Avangyarudo to dokyumentarii* (Discovery of the image: avant-garde and documentary) (Tokyo: Seiryū Shuppan, 2005), 244.

2. The screening was phenomenally successful, which led the Art Theatre Guild (ATG) to fund Ōshima's acclaimed narrative film *Death by Hanging* (*Kōshikei*, 1968).

3. Kashihon Mangashi Kenkyūkai, ed. *Kashihon Manga Returns* (Tokyo: Poplar, 2006), 22.

4. Quoted by Yomota Inuhiko in *Shirato Sanpei ron* (A theory of Shirato Sanpei) (Tokyo: Sakuhinsha, 2004), 11. Shirato's works, such as *Band of Ninja* and *The Legend of*

Kamui, found a particularly large readership among leftist student activists and intellectuals in the 1960s.

5. I should note that the person who introduced *Ninja bugeichō* to Ōshima was Sasaki Mamoru, a scriptwriter who also worked for the television industry and wrote scripts for popular children's programs, such as the *Ultraman* series. Sasaki was also involved in a more activist circle of filmmaking led by people such as Adachi Masao and Matsuda Masao and frequently contributed to their journal *Eiga Hihyō.*

6. My use of the term "remediation" directly draws on the concept developed by Jay David Bolter and Richard Grusin in their book, *Remediation: Understanding New Media* (Cambridge, Mass.: MIT Press, 1999).

7. Okada Susumu, Sasaki Kiichi, Satō Tadao, Hani Susumu, eds. *Gendai eiga jiten* (Encyclopedia of contemporary cinema) (Tokyo: Bijutsu Shuppan, 1967), 155.

8. Ōshima Nagisa, DVD Pamphlet for *Ninja bugeichō,* in *Ōshima Nagisa 1*, DVD box set (Tokyo: Kinokuniya Shoten, 2008), 4.

9. Indeed, in the combination of stillness and camera movement, this film may evoke not only limited animation but also *kamishibai,* or "paper theatre," a medium with which Shirato himself was heavily involved before his transition to *gekiga* or comic books. For a detailed account of Shirato's career as a *kamishibai* artist, see Yomota Inuhiko, *Shirato Sanpei ron* (A theory of Shirato Sanpei) (Tokyo: Sakuhinsha, 2004), 28–35. For a consideration of the relation between *kamishibai* and limited cel animation, see Thomas Lamarre, *The Anime Machine: A Media Theory of Animation* (Minneapolis: University of Minnesota Press, 2009), 192–93, and Marc Steinberg, *Anime's Media Mix: Franchising Toys and Characters in Japan* (Minneapolis: University of Minnesota Press, 2012).

10. Ōshima Nagisa, "'Ninja bugeichō' no kao," *Art Theater: Ninja Bugeichō* 47 (February 1967): 12–13.

11. Noël Burch, *To the Distant Observer: Form and Meaning in the Japanese Cinema* (Berkeley and Los Angeles: University of California Press, 1979), 333.

12. One thing we must note is the fact that by the mid-1960s the style of limited animation had become solidified primarily through the works of television animators such as Tezuka Osamu and his production team.

13. According to Livia Monnet, the notion of intermediality "can account simultaneously for the interactions, mutual remediations or transformations, and the conceptual convergence between various media in a particular medium or (media) culture, as well as for the mutations in the discursive, representational and cultural practices produced by such (inter)media relations" (230). See Livia Monnet, "Towards the Feminine Sublime," *Japan Forum* 14, no. 2 (2002): 225–68. In her essay in this volume, Miryam Sas also points out the rising currency of the term "intermedia" in Japan during the 1960s. In addition, it is worth noting that a 1967 essay by Matsumoto Toshio references intermediality as one of the characteristics of underground American cinema, though he remains critical of the impression of novelty this term may imply. See Matsumoto Toshio, "Andaaguraundo shinema no kakushin" (The core of underground cinema), in *Hyōgen no sekai: Geijutsu zen'ei tachi to sono shisō* (The world of expression: The fine art avant-gardes and their philosophy) (Tokyo: San'ichi Shobō, 1967), 65–68.

14. Just to highlight this difference, it would be useful to see a brief clip from a television animation, *Shōnen ninja Kaze no Fujimaru* (Fujimaru of the wind). This was a

popular television animation series made by Toei Animation and aired between June 1964 and August 1965. *Shōnen ninja Kaze no Fujimaru* was also based on Shirato Sanpei's *gekiga*, called *Ninja senpū* (Ninja whirlwind). Made one and a half years later, Ōshima's film *Ninja bugeichō* is in many ways antithetical to the televisual adaptation of Shirato's work in *Shōnen ninja Kaze no Fujimaru*. Their differences, I argue, derive not only from the venues of their exhibition and distribution (movie theater and network television) or from their formats (serial and nonserial) but also, and more important, from the ways in which *Ninja bugeichō* foregrounds the audiovisual redundancy between the original comic book and the film, while *Shōnen ninja Kaze no Fujimaru* eliminates this redundancy.

15. It is hard not to see direct echoes of these techniques in Matsumoto's own films, in particular *Security Treaty* (1960, *ANPO jōyaku*), in which collage-like treatments of press photographs, drawings, and news footage abound. Matsumoto's "aggressively experimental filmmaking that politicized film style itself" was not well received. See Abé Mark Nornes, *Forest of Pressure: Ogawa Shinsuke and Postwar Japanese Documentary* (Minneapolis: University of Minnesota Press, 2007), 21. Matsumoto's fellow critics and filmmakers associated with the journal *Kiroku Eiga* denounced his arty "vanguard elitism" on the premise that the film was incomprehensible for the masses. See, for instance, Kizaki Keiichirō, "Zen'ei eriito no taishū sogai: Kiroku eiga undō no taishūteki genjitsu ni tsuite," *Kiroku Eiga* 24 (January 1962): 24–26.

16. Matsumoto, "Zen'ei kiroku eiga ron," 55. My translation.

17. Ibid.

18. This was the film Matsumoto made at the request of Tokyo Broadcasting System (TBS) television. While the original intention of TBS television was to produce a standard documentary program introducing Satow's photojournalistic career, Matsumoto took this opportunity to radically remediate Satow's photographs and to create a wholly new cinematic work. In order to do so, he was willing to sacrifice the very integrity of the original artwork. In Matsumoto's view, this violent remediation of the original was necessary in order to see beyond the surface, and to present this process of seeing otherwise as the basis of his avant-garde documentary method. Matsumoto's awareness of the transformative process of remediation is evident in his reflexive reading of his own act of filming *The Song of Stone*. The motif of stonecutting in Matsumoto's view allegorizes the very process of appropriating and transforming the still image medium of photography into the moving image medium of cinema. Just as Matsumoto animates Satow's photographs, the stonecutters bring life to inanimate stones. The technique of stop-motion animation is hence more than appropriate in this regard, as it allegorized the content of the images in its form. Matsumoto's *The Song of Stone* thus remediates a finished work created in the noncinematic medium in order to create an intermedial work, which retains the recognizability of the original work yet negates its integrity through a radical restructuring.

19. André Bazin, *What Is Cinema? Volume 1,* trans. Hugh Gray (Berkeley and Los Angeles: University of California Press, 1967), 169.

20. Ibid.

21. While I do not elaborate on this point, there was a series of essays published in 1958–60 that problematized the notion of *eizō*. This series constitutes what is known as the "Debate on the Image" (*eizō ronsō*).

MIRYAM SAS

Moving the Horizon: Violence and Cinematic Revolution in Ōshima Nagisa's *Ninja bugeichō*

Ōshima Nagisa's 1967 film *Ninja bugeichō* (*Band of Ninja*) and Walter Benjamin's 1921 "Critique of Violence" participate in two very different historical horizons of the theorization of violence. Yet they have something structurally in common: both envision or imagine an "other form" of violence that would interrupt the naturalized continuities of time and would challenge the current orders of law and state power. Both interrupt a temporal horizon, layering and challenging the perspectives of linear historiography with an altered trajectory of time. But in the case of Ōshima, this vision of a violent disturbance to the current order of law is performed through a literal movement of lines, the curving and curling, crossing and swirling of Shirato Sanpei and his sister's drawings, which Ōshima films directly into his rapid-fire and extended (131 minutes), nearly overwhelming montage, *Ninja bugeichō*.

Benjamin's ideas of violence, though obscure, were already a presence in the philosophical apparatus of the late 1960s and early 1970s Japan. Iconically, in Higashi Yōichi's slightly later film *Yasashii Nipponjin* (1971, Gentle Japanese), a politically engaged character working at a motorcycle repair shop reads out an excerpt from Benjamin's "Critique of Violence," while another character says bluntly that he has no idea what it means, no idea what such

264

philosophical discourse has to do with the day-to-day reality of the political struggle at hand.[1] The position Ōshima takes in his writings on this film draws in both poles of their debate: he argues that the "spirit of revolution" (political struggle) *and* the "spirit of experimentation" (philosophically, in relation to the medium) are both crucial to the "leap" that is *Ninja bugeichō,* a leap he asserts is necessary to challenge commonsense frames of cinema and social forms more broadly.[2]

Benjamin defines a contrast between lawmaking and law-destroying violence. He writes:

> If mythic violence is lawmaking, divine violence is law destroying; if the former sets boundaries, the latter boundlessly destroys them. If mythic violence brings at once guilt and retribution, divine power only expiates; if the former threatens, the latter strikes; if the former is bloody, the latter is lethal without spilling blood.[3]

On the surface, what could appear to be more in line with animation's plasticity than the image of a bloodless violence? Divine violence, which for Benjamin is a saving form of violence, "destroys boundaries" and as such moves edges, switches the lines around, changes fixed frames and perspectives. In his writings on this film, it is true that Ōshima is boundlessly interested in blood, "how people shed blood in order to change situations (*jōkyō*), and how history is moved by that blood."[4] Yet the blood thematized here is a form of line, a structure of perception that generates a perpetual, nonfinal, endlessly successive subjectivity of revolution.[5] In other words, what is important in *Ninja bugeichō* is not so much the individual death, the individual's blood, as the continual revival of what the film and *gekiga* envision as the energy and power of revolution from one generation and historical moment to another.

Kagemaru, the hero of *Ninja bugeichō,* represents a force of violence outside the law, like that theorized by Benjamin as follows:

> But if the existence of violence outside the law, as pure immediate violence, is assured, this furnishes proof that revolutionary violence, the highest manifestation of unalloyed violence by man, is possible, and shows by what means. Less possible and also less urgent for humankind, however, is to decide when unalloyed violence has been realized in particular cases.[6]

For Benjamin, though he is also interested in the possibilities of nonviolence, there is an interruption or breach, a caesura that comes to receive the name

Gewalt (a term that also means "power") that would be law destroying, breaking the naturalized continuity of time and "fate." Rather than "mythic violence," which for Benjamin constitutes a pernicious and rotten equivalent of law-making and the semi-invisible law-sustaining violence, this *other* kind of (somewhat messianic, call it "Kagemaru") violence is a saving violence, associated with life and with happiness. Benjamin calls it "pure power over all life for the sake of the living."[7] Though many scholars have commented on Benjamin's provocative declaration about the fundamentally brutal underpinnings of state military and legal sovereignty in order to critique recent political events, in looking at the horizon of 1960s Japanese film, it is resonant to consider the so-called divine violence side of his formulation. Activists in the 1960s were also interested in visualizing a kind of violence of revolution that would have a saving power and in creating the conditions of possibility for challenging that other more pernicious kind of violence. That said, the place of the activist is complicated in Benjamin's articulation by the assertion that it is not possible from a human perspective to know for certain when this saving violence of *Gewalt* has, in fact, been realized in particular instances. This may be because there is no human position fully outside the law, or in any case, even the imagining of a position for Benjamin requires the invocation of the divine or the "soul of the living."[8]

The narrator of Ōshima's film asks over and over about the film's hero, Kagemaru, "What are you?" In the opening of the film, the hero supports and provokes the peasants as they attack Fushikage castle, but he also does not hesitate to save the life of Sakagami Shuzen, the resident lord of the mansion, giving him a horse to escape the peasants' attack. His *Gewalt* (power/violence) and provocation have an enigmatic and anonymous quality, coming from the terrain of the beyond, where we are no longer in a position to judge in simple moralistic terms of good and evil.

Ōshima's 1967 *Ninja bugeichō*, distributed by the Art Theater Guild, came from a milieu where the question of revolutionary violence was rarely far from people's minds—nor, for that matter, were questions of military violence in relation to Japan's economic growth, to the U.S.–Japan Security Treaty (*Anpo*), and to Japan's support role in the Vietnam War. In the year of its release, the radicals of the anti-Narita airport struggle implemented a new kind of militant tactics for the first time.[9] Ōshima had long explored corporeal and sexual violence in cinema in relation to social revolution, from his *Night and Fog in Japan* (1960, *Nihon no yoru to kiri*), which most explicitly evoked debates and factional politics in the student movements, to *The Man Who Left His Will on Film* (1970, *Tokyo sensō sengo hiwa*), about which he wrote—in relation to the

Red Army Faction's so-called Tokyo War—that he was trying to discover in that film "whether one can engage in terror against oneself" (*mizukara no teroru suru koto ga dekiru ka*).[10]

Ninja bugeichō is the 1967 "direct" adaptation of Shirato Sanpei's hit *gekiga* (long-form dramatic manga) that appeared in seventeen volumes from 1959 to 1962. The movie played for a long run at Shinjuku Bunka theater under the genre title, *chōhen firumu gekiga* (feature-length film *gekiga*). There are significant things to be said about Ōshima's film as it functions *within* its commercial milieu—for example, his use of recognizable star voices, such as having Kagemaru voiced by Tōra Rokko, who had also starred in *Night and Fog in Japan* and in TV dramas, or having music composed by the well-known Hayashi Hikaru.[11] There are things also to be said about the cost-saving measure or material conditions of using Shirato's manga "as is," without making the drawings move in the conventional animated sense. In an article in this volume, Yuriko Furuhata writes about the film's place between media, as part of a discourse that holds to cinema's specificity while also marking cinema's loss of its privileged place in the broader realm of image-based media. The reflection on medium that this film performs is directly related to its stated intent as it was also presented to viewers: an appealing condensation of a "must-know" *gekiga* precisely on the subject of revolution, a revolution of the sixteenth century (1570s, the Eiroku era) that mapped interestingly onto contemporary theories and media representations of violent uprisings, including contemporary student protests, antiwar movements, and critiques of high-growth capitalism.

In other words, this is both a "popular" work, on the one hand—Ōshima wanted to reach as wide an audience as possible—and an "avant-garde" or experimental work, on the other, showing the permeable boundaries (or lack of separation) between these two realms in Japan in the 1960s. It is a work "about" violence and revolution, but it is also a work that knows that perceptions of violence in this historical moment are conditioned by the forms and consumption practices of image-based media, including manga, cinema, and television. Long and epic, the film can be overwhelming at 131 minutes. Shōchiku offered to distribute it only if Ōshima made significant cuts; and in the end, only ATG and Shinjuku Bunka's Kusui Kinshirō supported the work in its excessive and rapid-fire, mentally overloading form. Stills with voice-over

> RATHER THAN "MYTHIC VIOLENCE," WHICH FOR BENJAMIN CONSTITUTES A PERNICIOUS AND ROTTEN EQUIVALENT OF LAW-MAKING AND THE SEMI-INVISIBLE LAW-SUSTAINING VIOLENCE, THIS *OTHER* KIND OF VIOLENCE IS A SAVING VIOLENCE, ASSOCIATED WITH LIFE AND WITH HAPPINESS.

> "PEOPLE BELIEVE I AM MANIPULATING THE PEASANTS, BUT IF THEY DON'T HAVE ME, SOMEONE LIKE ME WILL COME INTO BEING. . . . EVEN IF I DIE, SOMEONE WILL FOLLOW."

and sound effects is a form Ōshima began to work with in the *Diary of Yunbogi* (1965, *Yunbogi no nikki*) two years before, and even earlier, it had found a place in works such as Matsumoto Toshio's *The Song of Stone* (1963, *Ishi no uta*); yet the narrative and visual overload of this film far exceeds the more bounded ambitions of these prior works. The script of *Ninja bugeichō* was published in the leading film journal *Eiga hihyō* (Film criticism) alongside that of Chris Marker's *La Jettée* (1962), another film consisting of rephotographed still images. While the work highlights its status as an experiment and reflects on visual temporality and memory like Marker's, it also explicitly thematizes here the problem of reaching a wide audience—of complicity with capital, of reaching the "masses," of what kind of leadership is necessary for a popular revolution to be truly popular. In their famous debates in 1968, Matsumoto Toshio criticized Ōshima for being too interested in drawing in a large audience and for continuing to work with the distribution networks of the large studios to achieve that end. Matsumoto argued that cinema could not be fundamentally transformed from within its existing structures. But within *Ninja bugeichō,* it is clear that Ōshima's stance on this issue is not fully one-sided: the problem of the relationship to the public remains an open question in this work.

In a key utopian moment, when the young ninja Jūtarō interrogates Kagemaru about his seemingly fruitless fight, Kagemaru replies: "People believe I am manipulating the peasants, but if they don't have me, someone like me will come into being. . . . Even if I die, someone will follow" (Figure 1). Kagemaru's battle cry describes a continual violence, an unending struggle of revolution whose agency is ultimately located outside himself. Throughout the film, he is shown both as a catalyst of peasant revolts against power and as a mysterious figure whose allegiances are unpredictable. He also never seems to die—his undeath perfectly suited to the still drawings and voice-over in a way that raises this aspect of the work to a reflection on the structure of the animated medium. Like Benjamin, Kagemaru (in the low, resonantly booming voice of Rokkō) invokes "happiness": "Even if they are torn or ragged, people will aim for their goal. . . . Until the day comes when the majority of people are equal and happy they will keep fighting"[12] Ōshima echoes this idealistic closing statement by Kagemaru in his writings on the film as if it were also his own motto in making the work.

Ōshima describes an unending but violent struggle that is posited as a "saving" form of violence. Even while the film ends with almost all the

characters dead, it is presumed that the few who live on, or the spirit they carry, will be revived in a later historical moment. Death is contingent here, and at least sometimes "bloodless"; and the emergent violence is undergirded with histories of loss and grieving. Kagemaru's (and elsewhere his teacher Mufū Dōjin's) refusal to die, refusal to rot, emblematize this "bloodless" loss, the living on beyond death, the spiritual survival of the fight. Whether framed in terms of plasticity or remediation, this survival finds ways formally to extend and interrupt the terminality of the moment and the horizon of singular perspective within a space of surprise.

FIGURE 1. Kagemaru declares: "If I did not exist, someone like me would always appear."

In a key scene, Mufū Dōjin brings Kagemaru's head to the powerful lord Oda Nobunaga, who has to pay Mufū Dōjin five thousand gold sticks for it (Figure 2). Still, the detached head speaks, and after its arrival (without the body) Nobunaga throws

FIGURE 2. The severed head of Kagemaru laughs.

one more sword at it to no effect. The smiling head laughs: it does not rot but just disappears mysteriously from the gate where it is later hung.[13] Questions of the medium come to the fore in the structural choices: the abrupt cuts, sometimes called aspect or affective transitions, reveal the *gekiga*–cinema interface. Is it the spirit of peasant revolt as mapped onto antiwar protests, the spirit of violent protest that will not die? If so, the structure of this violent interruptive power is one that embraces both (law-destroying) caesura and (revolutionary) continuity.

Ōshima finds that Shirato's *gekiga* has been seen as "nearly impossible" to adapt for the screen, except by the method he arrives at, of using the drawings as "material," "as they are." *Naite tamaru ka: manga jinsei* (March 1967, Crying, can you stand it? A manga life), a hit television series at this time, uses live action mixed with drawn stills to show ninja magic. These expectations of

> THE THRILL OF WATCHING THE NINJAS'
> MAGIC FIGHTING TECHNIQUES IS
> MOBILIZED (AND ALSO IMMOBILIZED)
> AS A MODE OF CINEMATIC PLEASURE
> AND AS A CALL TO REVIVAL OF
> REVOLUTIONARY ENERGY.

the ninja genre, on the one hand, and epic ninja genre music, on the other hand, make possible the "consumption" of this story, with its gorgeous reflections on the relations between *gekiga* and cinema, the deep intertwining of these media, and its exploration of the graphic force of both the moving and the still image in a kind of unlayered, hyperlimited animation. The incitement to the "right kind" of violence here collides with issues of commodification and/ or spectacularization—the force of the moving image, as it were, redirected into the interests of consumption, issues thematized in this work when the magic of ninja techniques comes to seem an allegory for cinema's magic—and the film asks the question: for whose benefit this magic, these techniques? The thrill of watching the ninjas' magic fighting techniques is mobilized (and also immobilized) as a mode of cinematic pleasure and as a call to revival of revolutionary energy.

Through the doubling and multiplication of identities and false faces or heads, the film continually brings into question what the "real" identity and goals of the "savior" figure are, and how to determine the right direction for this vital energy of revolution. What form of violence or breach or rupture is the "saving" kind? Is it possible from a human perspective, an agentic perspective (or even the spectatorial perspective) to be "outside the law," outside these power structures that at the very least constitute the conditions for, if not perniciously suppress, revolutionary hopes for historical change? How can one distinguish the "saving" kind of violence? What law of perspective, what mode of vision beyond the linear, would make it possible to envision this?

Affective identification with the characters and visual regimes is continually interrupted—one might say violently interrupted—by the constant cutting, lateral, sometimes shaking, movement of the camera, by the excessive epic complexity of the sheer number of characters, and by the continual rapid-fire montage of these drawn image materials "as they are." There is some degree of visual violence here: treading a fine line—allowing or tempting entry and then, by continual switching, exceeding the boundaries of one's grasp. Even the celebrity system comes up for thematization, with the crowd's "ha"s and "oh"s at Kagemaru's appearance.

Returning to Benjamin's "kinds of violence," then, we recall that the Japanese student movements also used the term *Gewalt* to distinguish their forms of violence from repressive police violence—for example, with their *geba-bō*

sticks, named for the German term. Popularly, we sometimes think of Ōshima as idealizing or even romanticizing violence—as a means of revolution, as a way "outside" the frames of the social, as opposed to Matsumoto's critiques of subjectivity "always-already-embedded-in-capital." But this work reminds us that in this moment of crisis for cinema as a whole, this moment of some confusion for the directionality of the student movements, Ōshima formulates a critique very much enmeshed in questions of capital, power struggles, problems of violence, and (capitalist and cinematic / spiritual and technological) reproducibility. Through this one-time technical exploration and "adventure," he participates in a larger milieu of animetic experiments that bring key questions of violence to the fore allegorically, thematically, and formally.

Some aspects of the belief in violent revolution are already being critiqued in the moment they are formulated, and the aspiration toward "violent revolution" may seem naïve in the present moment. Yet this work raises many questions relevant for contemporary studies of anime and manga. As 1960s animation feeds directly into more contemporary representations of violence in animation and limited animation forms, we can here begin to examine animation's complicities in and critiques of the orders of late capitalist culture. Becoming clear about the historical stakes and visual horizons for imagining the meanings of violence and revolution, we can frame an altered view of the relation between experimentality and commercialism, between representational violence and globalized media networks, or between transmedial practices and varying kinds of violent social forms.

Already in the early 1960s, one can see how the force of animation's moving image, and limited animation's specific uses of perspective may be mobilized for reflective (and in Ōshima's terms, "revolutionary") thought, while they may be (simultaneously) directed to forward commercial interests in the circulation of media itself. Problems crucial to understanding the nexus of limited animation's critical potential and the flow (redirection) of that potential into channels of "flatness" (sometimes linked to market globalization) are already seen in a revealing and intricate way, and are intimately a part of the struggle Ōshima and his collaborators open through the film *Ninja bugeichō*.

INTERMEDIA MOMENTS IN 1960S ANIMATION

Shirato Sanpei's *gekiga*, like all *gekiga* of this time, is already cinematic. The structure of its framing follows and is inspired by the kind of editing done in cinema; as in Tezuka Osamu's work, this is a crucial part of the form that allows

the creators to open out and spin long stories for volumes upon volumes. In this sense, *gekiga* is already an "intermedial" medium. At this moment, when cinema studies is focused increasingly on new media, on the "end" of cinema and mobility of platforms, it is useful to realize how prevalent the discourses of intermedia were in the mid-1960s,[14] and the kinds of experiments being performed across media at the moment when even the term "anime/*animeeshon*" was just coming to crystallize into the denotations it has today.[15]

Shirato's *gekiga* was in some sense an "underground" work, according to writer, director, and manga critic Takatori Ei. Takatori writes that, though Shirato at the time was publishing his serial stories in *Shōnen* (Boys) magazine and was a successful manga artist, *Ninja bugeichō* was published as a *kashihon gekiga,* which meant that it was not sold in bookstores. To read it, one had to go to rental book shops (*kashihonya*) located in small alleys. The *gekiga* series was published from 1959 to 1962 in seventeen volumes and was a big hit. Still, "no adolescent magazine that existed at the time would publish *Ninja bugeichō.*"[16] Ōshima writes that he read Shirato's work at the suggestion of Sasaki Mamoru, Abe Susumu, and Sano Mitsuo in fall of 1962.[17] Sasaki later wrote the screenplay. Ōshima came up with the intention to cinematize Shirato's work "as it is," using the original drawings by Shirato and his sister. Ōshima writes:

> The original drawings were 1.2 times as large as the published *kashihonya* book version, which is not very large. We shot these drawings with a close-up lens called Macro Kilar. The original drawings had some dirty spots and grids on them, so we lit them with a very bold light and used Eastman Plus X film to emphasize whiteness. In the book version, besides black and white there were grey parts called *hosome* (shading) that are not on the original drawing but are put in during printing, so here, without those, the black and white are accentuated even more.[18]

When one looks at the lines and shapes of Shirato's original drawings, one sees they are already full of movement, evoked by the curves and lines of the landscape and figures (Figure 3). When we study Ōshima's film frames, what is striking is both the immense *flatness* of using a drawing—like the visions of Picasso's painting in Alain Resnais's *Guernica* (1950), made famous in Japan by Matsumoto Toshio—and, at the same time, the gentle sense of depth and indeed shadow introduced by those gray lines and grids and erasures on the original drawing that Ōshima's bright light overexposure almost but not completely effaces. Is this the moment of moral ambiguity, the layers of

the image's history reminding us of the imperfect distinctions of "black" and "white," of shadow and layers of grey?

The Kage (shadow) clan is at the center of the story, a band of ninja mostly not related by blood but styled as a "family." They come to their warrior arts through a history of devastation, sorrow, and loss during times of war. The layers of the image remind me of William Kentridge's drawn films on South African apartheid, where the previous layers of the drawing remain visible under erasure, as a link to loss and a visualization of the potential generativity from out of that loss. The underlayers of these drawings by Shirato (and his rarely mentioned shadow co-artist, his sister) give a sense of temporal strata in a story that is very much *about* the superimposition of historical moments. This layering takes place on several levels. First, the time

FIGURE 3. Lines of landscape in Shirato's drawings, from the opening scenes of *Ninja bugeichō*.

of the student protest movements of the late 1960s is placed in parallel with the sixteenth-century peasant revolts against the aristocracy. But beyond this, within the extremely recursive drama itself, one sees the continual reappearance (and disappearance) of Kagemaru as he provokes yet another round of revolt and rebellion on the part of the oppressed. Further yet, the layers of identity of the Kage family work such that each is a *bunshin,* a potential substitute, for the others.[19] They are not just unionized or contractually linked, for, as Ōshima says, being merely "unionized" or organized does not suffice: they are intimately linked not just as a family but as alter egos for each other. And lastly, among the characters, it is not always clear who is who. Clearly, the making of the *gekiga* itself involved thousands of replicated drawings, hundreds of each character, but at times, within the narrative, the plot turns on the fact that identical characters are indistinguishable from each other. This element becomes significant especially around moments of beheading—of

determining who is killed or not killed. The character Onikichi, when beheaded, splits into eight identical copies of himself, and he asks his son to help find him his real head. At one point Onikichi peels off his face and reveals Kagemaru underneath (Figure 4). The shadow, the replication, the layers all thematize the layered quality of time itself (and of art); how the very idea of revolution and its formal process, the "spirit of the will of the people" as Ōshima idealistically puts it, is infused with shadow—or in this case one might also say the echo—and the voices and images of the people that come before.[20]

One might draw a link to the distributions of the sensible theorized more recently by Jacques Rancière—the coming into visibility or audibility of a particular world of phenomena that were otherwise outside of perceptibility—and how he links this to the "*quelconque*," the anonymous. For Kagemaru, our hero, masquerades as a figure of centrality, yet at his base he is an icon, holding the iconicity of animated figures' plastic lines and also the plasticity or replaceability of such an icon. On the one hand, Kagemaru has a distinct and recognizable, even beautiful, face; he is a "divine" or "ideal" figure, and his smile embodies hope. Ōshima said he wanted to make an "ideal immortal, ideal figure."[21] On the other hand, he holds a certain anonymous quality, a quality of the "*quelconque*." In his inimitable voice, he paradoxically declares his dispensability, his ultimate anonymity:

FIGURE 4. Onikichi splits into identical copies (*top*). Onikichi beheaded—his son's surprise as Onikichi asks the son to look for his head. Onikichi removes his face to reveal . . . Kagemaru underneath.

"If I were not to be here, someone would always come in my place." Ōshima puts it this way: "Kagemaru does not symbolize a self-proclaimed revolutionary party or a group. He symbolizes the will and

the power of the people who aim for change."[22] In the logic of the narrative, Kagemaru is one who can show up at any time, at any place. His shadow lurks under every line. His life lurks under every shape. Ninja magic is inherently possible at every moment of devastating loss, as a new life that can spring up and become part of the power of the shadow, the shadow that moves the horizon line of power that overturns the hierarchies of class and time.[23]

What happens when one takes these images and combines them into a film? Ōshima alludes to Eisensteinian montage, as yet one more layer.[24] Though the editing is extravagant in some ways, Ōshima also severely limits his options, using cuts, pans, tilts, close-ups with voice-over, sound, and music only with a direct appropriation of Shirato's original drawings "as they are." Abe Kashō calls the feeling of the editing a "gasping breath," an "absence of margins." He points out that in this rhythm, Ōshima may be influenced by the work of Masumura Yasuzō and Nakahira Kō, creating a sense of speed. Ōshima explicitly experiments with overturning the expected rhythms of cuts in live-action films. The effect of the editing in *Ninja bugeichō* is one of intense density, a sensory excess. After completing the film, Ōshima, in the hospital, writes the following note: "Edit based on the rhythm of the images themselves. [. . .] All current films are based on dialogue. Destroy this."[25]

This rhythm has intimately to do not only with shot length but also with the movement within images and hence with the structures of visual form within individual frames. A moment in the film that sums up this perspectival shift is the moment of *jibashiri* (running earth), when a violent conflict among characters is arrested by an inexplicable wave, something coming from the distance, that turns out to be an unstoppable swarm of (lemming-like) mice coming toward them, devastating everything in its wake until they reach the sea. The drawings show the skeletons the mice have picked over as they flatten the landscape. The lines of their approach shake as the camera shakes: "it is as if the horizon were moving," intones the deep voice of the narrator (Figure 5). The *jibashiri* sequence carries an allegory for the masses of starving peasants and children we have seen rise up behind or under the subtle provocation of Kagemaru to try to defeat and lay waste to oppressive regimes. But what is most striking in this scene is the quality of the line, the shaking horizon, the sense that the film itself might come undone at any moment. It is

FIGURE 5. The horizon moves. It is a swarm of mice approaching . . . and passing by.

the *n*th degree of movement: the already vibrant and plastic movement of Shirato's *gekiga,* itself an echo of the crosscuts and motion forms of live-action cinema, now cited back into a series of rapid-fire montages, camera stills and movement, visualizing a kind of insurgence (*ran*) of social forces almost as if they were (the ghostly echo of) the forces of nature, and also, an insurgence, a saving violence, of the cinematic realm itself.

Of course, one might hesitate to be too optimistic. People went to Shinjuku Bunka late at night, and they came home. Perhaps they came home all the more enamored of their favorite stars and composers, all the more ready to participate in the commercial culture of their time, all the more ready to watch more movies. The *flatness* of the landscapes of this film, along with their motion, points the way for Ōshima's participation in the landscape theory debates with his film *The Man Who Left His Will on Film* (1970, *Tokyo sensō sengo hiwa*), and here he has come to recognize, by the 1970s, that it is no longer a question of shedding blood: "In spite of the promise that each sect would fight with the determination to die, no one died. The battle of the 1960s came to an end. How can I die in the 1970s?" The understandings of violence shifted as the 1960s came to a close. The belief in a saving form of violence, the force of that belief and its visual and rhetorical discourses,

was redirected—without exactly being lost—into other horizons of movement. Some of these movements had to do with critiques of sexuality, as we see the movement of beheading and refusal to die shift in works like Ōshima's *Kōshikei* (1968, Death by hanging) and others. The 1970 Anpo generation nonetheless took one of Kagemaru's lines as a slogan for their struggle, a slogan that can itself crystallize the repetitive motion involved in pushing back the horizon of a political movement that has already been (and already, according to many, failed): "We have come a long way; and we have a long way to go." Abe calls it the "infinite succession of the revolutionary subject."[26] And yet, it should not be an infinite repetition without difference: the movement of lines and faces, the layers of shadow filmed by Ōshima in Shirato's images, show that the shadow of what came before lingers within or alongside the force of each new round of motion, each fresh and intimately "present" line—like the hand of Shirato's sister alongside his more famous one, like the tracing paper they each must have used to trace the lines and ninja arts/ techniques of the other. And then, like Benjamin says, it is not possible to ascertain whether "pure violence" of that kind has been attained in an individual case; in Ōshima's questioning terms, "for an age of change to move in a direction that can truly serve the people's happiness, what must we do?"[27] While it experiments with specific techniques of pure, hyperlimited animation, Ōshima's *Ninja bugeichō* is also a film that draws together, in exemplary ways for its era, how the problems of cultural transformations of thought ally with a horizon of linear movement framed and reframed on the boundaries of media.

Though its overall effect may exhaust, our minds can nonetheless hold however briefly to these constellations or specific moments, freeze-frames when, already ejected from Cartesian perspectivalism, we can synthesize an alternative visual horizon with the actively changing social process that Shirato and Ōshima put forward in this foundational work. Beyond the capacity or point of view of a single mind, we may be able to envision or imagine its "expiating" and "boundary destroying" path, its proposal of an animetic violence that could possibly be productive, lethal without spilling blood.[28]

Notes

1. Jonathan Mark Hall discusses this film in detail in "Gentling Okinawa: Walter Benjamin, Higashi Yōichi, and their Critiques of Violence" (Japanese Arts and Globalizations Conference, University of California, Riverside, May 16, 2010). An earlier version of this article was presented at that conference.

2. Ōshima focuses on the ways in which social forms are mediated, such that mass media is inseparable from social form. See the film's pamphlet (*chirashi*) notes, "Bōken, jikken, kakumei—*Ninja bugeichō* ni tsuite" (Adventure, experiment, revolution—On *Ninja bugeichō*) published in his volume of reviews *Kaitai to funshitsu: Ōshima Nagisa hyōronshū* (Dismantling and erupting: Collected essays of Ōshima Nagisa) (Haga Shoten, 1970) and also reproduced in *Ninja bugeichō* (Tokyo: Kinokuniya, 2008), 4–5.

3. Walter Benjamin, "Critique of Violence," in *Walter Benjamin: Selected Writings*, vol. 1 (Cambridge, Mass.: Harvard University Press, 1996), 249. Original in Benjamin, "Zur Kritik der Gewalt," in R. Tiedemann and H. Schweppenhäuser, ed., *Walter Benjamin Gesammelte Schriften*, vol. 2.1, (Frankfurt: Suhrkamp, 1999), 179–204. One might imagine reading these terms alongside the "constitutive" (lawmaking) and "constituent" power of the *otaku* movement.

4. "Bōken, jikken, kakumei—*Ninja bugeichō* ni tsuite," in *Ninja bugeichō*, 5.

5. Abe Kashō discusses this successive subjectivity of revolution in "Ōshima Nagisa no kokyū, Shirato gekiga no sen" (The breath of Ōshima Nagisa, the line of Shirato's *gekiga*), in the essay pamphlet released with the DVD of *Ninja bugeichō* (Tokyo: Kinokuniya, 2008), 20.

6. Walter Benjamin, "Critique of Violence," 252.

7. Ibid., 250.

8. Ibid.

9. See Sunada Ichiro, "The Thought and Behavior of Zengakuren: Trends in the Japanese Student Movement," *Asian Survey* 9, no. 6 (June 1969): 457–74.

10. Ōshima Nagisa, "How Do We Die in the 1970s?" (A brief comment on "Tokyo sensō sengo hiwa"), *Ōshima Nagisa chosakushū* (Collected writings of Ōshima Nagisa), vol. 3 (Tokyo: Gendai Shichō Shinsha, 2008), 136–38.

11. Hayashi was a composer who ultimately composed more than one hundred film scores, including that year's Ōshima selection *Nihon shunkakō* (1967, Sing a song of sex: A treatise on Japanese bawdy songs), the later *Kōshikei* (1968, Death by hanging) as well as *Akitsu onsen* (1980, Affair at Akitsu), among many others.

12. "Yaburete mo, hitobito wa mokuteki ni mukai, ōku no hito ga byōdō ni shiawase ni naru hi made tatakau no da."

13. Abe Kashō links this moment of Kagemaru's "audacious smile" upon beheading not only to numerous instances of beheading and strangulation in Ōshima's films but also to a famous line in the kabuki play *Tōkaidō yotsuya kaidan* (1825, Ghost stories at Yotsuya on the Tōkaidō) often cited by the film critic Hanada Kiyoteru, who was close to Ōshima. Abe Kashō, "Ōshima Nagisa no kokyū, Shirato gekiga no sen," 19.

14. "Intermedia" as a term was popularized in the mid-1960s by Dick Higgins, one of the founders of the Fluxus movement, who situates intermedia "in the field between the general idea of art media and those of life media." See Dick Higgins, "Intermedia," *Something else newsletter I*, no. 1 (1966): 1; Hannah Higgins, *Fluxus Experience* (Berkeley and Los Angeles: University of California Press, 2002), 221 n. 46. In Japan, by 1969 the term "intermedia" already had full acceptance, as demonstrated in the "Intermedia Arts Festival"—see the poster/brochure for this event in the archives of the Getty Institute. But well before Dick Higgins popularized the term, Sōgetsu Art Center in Tokyo was a crucial space in the late 1950s and especially early 1960s for supporting and developing an emergent

range of experiments across media that would come to be understood under the term. See also Miryam Sas, "By Other Hands: Environment and Apparatus in 1960s Intermedia," in *Oxford Handbook of Japanese Cinema,* ed. Daisuke Miyao (Oxford University Press, forthcoming), and "Intermedia," in *Tokyo: A New Avant-Garde,* ed., Doryun Chong (New York: Museum of Modern Art, forthcoming). In this volume, Yuriko Furuhata's essay, "Audiovisual Redundancy and Remediation in *Ninja bugeichō,*" for its reflections on remediation.

15. At a recent Eizō Gakkai (conference of the image/film studies association of Japan), Nishimura Tomohiro pointed out that the term "animation" came to be used as it is today to talk about a particular medium and process of production only in the postwar period, in the 1960s, through the work of *Animeeshon sannin no kai* (Three-person animation event) at the Sōgetsu Art Center and the simultaneous development of the Annécy Animation Film Festival. Before that time, a number of things could be called animation, under different names: *kage'e* (shadow pictures), puppet films, and certain geometrical abstract films under the title *zettai eiga* (absolute films); and then, of course, *manga eiga* (comic films). But the term *animeeshon,* as used in the early 1960s, and in particular in the 1964 Animation Festival at Sōgetsu, still encompassed quite a number of possibilities, not all of them necessarily using frame-by-frame shots of moving or changing drawings. Ōshima does not use the term, but calls this work a "chōhen firumu gekiga" (feature-length film *gekiga*).

16. Taketori Ei, "'Ninja bugeichō kagemaruden' no shōgeki" (The shock of 'Ninja bugeichō': the legend of Kagemaru), in *Ninja bugeichō,* 15.

17. "Ninja bugeichō seisaku memo" (Memo on producing *Ninja bugeichō*), in *Ōshima Nagisa chosakushū,* vol. 3 (Tokyo: Gendai Shichō Shinsha, 2008), 55–57.

18. Ōshima Nagisa, "*Ninja bugeichō* no kao" (The faces of *Ninja bugeichō),* in *Ninja bugeichō* (Tokyo: Kinokuniya, 2008), 8.

19. Ōshima, "Dokusōteki na, Kage ichizoku no kyarakutaa" (The original characters of the shadow clan), first released as an afterword in the ninth volume of *Ninja bugeichō* in 1969, when it was released in publisher Shōgakukan's "Golden Comics" series. Reprinted in *Ōshima Nagisa chosakushū,* vol. 4, 128–31.

20. Furuhata draws differing conclusions from another particular aspect of layering, the movement from manga to film. See her essay, "Audiovisual Redundancy and Remediation in *Ninja bugeichō*" in this volume.

21. Ōshima, "Dokusōteki na, Kage ichizoku no kyarakutaa," 131.

22. Ibid.

23. Ōshima writes on Shirato's work: "The [Kage family's] strange ways of fighting are acquired in the course of the struggles of an alienated and excluded life. These are the 'weapons' of life. They become arms for the struggle against the enemy in a class battle. Has there yet been a work that grasps the link between the life of the oppressed class and their struggle so clearly? Has there yet been a work that captured in such decisive images what arms are for the oppressed classes?" (Ōshima, "Dokusōteki na, kage ichizoku no kyarakutaa," 130).

24. "In the past, Eisenstein aimed to make a film out of a theory of capitalism. I am not so proud as to compare myself to Eisenstein, but I also don't aim to hide the fact that I am attempting to inherit/succeed him in his goal." "Bōken, jikken, kakumei," 4. Noël Burch follows this thought, calling this film, along with *Hakuchū no torima* (1967, *Violence*

at Noon), "significant attempts to come to terms with certain aspects of the radical edit-ing of Eisenstein's silent films." He points out that "each of these films [. . .] involves more than 2,000 separate shots (by way of comparison, we may recall that *Battleship Potemkin* contains about 1,500)." Burch, *To the Distant Observer: Form and Meaning in Japanese Cinema* (Berkeley and Los Angeles: University of California Press, 1979), 330. Ōshima claims that it is in fact about 4,000 shots, edited down from the 10,000 that he originally filmed, though I have not counted. Cited in Abe, "Ōshima Nagisa no kokyū, Shirato gekiga no sen," 22.

25. Ibid., 21.

26. Ibid., 20.

27. Ōshima, "Bōken, jikken, kakumei—*Ninja bugeichō* ni tsuite," 4.

28. One notes how the potential ethics proposed by this kind of movement stand in apparent contrast with the ethics of vulnerability (an ethics based on the inevitability of loss) envisioned by Judith Butler, following Emmanuel Levinas, in *Precarious Life: The Powers of Mourning and Violence* (London: Verso, 2004). But perhaps this film's emphasis on the face, the faces, can lead us back toward Levinas's "face of the other"; and the emphasis on shadow, on the loss underlying each new line, can also help align this form of animetic ethics with the fact of loss and inevitable erasure, at least for the instance of this work.

Anatomy of Permutational Desire, Part III: The Artificial Woman and the Perverse Structure of Modernity

This last installment of my essay on perversion in Hans Bellmer and in Oshii Mamoru's anime *Innocence* argues that the film elaborates a massive theory of the perverse structure of modernity. This theory manifests itself in three main forms: (1) the transformation of the human into a universal equivalent that promises yet fails to hold together a broad range of discourses on the modern subject; (2) the consequent stretching of the figure of "Man" to the snapping point, which is also registered as a crisis in the unities of classical animation; and (3) a moment of crisis of modernity that perversion can no longer manage, and this is where a new figure emerges, the gynoid. But rather than stepping in to ground the modern human subject and "his democracy," the gynoid forces us to begin modernity and democracy all over again, as if for the first time, but not in the form of critical or juridical reason but in material configurations themselves.

STRETCHING THE MODERN SUBJECT

When Batou (or Batō) and Togusa arrive at Kim's mansion, Kim hacks into their e-brains, generating three virtual-reality simulations to stall their

investigation. The simulations repeat with only slight variations. While Kim pretends to be dead in all three immersive VR "movies," he appears as his "real" self—a cyborg with a mechanical-electronic body and a partly human e-brain—only in the first simulation. In the second simulation, he adopts Togusa's appearance, and in the third, Batou's. Both Togusa and Batou burst open during these VR simulations, revealing an artificial anatomy of titanium parts and electronic circuitry that is indistinguishable from that of the gynoid dolls—an unequivocal indication that the two Public Security detectives, like Kim and Kusanagi Motoko, differ very little from the gynoids in their basic make-up. There are other variations. In the first simulation, Motoko appears as a doll pointing to a card on the floor inscribed with the Hebrew word *aemeth* (emet/truth), and in the second, she points to a similar card with the word *meth* (met/dead).[1] In the third simulation, Motoko does not appear, but leaves behind a card inscribed with her and Batou's secret communication code, the number 2051.

These virtual reality sequences are characterized by forms of reflexivity: reflexive moments in which their computer-generated nature is revealed (the white seagulls arrested in mid-flight in the inner patio of Kim's mansion) and explicit references to the "external memory database" in which individual and collective memories, knowledge, and sensory data are stored. In one scene, for instance, Kim zips through the simulations in an extremely rapid, "fast backward" fashion, to identify the intruder who has breached his firewalls.

The sequence also entails discursive reflexivity. Kim expounds on the perfection of soulless dolls, and on the continuity between eighteenth-century discourses on the human machine and contemporary discourses on artificial life and artificial intelligence. Referencing thinkers as diverse as Descartes, La Mettrie, Kleist, and Freud, Kim offers a rough, simplified overview of a complex philosophical tradition that sits at the crux of *Inosensu*'s philosophy of dolls and the human machine. Kim's speech entails a database structure insofar as various forms of knowledge, histories, and modes of thinking appear to be coeval and equivalent, within a personal "external memory database" that is but a fraction of the huge World Wide Web or "global memory database." What is more, because Kim's monologue takes place within the virtual reality simulations, it is situated as just another set of files within a larger database. Let us look at Kim's speech with its database structure in mind:

> KIM: The human is no match for a doll, in its form, its elegance in motion, its very being. The inadequacies of human awareness become the inadequacies of life's reality. Perfection is possible only for those without consciousness,

or perhaps for those endowed with infinite consciousness. In other words, for dolls and for gods. Actually, there is one more mode of existence commensurate with dolls and deities.

TOGUSA: Animals?

KIM: Shelley's skylarks are suffused with a profound, instinctive joy. Joy we humans, driven by self-consciousness, can never know. For those of us who lust after knowledge, it is a condition more elusive than godhood.

The doubt is whether a creature that certainly appears to be alive, really is. Alternatively, the doubt that a lifeless object might actually live. That's why dolls haunt us. They are modeled on humans. They are in fact nothing but human. They make us face the terror of being reduced to simple mechanisms and matter. In other words, the fear that, fundamentally, all humans belong to the void. . . .

Further, science, seeking to unlock the secret of life, brought about this terror. The notion that nature is calculable inevitably leads to the conclusion that humans, too, are reducible to basic mechanical parts.

BATOU: "The human body is a machine which winds its own springs. It is the living image of perpetual motion."[2]

KIM: In this age, the twin technologies of robotics and electronic neurology have resurrected the eighteenth-century theory of man as machine. And now that computers have enabled externalized memory, humans have pursued self-mechanization aggressively, to expand the limits of their own function. Determined to leave behind Darwinian natural selection, this human determination to beat evolutionary odds also reveals the desire to transcend the very quest for perfection that gave it birth. The mirage of life equipped with perfect hardware engendered this nightmare.

The interest of Kim's extended meditation on dolls and the modern paradigm of the human machine lies not only in its conflation of several symptomatic discourses but also in its evocation of what might be called *the perverse structure of modernity*. Kim begins by paraphrasing Heinrich von Kleist's "The Puppet Theater" (1810, "Über das Marionettentheater")[3] as well as Sigmund Freud's *The Uncanny* (1919, *Das Unheimliche*). Subsequently, as he evokes "science, seeking to unlock the secret of life," he builds on seventeenth- and eighteenth-century debates on the human machine (*homme-machine*

or man-machine) in which philosopher-scientists such as René Descartes, Thomas Willis, and Julien Offray de la Mettrie participated. Kim's monologue clearly strives to trace a certain lineage of the modern subject: from the mechanistic (Cartesian-cum-Enlightenment) paradigm, to the romantic notion of the man-of-imagination (via Kleist), and to the psychoanalytic Oedipal subject (via Freud's theory of the uncanny). Kim then moves from the Freudian subject to the postmodern cyborg, and finally to the utopian-dystopian notion of the posthuman, "postevolutionary" subject of human genetics and advanced communication technologies and techno-science.

> EVEN AS *INOSENSU* DRAWS ON A BROAD RANGE OF REFERENCES—LA METTRIE, DESCARTES, BELLMER, FREUD, GENETICS, AI, AL, AND CYBORG THEORY, THE FILM DRAWS ON THEM IN A MANNER THAT HIGHLIGHTS THE PROBLEM OF HUMAN LIKENESS AND HUMAN AS A SORT OF "UNIVERSAL EQUIVALENT."

Clearly, given its breakneck pace of historical allusion and philosophical citation, the speech aims not for accuracy but for speculative force. It thus conflates a series of subjects: the classic Cartesian subject, the subject of Enlightenment philosophies of the human machine, the disciplinary subject of the nation-state and modern disciplinary institutions such as psychoanalysis, and the "postevolutionary" subject of robotics, nanotechnology, and artificial life / artificial intelligence research. As Thomas Lamarre, Alison Muri, and other critics have noted, this type of conflation is rather common not only in postmodern and cyborg theory but in anime and critical writing on anime as well.[4] But such conflation has its reasons, both "internal" (that is, related to the discursive, aesthetic, and animetic logic of the film) and "external" (that is, related to the film's evocation of the discourses mentioned above, which come to the film as if from without).

Take, for instance, the film's engagement with Kleist's "The Puppet Theater." As Bianca Theisen has shown, in the puppet's center of gravity, Kleist sees a convergence of the dancing puppet, the puppeteer, and God.[5] Yet these figures remain effectively blind to one another. The puppet, for instance, does not know that it partakes of God's divine innocence and grace. Kim's speech evokes a similar paradox in its reference to the grace of dolls and of God (or gods), and its suggestion of an overlap between dolls, deities, and animals. Yet, just as Kim comments that "(dolls) are nothing but human," the film *Inosensu* insists on the problem of the imposition of human likeness upon dolls, gods, and animals, thus highlighting a question of the human that remains muted in Kleist's essay.[6] At stake then is the function of the human in establishing equivalency across domains. Indeed, even as *Inosensu* draws

on a broad range of references—La Mettrie, Descartes, Bellmer, Freud, genetics, AI, AL, and cyborg theory, the film draws on them in a manner that highlights the problem of human likeness and human as a sort of "universal equivalent."

In a similar manner, albeit for different reasons, Bellmer's theory of perversion establishes an equivalency or interchangeability between the human and the universe that also brings together doll, human, and universe. In Bellmer, such a "human–universal equivalent," needless to say, implies a perverse desire to abolish desire, to eradicate the other, and to reach "the limits of all objects" whereupon a sort of transcendence is achieved through a "cosmic marriage."[7] In other words, Bellmer's account reminds us that, when the human is situated as a sort of universal equivalent, it becomes stretched, twisted, distorted, or, in a word, perverted. It is not a comfortable place to be, and yet it is precisely this discomfort that Bellmer transforms into pleasure, into a liberation of desire via the bits and pieces of the human made exchangeable.

This is precisely what emerges in *Inosensu* with its evocation of diverse theories and philosophies and with its establishment of a sense of interchangeability and equivalency between humanoid characters—the Hadaly 2052 gynoids and Batou, Togusa, Kim, Kusanagi, coroner Haraway, other cyborgs, robots, and enhanced humans: a human–universal equivalent. And the film tracks three consequences of this situation. First, the human subject is paradoxically everywhere and nowhere. There are signs of the human at every turn, and yet the human subject is not merely split or under erasure; it drops out of existence. Second, insofar as violent demonstrations of human nonexistence fall predominantly on gynoid or "womanoid" characters, the film forces us to ask why the problematic of being human so insistently settles on woman, and what are the consequences for women? Third, as the example of Kim's speech suggests, the transformation of the human into a sort of universal equivalent is grounded in a database structure, which is in turn linked to the materiality or medium of animation. In sum, the establishment of a human equivalent is not merely a neutral or empty gesture. It entails a twisting of human and modern humanism in these three registers, which I refer to collectively as a perverse structure of modernity.

Before I look more closely at implications of "woman" and "animation" in *Inosensu,* however, I wish to conclude this section on the human equivalent with a qualification. When I speak of human nonexistence (as the other side of nonhuman existence), I am referring to the disappearance of the human as subject. Yet the human remains, and insofar as it plays the role of equivalent

(doubles the database structure), it remains precisely as *fiction*. The human image persists as a necessary fiction, necessary for the maintenance and perversion of the fiction of modernity.

THE PERVERSION OF ANIMATION

The tenuous fiction of the modern subject, then, is the first act in the staging of the perverse structure of modernity envisioned in *Inosensu*. Another staging concerns the paradoxical role of the woman, female doll, or gynoid. Why does the question of the human (as the modern subject) settle on female figures? In particular, the Hadaly gynoid is a central figure in so many different registers of the film that we cannot decide what she is: anagram, symptom, sign of perversion, paradigm, or a site of intersection or convergence of paradigmatically modern figures? In any event, the Hadaly gynoid somehow comprises such figures as the human machine (as in La Mettrie's model of "man" as a self-governed mechanical apparatus "that winds its own springs"); the doll; the puppet; the automaton (as in Romantic writers such as Kleist and E. T. A. Hoffmann; in Freud, and in the historical avant-garde writers including Bellmer and his fellow surrealist artists); and the female (and male) hysteric (as conceptualized by late nineteenth-century neurology and psychology and by countless other writers and artists, including Auguste Villiers de l'Isle-Adam and the surrealists André Breton and Bellmer). Oshii's Hadaly 2052 gynoid also evokes the female robot in modernist and avant-garde cinema (e.g., Fritz Lang's *Metropolis*) as well as the female cyborg in cyberpunk and post-cyberpunk film and fiction (e.g., the *Ghost in the Shell* and *Matrix* worlds) and in feminist cyborg theory (e.g., Donna Haraway).[8] In other words, the actual burden of equivalency falls on the gynoid. As such, we need to ask if (or to what extent) such a gesture constitutes a form of misogyny. After all, if the gynoid is asked to do so much work, is it because women are seen as readily exploitable, or inherently flexible and thus transgressive, or ideally suited for embodying and disavowing the negative effects of modernity, or all of the above? Insofar as it is possible to answer "all of the above," the gynoid serves as the absolute Other grounding the perverse structure of modernity. In this respect, as the ground for the film's structure, she is remarkably analogous to animation itself, that is, the ground of the film's expressiveness. Or more precisely, as I shall explain below, the gynoid embodies a crisis of animation, which corresponds to a crisis of the stability of male action as the embodiment of the modern subject.

Inosensu makes us aware of animation, as in the sequence of virtual-reality simulations, in which attention becomes focused on the minor details and thus technical features of animation as medium. As Kim discursively stretches the figure of the human across histories and philosophies, we watch human characters replay the same actions with slight differences, which forces awareness of them as actors, and not just as actors, as animated forms, stretching the human equivalency in another, performative dimension. The performative dimension is also evident in Kim's performance as Togusa, or in Batou's performance as a mechanical robot that explodes in the midst of delivering La Mettrie's aphorism on the human being as a mechanism that winds its own springs (Figure 1). These examples show how animation expression and modern discourses on the human act together to make flexible the human subject in specific ways.

But it is the Hadaly 2052 gynoid that becomes the archetypal character embodying the essence of animation. "She" may be said to at once condense, embody, and express what Lamarre calls the multiplanar animetic machine, becoming a specific instance of the *soulful-body-as-time-image*—an iconic figure produced by the crisis in the ability of character animation to coordinate movement across images.

Building on Guattari's notion of machinic heterogenesis, Lamarre argues that anime—or animation in general—may be regarded as a heterogeneous machine that unfolds into divergent series while at the same time folding into it, in a continuous process of implication, various modes of expression, abstract machines, and operative functions. While the basic technology of animation is the animation stand (or various techniques of compositing, often implemented with software in the case of digital animation and CGI), what enables the folding-out and folding-in, or explication into divergent series and implication of other machines, is the *animetic interval*—the indetermination, gap, or spacing that is generated by the encounter between the force inherent in the mechanical succession of images and the layers of drawings / layers of texture constituting the animated image. Underlying the apparatus of animation is a multiplanar machine, a technics of compositing that works through the multiplanarity or multiple layers of the image, working with the relation between the planes of the image to make it hold together under conditions of movement. Thus the anime machine entails a specific mode of *technical determination* rather than technological determinism, operative submission, or submission to the logic of the market or to media convergence.

Techniques of limited animation, in Lamarre's account, tend to flatten

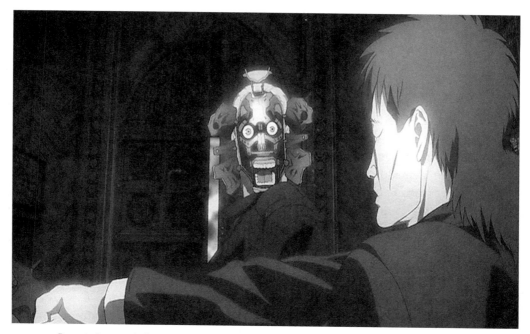

FIGURE 1. Batou's face explodes, revealing a robotic anatomy identical to that of the gynoids. From the sequence of virtual simulations sent by Kim, in *Inosensu* (2004).

the animetic interval and to bring its forces to the surface. Multiplanarity is flattened into superplanarity, tending toward a superplanar image favoring techniques of flat compositing, and generating a distributive field—a perceptual field whose elements are at once densely packed and dehierarchized, and which implies lines of sight across structures of exploded projection (or unfixed, mobile viewing positions). As a result of the superplanar image's production of a distributive field, and of its disseminating of the force of the animetic interval across the image surface, there ensues a crisis in the ability of character animation to coordinate movement. Anime's "solution" to this crisis (which is analogous to the crisis in the movement-image that generated the time-image in Deleuze's account of modern cinema) is to produce its own time-image: a character that is unframed, liberated as it were from classical cinema's or full animation's logic of frame, montage, and suture. This is what Lamarre calls the *soulful body*—an "encephalized" anime character whose heart, soul, and mind are inscribed on its body, and whose erratic, uncoordinated leaping across various media forms and platforms generates countless character franchises, as well as prequels, sequels, and spin-offs in manga, videogames, television series, and feature films. Epitomizing anime's explosion across a vast range of media in an effort to implicate other abstract and expressive machines while folding out into divergent series, the

time-image-soulful-body is more often than not cast as a gynoid/shōjo girl who is assigned the mission to save (or destroy) the world.[9]

Something analogous happens in *Inosensu*: as the figure of the human (Man) is stretched to the limits of its ability to ground equivalency across domains of existence (animals, machines, deities), the classical paradigm for grounding truth and human action goes into crisis. Yet there is precisely where the gynoid appears. Consider, for instance, the gynoid's identity as a revamped Bellmerian Doll / Bellmerian woman appearing as an animated image on Batou's GPS detector in the movie's introductory sequence, or appearing as male doubles—Batou, Togusa, and Kim—in Kim's virtual-reality simulations. The Hadaly gynoid seems to embody the crisis of male action as the stable embodiment of the human subject in several ways.

First, she provides a *principe de perversion* that literally connects heterogeneous domains of *Inosensu*'s narrative and visual worlds. She is, for instance, conflated with both Motoko and Kim, who, as experienced hackers, can infiltrate any e-brain, mind, or computer system, and produce any number of animated images or simulations. As such, Motoko and Kim are instances of *image-producing machines* that exfoliate or unfold into divergent series. But, insofar as these series then double back or fold over on themselves, they become instances of *machinic perversion,* at once implying mediatic analogies to the psychic hystericization of perversion, and doubling psychoanalytic and philosophical discourses on perversion.

Second, the gynoid dolls and their doubles traverse and thus produce relations across heterogeneous domains of the social: the environment of the affluent businessmen and bureaucrats who purchase gynoids as sex toys; the yakuza underworld mediating between these rich clients and Locus Solus; and "incorporeal Universes of value"[10] such as seventeenth- and eighteenth-century philosophies of the human machine or postmodern cyborg theories. As such, they become abstract machines in their own right, taking on what Guattari calls "an efficiency, a power of ontological affirmation."[11] I would qualify this sort of abstract machine as perverse, because, even as it connects disparate domains, it doubles implied connections between male actors and/or male worlds.

Finally, there is Kusanagi Motoko's position as a "perverse" political seer. Her positionality is perverse insofar as it appears to operate at once outside and between dominant institutions and dominant discursive or visual regimes. Apparently, she is thus able to inhabit and to manipulate the animetic interval, or the gap between layers of the image / layers of meaning. The site of crisis doubles as a site of control. In the virtual-reality simulations, for

instance, Motoko literally inhabits the space between the law (represented by Batou and Togusa) and Kim's world of perverse fantasies and delusions. Interestingly enough, this advantageous positionality—which allows Motoko not only to send warnings and coded messages to Batou but also to slip in and out of or between actual and virtual machines of visibility—also ejects her out of the frame, out of the logic of suture (of Kim's VR simulations). In this way Motoko is able to function, not only as perverse political philosopher, as

> THE CAST OF DOLLS, AUTOMATA, AND ROBOTS APPEARING IN *INOSENSU* NOT ONLY UNDERSCORES THE MOVIE'S CONCEIT ABOUT HUMAN(OID) MACHINES AND MACHINE HUMANS BUT ALSO POINTS TO THESE CHARACTERS' POTENTIAL TO GENERATE TRANSMEDIAL FRANCHISES.

animetic interval, and as double of the Hadaly gynoid / the Bellmerian doll but also as the iconic figure of the soulful body in Lamarre's conception of the anime machine.

Kusanagi literally leaps from body to body and screen to screen. She appears now as an elderly lady in the grocery store where Batou buys food for his dog, now as a doll in the entrance hall of Kim's mansion, now as a gynoid doll fighting alongside Batou, or as a luminous image on his GPS detector. At the same time, the character of Kusanagi has already been leaping across various media platforms and traversing various image regimes, databases, and planes of immanence, more animations, spin-offs, and tie-ins. Thus, in the end, it is possible to imagine the blonde, blue-eyed doll Togusa's daughter receives as a present in the film's finale as a spin-off of Motoko's borrowed form as a gynoid doll. As such, the cast of dolls, automata, and robots appearing in *Inosensu* not only underscores the movie's conceit about human(oid) machines and machine humans but also points to these characters' *potential to generate transmedial franchises.* The crisis in male action as an embodiment of universal equivalency seems to enable a multimedia "matrix" in which the gynoid is literally the underlying "matter" or body, perversely submitting to and controlling the world.

CONCLUSION: (THE WOMAN'S) BECOMING-WOMAN-OF-BECOMING-DEMOCRATIC

Looking at *Inosensu* in conjunction with one of its principal sources (Bellmer) has shown that the work of both Oshii and Bellmer is structured and informed by an anagrammar, a logic of permutation lying just below conscious

awareness that comes to the surface in modes of desire that may be characterized as perverse in that they at once flatter and defy the received, socially sanctified configurations of desire. In Bellmer this anagrammar verges on a desire for transcendence, via an experimental, quasi-metaphysical *principe de perversion* that ascribes to art the capacity to abolish the limits of the self and the body. Articulated in diverse forms—transgressive eroticism, pornography, fantastic-monstrous creatures, violent deformations and mutilations, and the suspension of gender and genre distinctions, Bellmer's art settles on the permutational Doll as the ideal fetish or perverse signifier. His theory of the "physical unconscious" provides not only a road map for interpreting his oeuvre but also one of the most cogent articulations of the central role of the perverse in twentieth century avant-garde art.

Inosensu translates the Bellmerian anagrammar of perversion into a database, or a distributive field of densely packed, dehierarchized elements that also functions as the material ground for animation, which sometimes surfaces in the film as a sort of metalanguage.[12] Perversion in *Inosensu* is consequently broader and more radical than in Bellmer, yet less psychoanalytically oriented: while hystericizing and feminizing the perverse worlds with which it engages, it also mobilizes perversion's reflexive, metadiscursive potential—its ability to question its own delusions and transgressions, and to create new perverse fictions and experiments that harness earlier modes of perversion as their own primary perverse structure. What I have described as the metaperversion of Motoko's politics of active involuntarism—the "perverse" posture of the Deleuzian thinker who is able simultaneously to evade dominant institutions, discourses, and activisms (including those of the left) and to articulate a strong critique of the global capitalist present—constitutes an instructive instance of *Inosensu*'s exploration of perversion's metanarrative potential.

Inosensu is also distinctive in its insistence on the *perverse structure of modernity*. Here, too, there is a metalevel articulation: the modern subject's paradoxical identity as a fiction or a fabrication that is also a blind spot of its own self-observations. At the same time, however, as we have seen, the film stretches the human to the snapping point as it strives to preserve the human as the universal equivalent for a sprawling set of modern discourses. Yet, I have argued, it is actually the figure of Man that is pulled so taut that the figure itself reaches a point of crisis: male action cannot ground a forward-moving, goal-oriented "classical" narrative but finds itself spread so thin that the remnants of narrative appear as nothing other than a perverse metalanguage. Out of this crisis appears a new figure, the gynoid, but rather than stitch up the film, she allows it to unravel across media worlds. Consider the

plural role of the Hadaly 2052 gynoid: at once serial killer and suicidal hysteric; guardian angel and *femme fatale*; and iconic, "encephalized," soulful-body-as-time-image that can be endlessly dis- and reassembled across media fields. As such, the film implies that animation itself is, in essence, perversion. And as if to prove its point, it constructs isomorphic series of perversion across different levels of the film and different media.

The result of this forced isomorphism that posits perversion at every level of existence is a vision of the *tragicomic nature of perversion*: *Inosensu* suggests that the Hadaly 2052 gynoid, as well as Batou, Togusa, Kim, and Kusanagi are tragic because they cannot own their own bodies and minds, or even their own perversion. It is as if they know that their pervertedness disguises an inherently tragic structure of subjectivity. These characters' perverse acts, then, imply trauma—their acts are symptoms suggesting that the characters themselves are little more than instruments of the Other's perversion. Take, for instance, Kim's choice to become a mechanical doll, Motoko's choice to remain an invisible artificial intelligence, and Batou's insistence that one's identity, perception, and experience may be but an illusion. With such existential dilemmas, *Inosensu* suggests that perversion may also be read as the subject's defense against the devastating truth of its tragic structure—the idea that "the structure of subjectivity always fails to realize the promise of reconciliation with respect either to the self or to the object."[13]

In its insistence on the notion that *perversion is always an Other's* (or is always the Other), *Inosensu* appears to agree with the arguments of Lacan, Copjec, Deleuze, James Penney, and other theorists regarding perversion's character as psychical structure, whose kinship is with psychosis and neurosis.[14] It also appears to resonate with a long-standing debate in animation theory concerning the tendency of animation to posit its characters and images either as "automata that struggle" to liberate themselves from animators' authoritarian control over their lives, or as archetypal characters whose "intelligence" and more or less evolving, adaptive behavior are part and parcel of the accidents and mutations of the algorithms and software constituting them.[15] Still, the movie's approach to perversion and animation, in other respects, is distinct from these readings: as I have suggested in this article, the difference in *Inosensu*'s conception of perversion lies above all in its articulation of the perverse across vast scales of existence, as the enabling condition of animation, as contemporary global capitalism, and as modernity in general.

In the second part of this essay, I explored the critical promise of the politics of active involuntarism in the context of Kusanagi Motoko. However, this promise of a relentless critique of the present by means of various forms

of "disengaged commitment" and the creation of new concepts remains ambivalent and mired in contradictions. An iconic soulful body produced by a multiplanar animetic machine she also embodies, Kusanagi is visualized as a dense constellation of more-or-less familiar concepts, images, and projections. Among such figurations we find an invisible, omniscient artificial intelligence corresponding to a neo-Platonic concept of the sexless mind; the clichéd male fantasy of the "battling babe"-as-guardian angel; the notion of a bodiless fugitive who is legally defined as a nonperson, or a *no-body*; an oxymoron whose existence is so tenuous and problematic that Batou can only define her as a package of data, an artificial memory that is indistinguishable from the Net, and which may be invaded or erased by other, equally powerful artificial memories (Figure 2).[16]

Yet, when we look at this active involuntarism in light of the crisis of Man that occurs when the human is stretched to the limits of equivalency, we are able to situate the active involuntarism of the female or gynoid characters somewhat differently. Insofar as her active involuntarism emerges from the crisis of male action, the human, and the modern subject, she emerges at a particular point of political crisis—that of the failure of political equality or democracy to ground itself in anything but modern rationality gone perverse. In this respect, then, the film affords a vision of *the becoming-woman of becoming-democratic*. As such, a whole new series of questions arises.

What if the movie's discourse on perversion were a deceptive lure, a simulation covering over another, even more complex "world" or (virtual) reality, that of political equality? What if the Hadaly 2052 gynoids were to build an alliance with other abused gynoids, female cyborgs, and female humans, and start a feminist or (a "gynoidist") revolution? What if a posthuman, egalitarian socialist society were to supplant the global domination of the corrupt, militarized, neocolonial techno-capitalism that is depicted in *Inosensu* (and which clearly reflects current global conditions)?

Such possibilities are briefly and rather evasively evoked in Oshii's movie: coroner Haraway, a female cyborg officer employed by the city police, suggests in her conversation with Batou and Togusa that the Hadaly 2052 gynoids' serial murders and suicidal drive are not so much motivated by personal revenge but rather by an emerging movement of resistance to humans' exploitation of robots among the robot population; Batou and Motoko express compassion for the Hadaly gynoids in their interrogation of the girl who seems to be the only survivor of Locus Solus's criminal "ghost-dubbing" business. (This sympathetic sentiment, however, becomes compromised by Batou and Kusanagi's merciless massacre of the robot dolls in the preceding sequence.) *Inosensu's*

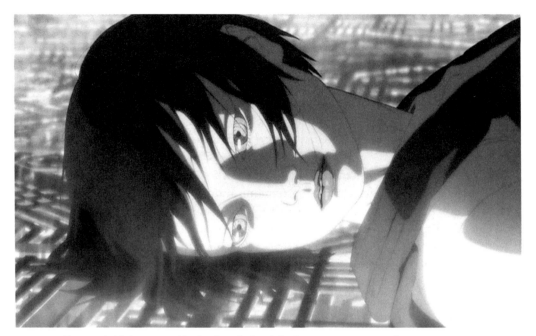

FIGURE 2. Kusanagi's lifeless gynoid body after she has left, disappearing again in the universe of the Net. From the finale of *Inosensu* (2004).

discourse on animals' innocence and devotion to beauty and life (which may be seen in Kim's lecture on dolls as well as in the tender bonding between Batou and his basset hound Gabriel) also seems to point to a utopian assemblage or an emerging human-machine-animal social formation.[17] Further promising possibilities may be found in the movie's ambivalent, humorous-parodic imagination.

Indeed, several scenes and episodes in *Inosensu* suggest that the movie does not take itself quite as seriously as it appears at first sight, and that its perverse unconscious, or "datanagrammar" of perversion, modernity, and the art of animation may be regarded as a parody. Instances of the comic-parodic imagination at work in Oshii's movie are legion: the touching scenes showing the basset hound Gabriel's boundless happiness when Batou finally returns to his lonely apartment late at night and begins to prepare the dog's favorite dish; Batou and Togusa's teasing banter on information-carrying DNA as the essence of life during their flight to Etorofu; the hilarious (if unmistakably sexist) portrayal of feminist cyborg theory guru, Donna Haraway, as a middle-aged, chain-smoking, masculine female cyborg advocating robot rights and artificial life research. As to Motoko, there may be more than meets the eye, too, in her ambivalent stance of simultaneous complicity with and rejection and transcendence of the system that has abused her: I am thinking here of

a "perverse scenario" in which Motoko would take full advantage of the very "perversity" of her position to institute a postperverse episteme of postdesire: since perversion, as we have seen, is synonymous both with the constant displacement, and with the abolition of the Other and of desire (i.e., the renunciation of *jouissance*); and since Motoko is able to function simultaneously as the woman who can create, control, and be her own image, and as a powerful metatechnology (or an abstract machine) that can manipulate, or even substitute herself for the Other; as the plane of immanence, and the becoming-woman through which all other (nonhuman) becomings and (nonhuman) forces of the cosmos have to pass in their desire to escape the traumatized bodies with which modernity and global neoliberal capitalism have endowed them, it would seem that *Inosensu* identifies Motoko as the only locus for the articulation of a *new, postperverse paradigm of democratic feminine becoming.* The perverse in this post-utopian, postevolutionary vision would still be effective, but as its very opposite—such that the other would only be real if it absorbs an other's becoming-woman and nonhuman becoming, and if it offers the other, in its turn, its own becoming. In this new paradigm conservation—rather than endlessly expanding consumption—, mutual interfacing and mutual enlightenment—rather than ruthless exploitation, competition, and exclusion—would be the rule. Does this mean that perversion can be written out of the picture? *Inosensu* suggests that it may, at the very least, be written over, laughed at, and turned against itself. Both Bellmer and Oshii, in their fascinated contemplation of the avant-garde's/modernity's *principe de perversion*, seem to have overlooked a simple truth: the Artificial Woman (who they thought would be amenable to the constant dis- and reassemblings provoked by their perverse, masculinist fantasies) has a mind of her own.

Notes

1. The cards showing the words *truth* and *death* allude to Jakob Grimm's version of the golem legend as recounted by Batou.

2. Batou quotes here from Julien Offray de La Mettrie's *L'homme machine* (1747, *Man a Machine*).

3. Also known as "On the Marionette Theater."

4. See Lamarre, *The Anime Machine: A Media Theory of Animation* (Minneapolis: University of Minnesota Press, 2009), 427, and Alison Muri, *The Enlightenment Cyborg: A History of Communications and Control in the Human Machine 1660–1830* (Toronto: University of Toronto Press, 2007), 28–29.

5. Theisen, "Dancing with Words: Kleist's 'Marionette Theatre,'" *MLN* 121, no. 3 (2006): 522–25.

6. While *Inosensu*'s recourse to Kleist's essay is rarely mentioned in the sizable body of critical and theoretical commentary on the movie, it is fairly explicit. Compare the first paragraph in Kim's monologue on the perfection of dolls with the passage describing the grace of puppets in Heinrich von Kleist, "The Puppet Theatre," in *Selected Writings*, ed. and trans. David Constantine (Indianapolis: Hackett Publishing Company, 2004), 413–14, 416.

7. The reference is to Bellmer's theory of perversion, and to Hal Foster's reading of Bellmer's Doll as a perverse Bataillean erotic object. See my discussion in "Anatomy of Permutational Desire: Perversion in Hans Bellmer and Oshii Mamoru," *Mechademia* 5 (2010): 285–309; and "Anatomy of Permutational Desire, Part II : Bellmer's Dolls and Oshii's Gynoids," *Mechademia* 6 (2011): 161–62, and 168, note 18.

8. *Inosensu*'s evoking of a wide spectrum of archetypal figures of modernity occurs directly through citation (as in the brief appearance of a variant of the Bellmerian Torso Doll in the opening sequence, or in the quotes from Villiers's *L'Eve future* and La Mettrie's *Man a Machine*) and indirectly through paraphrasing, allusion, and other intertextual/ intermedial operations.

9. See Lamarre, *The Anime Machine*, 1–44, 471–91. See too Félix Guattari, *Chaosmosis: An Ethico-Aesthetic Paradigm,* trans. Paul Bains and Julian Pefanis (Bloomington: Indiana University Press, 1995), 40–45, 50–53, 55–56; and Gary Genosko, *Félix Guattari: An Aberrant Introduction* (London: Continuum, 2002).

10. See Guattari, *Chaosmosis,* 53.

11. See ibid., 35.

12. The term "metalanguage of animation" is inspired by Lev Manovich's recent argument that contemporary animation-based artworks show recurrent characteristics such as deep remixability, variable forms, and continuity. According to Manovich, this aesthetics points to contemporary animation's character as metalanguage or metamedium. See Manovich, "Understanding Hybrid Media," in Susan Buchan et al., *Animated Painting,* 36–45 (San Diego: San Diego Museum of Art, 2007).

13. See James Penney, *The World of Perversion: Psychoanalysis and the Impossible Absolute of Desire* (New York: State University of New York Press, 2007), 34.

14. See ibid., 1–34, 173–219.

15. Cathryn Vasseleu, "A Is for Animatics: Automata, Androids, and Animats," in *Living with Cyberspace: Technology and Society in the 21st Century,* eds. John Armitage and Joanne Roberts (New York: Continuum, 2001), 85, 91.

16. Consider, for instance, Batou's comment to Togusa that his "guardian angel" Motoko is definitely alive, merging somewhere with the global digital information network.

17. On the utopian machinic assemblage of human beings and animals in *Inosensu,* see Steven Brown, "Machinic Desires: Hans Bellmer's Dolls and the Technological Uncanny in *Ghost in the Shell 2: Innocence,*" *Mechademia* 3 (2008): 222–54.

CONTRIBUTORS

DAVID BEYNON is senior lecturer in the School of Architecture and Building at Deakin University, Australia, and practicing architect at alsoCAN Architects in Melbourne, Australia.

FUJIMOTO YUKARI is associate professor of global Japanese studies at Meiji University. She is the author of *Watashi no ibasho wa doko ni aru no: shōjo manga ga utsusu kokoro no katachi* (Where do I belong? The shape of the heart as reflected in girls' comics), *Kairaku denryuu: onna no, yokubo no, karachi* (Electric current of pleasure: The form, of women's, desire), *Shōjo manga tamashii* (The soul of shōjo manga), and *Aijō hyōron: "Kazoku" o meguru monogatari* (Love critique: Stories of "family").

YURIKO FURUHATA is assistant professor of East Asian studies and faculty member of World Cinemas Program at McGill University.

CRAIG JACKSON is assistant professor of mathematics at Ohio Wesleyan University.

REGINALD JACKSON is assistant professor in the Department of East Asian Languages and Civilizations at the University of Chicago.

THOMAS LAMARRE teaches East Asian studies, art history, and communication studies at McGill University. His books include *Shadows on the Screen: Tanizaki Jun'ichirō on Cinema and Oriental Aesthetics*, *Uncovering Heian Japan: An Archaeology of Sensation and Inscription*, and *The Anime Machine: A Media Theory of Animation* (Minnesota, 2009).

JINYING LI is assistant professor of film studies at Oregon State University.

WAIYEE LOH is a doctoral student in the Department of English and Comparative Literary Studies at the University of Warwick. She was formerly a librarian at a performing arts library in Singapore.

LIVIA MONNET is professor of comparative literature, film, and Japanese studies at the University of Montreal. She has published extensively on animation, media art, and Japanese and world literature and cinema.

SHARALYN ORBAUGH is professor of Asian studies at the University of British Columbia.

STEFAN RIEKELES lives in Berlin. He was the program director of the International Symposium on Electronic Art in 2010 and the artistic director of the Japan Media Arts Festival Dortmund 2011. He has curated the exhibition *Proto Anime Cut—Spaces and Visions in Japanese Animation*, currently on tour in Europe. He is the deputy chairman of Les Jardins des Pilotes.

ATSUKO SAKAKI is professor of East Asian studies at the University of Toronto. She is the author of *Obsessions with Sino-Japanese Polarity in Japanese Literature* and *Recontextualizing Text: Narrative Performance in Modern Japanese Fiction* and the translator and editor of *The Woman with the Flying Head and Other Stories* by Kurahashi Yumiko.

MIRYAM SAS is professor of comparative literature and film and media at the University of California, Berkeley. She is the author of *Experimental Arts in Postwar Japan: Moments of Encounter, Engagement, and Imagined Return* and *Fault Lines: Cultural Memory and Japanese Surrealism*.

TIMON SCREECH is chair of the history of art and archaeology at the School of Oriental and African Studies at the University of London and permanent visiting professor at Tama Art University, Tokyo. He is the author of several books, including *Obtaining Images: Art, Production, and Display in Edo Japan* and *Sex and the Floating World: Erotic Images in Japan, 1700–1820.*

EMILY SOMERS is a transgender academic, currently a Social Sciences and Humanities Research Council postdoctoral fellow at Simon Fraser University.

MARC STEINBERG is assistant professor of film studies in the Mel Hoppenheim School of Cinema at Concordia University, Montréal, Canada. He is the author of *Anime's Media Mix: Franchising Toys and Characters in Japan* (Minnesota, 2012).

MATT THORN is associate professor in the Faculty of Manga at Kyoto Seika University. He is the translator and editor of Moto Hagio's *A Drunken Dream and Other Stories* and Shimura Takako's *Wandering Son.*

CALL FOR PAPERS

 The goal of *Mechademia* is to promote critical thinking, writing, and creative activity to bridge the current gap between professional, academic, and fan communities and discourses. This series recognizes the increasing and enriching merger in the artistic and cultural exchange between Asian and Western cultures. We seek contributions to *Mechademia* by artists and authors from a wide range of backgrounds. Contributors endeavor to write across disciplinary boundaries, presenting unique knowledge in all its sophistication but with a broad audience in mind.

The focus of *Mechademia* is manga and anime, but we do not see these just as objects. Rather, their production, distribution, and reception continue to generate connective networks manifest in an expanding spiral of art, aesthetics, history, culture, and society. Our subject area extends from anime and manga into game design, fan/subcultural/conspicuous fashion, graphic design, commercial packaging, and character design as well as fan-based global practices influenced by and influencing contemporary Asian popular cultures. This list in no way exhausts the potential subjects for this series.

Manga and anime are catalysts for the emergence of networks, fan groups, and communities of knowledge fascinated by and extending the depth and influence of these works. This series intends to create new links between these different communities, to challenge the hegemonic flows of information, and to acknowledge the broader range of professional, academic, and fan communities of knowledge rather than accept their current isolation.

Our most essential goal is to produce and promote new possibilities for critical thinking: forms of writing and graphic design inside as well as outside the anime and manga communities of knowledge. We encourage authors not only to write across disciplinary boundaries but also to address readers in allied communities of knowledge. All writers must present cogent and rigorous work to a broader audience, which will allow *Mechademia* to connect wider interdisciplinary interests and reinforce them with stronger theoretical grounding.

Due dates for submissions for future *Mechademia* issues

January 1, 2013 Mechademia 9: *Origins*

January 1, 2014 Mechademia 10: World Renewal: *Parallel Universes, Possible Worlds, and Counterfactual Histories*

Each essay should be no longer than five thousand words and may include up to five black-and-white images. Color illustrations may be possible but require special permission from the publisher. Use the documentation style of the *Chicago Manual of Style*, Sixteenth Edition. Copyright permissions must be sought by the author. Forms will be provided by the *Mechademia* staff.

Submissions should be in the form of a Word document attached to an e-mail message sent to Frenchy Lunning, editor of *Mechademia*, at flunning@mcad.edu. *Mechademia* is published annually in the fall.

Please visit http://www.mechademia.org for more information.